WHITE SIGHT

WHITE SIGHT

VISUAL POLITICS AND PRACTICES OF WHITENESS

NICHOLAS MIRZOEFF

THE MIT PRESS
CAMBRIDGE, MASSACHUSETTS
LONDON, ENGLAND

The MIT Press would like to thank the anonymous peer reviewers who provided comments on drafts of this book. The generous work of academic experts is essential for establishing the authority and quality of our publications. We acknowledge with gratitude the contributions of these otherwise uncredited readers.

This book was set in Arnhem Pro and Frank New by New Best-set Typesetters Ltd. Printed and bound in the United States of America.

Library of Congress Cataloging-in-Publication Data

Names: Mirzoeff, Nicholas, 1962– author.
Title: White sight : visual politics and practices of whiteness / Nicholas Mirzoeff.
Description: Cambridge, Massachusetts : The MIT Press, [2023] | Includes
 bibliographical references and index.
Identifiers: LCCN 2022009613 (print) | LCCN 2022009614 (ebook) |
 ISBN 9780262047678 (hardcover) | ISBN 9780262373098 (epub) |
 ISBN 9780262373104 (pdf)
Subjects: LCSH: White people—Race identity | White nationalism. | Slavery. | Visual
 communication.
Classification: LCC HT1575 .M57 2023 (print) | LCC HT1575 (ebook) | DDC
 305.8—dc23/eng/20220429
LC record available at https://lccn.loc.gov/2022009613
LC ebook record available at https://lccn.loc.gov/2022009614

10 9 8 7 6 5 4 3 2 1

CONTENTS

ACKNOWLEDGED

My work here must begin by acknowledging who I am. I acknowledge my own complicities and engagements, disavowals and refusals of and with whiteness and white masculinity. To begin at the beginning, I acknowledge being a person clearly identified as white in the United States. In the United Kingdom where I grew up, I was identified as not-Black but not fully English. My last name and being visibly Jewish disqualified me at once. This particularly English situation is one that Black British scholar Hazel Carby calls *"The Question!"*[1] The question is often, "Where are you really from?" Or "That's not an English name is it?" In whatever form, it demands an answer, sometimes under threat of violence, real or symbolic. These tensions led to the use of Black in 1970s' Britain as a political affiliation against organized racism when I was a teenager, bringing together people of African, Caribbean, and Asian descents. Identity became something that was worked toward, creating what Stuart Hall called an "unfinished conversation." In John Akomfrah's elegiac film of that title, Hall joked that when he asked people where they're from, "I expect a very long answer."[2] If whiteness is a place, this book is my response to that question.

In the United States, almost all the operations of the color line in the settler colony remain active, and I acknowledge that I have, like it or not, benefited from its privileges. No one needs to remind me that I am far from perfect in this or any other regard. It's not about me, though. It's about the kind of "we" that we want to be. I acknowledge writing to you from Lenapehoking, the ancestral lands of the Lenape people, who have been for the most part expelled from the region, even though New York City still has the largest "urban Indian" population in the country. What is now Washington Square, where I live and work, was also part of an area known as Land of the Blacks under the Dutch. A small group of Africans were designated as "half free" on condition that they grew food for the nascent settler community. The land that they farmed is buried today

beneath a thirty-foot layer of soil, comprised of ballast from transatlantic shipping.[3]

To acknowledge beginning from this kind of ground is to think in layers, or as geologists put it, stratigraphically. Art historian Sarah Elizabeth Lewis resonantly calls it "groundwork."[4] In the making of white sight, those layers sediment on top of each other to form what the revolutionary psychiatrist Frantz Fanon called the "white mask."[5] The mask is not the skin, given that Fanon specified "Black skin" as its counterpart. Nor is it the face. It is a set of assumptions, concepts, infrastructures, learned experiences, symbols, and techniques that form a screen by which a person makes white reality. The point of the mask is to keep whiteness's dominance invisibilized. As a central figure in what Cedric J. Robinson named the Black radical tradition, Fanon's insights have resonated with me, not least for his persistent engagement with Jews (see especially chapter 6).

Throughout this book, I've learned from the Black radical tradition, from James Baldwin, Angela Y. Davis, and C. L. R. James, to Robinson himself, how to think white sight. Legal scholar Joanne Barker points out how laws regulating Indigenous "status and rights are central in defining the conditions of power for those classified as 'white.'"[6] This book engages with this long contemporary, which Lorenzo Veracini calls "the settler colonial present."[7] The same is of course true for Black people as the simple list *Dred Scott v. Sanford*, *Plessy v. Ferguson*, and *Brown v. Board of Education* makes clear. In that context, as Christina Sharpe has shown, "Black being appears . . . as the insurance for, as that which underwrites, white circulation as the human."[8] It follows that in defining a Black gaze, Tina Campt has written, "Blackness is the elsewhere (or nowhere) of whiteness."[9] Whiteness cannot be understood without thinking at those intersections and with this learning. My work here situates my own ambivalent placing within that whiteness as a person in Jewish diaspora whose very body is the product of empire, primarily in relation to the Indigenous and Black radical traditions in the Atlantic world. I acknowledge that this framing is "all incomplete," while also bearing the knowledge that no one person or book can be adequate to the task.

I acknowledge learning in particular from these traditions about the use of visual materials in discussing the making of whiteness. Placing racist imagery in circulation yet again in order to criticize it is not going

to make the change I want to see and perpetuates harm. It is more important to keep the focus on making whiteness on and around white bodies than to once again share racist caricatures of Africans. To that end, I have sometimes redacted racist imagery and often not reproduced it. For example, I chose not to reproduce J. T. Zealy's daguerreotypes (chapter 2) while Tamara Lanier's court case for the restitution of the depictions of her ancestors Renty and Delia Taylor was underway. By the same token, I have used activist images rather than the work of photojournalists wherever possible (unless the photo is itself the story) because visual activism frames the world in different ways.

Far from marking a new moment in human history, the financial globalization known as neoliberalism that was brought to a halt by the COVID-19 pandemic was another inflection within this long history of colonization. Everything from biometrics to drones and the era of big data has recently been understood as part of the five-centuries-long structure of European racializing, settler slavery, and settler colonialism.[10] What remains to be done, as it has since "1492," the mythical origin of that project, is to finally decolonize.

Nowhere has this been more the case than with whiteness. The five years during which I worked on this book were constituted by repeated shocks known as Trump, Brexit, and Bolsonaro (to mention just three), marking the resurgence of what had, perhaps optimistically, been thought to be a past moment of overt white supremacy. When I presented my work around the Black Lives Matter movement at colleges and universities in 2016, it was uncomfortably obvious that the audience was almost entirely white.[11] Just as some friends and colleagues had urged me, whiteness was the subject presenting itself. Aware of existing whiteness studies from scholars such as Cheryl Harris, Matthew Jacobson, George Lipsitz, Nell Irvin Painter, David Roediger, and my former graduate instructor Richard Dyer at the University of Warwick (to name but a few), I was not sure how I could contribute.[12] The historians like Jacobson and Roediger had given us a clear road map of how different people became considered to be white over time. Legal scholar Harris showed how whiteness is a vital form of "property interest," while Painter's monumental history of the concepts of whiteness has become a classic. I acknowledge in particular Lipsitz's concept of the "white spatial imaginary."[13]

When I watched with appalled amazement the 2017 Unite the Right rally in Charlottesville, Virginia, around the statue of Confederate general Robert E. Lee, leading to the murder of counterprotester Heather Heyer, it became horrifyingly clear that as well as this scholarship had been done, there was now more to do. In his 1997 classic *White*, Dyer urged his readers that "it is important to come to see whiteness."[14] Now whiteness was as visible as can be, yet the problem was far from solved. Dyer was fully aware of what he called "the power of whiteness," but it would not then have been possible to imagine a US president hailing murderous neo-Nazis as "very fine people." In the interim, whiteness had been powerfully rethought by scholars like Houria Bouteldja, Alana Lentin, Aileen Moreton-Robinson, Dylan Rodríguez, and Patrick Wolfe.[15] I am working in the wake of this changing tradition.

I had worked on monuments, museums, public art, and statues in the 1990s and early 2000s at the beginning of formulating what became "visual culture," a now-commonplace but once controversial formula. In 2017, it became clear that whiteness was deeply connected to everything that visual culture might be. My task was to learn how to use the new ideas about whiteness in this dramatically changed context. Of course, in thinking about making whiteness in the visual field, I come in the wake of many—perhaps first the many Bergers: John Berger, the lamented Maurice Berger, and Martin Berger.[16] Then come a host of illuminating writers like Daniel Blight, Jill Casid, Aruna D'Souza, Shawn Michelle Smith, and Laura Wexler, to name but a few.[17] And yet the context is worryingly different. The general crisis of whiteness that became visible in 2016 accelerated to the point of insurrection in 2021. I acknowledge, finally, that the whiteness discussed in this book is always concerned with the long formation of this crisis, meaning that there are many other optics I am aware have not been covered in one short book.

INTRODUCTION
THE STRIKE AGAINST WHITENESS

[handwritten annotation: yes, in theory — but how much control do children of white parents really have?]

White sight is a key operating system of what it is to make whiteness. To adapt feminist Simone de Beauvoir's formula, one is not born but rather becomes white. It is a learned cultural system, not an innate characteristic. It follows that one person by themselves does not have white sight. The invented collective "white people" do. Always seeing from above, white sight surveys land and places all life under surveillance. To do so, it connects a set of infrastructures, centered first on the statue and state, backed up by statute, and later on the imperial screen. Today that screen has shattered into countless personal devices. White sight does not see everything there is to see but projects a white reality. Any failure to conform to this reality is corrected with violence.

Caribbean philosopher Sylvia Wynter defines this way of being in the world as "monohumanism," which acts "as if it were the being of being human."[1] Monohumanism means that there is only one way to be fully human, which becomes known as whiteness. Other-than-white people, needless to say, see and experience lived realities. The visual politics and practices of whiteness nonetheless seek to create a time and space such that people identifying as white can act as if their reality is all there is. The philosophers have only interpreted this sensory world.[2] My point is to strike against it. The strike is the refusal to live within white sight's erased, patriarchal, racializing, violent reality.[3] It is a general strike for consent in the visible relations between people.

[handwritten annotation: LOVE THIS]

[handwritten annotation: useful universalism reference]

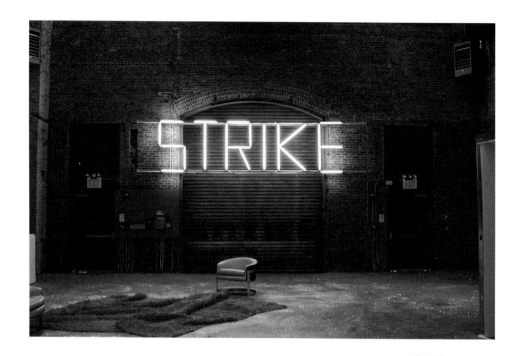

Claire Fontaine, *STRIKE (K. font V.I)*, 2005.
Wall mounted, white fluorescent tubes,
red gelatine filters, transformers, spacers,
movement detector and circuit-breaker.
135 × 6,500 × 40 mm. Installation view:
Grey Flags, The Sculpture Centre, New
York, May 2006. Courtesy the artist and Frac
Aquitaine, France. Photo: James Thornhill.

White sight came into being in Renaissance Europe as part of the transition to Atlantic world racial capitalism, enabled by slavery and colonialism.[4] At the other end of this long historical journey, the strike against whiteness now seeks to make the transition into a decolonized and decolonizing future. These are the politics of the long contemporary that stretches back to 1492. The contemporary is a way of being with those times that are present, those histories that constitute our present, and are still present. The contemporary is time "out of joint," in Hamlet's words, in which the delayed and disrupted present and future of decolonizing exists alongside past forces of colonization, and future ambitions of neo-colonialism. The strike in this contemporary is old and always renewing itself. It has to refuse and resist the external structures of whiteness, and its internal cultural unconscious. Whiteness lives, as it were, in this reservoir of type and stereotype that continues to return like the monster in a horror movie.

In 2020, all of those material, psychological, and temporal layers became visible as what the theorist of the Black radical tradition Cedric J. Robinson called a "racial regime."[5] White reality was torn and began to fail, creating a general crisis of whiteness. This crisis made visible the multiple pasts that are present in the version of reality that white sight projects. And it made another future possible. The strike against whiteness transformed local and personal refusals into a global movement. It opened what the writer Arundhati Roy called a "portal" to a different future.[6] To make that opening into a space where it might be possible to live, white reality must be unbuilt.[7] Whiteness's strike-breaking response was the US Capitol insurrection on January 6, 2021—a literally monumental act to reconstitute white reality. This insurrection continues at the time of writing, targeting democratic and reproductive rights. The feminist strike against whiteness and insurrection for patriarchal white supremacy are both possible futures at present.

It is this ongoing struggle that is both the backdrop to this book and its rationale. It is not a history of white people, which we already have, or a history of representations of whiteness, which is implicit within art history.[8] It is a tactical mapping of the contemporary forms of white sight and white reality—and the strike against them—that constitute our present and are still present. In this introduction, I first set out the

"implicit" is the relevant word
for me — I'm trying
to make that explicit

key features of white sight, white infrastructure, and the cultural unconscious of whiteness that sustain white reality. I then turn to the constitution of the strike against whiteness that makes another world visible. I conclude with a summary of how the book maps the historic layers and circuits of whiteness in the contemporary Atlantic world across its eight chapters.

relevant for my analyse of perception

THE VISIBLE

What is visible in white sight is not simply the result of vision. The visible is an event that takes place between more than one person. Vision is personal, always interfaced with other forms of perception. The visible event in question here is the embodied interface between people, between people and other-than-human life, between people and media, and between people and machines. By machines, I mean not just today's CCTV and optical scanners but also the plantation, ship, and state, all of which were understood in their own time as artificial machines. In short, what white sight sees is made, not found. → *active*

The visible is "raw material, product, and labor too."[9] Any visible event is its raw material. Its products range from surveying to surveillance and the visualized forms of data, from the graph to maps and the digital photograph. There is labor in looking, and even more in the looking that makes a person appear as white. As Karl Marx famously put it, "The *forming* of the five senses is a labor of the entire history of the world down to the present."[10] When engaging in "racializing surveillance," that labor is also designed to ensure the labor of others, which is the work of the overseer on the plantation, the foreman (gender intended) in the factory, and today's ubiquitous supervisors.[11]

As these examples suggest, visible events do not take place in conditions of our choosing but rather according to the "levels of the relations of force" operating within the visible.[12] The resulting products of the visible are arranged in a hierarchy, necessarily unequal and unstable. In this case, whiteness is its product, always rendered visible. This visible is not "natural," even when expressed through bodily characteristics like skin tone or skull shape. It is a relation of force. It forms a series of layers, as

used today in the Adobe Photoshop software that is the dominant means of visualizing data. Some layers are seen in the final output, and others are invisible yet nonetheless there.

The resulting visible divides and hierarchizes human perception into distinct senses, rendered visible but not simply visual.[13] In this way, the Black feminist theorist of visual culture Tina Campt has shown how to listen to images by conceptualizing "sound as an inherently embodied process that registers at multiple levels of the human sensorium."[14] These layered relations of force produce white sight as a hierarchy, at once racializing and patriarchal, which is then projected onto external reality. It is "real" in that it constrains and shapes experience every day, but it is not equally experienced, let alone simply "true."

> great quote for intersection of whiteness with patriarchy in sight

WHITE SIGHT

How does white sight see white? Perspective was the means of white sight for Atlantic "settler slavery," as historian Zach Sell has named the colonizing expansion of Europe.[15] As this process began to take off, Abraham Bosse (1602–1676), professor of perspective at the Royal Academy of Painting and Sculpture in Paris, imagined seeing as a projection in which the eye sent out curved rays because the eyeball is curved.[16] Bosse drew the artist sitting down, looking up at the nude goddess Venus. The male gaze is already here, long preceding its global dissemination in film. Its projection takes possession of the woman's body, just as colonization was depicted by means of a white man gazing at a nude Indigenous woman. In the psychoanalytic sense, male desire is being projected onto the modest yet enticing Venus, making the male viewer innocent.

Bosse taught artists to use perspective to correct for this curvature. In his drawing of perspective, three white men in uniform stand, heads tilted down, holding four strings to their eye in perfect straight lines to mark a space on the ground. Together the string and lines make a pyramid going into the eye. If white vision was a projection, it was combined in perspective with light coming into the eye to form white sight.[17] This engraving is not just a technical drawing, as has so often been discussed. I see it now

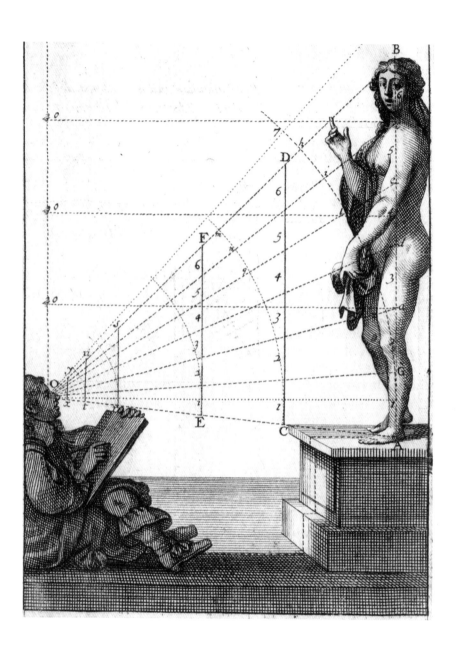

Abraham Bosse, "On the Practice of
Drawing by Eyesight," in *Traité des pratiques
géométrales et de perspective* (Paris, 1665).

as a metonym of white sight and its colonizing processes. All the soldiers look from above, using the "bird's-eye view" that has underpinned visuality as a colonial technology. They claim the space in the square that they have erased by their looking, reinforced with the threat of force from their swords. As W. E. B. Du Bois put it, whiteness is "ownership of the Earth forever and ever, amen!"[18] White sight registered, maintained, and administered that ownership.

To state the obvious, the soldiers in Bosse's engraving are white, chromatically and in the racializing sense, and unimpeded by any shadow or reflection caused by the strong light source coming from outside the frame to the right. Perspective was a powerful place from which to survey and conduct surveillance—the key practices of white sight. In this looking unfolds a process which the theorists Fred Moten and Stephano Harney call "a conversion of emptiness into world."[19] Notice the letters defining the erased white space as calculable data. White sight is always measurable, quantifiable, and therefore real, creating one of the first forms of an ongoing "data colonialism."[20] It makes a white reality in which "'what there is' depends on the way 'one sees it.' And the way one sees is shaped today by the coloniality of knowledge and of being (sensing, seeing, feeling, hearing)."[21] The strike against whiteness is, and has always been, anticolonial. Here and elsewhere I use *anticolonial* to mean practice and politics in support of decolonizing, whether by the colonized or their allies.

White sight measured land taken from the Indigenous and worked by enslaved labor in chains, a unit of approximately twenty-two yards. It surveyed real estate, meaning both land and enslaved human beings in the British Empire. Both could be mortgaged, creating the debt-financed global economy.[22] The real here means "royal," from the Spanish. Sovereignty—the power of the king or state—is the colonizing capacity to distribute, order, and withhold life. Bosse's drawing, which depicts no act of bodily harm, is as violent an image as can be imagined—a seeing in chains (see chapter 1).

Imperial white sight placed an imaginary screen between the colonizer and colonized. As described by British art critic and imperial apologist John Ruskin (1819–1900), the English viewer should assume that a mile-square sheet of glass was placed between him—gender intended—and

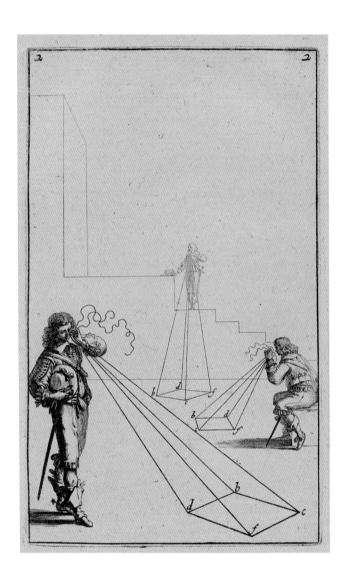

Abraham Bosse, "Perspective," in *Manière
universelle de M. Desargues pour pratiquer
la perspective par petit pied* (Paris, 1648),
pl. 2. Courtesy of the Royal Institute of
British Architects.

relevant for "Llyn -y- Can"

what was to be depicted (see chapter 4). The work to be made was then focused by a perspective structured around what Ruskin called a "sight point," rather than the vanishing point of classic perspective.[23] As intended, the imperial screen created an emotional and cultural barrier, preventing the viewer from identifying with what was being looked at. To be on the imperial side was to be white, the powerful sensation of being the spectator, not the show. This distancing was more than a place to see. It became a place to shoot, whose emotional and physical separation allowed for the perpetration of astonishing violence at home and in the colonies.

The domestic consequences included spectacular misogyny and heteropatriarchy. There is no better example than Ruskin himself, divorced from his wife, Effie Gray, for "non-consummation" of the marriage caused by what she said was his "disgust" at her body. He was nonetheless an avid consumer of images of young girls, causing his own biographer to label him a pedophile.[24] In the colonies, the violence was such that contemporary archeologist and curator Dan Hicks has called it "World War Zero."[25] At the 1898 "battle" of Omdurman in what is now Sudan, the British Army machine gunned 11,000 people to death and wounded 16,000 more—many of whom were subsequently executed—at the cost of only 48 deaths and 342 wounded.[26]

World War I broke the imperial screen by applying its techniques of mass slaughter at "home" in Europe. In the middle of the war, white supremacist Madison Grant, later a board member of the American Museum of Natural History, published the first popular expression of what has become known as the "replacement theory," the panic that white people are being replaced by immigrants. Motivated by photographs of the dead published in English newspapers, Grant called for "the elimination of those who are weak or unfit" in defense of the threatened "Nordic" race.[27]

When examining the case made by anthropologist Pierre Clastres that Amazonian peoples resisted the state, anthropologist David Graeber suggested that Amazonian men really feared the imposition on them of the kind of violent power they deployed over women.[28] The same can be said of whiteness. It can only imagine its own violent hierarchy reversed so that the out-of-control killing it practices, whether via the police, punitive expeditions, or single-person mass shootings, would be visited on white

people. This projection has been constitutive of white sight since the first failure of the imperial screen, prompting the compulsive effort to restore it. The settler colonialism that did its best to replace Indigenous peoples now fears a turnabout.

American studies scholar Dylan Rodríguez has accordingly identified the past fifty years as a "White Reconstruction," a resurgence of the violent aspiration toward Wynter's monohumanist "White Being" that nonetheless rests within "the ongoing half-millennial civilizational project."[29] Its visualizing avatar is the drone.[30] In 1982, at the beginning of what is now called neoliberalism, a drawing published in *Aviation Week* showed an uncrewed aerial vehicle made by Israel Aircraft Industries in combat "operations against surface-to-air missiles in Lebanon" (no artist was credited). It emits a narrow pyramid of lines that form a white square, reminiscent of Bosse's perspective.[31] The square projected by the drones is formally known to the military as a "kill box." The kill box is exactly what it sounds like: an arbitrary area visible to the drone, in which the drone operator is given permission to kill.[32] That operator is not present on-site but looking at a screen, often thousands of miles away. The result is a layering of white sight, combining the narrow viewpoint of perspective with the imperial screen.

→ this is everything for my approach!
Networks of whiteness.

WHITE INFRASTRUCTURE

As the example of the drone makes evident, white sight is always supported by a material infrastructure. In this way, it can "see" even when no human is watching. As media scholar Sean Cubitt puts it, "So much that occurs in the mass image is invisible."[33] The infrastructure of whiteness is a powerful network connecting material structures in physical and psychic space. I'm drawing here on both senses of infrastructure, as defined by anthropologist Brian Larkin. First, there are "built networks that facilitate the flow of goods, people, or ideas and allow for their exchange over space." Larkin adds that infrastructures "emerge out of, and store within them, forms of desire and fantasy . . . the collective fantasy of society."[34] The racist and colonial statues that have become so controversial create an infrastructure in both of these senses: one that stores the collective

unconscious of whiteness like an archaic database and connects to the state, and vice versa.

This white infrastructure was especially vital in sustaining white settler colonies. The "founding father" Patrick Henry, the first postcolonial governor of Virginia, told the first Continental Congress in 1774, "Government is dissolved. . . . Where are your landmarks, your boundaries of Colonies? We are in a state of nature."[35] That is to say, colonial government *is* boundaries and landmarks. Boundaries define territory. Landmarks define culture and the boundaries of estates within the territory. Without them, a state of nature results, meaning that there would be no enclosure and no property. In this version of white reality, the result would be what philosopher Thomas Hobbes described as a life "nasty, brutish [animal-like], and short."[36] Two years after Henry's speech, revolutionaries put it into action by overturning the statue of George III in New York City and making it into bullets.[37]

In 1961, the revolutionary psychiatrist Frantz Fanon still understood colonialism to be "a world compartmentalized, Manichean, immobile—a world of statues."[38] Statues spatialize. They create a lived reality experienced as segregation and division, epitomized by the Confederate statue just outside a courthouse.[39] The world of statues includes all the material and visible means to divide and thereby racialize, including neoclassical architecture, museums, national parks, prisons, triumphal arches, tombs of the unknown soldier, universities, zoos, and all. It was so effective because as Austrian novelist Robert Musil famously observed of monuments, "We cannot say we do not notice them; we should say they de-notice us, they withdraw from our senses."[40] All infrastructure works best when de-noticed. Those used to an electric supply find its disruption infuriating. So too have some white people been outraged to have their infrastructures become visible.

White infrastructures connect, distribute, enable, and store the set of desires and fantasies that comprise what it is to make whiteness. They do so by connecting material forms to the cultural unconscious (see chapter 6). This collective unconscious is the sedimented product of the assemblage of types and stereotypes from statues to cartoons and what Du Bois called "racial folklore."[41] It is collective not individual, and while it is sustained by imaginary relations, it has all too real effects. As gender studies

YES! We don't notice landscape paintings
either

scholar Gloria Wekker puts it in the Dutch context, "An unacknowledged reservoir of knowledge and feelings based on four hundred years of imperial rule have played a vital but unacknowledged part in the dominant meaning-making processes."[42]

These means of making and supporting white reality extend far beyond depictions of skin tone, to urban spaces, landscapes, natural history, monuments, and museums. In his psychiatric work, Fanon saw such "cultural racism" as part of the collective cultural unconscious created by mass media societies: "Literature, the plastic arts, songs for shopgirls, proverbs, habits, patterns, whether they set out to attack it or to vulgarize it, restore racism."[43]

RACIALIZING SURVEILLANCE CAPITALISM

→ this basically helps condense my lit. review

As is widely understood, if "race" does not have a specific meaning, racism certainly does. Cultural studies theorist Stuart Hall concluded that "hateful as racism may be as a historical fact, it is nevertheless also a system of meaning, a way of organizing and meaningfully classifying the world."[44] In this book, I use the word "racializing" to stress that "race" is always being made, never found. Abolitionist geographer Ruth Wilson Gilmore accordingly defines racism not in terms of skin tone variations but as "the production and exploitation of group-differentiated vulnerability to premature death."[45] Which is why this matters.

Gilmore likes to say that abolition means changing just one thing: everything. To give that everything a name, it is "racializing surveillance capitalism." The concept of racializing surveillance capitalism begins with Robinson's now classic thesis that all capitalism is racial capitalism: "The tendency of European civilization through capitalism . . . was not to homogenize but to differentiate—to exaggerate regional, subcultural and dialectical differences into 'racial' ones."[46] Where Slavs had been the "natural" slaves in the Middle Ages, people in Africa and Asia came to fill this role from the sixteenth century on. It is at that inflection point in racial capitalism, whose consequences are all around us today, that this book begins.

→ but N.M. addresses this clearly

but I think that this is inherent within ALL HUMANS. ie the history of whiteness's power is what gives whiteness more power today

I connect "racial capitalism" with media scholar Simone Browne's concept of "racializing surveillance," meaning "a technology of social control where surveillance practices, policies, and performances concern the production of norms pertaining to race." For example, technologies like facial recognition and biometry emerged from the Atlantic world "technology of tracking blackness that sought to make certain bodies legible as property."[47] Despite recent assertions that surveillance is a new part of a "rogue mutation of capitalism," there is no capitalism other than racializing surveillance capitalism, from the surveillance cities of Spanish Mexico, to the plantation with its overseer, the factory with its foreman (gender intended), mass incarceration, the "carceral reservation world" invented by settler colonialism for the Indigenous, and today's CCTV megacities on quarantine lockdown.[48] These racializing legacies have been identified across the technology sector.[49] In this book, I emphasize the machines of social control created by extraction of all kinds, running on plantation time.

METAMORPHOSIS MACHINE

Using the machines of states, ships, and plantations, white sight organized white reality into a metamorphosis machine. Decolonial theorist Macarena Gómez-Barris has identified "the extractive view," by which the Indigenous were rendered invisible. In that erased space, white sight extracts value as a process of transformation or metamorphosis.[50] It transformed land that could not be owned in Indigenous worldviews into the white colonist's absolute property. On that colonized land, there was a new metamorphosis in which human life was transformed into financial value by means of violence.[51] As historian Walter Johnson puts it, enslaved production changed "lashes into labor into bales into dollars into pounds sterling."[52] In economic language, this process is usually considered as exchange, but while dollars can be exchanged for cotton and other things, lashes and their resulting pain cannot (or should not) be exchanged at all.[53] Yet forced labor in settler slavery was turned into spectacular profit. Tiny islands like Madeira, then Barbados, and then Saint-Domingue

(present-day Haiti) became the sites of the greatest profit in the Atlantic world (see chapter 1).[54]

The final component of white sight is time, in simple and compound ways. Time was directly extracted from those subject to the surveillance of white sight. In 1860s' England, this extraction of time was described in surprisingly poetic terms by inspectors of factories: "Moments are the elements of profit."[55] The more time you can extract from a worker, the greater your profit. Enslaved and indentured labor provided for the maximum level of such extraction. From the plantation, there was a compound temporal projection from past conquest into present and future dominion. Black geographer Katherine McKittrick calls the result "plantation futures," which is to say, "a conceptualization of time-space that tracks the plantation toward the prison and the impoverished and destroyed city sectors."[56] Marx drew similar parallels between the plantation, colony, and factory in terms of their "werewolf-like hunger for surplus labour" along with the endlessly extended working day.[57] Plantation time-space gives white reality depth and dimension, while the projected plantation future gives it direction. While white reality continues, its present is a past plantation future projected onto the imperial screen.

THE STRIKE AGAINST WHITENESS

The strike against whiteness refuses this extractive system. It unbuilds the static field of white sight, constituted by the screen, statue, state, and its statutes. It makes another world visible by activating what I will call the "visible relation," following Caribbean philosopher Édouard Glissant. Relation evokes "the conscious and contradictory experience of contacts among cultures."[58] By extension, the visible relation is an expansive and contradictory mutual experience. It works at the conscious level, countering the impulses of the received cultural unconscious. It always allows for the "right to opacity," to not be visible and transparent to all. Relation is the counter to what Glissant called "root identity," which is centered around the self and a specific territory.

At the heart of Glissant's push for relation is his phrase adopted by Fred Moten as the title of his recent trilogy: "Consent not to be a single

Whiteness does not give consent to be seen (my idea)

CONSENT

being."[59] While the intricacies of these gifted philosophers would require many pages to fully think through, I want to pause on that word "consent." For Moten, consent is a "nonnegotiable" precondition. It is central to what is meant by justice. This condition is not one that currently holds good, except when temporary moments of visible relation are established. The strike against white sight is not a strike about terms and conditions. It is a feminist strike to establish consent as the condition for human encounter in visible relation. I can consent to be seen, or you may evoke your right to opacity. From that point, we can assemble.

This strike has many forms. Far from being a single unified event, for the revolutionary Rosa Luxemburg, the mass strike was a range of refusals, arising when the "proletarian mass, counted by the millions, quite suddenly and sharply came to realize how intolerable was that social and economic existence which they had patiently endured for decades." It created what she called a "picture . . . of the revolutionary movement as a whole."[60] It was the strike as visible relation. What makes the strike general is not that everyone participates, or that all take one action, but rather that the social and economic order as a whole is resisted. It demands new forms of relation. It manifests as becoming ungovernable, or as Moten and Harney put it, "unfit for subjection."[61] Today, the human strike is the "most general of general strikes," which makes what is common visible.[62]

The actions of the strike include imagining, refusing, unbuilding, and tearing white reality. It departs from the "queer formula" offered by Herman Melville's character Bartleby: "I would prefer not to."[63] Refusal creates resistance futures, where the unexpunged energy of past refusals to move along or pretend there was nothing to see become active again. Refusing disrupts time. The strike reclaims time from the plantation, factory, bureaucrat, school, office, or welfare system.

Just as the transition to capitalism centered around subjecting the body to the rhythm and tempo of waged labor, the transition to the strike against whiteness is a new relation to time-space. It escapes plantation futures to find or to found the contemporary. Speaking at the moment of Ghanaian independence in 1957, Kwame Nkrumah declared, "We face neither East nor West. We face forward." Beyond Cold War politics, to face forward was a place from which to see that was against racializing

capitalism, facing the future outside the direction set by plantation futures.[64] To look forward is to look toward future decolonizing.

To borrow the slogans of the Argentinean feminist strike that succeeded in winning reproductive rights in 2020, the strike against whiteness mobilizes "thinking, visibilizing and feeling" of all that has been disappeared, with "the desire to change everything."[65] For Argentinean feminist Verónica Gago, this strike is a "lens," precisely to enable "visibilizing hierarchies."[66] To visibilize is the active process of de-invisibilizing, or undoing invisibility and disappearance in whiteness' symbolic reality.

Any such strike against the state is a feminist strike because, as Kahnawà:ke Mohawk scholar Audra Simpson observes, "The state is a man." She identifies in the colonial sovereign a "death drive to eliminate, contain, hide and in other ways 'disappear' what fundamentally challenges i[t]s legitimacy."[67] At the heart of that drive was rape, central to both the imaginary and practice of Atlantic world racializing capital. In Titian's *The Rape of Europa* (1560), depicting one of Ovid's metamorphoses, the god Zeus carries Europa away, disguised as a white bull.[68] Europa waves a red flag in panic, and her friends on the shore react with alarm. Sea monsters, perhaps cousins to the Leviathan, surround the rape scene, and an oceangoing colonial ship sails in the background. As a result of her rape, Europa gave birth to Minos, king of Crete, then presumed to be the founding of European civilization. By extension, as Muscogee (Creek) Nation of Oklahoma scholar Sarah Deer has argued, rape "can be employed as a metaphor for the entire concept of colonialism."[69] The many depictions of colonization as taking possession of an Indigenous woman's body were redeployments of Europa's rape (see chapter 2).

Rape was not only a metaphor. It was an everyday practice of racial capitalism. Abolitionist Olaudah Equiano recorded his time as an enslaved mariner in the eighteenth-century West Indies: "I used frequently to have different cargoes of new negroes in my care for sale; and it was almost a constant practice with our clerks, and other whites, to commit violent depredations on the chastity of the female slaves. . . . I have even known them [to] gratify their brutal passion with females not ten years old."[70] As vile as these actions were, they made "sense" within the logic of racial capital. In Atlantic world slavery, any child born to an enslaved woman was also human property by the legal sleight of hand called *partus*

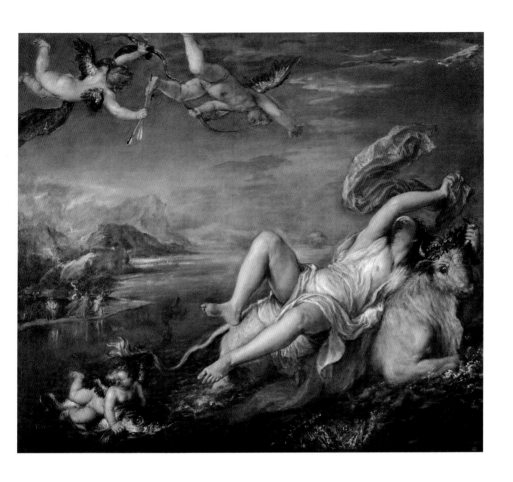

Titian, *The Rape of Europa*, 1560. Oil on
canvas, 178 × 205 cm. (70 1/16 × 80 11/16 in.).
Isabella Stewart Gardner Museum, Boston.
© Isabella Stewart Gardner Museum /
Bridgeman Images.

sequitur ventrem, meaning that the mother's legal status determined that of the child. It entailed a "profound reversal of European notions of heredity" contained in the system of patriarchal primogeniture.[71] But it made rape economically profitable by generating new human property, central to racial capital's metamorphosis of life into value by violence.

In the independent United States, whiteness came to have its own wage. To be white was to receive the peculiar value extracted by white sight that historian David Roediger labels "the wages of whiteness."[72] The strike against whiteness is a strike against these wages, paid in affect and kind rather than in cash. Roediger built on Du Bois's insight that while Jim Crow gave whites "a low wage, [they] were compensated in part by a sort of public and psychological wage."[73] Receiving deference and courtesy offered a sense of superiority, consisting of exclusive access to certain forms of public space like parks, and differential access to all public facilities from water fountains to schools and health care.

For the 1860s not only saw what Du Bois called "the general strike against slavery."[74] It was the first time that most white US citizens found themselves in the waged labor force rather than as agricultural workers. Whatever else a white worker might lose, they would not lose their whiteness and its associated privileges (see chapter 2). Since 2016, it has become clear that for many white-identified people, retaining the wages of whiteness is their top priority, even beyond personal health and safety (chapter 8).

The strike against whiteness refuses all racialized hierarchy. Expanding René Descartes's philosophical principle, decolonial activist Houria Bouteldja writes, "I think therefore I am the one who decides, I think therefore I am the one who dominates, I think therefore I am the one who subjugates, pillages, steals, rapes, commits genocide."[75] If the cogito, as it is known, is the logic of violence, then the strike is the human strike, asking with artist collective Claire Fontaine "the question, 'How do we become something other than what we are?'"[76] Which is to say, to be not white, not claiming to be thought itself, not at the top of a hierarchy or even in a hierarchy at all, and not heading to a plantation future, even as we are not without history, ethnicity, or direction.

Striking whiteness's symbolic reality is a strike to render all persons "levelly human," as the Combahee River Collective put it in 1977.[77]

It is what Gago calls the feminist general strike because "it reaches all space . . . it makes visible the chain of efforts that trace a continuum between the household, the job, the street and the community."[78] The strike expands and extends the space of visible relation. The conditions for working out this visible relation were articulated at the 2016 Standing Rock encampment to protect the water from the risks posed by the Dakota Access Pipeline for heavy tar sands. Resonantly, these conclude, "This is a ceremony. Act accordingly." There are no simple rules, no colonizing choices between good and evil. As the settler, I must observe, follow, listen, learn, remove, repair, and repatriate.[79] If it took over five hundred years to make white reality in its present form, its unbuilding will not be instantaneous. Nonetheless, it happens in the strike, even if temporarily, as seen at Standing Rock, during Black Lives Matter actions, in the fifteen-thousand-person turnout for the 2020 Black trans rally in Brooklyn, or at the women's strike. The longer such assemblages "hold," the more is learned, and the space in which to see each other so as to live together becomes ever more possible.

we need to acknowledge way of getting people on side

TEARING WHITE REALITY

→ I'm not sure this is the first step.

If the first step toward the strike against whiteness is refusal, next comes what architects Sean Anderson and Mabel O. Wilson portrayed in their 2021 exhibit Reconstructions: the "processes of 'unbuilding' structural racism."[80] The master's tools will not do that work, as poet Audre Lorde taught us. Those of us identified as white must look at its blueprint and refuse to let it work, striking its operations. As the task is now to unbuild the imperial screen, the strike against whiteness has developed its current tactics in the period of decolonization (chapters 5–7).

Creating a different reality in which to live is the "demand" of the strike against whiteness. It involves both unbuilding physical infrastructure, like statues and borders, and undoing the symbolic order of whiteness and its cultural unconscious. Anthropologists Nika Dubrovksy and David Graeber describe the connection: "Police are, essentially, the guardians of the very principle of monumentality—the ability to turn control over violence into truth."[81] Both police and statues convert colonial

contrary to olive Dondens letter to museum directors

I think of infrastructure differently, more like networks of living hip

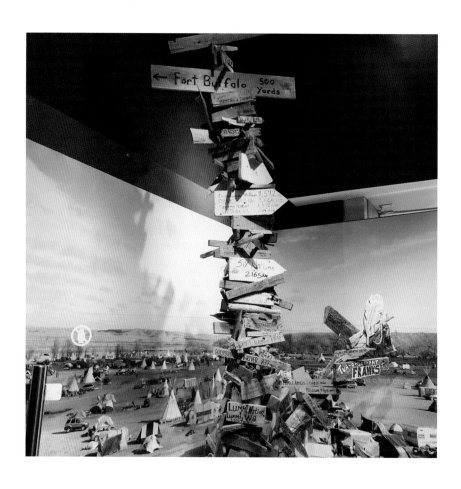

Standing Rock signpost in the National
Museum of the American Indian. Photograph
by the author.

we have to acknowledge that revolution, while necessary, is also divisive — therefore may not allow for a critical mass of change?

this presumes that — lie revolution works —

violence into truth, just as the overseer converted violence into value. Statues do not just mark past achievement but play an active role in shaping the present too. The statue makes the state visible but "normal." Removing the statues makes its many violences all the more visible.

When the violence of white sight's white reality fails, when there are other ways to say what there is to see, then a tear is made in the fabric of whiteness. It could be seen when the statue of former British governor Cecil John Rhodes was removed from the University of Cape Town campus in 2015 or the monumental statue of Confederate general Robert E. Lee was taken down in Richmond, Virginia, in 2021. When colonial reality is torn, it no longer conforms to the Cartesian coordinates of the real, outlined by Bouteldja. It becomes surreal. Surrealism here is not so much the unleashing of the libido, which is all too visible in white sight's violent taking possession, but rather the refusal to accept erasure and violence as the markers of reality.[82] It makes possible what Oglala Sioux poet Layli Long Soldier calls "the space in which to see."[83]

Artist Charlotte Schulz's work makes the tear in white reality visible. In her drawing *Forest Circus* (2021), the paper itself is torn, disrupting the neat perspectival box. Where the perspective diagram tried to make its paper ground invisible, Schulz works her paper to make the cracks in white reality open up. The drawing constitutes a surreal—because not white real—ground. Ruined trees struggle to survive, as if on a World War I battlefield, the broken imperial screen. This is a densely layered feminist space, inspired by a Margaret Atwood poem, visualizing the general crisis of whiteness. The cracks are the spaces from which to refuse white reality. They make the drawing into a set of panels. Birds fly in wild space and domestic space, finding freedom in three dimensions.

To make such space a viable place to live, finally, needs all the imagination that can be mustered. In place of white reality, the strike "prefigures reality without determining it."[84] As Claire Fontaine assert, "We need to become visionaries and to imagine practices of freedom."[85] To make a reality from those practices, the other side of Roy's portal, it is necessary to mobilize "the constituent power of lived imagination."[86] Such imagination is "the power to bring new things and new social arrangements into being."[87] It counters the constituent power deployed by states to write constitutions. Once so constituted, this power enables the police in all

who is "we"?

This sounds like a manifesto but what actually is the answer?

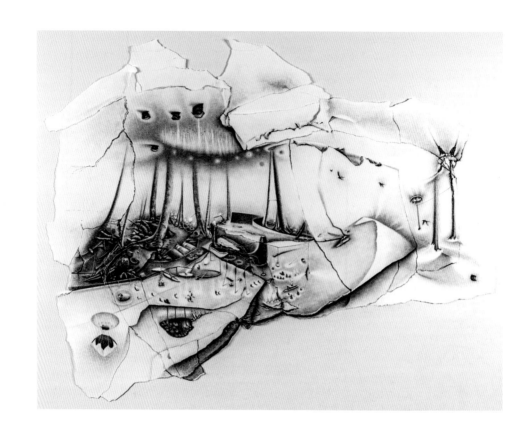

Charlotte Schulz, *Forest Circus*, 2021.
Charcoal on paper, 40 × 52 × 1 in.
Courtesy of the artist.

senses. Constituent imagination is a strike against both this constituted power and the regime of "creative capitalism."[88] It changes the direction of time from repairing static white reality ("making America/Britain great again") to resistance futures, which writer adrienne maree brown calls "a time-travel exercise for the heart."[89]

Often it is said that systemic change is impossible and the best that can be hoped for is some incremental improvements. Facing the earth system crisis brought about by white dominion over nature, radical transformation is now the only option. It's a different state of mind—one that begins with the intersection between all living things. No single types, no statues exemplifying hierarchy, no sovereign surveillance states, no flat perspectives, but a new plurality in three dimensions, facing forward. Which is to say, what if we were to see like birds rather than from the bird's-eye view of CCTV and the drone (see chapter 8)?

SIGNPOST

The chapters that follow separate the sedimented layers of the contemporary into a transnational historical narrative from slavery to imperialism and the decolonial present. Following white sight in its circulation around the Atlantic world, chapters are cued from present-day experience to indicate how each segment of past time remains contemporary. The first chapter begins with artist Isaac Julien's 2003 film *Baltimore* and its meditation on perspective as the white way of seeing. The Renaissance city-state, as depicted in *The Ideal City* panel seen in *Baltimore*, organized its carceral and colonial space in perspective, and around the monument. This assemblage condensed into philosopher Thomas Hobbe's Leviathan, the imagined statue of the colonial state, surrogated in practice to the overseer. The plantation "machine," as it was known, connected the surveying of land, measured in chains, to the surveillance of the enslaved and the statutes of slave law, making a seeing in chains that sustained white space.

Chapter 2 describes how the statue became the "perfect" white body, also described in the European Enlightenment as a "machine," but one that was the source and type of beauty. Statues are, then, not just statues.

Collectively, they are an infrastructure of whiteness, an emblem of the state, and the exemplar of white beauty. The statue of statues from the point of view of this white infrastructure is the *Apollo Belvedere*. A second-century CE marble copy of a Greek bronze original, rediscovered in late fifteenth-century Italy, the *Apollo Belvedere* at once became the model for Adam in the Garden of Eden, reimagined as the Americas. In the Enlightenment, the founder of art history, Johann Winckelmann, saw it as the perfect form of white male beauty. No sooner had the "unthinkable" Haitian Revolution begun in 1791 than the *Apollo Belvedere* became the racializing type of whiteness, perfect in a way no actual person could be. In the United States after the defeat of slavery, Robert E. Lee took on the mantle of the perfect statue-form of white supremacy.

White dominance was made natural and in turn claimed nature as part of its domain, explored in chapter 3. Undominated nature was what colonial law portrayed as terra nullius, literally nothing land, meaning supposedly wasteland that could be claimed by any white colonist. As the settler colony expanded its control, extraction turned into extinction from the dodo to the bison and the passenger pigeon. Nature became a display from the natural history museum to the zoo and wildlife refuge. This display expanded white infrastructure, in Hicks's succinct formula: "*As the border is to the nation state so is the museum to empire*."[90] Landmarks and borders were the signposts of the settler colony. The museum displayed empire by collecting that which it was making extinct. Concentrating on birds, I show how ornithology came to be racialized from John James Audubon (1785–1851) to the American Museum of Natural History's dioramas. This museum was the exemplar of the resulting "New Museum Idea," a visual education for the masses in everything from botany to public health and racial types.

The second part of the book accordingly concerns white sight and empire, centering on the British Empire in the century from First Indian War of Independence in 1857 to the onset of decolonization after the Second World War. In these chapters, I show that imperial modernity always saw itself at risk of collapse. It is not that empire is now coming to an end. Rather, empire always creates moral panics about its impending collapse. It's a personal and political account. Throughout my academic career, the fall and revenge of empire has been intensely debated. At the same time,

I am literally the product of the decline of empire as my four refugee and migrant grandparents all ended up in London.

The colonial techniques of mapping, surveying, and surveillance, enforced by violence, were expanded and supplemented in the high imperial period by the great imperial screen, as noted above and examined in chapter 4. As intended, the screen created an emotional and cultural barrier, a form of affective border, preventing the imperial viewer from identifying with what was being looked at. To be on the imperial side was to be white, enabling the perpetration of extreme violence at home and in the colonies. "Behind" that glass, queers, women, and Jews nonetheless used white masks to evade the imperial gaze in 1890s' London, until a new carceral regime registered them as lesser types within whiteness. The imperial screen was deliberately broken by the suffragettes in their sustained window-breaking campaign across Britain (1908–1914), challenging imperial patriarchy in everyday life. If the suffragettes made another space possible within white reality, the First World War brought the hyperviolent tactics of imperialism back to Europe, both shattering the imperial screen and creating a compulsion to rebuild it.

In chapter 5, I describe how Barbadian poet George Lamming, in exile in 1950s' London, de-invisibilized white sight and registered the anticolonial contemporary. Lamming saw how English poets gathered at the new Institute for Contemporary Art attacked East End radical Jewish poet Emmanuel Litvinoff for criticizing Anglophile US poet T. S. Eliot's antisemitism. He coined the phrase "way of seeing" to capture this reflexive recognition. His anticolonial viewpoint connected the violence at the 1951 poetry reading with racialized violence in the streets of Notting Hill. It expanded the contemporary beyond the realms of elite culture, bringing different times and spaces into contact. At the same time, it mapped the emergent hostile environment of white nationalism. Notting Hill became a "zone of transition" that registered the shift from colonialism to globalization in urban space.

Lamming's moment of poetic clarity followed his encounter with Fanon at the 1956 International Congress of Black Writers and Artists in Paris, where Fanon also used the expression "way of seeing" in analyzing racism and culture, as discussed in chapter 6. Fanon innovatively understood racism to be formed by the collective cultural unconscious created

by mass media societies. His vision was that those entirely excluded from this culture, the urban dispossessed, would be capable of creating a new humanity no longer subject to these phantasms. It inspired both the Black Panthers and Hall's foundational work in cultural studies to different forms of anticapitalist resistance.

From Algerian independence in 1962 to that of Angola and Mozambique in 1974, a decolonial wave of toppled statues flowed down Africa, only to halt at the breakwater of apartheid South Africa, described in chapter 7. By 2015, South Africa's "born-free" generation—those born after the end of apartheid—found those symbols intolerable. The removal of the statue of Rhodes marked the completion of a "Cairo to the Cape" (to reverse the direction of Rhodes's imagined railroad) removal of colonial symbols. This impetus jumped the Atlantic Ocean following the forced journey made by so many thousands of Africans to unsettle the symbolic order of the Americas, beginning with the statue of Lee in Charlottesville.

In the conditions created by the intersection of the coronavirus pandemic with the George Floyd Uprising in 2020 and Capitol insurrection of January 6, 2021, that symbolic order was at once de-invisibilized, challenged, torn down, and violently reasserted. Chapter 8 maps the general crisis of whiteness in that year from the first impact of the virus in March to white claims to immunity from the virus in April and the impact of the George Floyd Uprising starting in May. The Capitol insurrection was a literally monumental effort to reconstitute white reality as the joint creation of a mythical "1776" and the police power that was now imagined to belong to white people, known as "Back the Blue." In the wake of this continuing insurrection, manifested in challenges to reproductive rights and voting rights, the strike against whiteness must find a different, communal relation to each other and other species. Like birds.

I

WHITE SIGHT IN THE WORLD OF ATLANTIC SLAVERY

1

THE CITY, SHIP, AND PLANTATION

In 2015, twenty-five-year-old African American Freddie Gray was murdered by police in Baltimore, Maryland. He had committed no crime, but Baltimore police were spurred to make an arrest because he made "eye contact" with them.[1] The tragedy recalled the period of Atlantic slavery, when overseers punished "eye service" by the enslaved, meaning unauthorized eye contact indicating insubordination. When Baltimore rose up in 2015, the FBI sent a drone over the city to monitor the protests. The drone made a similar connection between seeing, power, and racial hierarchy for the digital age. This chapter examines how and why these connections between perspective, political and economic power, and making race first cohered in the early modern Atlantic world in such a way that they are still in effect hundreds of years later.

I am inspired here by Black British artist Isaac Julien, whose work I have followed since his black-and-white film *Looking for Langston* (1989) used jazz dancers from Dingwalls, the club where I was then a regular. Julien used footage from the 2015 Baltimore drone in his 2019 film *Lessons of the Hour*, a ten-screen installation reached by passing still photographs depicting the 1982 police murder of Colin Roach in London that I vividly recall from my youth and that was the subject of his first film, *Who Killed Colin Roach?* (1983). The beautifully made *Lessons of the Hour* centered on reenacted speeches by abolitionist Frederick Douglass. Douglass's insights on photography are still revelatory (see chapter 2). Douglass had

Isaac Julien, *Lessons of the Hour–Frederick Douglass*. Installation view, 2019. Metro Pictures, New York. Courtesy of the artist and Metro Pictures, New York.

come of age in Baltimore, from where he escaped slavery on a ship using borrowed freedman's papers.

When people in Baltimore joined the 2020 George Floyd Uprising, police drones were again sent up to monitor them, following the flight path taken in 2015. Activists posted the 2020 flight data on social media. On both occasions, the aircraft circled over the Walters Art Museum in downtown Baltimore. In 2003, Julien had made *Baltimore*, a three-screen blaxploitation homage film set in the city.[2] Julien's New York City gallery, Metro Pictures, streamed *Baltimore* online in June 2020 as a Juneteenth tribute. The film has an extended sequence in the Walters. Watching *Baltimore* again in 2020, I was struck by the moment in which African American film director Melvin Van Peebles, legendary for the film *Sweet Sweetback's Baadasssss Song* (1971), steps up to a Renaissance painting in the museum, titled *The Ideal City*. The painting is one of three known panels from the late fifteenth century depicting idealized city spaces in strict one-point perspective, the then-new (or revived) technique to create the illusion of depth on a two-dimensional surface. Van Peebles's quizzical gaze questions whether the ideal city is the white city and what his place in it might be.

Julien's camera dwells in close-up on the painting, especially its Roman-style amphitheater, before cutting to sequences of Dr. Martin Luther King Jr. and Billie Holiday. King's dream and Holiday's warning of the "strange fruit" of lynching placed in counterpoint a future ideal nonracial city and the far from ideal realities of US cities. The whole film, to quote Julien's website, is "characterized by oscillation and an insistent formal play with linear perspective." *Baltimore* made me understand linear perspective as white seeing in white space. Perspective was one of a set of artificial machines, extending from the city, to the ship, plantation, and colonizing state that produced colonial white reality. That trajectory connects the Renaissance city-state to plantation slavery and ultimately the drone.

IDEAL CITY SPACE

Baltimore's *Ideal City* panel is one of a series of three, echoed by Julien in the triptych format of his original 2003 installation. The past triptych

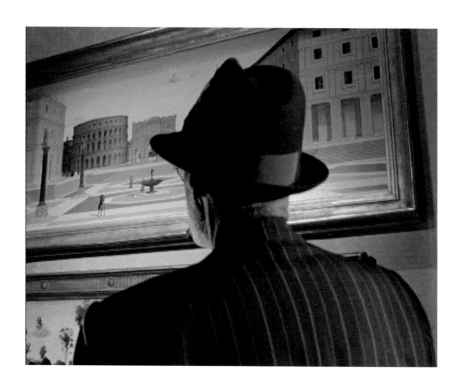

Isaac Julien, *Baltimore*, 2003. Film still.
Courtesy of the artist.

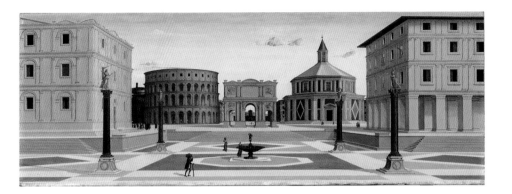

of *Città ideale* (the ideal city) in question comprises the Baltimore panel, formerly attributed to Fra Carnevale; the better-known painting of the same title, formerly attributed to Piero della Francesca, now in Urbino, Italy; and a third panel now in Berlin, sometimes attributed to Francesco di Giorgio Martini.[3] Each is now taken to exemplify the new technique of perspective, especially the Urbino panel, which is taught in every Western art history survey class. These paintings have been used to teach how to see and yet their own content has often been overlooked. The paintings create illusions, one of which is depth. This perspective also gives material form to the claim to be the apex of human accomplishment that has come to be known as whiteness. The conquest of the Americas produced what decolonial scholars call the "colonial matrix of power."[4] The phrase is used figuratively, but the pyramidal depiction of vision created by perspective is its material counterpoint.

The three panels are strongly related visually. The narrow rectangles each depict a city scene by means of its architecture. Depth is conveyed first by the apparently receding buildings, then by paved flooring drawn so that each line converges on a vanishing point in the middle of the

Formerly attributed to Fra Carnevale, *The Ideal City*, 1470–1518. Walters Art Museum, Baltimore; acquired by Henry Walters with the Massarenti Collection, 1902. Photo: Wikimedia Commons.

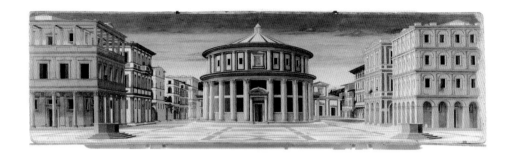

picture space, and finally by the horizon. Together, they create a contained and containable seeing-space that can be navigated. For art historian Hubert Damisch, whose exhaustive study *The Origins of Perspective* remains the most detailed account of the panels, these techniques are nothing less than the "configurations through which the subject constitutes itself as such" (419). Here I understand that subject to be the white colonizer, whose goal was always to find "everything in its place" (267), with the Platonic order embodied as a racializing hierarchy.[5] This is not really news, for art historian Erwin Panofsky had announced in 1927 that perspective was the visualization of "anthropocracy," meaning the rule of man.[6] By now it is a routine gesture to acknowledge that this "Anthropos" (man) is always the white man.[7] "Whiteness" was formed in the making of this perspective rather than being something external to or represented in it. It is the colonization of space as space, presaging Europe's half millennium of expansion.

Damisch famously called *The Ideal City* panels a "transformation group" (282), borrowing a term from mathematics to suggest that even though it is not clear who painted them, and when (within a fifty-year range from 1470 to 1520) or even where, these paintings can nonetheless be grouped together and used to map the transformation into perspectival forms of representation. This transformation of space and time into

Formerly attributed to Piero della Francesca,
The Ideal City, 1470–1518. Galleria
Nazionale delle Marche, Urbino. Photo:
Wikimedia Commons.

value is its metamorphosis. All points within these perspectives—painted space or built environment—are both imaginary and real at once. Taken together, the pictures represent movement. One transformation within them is to cross Tuscany from Urbino to Florence to reach the sea at Livorno and set out toward colonial domination.

The Baltimore panel in the "middle" of the sequence expresses the ideal city's wealth, stored in warehouses at the back. In the foreground, four statues on pillars represent Justice, Strength, Temperance and Abundance. This last replaced the traditional Prudence, implying that profit had already overtaken care. Abundance (*dovizia*) was strongly associated with Florence, indicating it is the city in question. In the actual Baltimore outside the Walters Museum, four Confederate statues had been removed after the Charlottesville Unite the Right rally in 2017. On July 4, 2020, protesters toppled the city's Christopher Columbus statue and threw it in the ocean (see chapter 7).

The sight of the sea in the Berlin panel provides a narrative to the group as a whole, as the shift from local to global power. In the Berlin panel, the sea is the horizon. The receding lines of the pavement run right into the water, and the vanishing point is among the ships on the water. These ships evoked the emerging regime of European colonization and its means because they were not rowing-powered galleys, as was then typical for Mediterranean use.[8] In the Berlin panel, there are two carracks, oceangoing sailing vessels developed in Spain and Portugal, and used first for trade to the Baltic, and then to Africa and the Americas. Also visible in the panel are two smaller caravels, highly maneuverable craft often used in journeys to Africa. The harbor was painted to suggest voyages beyond the confines of the Mediterranean to Africa and the Americas. Figuratively, all three panels continue from here into the Atlantic world and the plantation future. The real transformation in these panels was the formation of what is now called the Atlantic world, with its triangular trade from Europe to Africa and the Americas, with the resulting spectacular profits and terrible human cost.

Whenever they were painted, whether as early as 1470 or as late as 1518, all the panels were part of the colonizing moment.[9] The city-states in what is now Italy were already colonial in the Middle Ages, whether in their territorial ambitions in the Levant or their financial investments in

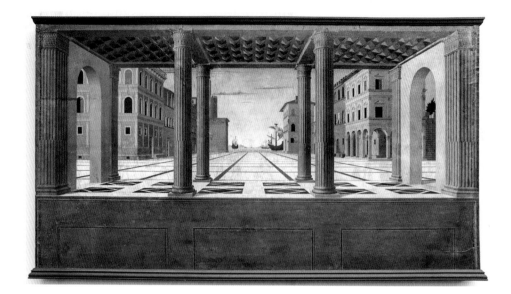

"the entire structure of Portuguese power."[10] The Spanish colonization of what are now known as the Canary Islands began in 1402, while fifty years of Portuguese exploration in Africa from 1440 on culminated with the construction of the infamous slavers' fort at Elmina, in present-day Ghana, from 1471 to 1481. Italian capital funded all of these ventures: "Without them . . . it is doubtful that a Portuguese empire would ever have come into existence. Without that empire, nothing would be as it is."[11] Although the Italian states were not directly colonizers at the time the panels were made, the circulation of Italian capital enabled the colonial expansion of Europe.

Perspective is seen by one eye from one viewpoint. By opening holes in it or finding the holes that are already there, multiple ways of seeing might become possible, from a simple look back to a rending of the fabric

Attributed to Francesco di Giorgio Martini,
Veduta architettonica ideale, 1490–1500.
Gemäldegalerie, Berlin. Eigentum des Kaiser-
Friedrich-Museumsvereins. Photo: Saiko via
Wikimedia Commons.

CHAPTER 1

of white sight altogether. Damisch discovered that the painter of the Urbino panel did not deduce its perspective from drawn geometric lines, as is so frequently assumed. He found a small hole in the panel where a nail had been placed, to which the painter attached strings to mark the receding lines (341). Instead of a mathematical vanishing point, a material web spread out across the surface guiding the work. It's as if the painting had rigging so that, with a little poetic license, the perspectival panels were themselves ships. Both were machines of artificial vision. For all the talk in the perspective manuals, and their subsequent interpretations of two-dimensional slices and cuts across the "window on the world," the perspectival way of seeing was from the beginning three-dimensional and material.

Imagine for a moment that the hole extended right through the panel. *The Ideal City* would then also be a pinhole camera. It's exactly this way that Damisch defines perspective through the famous and possibly apocryphal anecdote of artist Filippo Brunelleschi asking people to view his perspective through a pinhole aperture in the back that allowed them to see his work in a mirror. The illusion created was said to be analogous to reality itself. The result was that the person seeing this reality was themselves invisible behind the panel. It is easy to understand why Damisch sees affinities between perspective, photography, and surrealism. Many of us have experienced a similar illusion with Oculus Rift or other 3-D immersive reality experiences in which the quality of the illusion is what impresses. I did not mistake it for reality but was amply aware that a seeing-space had been created, like the perspective from which it was derived, available for one person at a time only. So, too, Brunelleschi's reflected space offered a viewer the conceptual and material means to imagine themselves in hierarchical relation to other people through the illusion of depth.

IDEAL WHITE CITY: LIVORNO

In the late sixteenth and early seventeenth centuries, the Medici family, legendary art patrons and rulers of Tuscany, turned the ideal city from imagination to colonial reality. First the Medicis sought out objects, texts,

and information about the Americas to advance their imaginative possession. Then they built an ideal colonial port city: Livorno. After the formation of the Grand Duchy of Tuscany in 1530, the Medicis radically transformed Livorno from almost nothing among malarial swamps into the primary port of the new state.[12] It was intended to be the stepping-stone by which Tuscany became a colonial power.

The Berlin *Ideal City* panel was an imagined version of Livorno. In the distance, it shows two islands. According to art historian Alessandro Parronchi, the islands are Capraia and Gorgona, two small islands off the Tuscan coast.[13] While Gorgona was believed by Romans to be the home of the mythical Gorgon whose look turned people to stone, Capraia is just a small island facing Livorno. Capraia was a real, geometric destination to be sailed toward. It indicates that perspective was a central component of white sight as the operating system of colonialism. Gorgona was where people were turned to stone, making statues.

The statue was a key part of the system of racializing surveillance both in Europe and the colonies. Livorno centered its carceral geography around a monument to Grand Duke Ferdinando de' Medici (r. 1587–1609) that gave material form to racializing hierarchy and white seeing. The metamorphosis of enslaved labor into white extraction that this monument depicted is the archetype for all such monuments and colonizing spaces.

The first stage of this process was what art historian Lia Markey has termed the "vicarious conquest" of the Americas in Italy. This cultural conquest was mutually constitutive with the violent process of military conquest. It involved acquiring objects and texts from the Americas, alongside the removal of human, plant, bird, and animal life to Europe for display and assessment. For Markey, these processes "create a sense of symbolic possession or ownership."[14] The agent of this transformation was Ferdinando, who returned from Rome where he had been a cardinal to become duke. Ferdinando acquired Indigenous materials and commissioned artworks symbolizing the conquest of the Americas. In Rome, he had been an "avid collector of American objects," including the *Historia general de las cosas de Nueva España* (General history of the things of New Spain), an illustrated codex describing life in the new Spanish dominions before, during, and after the conquest.[15] It was written by Franciscan

friar Bernardino de Sahagún (1499–1590) with assistance from Indigenous writers and artists, including sections in Nauhatal. Prohibiting the book, King Philip II of Spain declared, "Do not allow any person to write things having to do with the superstitions and the way of life of the natives."[16] Nonetheless, Ferdinando brought it with him to Florence, and its illustrations influenced Ludovico Butti's ceiling for the Armory at the Uffizi.[17] In this way, cultural possession took physical form.

Taking possession was the subject of one of the best-known cultural projects concerning the Americas made in sixteenth-century Florence. In the late 1580s, Giovanni Stradano (1523–1605), also known as Jan van der Straet, made a set of engravings representing the discovery of the Americas. In the best known of these prints, Amerigo Vespucci is seen setting foot in the Americas, flag in hand, to claim sovereignty. He encounters a naked woman, of whom he takes possession as the symbolic form of "America," whose name is spelled out in the image. America's hammock and Tupinamba club resemble objects in the Medici collection that Stradano could have seen.[18] The scene depicts what can be called the rape of America, adapting a familiar theme from European art, epitomized by Titian's *Rape of Europa* (ca. 1560), meaning the symbolic and material taking possession of the Americas via a female body. In the background, placed in between America and Vespucci, Indigenous people can be seen cooking human body parts, providing white viewers with a visual justification for conquest.

Building on this symbolic possession, Ferdinando invested heavily in making Livorno into a new gateway for slavery and colonialism. Importing goods from the Americas like wood and sugar, Livorno welcomed people from across Europe, including "Jews, Turks, and Moors, Armenians, Persians and others."[19] In 1608, Ferdinando financed a speculative colonial mission to Brazil (although it landed in what is today known as French Guyana). Led by British pirate Robert Thornton, the expedition reached the Amazon, but did not find any precious metals. It brought back maps and six Indigenous people, described by the ship's cartographer, Robert Dudley, as "Caribs [Kalinago], who eat human flesh." Five died at once from European disease, but one survived, learned Italian, and served at the Medici court for a number of years.[20] His name was not preserved.

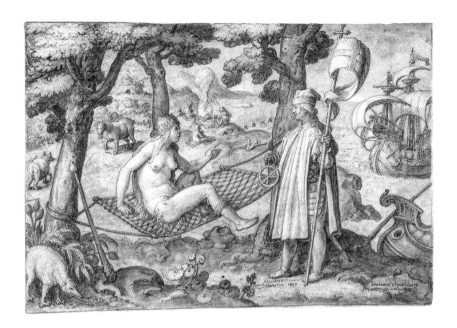

The dramatic transformation of a small village into a transnational port, built on a grid like Spanish colonial towns, was made possible by an innovative carceral geography for enslaved labor.[21] While the enslaved constituted around 4 percent of the population in Italian sixteenth-century ports, in Livorno it was close to 30 percent.[22] The majority were Turkish or North African, but there were enslaved Armenians, Greeks, and Jews. As a carceral port city, dependent on enslaved labor, much as Baltimore and other ports in the Americas would become, Livorno was the updated form of the ideal city. Giorgio Vasari the younger, nephew to the famous art historian, wrote an architectural treatise called *The Ideal City* (1596) in which he noted, "One finds that many Important Princes (who have sea vessels and slaves) have a large structure to keep their slaves while the ships are in port; this place is commonly called the *Bagno*, or Sultan's

Jan van der Straet, a.k.a. Stradanus, *Allegory of America*, ca. 1587–1589. Metropolitan Museum of Art; gift of Estate of James Hazen Hyde, 1959. Open Access Collection.

palace, or Slave Prison, wherein they can make ship repairs, weave, and carry out other things which serve for navigation."[23] Vasari imagined the enslaved as extensions of the maritime economy, ranging from war to trade and colonization.[24]

Just so, Livorno centered around a "purpose built architectural structure known as a slave *bagno* [bath]. This self-contained, fortified edifice incorporated military and commercial functions, including dormitories, a penitentiary, galley hospital, and bureaucratic offices to manage the slave trade."[25] All the enslaved and those sentenced to forced galley labor as criminals were being punished, even as the hospital, shops, and offices disciplined that population. The bagno was where the enslaved lived when not at sea, but they were not required to spend all of their time inside. Instead, as historian Stephanie Nadalo puts it, "The slaves' physical attributes, such as their racial profile, clothing, and shaved head, were perceived as adequate in preventing their escape."[26] White surveillance of othered bodies made the entire city into a prison for the enslaved, even as it offered certain freedoms to non-enslaved Jews and other exiles.

MONUMENTAL WHITENESS

This racializing, spatial hierarchy took symbolic form in the monument to Ferdinando built after his death. Its centers on a marble statue of Ferdinando by Giovanni Bandini, sculpted between 1597 and 1599.[27] Left at the side of the square for a number of years, the monument was completed by Pietro Tacca in 1626.[28] Bandini's statue was unremarkable. It comprised an imposing man clasping a baton of authority in his right hand with his gaze fixed on the horizon. When the statue was placed on a pillar in Livorno's waterfront square looking out to sea, the colonizing resonance was clear. The statue was entirely typical of the genre of male authority figures on pedestals, running right the way to the 1884 statue of Robert E. Lee by Alexander Doyle placed on the waterfront in New Orleans and removed in 2017. What makes Ferdinando's statue so remarkable is what Tacca then did to it. He chained four statues of enslaved Africans to the base, known collectively as *I Quattro Mori* (*The Four Moors*).[29] Although they are larger than life-size, it was said that Tacca based the statues on wax casts made

Pietro Tacca, *Monumento dei quattro mori a
Ferdinando I*, 1626. Livorno. Photo: Giovanni
Dall'Orto via Wikimedia Commons.

from the bodies of enslaved persons. Tacca certainly studied the enslaved in the bagno in 1607–1608.[30] Two of their names survive: Alì and Morgiano.

Alì has a recognizably North African appearance, while Morgiano appears to be from sub-Saharan Africa. Art historian Steven F. Ostrow has documented in records of the enslaved from the time one "Margian [son] of Macamutto from Tangier, twenty-five years old, to be sold" and three enslaved people named Ali. "Marjan" was a name given to enslaved people based on the dark grape Morgiano. These statues "should be recognized as the earliest sculpted likenesses of named slaves in the history of western art."[31] Unlike the statue of Ferdinando, they are intensely realistic. Their stomachs crease as if they were underfed, and their brows are wrinkled with fatigue or sorrow. Each statue has their hands bound behind their back and a metal chain attaches them to the base of Ferdinando's monument. Their slavery is all too real. What Tacca's monument makes visible is what the infrastructures of whiteness will later try to conceal, namely the process by which enslaved labor created the both the wealth and resulting presumption of superiority for those being made white in the colonial world of the Americas. All such monuments should be viewed today as if there were chained, enslaved figures at the base. British artist Mukhtar Dar has created a poster in this vein, montaging a photo of Home Secretary Priti Patel, notorious for her hostility to migrants and refugees, with the base of Tacca's statue.[32]

Tacca visualized the transformation of life into value by means of violence, the fundamental colonial metamorphosis. In his long poem cycle *Metamorphoses*, Roman poet Ovid described "forms changed into new bodies."[33] Tacca did so in concert with the famous metamorphosis depicted by Gian Lorenzo Bernini's sculpture *Apollo and Daphne* (1622–1625).[34] In the legend told by Ovid, the nymph Daphne had committed to remaining a fugitive from patriarchy. But Apollo, smitten with violent passion for her by Cupid, pursues her with intent to rape, so she asks her river god father, Peneus, to shape-shift her and she changes into a tree. Even in her form as a laurel tree, Apollo still assaulted her and then adopted her as his tree.

Bernini took the design of Apollo from the *Apollo Belvedere*, which depicts the god killing the python—the story before Apollo and Daphne in Ovid. Bernini's sculpture is, as it were, the next scene in the sculpted

movie. He made Apollo a tad more svelte than the Belvedere and shifted his weight onto the front foot. By himself he is every inch the homoerotic icon that the *Apollo Belvedere* was to become. But his forward-reaching hand is now grabbing Daphne's hip, which seen from the left side, has caused her to lose her balance, even as her body metamorphoses into a tree. Her flesh does not give way at his touch—unlike Bernini's *Proserpina*—because she is already arboreal. While Apollo's face is blank and emotionless, Daphne gives a gasp, perhaps her last breath as a human, rather than as a tree. Victory is still crowned with *daphne*—that is to say, laurel—while cultural success makes one a laureate. Violence was metamorphosed into value and victory.

Pietro Tacca, *Monumento dei quattro mori a Ferdinando I*. Detail.

Gian Lorenzo Bernini, *Apollo and Daphne*,
1622–1625. Detail of upper portion. Marble,
95⅝ in. (2.43 m) high. Galleria Borghese,
Rome. Photo: Alvesgaspar/Wikimedia
Commons.

Art historian Griselda Pollock evokes the "sound-scape" created by Daphne's gasping, open mouth and notes how her body is being "*imprisoned*" by the laurel.[35] From its dominant point of view, white sight metamorphoses the female body into a carceral form. Such imprisonment evokes both slavery and accounts by trans people of gender dysphoria. Daphne's metamorphosis out of whiteness into wood and incarcerated status could not but evoke the transformations of Atlantic slavery. Christina Sharpe names such histories the "Trans*Atlantic," where the asterisk "speaks to a range of configuration of Black being." Among these are "transubstantiation," often used to describe the Christian communion, which she takes to mean in this context "the making of bodies into flesh and then into fungible commodities while retaining the experience of flesh and blood. . . . Black life in and out of the 'New World' is always queered and more."[36] For all of its normative male violence, *Apollo and Daphne* cannot quite conceal that at the heart of racializing capitalism, there is an always denied queered or trans body being made. As trans theorist McKenzie Wark aptly remarks, "Gender is not necessarily a universal category, other than to the extent that a certain model of it was imposed on much of the world by colonization."[37] That's what's happening to Daphne and Apollo in engendering white dominion.

These two statues conveyed to European audiences the metamorphosis of enslaved labor into European capital from the formation of the global sugar economy in the seventeenth century into its various plantation futures. Whiteness came into being as a constantly "changing same," to borrow Paul Gilroy's formula.[38] The Ferdinando monument made explicit the enslaved base on which the superstructure of white culture rested. Bernini's marble was both dazzlingly white and tactile, giving material form to the ideas of making white and becoming statue, connected by rape, which would be so central to colonial practice and imaginaries. While Daphne was later redacted from depictions of Apollo, the gendered violence associated with her metamorphosis was always present. The transforming statue, making enslavement and rape first visible, and then invisibilized, was the point from which white groundwork was triangulated. While its dominance was symbolic, it set in motion real formations of state power around what I will call the statue-figure.

All the elements of making a sovereign white self came together in the statue-figure of Leviathan. Leviathan was Thomas Hobbes's imagining of the state, in which a "Multitude of men, are made One Person, when they are by one man, or one Person, Represented."[39] In the famous engraving by Abraham Bosse (see the introduction), produced in collaboration with Hobbes, the sea monster Leviathan emerges from its element, a giant single figure containing all the subjects of the state. Leviathan manifested what Hobbes called "visible power," the power to order, and thereby govern, by seeing what there is to see and being seen to do so.[40] In the plantation colony, this combination of administering power by seeing and racializing was the work of the overseer. Bosse's Leviathan served like the physical monument to triangulate space and was literally the peak of the visual pyramid in its frame, making it a perspective.

The notion of the statue-figure, a hybrid of the real and the symbolic, is adapted from the term "power-figures," made by African artists in response to the catastrophes of slavery and colonialism.[41] While the power-figure was a means to invoke the protection of the ancestors, the statue-figure expressed the relations of power in the emerging regime of racializing surveillance capitalism, mediating between the figure of the state, overseers on plantations imagined as statues, and their connection by oceangoing ships.

As an imaginary means of visualizing the state, Leviathan was the first form of what is now labeled artificial intelligence. Leviathan was a machine—one that produced and sustained sovereignty using artificial vision. For Hobbes, the Leviathan was always already an "artificial" creation, as Susanna Berger has emphasized.[42] Hobbes defined sovereignty itself as "an Artificial Soul" that gives "life and motion to the whole body."[43] It was always a colonial enterprise. Radical thinkers Michael Hardt and Antonio Negri show how, for Hobbes, sovereignty "is conceived explicitly in relation to the natives of 'America,' who are considered populations that remain in the state of nature."[44] Hobbes first visualized this imaginary as a choice between Empire (*Imperium)* and Freedom (*Libertas*) in the 1642 frontispiece to his *De Cive* by French engraver Jean Matheus. The two colonial statue-figures of Empire and Freedom stand on plinths.[45] They

are presented as a choice. Empire was crowned sovereign, albeit shakily, and raises her sword, pointing to the Last Judgment above, while dangling the already uneven scales of justice. Behind her, people labor in the fields with churches and a fortified city in the background. Empire requires subjected field labor, both at home and in the colony, and is always contrasted to liberty.

According to Quentin Skinner, the figure of Liberty was "an iconographically unprecedented view."[46] This is an oxymoron; iconography is supposed to draw on tradition.[47] Hobbes's innovation came at the outset of the English Revolution, a moment of radical questioning of icons and images.[48] It's hard for present-day viewers to see this moment of visual

Abraham Bosse, frontispiece of Thomas Hobbes's *Leviathan* (London: Andrew Crooke, 1651).

rupture in the caricature of the Indigenous after centuries of such stereo-
types. Behind Liberty were scenes of people hunting with bows and clubs,
and hanging what appears to be a human limb, in preparation for cooking,
in the same way as in Stradano's engraving. These scenes present Liberty
as "savage" or wild freedom, where freedom is simply a lack of restraint,
epitomized by cannibalism, rather than the traditional icon of the eman-
cipated Roman slave holding a liberty cap on a pole.

A decade later in *Leviathan*, Hobbes merged both of these statue-
figures and their background scenes into the state-as-a-machine. The
Leviathan represents the multitude in one man, reversing the gendering
of Empire and expelling Liberty altogether. Hobbes imagined all (white)
persons voluntarily giving up their freedom in exchange for the protection
of the state. All the people depicted inside Leviathan were white. But in

Jean Matheus, frontispiece of Thomas
Hobbes's *De Cive* (Paris, 1662).

the late sixteenth century, England's Queen Elizabeth I had notoriously complained that the country was overrun with "blackamoors," none of whom were visible inside Leviathan. Bosse's Leviathan did incorporate a little white dissent, as several of the little figures within his frame do not looking up at him in the prescribed fashion but look away or even out at the viewer.[49]

Leviathan appears in a colony with a typical colonial fort visible at the right. The labor of the enslaved is erased from both the depiction of the colony and Leviathan. Bosse would have known Tacca's work from his statue of Henri IV in Paris, also surrounded by enslaved people. Bosse made the enslaved invisible in his colonial imaginary. Such erasure made the surrender of freedom by the state's subjects appear to be "rational" rather than a form of enslavement. Such formulas still exist as in the "rational choice theory" beloved of neoliberal economics. In 1642, Hobbes had offered his readers a choice between empire and liberty. By 1651, after the turmoil of the English Revolution had revealed kings to be mortal, the choice was Leviathan or death.

Hobbes imagined the Leviathan as a "mortal god," equivalent to Hercules and other creatures of legend.[50] He saw the formation of such "compound creatures," as he called them, as a special instance of the power of colonial imagination, or what he termed "Fancy." Fancy was not simply an artistic or creative attribute; "whatsoever distinguisheth the civility of *Europe*, from the Barbarity of the *American* savages, is the workmanship of *Fancy*." Fancy created images, meaning "any representation of one thing by another."[51] Leviathan was the image of sovereign colonial authority as the white power to represent, of which the Indigenous were incapable. The sovereign had that power and capacity as a mark of their status as ruler. This compound imagination has been a part of colonizing sovereignty, with its compound interest in all senses, since the beginnings of Atlantic slavery.

Specifically, Leviathan was a biblical sea monster and in fact emerging out of the sea, with his legs as yet underwater. To make this clear, Bosse drew in the sea, complete with a ship, at the extreme right, often cut out of reproductions. Leviathan was both a sea creature and a technology—a ship. If not, all the people underwater would have drowned. Partly immersed, partly above the waterline, approaching a colonial settlement, Leviathan was not just a ship; it was a slave ship at that.

The slave ship was a floating prison. Those in the "hold" (technically a deck below the main deck) were compartmentalized, becoming Black, rather than Ibo or Kongo, through the monstrous agency of the Middle Passage.[52] Those above in authority on the main deck were becoming white. The main deck was also a space of potentially dangerous interaction. Africans would be brought up from the hold for up to eight hours a day, and on some smaller ships, they would be held captive on the main deck. But unlike other ships, as historian Marcus Rediker explains, the main deck of all slavers was itself divided by "the barricado, a strong wooden barrier 10 feet high . . . [which] bisected the ship near the mainmast and extended about 2 feet over each side of the vessel. This structure, built to turn any vessel into a slaver, separated the bonded men from the women and served as a defensive barrier behind which the crew could retreat (to the women's side) in moments of slave insurrection."[53] Snipers could then fire muskets or even cannons through loopholes in the barricado, or barricade. The Manichaean division of whiteness departs, in the sense of sets sail, from the slave ship.

If the colonizing state understood itself to be a ship, the ship of state, the ship itself was "the noblest and one of the most useful machines that was ever invented," according to naval architect Thomas Gordon in 1779.[54] It connected colony and metropole, allowing for a "union between . . . different parts of the same empire."[55] As a machine, the oceangoing ship was a platform for machine vision and the machine by which that vision was made. Managing a ship, slaver or not, was always a question of interactive sensory labor. Visual observation from the crow's nests in the masts was relayed to the deck. The visual perception of sea conditions and any nearby land was supplemented with the logged observation of wind and currents. When close to land, a ship would be "sounding," meaning the measurement of depth by throwing a weighted rope overboard from the bow. Using visual markers to indicate different measurements, the crew would then call out the depth in fathoms (5.5 feet for merchant ships, and 6 feet for warships). All of this information converged on the quarterdeck, a raised area at the back of the ship, for the attention of the senior officer present. It was the machinic platform from which to create a multidimensional and multisensory white sight.

The artificial state reached the colony in the Americas by its ship machine and set about creating a surveillance machine on the plantation. It was comprised of visual supervision, the clearing and division of the land, mapping, and legally regulated whiteness. The plantation machine produced a general and specific means of surveillance. It established what art historian Jill Casid has called a "scene of projection . . . an apparatus of power and a metaphor machine."[56] On the ground, surveillance was the job of the plantation overseer, a Leviathan in action.[57] Like Leviathan, his task was to "keep them in awe," preventing revolt and ensuring production.[58]

In the mythology of slaving, the overseer magically knew and saw everything that transpired on the plantation. In day-to-day operations, he actually relied on covert surveillance and information supplied by enslaved people to survive. In the widely used 1667 planters' manual by French Jesuit missionary Jean-Baptiste du Tertre, a set of prints showed the overseer in action across various controlled spaces on the French-colonized island of Martinique. In a depiction of the domestic labor of food preparation at the planter's house, known as the "menagerie," in the old sense of managing a household, du Tertre portrayed eleven enslaved persons laboring under the watchful regard of one white person, standing in the shade. Even the house seems to be an agent of this surveillance with nine windows and a door providing viewpoints. Shaded by a broad-brimmed hat, the overseer's eyes cannot be seen because they are imagined as seeing everything. Concealment was key to the aura of being observed. Solomon Northrup later recalled how when he was enslaved, his overseer "Epps . . . whether in the field or not, had his eyes pretty generally upon us. From the piazza, from behind some adjacent tree, or other concealed point of observation, he was constantly on watch."[59] Whether it was true or not, this perception of being constantly watched was what the overseer intended.

The land itself was organized to facilitate this watching. Planters cleared the land above and beyond the requirements of cultivation. Trees were cut down to enable the "dominion of the planter's gaze," so that the Caribbean islands quickly became deforested.[60] Barbados was the first to

significantly deforest, other than in its hilly Scotland district.[61] By 1700, its enslaved population was around fifty thousand people on an island of 166 square miles. Land was divided into geometric squares and rectangles for allocation or sale. Within the plantation, fields were arranged in squares and planted in rows, using regularly spaced holes for each plant.[62] These stacked squares were the counterpart to urban squares with colonial monuments in Europe. The square was also the fundamental unit of infantry organization in late medieval and early modern Europe. In the Americas, the squared plantation was the space that could be kept in white sight. It was intended to maximize return and minimize the possibilities of escape for the enslaved and indentured labor force.

The squared plantation was defined by the plat and chain. A plat was a line drawing of an estate as if from an aerial viewpoint. The plat visualized

Jean-Baptiste du Tertre, "Menagerie" in
Histoire generale des Antilles habitées par les
François (Paris, 1667–1671). Photo: author.

the space to be controlled by the overseer. It looked like the space being seen in Bosse's perspective drawing (see the introduction). Plats were produced using measurements made by enslaved labor, in units called "chains." Invented by English priest Edmund Gunter in 1620, the chain was measured with a metal chain, the material form of white sight. In British imperial measures it was 66 feet. The chain was the unit used by the US General Land Office to produce the grid of land expropriation in the nineteenth century. Later it calibrated the famous Ordnance Survey maps of Great Britain. The chain was the metonymy of the "landscape-empowered visuality of mastery" in the plantation, a seeing in and by chains.[63] This white sight was an artificial measure that nonetheless expressed the violent realities of coloniality.

Colonies were made known by maps. Maps created by colonists were not always geographically accurate and did not serve the purposes of navigation. A detailed survey map of Jamaica was made in 1763, after 250 years of colonization, but there was no detailed map of Saint-Domingue (now Haiti) made during the slavery period.[64] Maps were frequently more conceptual than topographic. Du Tertre's 1667 map of Martinique divided the island into French and "wild" (*sauvage*) zones, separated by a dotted line to represent the conceptual and material border. In the wild zone was a site where "the Caribs [Kalinago] have their assemblies." These eight- to ten-day gatherings worked by consensus, with all proposals requiring "common consent."[65] Wild democracy preceded and justified colonial order. It was erased to make the ground for plantations.

On the first map of Barbados, made by former overseer Richard Ligon in 1657, plantations were identified by the drawing of a little house and the name of the owner. One exception was in the middle of the island; a caption simply read, "The tenn Thousande Acres of Lande which Belongeth to the Merchants of London." Racial capital had already succeeded in abstracting production, although not quite entirely. At the top left, in what would be the north of the island, a drawing depicted a white man on horseback firing a pistol at two fugitive Africans, running to the hills. The drawing captures the fear recorded by later fugitives that they would be highly visible on the plain, especially to riders who had an elevated viewpoint.[66] But it also showed the high places where those outside the

plantation machine lived their own wild democracy, beyond the narrow window on the world of white sight.

From this division of forced labor under the surveillance of white sight, a spectacular new machine form of capitalism emerged. As Antigua planter Samuel Martin noted, "A plantation ought to be considered as a well-constructed machine, compounded of various wheels, turning different ways, and yet all contributing to the great end proposed."[67] The spectacular violence of the plantation kept the "machine" running and constituted its energy source. An earlier Jesuit writer described Africans as "machines whose springs must be rewound each time that you want

Jean-Baptiste du Tertre, "The Isle of Martinique" in *Histoire generale des Antilles*. Photo: author.

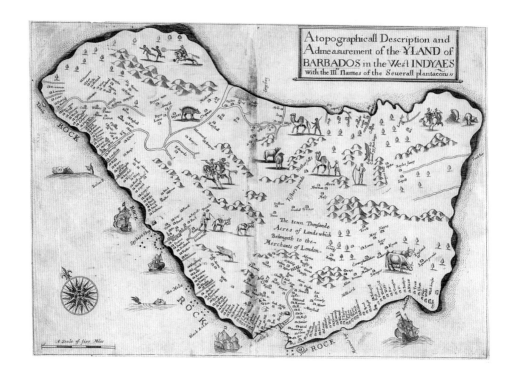

Richard Ligon, "A Topographicall Description
and Admeasurement of the YLAND of
BARBADOS in the West INDYAES: With the
Mrs. Names of the Severall Plantacons" [map
of Barbados] in *A True and Exact History of
the Island of Barbados* (London: Humphrey
Moseley, 1657). Photo: British Library.

them to move."[68] The African body was, then, the machine within the machine, subject to visible power and driven by violence. The pioneering historian of the Haitian revolution, C. L. R. James, pointed out long ago that the "field gang," the enslaved working directly in the fields to cultivate cash crops, was the first modern proletariat.[69]

By the same token, the overseer was the first modern manager, detailing crops and budgets with one hand, and administering violent punishment with the other. Oversight was a combination of discipline, with spectacular violence, and time management, double-entry bookkeeping, and other "modern" modes of time-work discipline. It became the method of government across the Americas. When the United States purchased Louisiana in 1803, it first erased the land of Indigenous presence using the Indian Removal Act of 1830 and Treaty of Dancing Rabbit Creek. It then embarked on a massive land survey, dividing the territory into 640-acre grids, subdivided into 160-acre quarter sections, which were the basic unit of sale.[70]

The plantation machine produced many things: coffee, cotton, death, human property, rape, sugar, violence, and so on. As the enslaved labor force marshaled more effective resistance, it also produced whiteness as a statutory distinction among people and practical means of surveillance. From the first, Atlantic world enslavement was for life, creating a permanent hierarchy whereby those not enslaved claimed "whiteness" as property.[71] Historians Peter Linebaugh and Marcus Rediker have cataloged the residents of Barbados in 1652: "English, French, Dutch, Scots, Irish, Spanish Jews, Indians and Africans." After the Restoration of the British monarchy in 1660, the planters and Parliament set out to increase African slavery as well as reduce European migration to produce a binary racializing divide.[72] The change was marked by the passing of the 1661 Act for the Better Ordering and Governing of Negroes, later known as the Barbados Slave Code. "Negroes" were defined as a "heathenish brutish and an uncertain dangerous pride of people," in need of "punishionary" ordering and governing.[73] Much of the Act was concerned with preventing and apprehending fugitives. Landowners were required to employ one "Christian" servant for every twenty acres they owned to enable the regime of overseen African labor, prevent fugitives, and resist revolt.

As African resistance continued and became better organized, the statutes became more stringent, and the order they imposed more violent. As media studies scholar Simone Browne has described, the 1712 uprising of the enslaved in New York led to detailed regulations as to how any "Negro or Indian slave above the age of fourteen years do presume to be or appear in any of the streets."[74] After the Stono Uprising of 1739, South Carolina similarly updated its Act for the Better Ordering and Governing of Negroes to state

that if any slave who shall be out of the house or plantation where such slave shall live, or shall be usually employed, or without some whiter person in company with such slave, shall refuse to submit or undergo the examination of any white person, it shall be lawful for any such white person to pursue, apprehend, and moderately correct such slave; and if any such slave shall assault and stricke [*sic*] such white person, such slave may be lawfully killed.[75]

Whiteness had now gained its own legal power to strike. It was against these legal strikes that the enslaved and others carried out their own strikes against slavery and whiteness. Whiteness was written into the law as a comparative (if absolute) hierarchy, excluding all Africans and allocating the power to kill to any "whiter" person should they be, as the police have it today, in fear for their lives.

After the alleged 1741 conspiracy of the enslaved in New York City, still more laws were passed requiring the "Negro, Mulatto or Indian slave" to carry a lantern after dark. Browne concludes that "the black body, technologically enhanced by way of a simple device made for a visual surplus where technology met surveillance . . . and encoded white supremacy, as well as black luminosity, in law."[76] Law, technology, and surveillance combined to keep the plantation machine running. One of its products was racializing, centered on the formation of whiteness. In the Atlantic world made by the settler colony and plantation, there was now a structuring opposition between white sight and Black luminosity. As Julien's film shows, to say nothing yet of the George Floyd Uprising (see chapter 8), the Anglo-American Atlantic world is still living in that plantation future. In the next chapter, we'll see why 2020's protesters against that white supremacy thought it was obvious for them to target statues and monuments.

2

THE WORLD OF STATUES IN THE AMERICAS

At the height of the 2016 US presidential election campaign, a new far right group called Identity Evropa announced a campaign called #ProjectSiege, centered around posters of classical sculpture.[1] The "siege" in mind was the purported hostility to a specific set of European and US cultural heritage declared to be "white." One of the most noticed Identity Evropa posters depicted the classical statue now known as the *Apollo Belvedere* with the caption "Our Future Belongs to Us," apparently borrowed from the song "Tomorrow Belongs to Us" in the musical *Cabaret*. Apollo remains resonant in US culture because the NASA moon rockets bore his name. NASA director Abe Silverstein thought Apollo had "attractive connotations" when naming the program in 1960.[2] In 2017, the Unite the Right rally in Charlottesville, Virginia, came together to defend the Robert E. Lee statue. By 2021, the Trump administration left office promising a sculpture garden of US heroes, even as the UK government was increasing the penalty for damaging a statue from three months to ten years. White supremacy continues to understand the classical statue not as an example of whiteness and white supremacy but rather as its very form.

This chapter describes how the statue of Apollo first became the symbol of colonization as Adam in the Garden of Eden in the Americas, even as Eden was also the location of an imagined commons. As Indigenous and African resistance grew, Eve was expelled from the white imaginary, while real women were renamed "Venus" and violated. Apollo became

the very "type" of whiteness. The Haitian Revolution (1791–1801) instead proposed a common humanity—one that it named Black (*Noir*) regardless of skin tone or ancestry.[3] In the United States, abolitionists followed this lead to imagine a visualized democracy, using Frederick Douglass's formula "pictures and progress."[4] In the ascendant from emancipation to Reconstruction (1863–1877), this progress ran into Jim Crow, which again upheld a white man as the apex of a racializing hierarchy of beauty.[5] Divine Apollo returned to earth as the all-too-human Robert E. Lee. The Lee statues were still standing until 2020, when the George Floyd Uprising removed them (see chapter 8). The global movement to remove racist statues challenges both the "white type" as a whole and the concept of the hero as a white man in particular. This is not a debate about sculpture or history but one that confronts domination with democracy.

APOLLO GOES TO THE AMERICAS

A Roman copy of a Greek statue that was rediscovered in the Renaissance, moved to Paris by Napoléon, and finally returned to the Vatican, where it still remains, the *Apollo Belvedere* has become the defining image of whiteness.[6] It is only white at all because its original bright colors disappeared over time.[7] Apollo was first a symbol of colonial dominion through his connection to the first man, Adam, when Eden became a metaphor for the Americas. This entailed the drama of the "Fall of Man," the moment when Adam and Eve eat the forbidden fruit of the tree of knowledge and are expelled from paradise. Apollo in the Americas cannot be separated from sin. Where there was Apollo, there was also Venus; where there was Adam, there was of course Eve. The patriarchal exaltation of mythical Apollo came at the expense of violated real women, often renamed Venus. From a colonized Garden of Eden with classical overlays, modern white supremacy converged on Apollo, seen as prefiguring Christ, in response to abolition and revolution. Apollo became whiteness's white mask.

Just a decade after Christopher Columbus's first encounter, German artist Albrecht Dürer engraved Adam and Eve in a hybrid European and colonial Eden.[8] To the left is Adam, his body, face, skull shape, and pose all derived from the *Apollo Belvedere*. Adam was later described by John

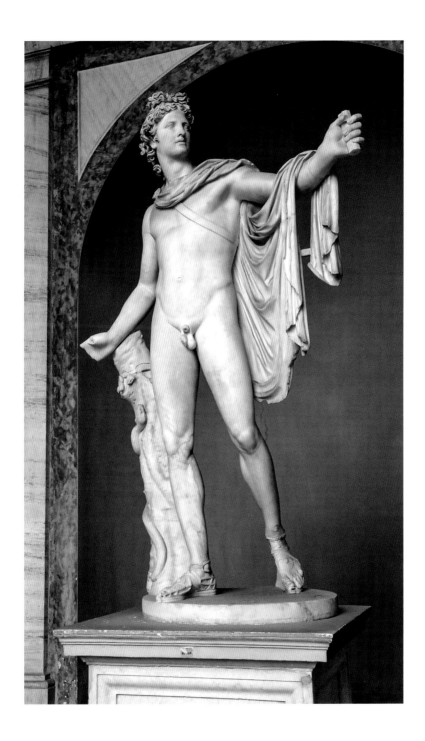

Apollo Belvedere, ca. 2nd century AD. Vatican
Museums. Photo: Wikimedia Commons.

Milton in his epic poem *Paradise Lost* as a mix of statue and sovereignty: "His fair large front and eye sublime declared / Absolute rule."[9] The high, white forehead of the Apollo became a cliché of visualized racial hierarchy and betokened absolute power. Adam was made in God's image, and as such, was the prototype of the image. In this sense, all images are "white" as long as Adam is understood to be white. To his left in the Dürer engraving stands Eve, derived from the icon of *Venus Pudica* (Modest Venus). Paradise was often imagined as a garden of Venus, as she was both "goddess of gardens and of the generative cycle."[10] Before the Fall, there was no reason for Eve to be modest, as the pair paraded in what Milton called their "naked glory."[11] But Apollo and Venus, if you follow Homer, were half siblings, so modesty might have been in order. Eve holds the fateful apple in her right hand, helped by the serpent. Adam doesn't see it, as he looks her directly in the eye. Or at least he tries to do so, but her look is directed down, modestly one might say, if she were not looking at both the apple of knowledge and Adam's genitals, perhaps not as concealed from her as they are from the spectator.

Around them, animals abound, with a parrot perched above Adam's head. Parrots come from the southern hemisphere, whether from Africa or the Americas. The craggy mountains in the background, complete with a mountain goat, are reminiscent of more northern regions. The parrot is out of place, there to direct the imagination away from specific locations to the all-but-completely imaginary (for Europeans) new paradise of the Americas. Dürer's scene was the last moment of the eternal possibility of paradise, with the beginning of human history, knowledge, and sin about to happen once the apple is eaten. Milton would evoke the encounter when describing how Adam and Eve covered themselves after eating the apple: "Such of late / Columbus found th'American so girt / With feathered cincture, naked else and wild, / Among the trees on isles and woody shores."[12]

So quickly did this parallel between Eden and the Americas become standard that the first plate in the first volume of Theodor de Bry's celebrated illustrated compendium of travel narratives, published in 1590, depicted Adam and Eve with no textual explanation whatever. De Bry (1528–1598) had no personal experience of the Americas, evidenced by his drawings that show Algonquin warriors with visible tails. In the

Albrecht Dürer, *Adam and Eve*, 1504.
Courtesy of Metropolitan Museum of Art,
Open Access Collection.

foreground of his *Adam and Eve*, neither looks at the other. Adam glances up, somewhere between perplexity and despair. Eve, now seen from behind, looks out as if seeing someone. A pair of rather scrawny lions loll at the first couple's feet, evoking prelapsarian peace and colonial paradigms alike. De Bry depicted the imminent Fall in the background, using an imprecise perspective and blurred finish to indicate the time shift. To the left, Eve sits in a simple shelter, holding an infant. To the right, Adam scratches at the soil with some kind of tool, while cows graze. The postlapsarian future of childbirth and hard labor was always there, even in the Americas that resembled the Garden of Eden. Art historian Maureen Quilligan notes that de Bry's engravings portrayed "an untouched paradise, ripe for conversion."[13] Yet this paradise was not quite the same as Eden because its inhabitants were subject to multiple falls, from their "heathen" condition, presumed idleness, and control of their own destiny. After the conquest, the European claimed knowledge, itself a condition of the Fall, and invented the Indian as those who must fall.[14]

EDEN AS A COMMONS

Both in the Americas and Europe, people resisted the mythology of the Fall as justifying domination. In Peru, Indigenous artist, writer, and politician Felipe Guaman Poma de Ayala (1535–1616) included Adam and Eve in *The First New Chronicle and Good Government* (1608–1616). This was a literally monumental text, some twelve hundred pages long in Spanish and Quechua with four hundred full-page drawings by the author. Descended from the ancestral Indigenous elite, Guaman Poma was also an officeholder in the Spanish colonial regime.[15] In his tumultuous life, he lived through the consolidation of Spanish colonial rule and lost many of his personal advantages in a series of legal actions. His book was addressed to King Philip III of Spain and so was meant to be read by non-Indigenous people, even as there is an underlying Andean cosmology. For Guaman Poma, time was structured in five layers, in which "the first mundo, or *pacha* in Quechua, a word that designates both space and time (among other meanings), begins with Adam and Eve."[16]

Theodor de Bry, *Adam and Eve in America*,
1590. Library of Congress Rare Book and
Special Collections Division.

In Guaman Poma's drawing of Adam and Eve, there was no sense of Eden, no nostalgia for a paradise that never was. Adam is breaking the soil, while Eve looks on, nursing one child and holding a rambunctious toddler, suggesting that the scene is about three years after the Fall. Pairs of chickens and doves dot the mountainous landscape, anticipating the Flood. Guaman Poma was demonstrating his understanding of Christian scriptures and theology, even as he layered it into Inca cosmology, to say nothing of the dramatic Andes in the background. Implicit within this scene is the second Fall that has just begun with the arrival of Europeans, creating the unanticipated fifth *pacha*. There is an unspoken but legible claim to a transhuman equality in which all humans are fallen.

If the Fall along with its division of space and time justified colonialism in the Americas, there was another imaginary of the Fall that sought to undo all property relations within Europe. In seventeenth-century England, coeval with Guaman Poma, it was believed, according to historian Christopher Hill, that "if Adam had not fallen, men would have been equal, property would have been held in Common; [but] a coercive state has become necessary to protect inequalities in property, which are the consequences of post-lapsarian greed and pride."[17] This official position countered the egalitarianism inherent within some readings of Genesis. In 1381, radical English preacher John Ball had set the Peasants' Revolt in motion with his couplet: "When Adam delved and Eve span, / Who then was the gentleman?" Eden had been a commons, Ball suggested, with the implication that before or after the Fall, there should be no hierarchy among people.

This radical tendency became again intensely visible during the English Revolution (1642–1651). Revolutionaries understood the Fall as a political regime that might be reversed, making for "the world turned upside down." Hill described this politics as the effort to "get back behind the Fall."[18] By contrast, the Fall was crucial to colonial practices of whiteness. Slavery was held to be impermissible before the Fall, but not after it. Calvinist William Perkins described slavery as "against the law of entire nature as it was before the Fall; but against the law of corrupted nature since the Fall, it is not."[19] This approach gave blanket permission to enslave. Abolition would, then, be a reversal of the Fall and change in the direction of time. The statue sought to foreclose any such possibility.

Adam and Eve, ca. 1565. Facsimile of a drawing by Felipe Guaman Poma de Ayala from his *El primer nueva corónica y buen gobierno*. Photo: Werner Forman Archive / Bridgeman Images.

APOLLO AS WHITE BEAUTY

This early modern history shows how radical and unlikely was the enshrining of Apollo, whether dressed up as Adam or not, as the very type of whiteness. In response to the challenges of abolition and revolution from the late eighteenth century to emancipation in the United States, whiteness invented aesthetics. Regardless of personal positions for and against slavery—which did not simply align with the new aesthetics—an unlikely coalition of philosophers, art historians, and natural historians reshaped the way white people imagined themselves. Followed in the history of ideas, this is an often inconsistent and even incoherent story, which has been skillfully described by historians of whiteness Nell Irvin Painter, David Roediger, Noel Allen, and others.[20] Within the contested history of pictures against types or progress against permanence, there is a simpler tale to tell. Apollo's statue exemplified beauty. Its beauty was also its whiteness. By condensation, whiteness became beauty, exemplified through the statue of Apollo. This was not a logical process but an aesthetic one. As philosophers like Jacques Rancière have insisted, the experience of the aesthetic was a new one in eighteenth-century Europe.[21] As much as it constantly claimed to be "disinterested," the aesthetic of whiteness could not have been more political.

From Johann Winckelmann, often considered the founder of modern art history, via a motley crew of natural historians to Jefferson Davis, president of the Confederacy, whiteness was perfect beauty. Incarnated in the statue of Apollo, this beauty increasingly entranced white sight. This trance was a mode of beguilement, in which male homoerotics were allowed free play as the desire for the same, meaning the white same, and to which there was no "female" counterpart. Looking at ancient sculpture and comparing it to living people, this way of seeing made white beauty into a permanent type. It identified certain markers of this type, above all skull shape and size, derived from statues, not people. Outside this type were what have become the wearisome and familiar stereotypes of supposed inferiority.

Philosophe Winckelmann created what Frantz Fanon would later call the "white mask" as an Enlightenment principle in 1763: "The true feeling for beauty is like a liquid plaster cast which is poured over the head

of Apollo, touching every single part and enclosing it."[22] The feeling was purely tactile, as all other senses are occluded. Beauty was a suffocating white mask that somehow sustained life from the divine statue within. The Apollo in question was still the *Apollo Belvedere*, not as a model for Adam but as the mold for whiteness. In the manner of Thomas Hobbes (see chapter 1), Winckelmann observed that the compound feeling for beauty evoked by Apollo was "inner" and "purified." It relied on an "accuracy of the eye" that was held to be rare, even among artists. This Platonic way of "feeling" beauty was by definition unavailable to the multitude and science alike.[23] Like the statue, this whiteness was elitist, unyielding, and yet vulnerable—marble shatters when dropped. This deeply strange set of ideas nonetheless underscores both whiteness and art history.

In the first paragraphs of his foundational *History of Ancient Art* (1764), Winckelmann mused on how Greek art united grandeur with beauty, but later "lost its grandeur; and the loss was finally followed by its utter downfall."[24] This fall was not the expulsion from Eden but one from beauty and whiteness. For at the beginning of the aesthetic, Winckelmann racialized beauty: "Our nature will not easily bring forth such a perfect body as that of [the statue] Antinous Admirandus." This statue, now identified as Hermes, is an ancient Roman figure of a nude young man, who was the lover of the Emperor Hadrian. While this statue was famed for its ideal proportions, curving gracefully at the hips, with the head bent forward as if in reflection or humility, it also made explicit Winckelmann's male homoerotics of white beauty. The ideal "Greek profile" that Winckelmann found in the *Apollo Belvedere* was, he claimed, "as peculiar to the ancient Greeks as flat noses are to the Kalmucks [Kalmyks] and small eyes are to the Chinese."[25] He did not forget to compare Africans to monkeys.[26] These imaginings came in the time of François Makandal's antislavery revolt in Saint-Domingue (1757), Tacky's Revolt in Jamaica (1760), and Pontiac's war against the British in North America.[27] As settler slavery came under serious challenge, so whiteness was asserted as divine and unique.

Driven by the fear of abolition, this racialized scale of "distinctions" between humans became absolute in defense of the absolute property that was slavery.[28] Beginning around 1770, anatomist Petrus Camper performed an extensive series of dissections on human corpses, including those of Africans.[29] He invented what he called the "facial angle" formed

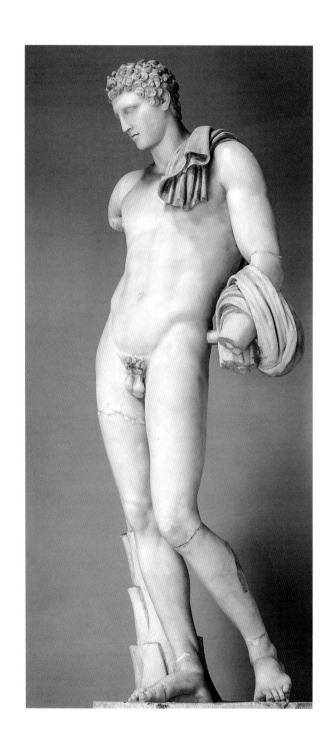

by the relationship of the jaw to the skull. This angle, usually portrayed by (good) straight or (bad) sloping foreheads, has become one of the longest-lasting visual myths of racism. Camper arbitrarily determined that a higher angle was better and the highest angle that could be found was not in nature but rather in Greek sculpture. The *Apollo Belvedere* produced a facial angle of a hundred degrees, a few degrees higher than other Roman sculpture at ninety-five degrees, and much higher than all actual humans.

In the intense debates produced within natural history on this topic, Camper found human difference to be inherent, following his dissection of fetuses, but not necessarily unchanging over the long term, noting that "Adam could have been created black, brown, tanned or white."[30] This offhand dismissal of Adam indicates that the paradigm of "man" had changed from the Bible to classical antiquity. History was now the tool of measurement being used. The present-day hue and cry concerning "erasing history" when statues are removed really means "erasing whiteness."

Nonetheless, Camper himself did not use the *Apollo Belvedere* in his work. It was added to his illustrative drawings in 1795, after his death in 1791, coinciding with the beginning of the Haitian Revolution.[31] In reaction, the aesthetic politics of natural history rearranged the theory of distinct types of human beings into a hierarchy of separate species of humans in which only the "white" or Caucasian was fully human. Art historian David Bindman has shown how "the Greek ideal represented the generic typology of 'civilized' Europeans, and one that was susceptible to measurement."[32] After the Haitian Revolution, a hierarchical scale of perfection was created as a counterrevolutionary tactic, first using art, and then applied to classifying human and other-than-human life in relation to the *Apollo Belvedere*. From this point forward, it was the shape and size of the skull that indexed beauty as whiteness and whiteness as beauty, static and out of time.

Hermes, formerly known as Belvedere Antinous, first-century Roman copy of fourth-century BCE Greek original. Vatican Museums. Photo: Marie-Lan Nguyen via Wikimedia Commons.

Just as Apollo was a rapist deity, the claim to beauty was accompanied by the practice of rape by the formation of a new Venus, as Saidiya Hartman has chronicled:

> Variously named Harriot, Phibba, Sara, Joanna, Rachel, Linda, and Sally, she is found everywhere in the Atlantic world. The barracoon, the hollow of the slave ship, the pest-house, the brothel, the cage, the surgeon's laboratory, the prison, the cane-field, the kitchen, the master's bedroom—turn out to be exactly the same place and in all of them she is called Venus.[33]

This Venus was not the object of beauty but instead the subject of violation. She was the frame for the Khoi-San woman, known via her Dutch name, Sara Bartmann (ca. 1789–1815), and renamed the "Hottentot Venus," who was put on display across Europe from 1810 to 1815, combining slavery, forced sex work, and purported science—the Atlantic world Venus.

For the violator, the boundaries of visibility and opacity did not apply. He was equally enabled in the hold of the slave ship or the pen that was deemed "out of sight," as he was in the field, or the prison that remains the domain of racializing surveillance. As Simone Browne observes, "The captive black female body asks us to reconceptualize the links between race, gender, slavery and surveillance."[34] On the slave ship *Wasp* in 1783, women prisoners rose up and took the captain prisoner. Recaptured, many refused to eat and died.[35] Faced with such resistance, slavers developed a tool to force food into their human property. Known as the *speculum orum*, the mirror of the mouth, this device forced open the mouth by simple leverage, allowing food to be inserted. In the twentieth century, it would be used to force-feed suffragettes in British prisons (see chapter 4). The capacity to force the body—whether to eat or have unwanted sexual relations—is the dark side of aesthetics.[36] Because if there is a hierarchy, there is always a place "below the line," whether literally in the hold of a ship or simply out of sight. In the hold of the slave ship, argues Hortense Spillers, even "gender difference" is lost.[37] From the homoerotics of colonial Apollo to the transubstantiating violence of the hold, there was no "normal" to be found in the metamorphoses of settler slavery.

Haiti's revolution knew that all of this hierarchy had to be undone.[38] It did not simply reverse racial capital; it tried to end it. Its 1804 constitution decreed that "no white man of whatever nation he may be, shall put his foot on this territory with the title of master or proprietor, neither shall he in future acquire any property therein." This clause sought to foreclose any future possibility of white supremacy, neocolonialism, or segregation. The constitution insisted, against the racializing hierarchy created by slavery, that all persons living in Haiti were to "be known only by the generic appellation of Blacks," using the revolutionary term *Noir* rather than the colonial and racist *Nègre*. This hitherto unimaginable metamorphosis from white, "colored," or *Nègre* to *Noir* is the specter that haunts modern whiteness—a common humanity without the aesthetic hierarchy of skin tone and skulls. Every person present in revolutionary space was "Black," regardless of past personal histories. It undid whiteness in Haiti and rewrote what it is to be human as Black, revolutionary affiliation, and abolition democracy. For this effrontery, the island has not yet ceased to be punished by debt, poverty, and neocolonization. Yet there is also an invitation here, as proffered by C. L. R. James: "These are my ancestors. They are yours too if you want them."[39] I have to earn the right to take up that invitation, but it is there, and that is remarkable.

THE TYPE OF BEAUTY

The reaction to Haiti was swift, ugly, and long-lasting. Four years after the revolution began in 1795, a new edition of Johann Friedrich Blumenbach's *On the Natural Variety of Mankind* made the "shift from a geographic to a hierarchical ordering of human diversity."[40] Blumenbach was the first to propose the name "Caucasian" for whiteness, claiming that these were "the most beautiful race of men."[41] He created an aesthetic hierarchy of race, based on beauty, descending from Caucasian, via Mongolian, Ethiopian, and American to Malay. All of these groups were supposedly degenerations from the Caucasian ideal. Winckelmann's aesthetics had now merged with natural history thinking to create a racializing aesthetic hierarchy of human types.

This hierarchy was completed with the addition of other-than-human life. Both Charles White, a British obstetrician, and French naturalist Julien-Joseph Virey mixed aesthetics and natural history to create a scale of life from the orangutan via the African to Greek sculptures. Virey declared that other than Europeans, there was nothing but a "vile rabble of barbarians. . . . Hence world empire is European destiny."[42] In the year of Haiti's independence, it was at best a cheap shot. Both books were full of assertions about facial angles and skull shapes. What made Virey's work so influential was its illustrations.

His book was accompanied by a set of highly influential engravings by the prolific book illustrator A. B. Duchamel (1736–?), who otherwise mostly drew fashion plates. Whether working to directions or on his own, Duchamel created the image of racial "common sense" in Europe after Haiti. Following rather mediocre depictions of both Apollo and Venus, his much-reproduced third plate showed three heads: the *Apollo Belvedere*, a caricature African, and an orangutan (in the illustration, I have redacted the "African" head). It looks now like a badly drawn diagram of evolution, but it was the exact opposite: a counterrevolutionary scale of absolute difference. Despite France's defeat by the formerly enslaved, Virey saw in the Greek statue "male and severe beauty . . . unknown to savage hordes or peoples who live situated in climates situated in extreme temperatures."[43] The southern Mediterranean statue had become a hardy northern European, perhaps because Napoléon had taken it from the Vatican after his 1799 Italian campaign and installed it in the Louvre. Even racism was looted.

In his second expanded edition in 1824, Virey now claimed that a larger skull indicated a larger brain and hence more intelligence. He changed the illustrations to match. Now the three heads were replaced with a set of skulls engraved by Madame Migneret (1786–1840), a printer and bookseller. She drew an entirely imaginary outsized skull for the *Apollo Belvedere* compared to skulls of other racial "types." Virey now asserted that the "common sensorium" of humanity was located in the anterior lobes, to be found in the front of those straight skulls, meaning that only Europeans were fully human.[44] Presumably the statue also had such a brain inside its huge "skull."

Pl. IV. T. II. P. 134

1. Profil de l'Apollon. 2. celui du nègre. *Duhamel S.*
3. celui de l'Orang-outang.

A. B. Duchamel, *Racial Types*, planche IV,
in J. J. Virey, *Histoire naturelle du genre
humain* (Paris: Crochard, 1801). Redacted
by the author.

1. *Crâne d'après l'Apollon* .
2. *Crâne de Géorgienne* .
3. *Crâne de Nègre* .
4. *Crâne de Pongo Singe* .

Madame Migneret, *Comparative Skulls of Racial Types*, in J. J. Virey, *Histoire naturelle du genre humain*, 2nd ed (Paris: Crochard, 1824).

These imagined statue skulls might seem almost funny, as does the fact that no actual person could express the perfection of whiteness. But their consequences were all too real. From this point on, sculpture was the key symbolic and material form of white infrastructure. In the argument of the period, sculpture was the only way to show the pure form of whiteness because the long history of cross-ethnic childbearing, whether with consent or forced, meant that no "pure" types still existed. When these statues are taken down, it is to counter the very form of white supremacy, now over two hundred years old.

Like a specter, the *Apollo Belvedere* made a return in the slave-owning Americas as a type. Despite the rising abolition movement and uprisings like Denmark Vesey's Haiti-inspired one in 1822, slavers found new energy in the 1850s, backed by the Fugitive Slave Law (1851) and notorious 1857 *Dred Scott* ruling that Africans had no rights that white persons were bound to respect. With this legislative and US Supreme Court backing, slavers claimed that the permanence of human "types" justified the permanence of enslaved labor. The racial typology of the United States was based on the cranial obsession of naturalist Samuel Morton, who claimed in 1839 that "the statues of Olympian Jupiter, and the Apollo Belvedere, convey an exact idea of the perfect Grecian countenance."[45] Although he was actually measuring the skulls of the Indigenous in the Americas, Morton nonetheless maintained that African brains were smaller than those of all other races. The *Apollo Belvedere* now stood for the "type" of whiteness on a scale of racial types that were held to be so radically distinct, they were created separately. Slavery's way of seeing thereby moved from the plantation to the scientific association and from there to the cultural unconscious by means of mass-reproduced images.

In 1850, Josiah Clark Nott, a doctor practicing in Mobile, Alabama, presented a paper at the American Association for the Advancement of Science meeting held in Charleston, South Carolina. His talk previewed his forthcoming book, *Types of Man* (1854), which became a best seller for its assertion that there were multiple, distinct "types" of human. The supposed permanence of the Jewish "type" was taken to prove this thesis, which ended with the claim that "the pure blacks, when left to themselves, have never been able to sustain a rational form of government and in Hayti [*sic*] barbarism advances as the white blood is expelled."[46]

Looking at Jews allowed white men to contend that Africans could not govern.

The respondent to Nott's presentation was Louis Agassiz. Agassiz, a student of natural historian Baron Georges Cuvier, came to fame for his studies of the glaciers in the Alps that led him to define the now-accepted Ice Ages in earth's history. He claimed to have a form of hypervision, which he called "the naturalist's gaze." Agassiz even recommended a special diet for naturalists "in order that even the beating of his arteries may not disturb the steadiness of his gaze, and the condition of his nervous system be so calm that his whole figure will remain for hours in rigid obedience to his fixed and concentrated gaze."[47] Glaciers, he noted, cannot simply be seen by looking but rather must be deduced like faint traces on a lithographic stone.[48] He inferred the Ice Age from the observation of "erratic boulders," massive rocks scattered unevenly, far above the then-present level of the glaciers. Looking at striations, faint scratches on rocks, he realized they could not have been produced by water, which tends to polish, but indicated the result of past friction. In these striations, Agassiz saw the past Ice Ages. For all of his claims to deduction, the extended glacier theory was first suggested by a peasant named J. P. Perraudin, who told it to a professor named Jean de Charpentier, who in turn relayed it to Agassiz.[49] All Agassiz did was take this local observation and generalize it.

This deductive generalization led him to project his curious obsession with creation and extinction into grand schemes of time and space. Agassiz realized that the expanded ice sheet was the cause of past extinctions, which like Cuvier, he imagined as sudden catastrophic moments. He then proposed that this extinction was a repeated event, creating "a complete scission" between each version of creation. Resemblances between living species and extinct ones indicated only the re-creation of "identical species."[50] For Agassiz, this geological cycle of catastrophes was visible only as "a prerogative of the scientific observer, who can tie together in their mind facts which appear without connection to the mob."[51] The peasant might observe that a specific boulder had been moved to its present position by a now-disappeared glacier. Only the "scientific observer" could see the deep patterns that connected the examples.

Agassiz then came to Harvard as professor of geology and zoology, and played a central role in the debates over visualizing whiteness in the

decade preceding the Civil War. In Charleston, Agassiz announced his position for the first time that "viewed zoologically, the several races of men were well marked and distinct."[52] Despite the aura of science, the meeting ended in an atmosphere more like a Trump rally, as described by one contemporary journalist: "The remarks at the close of the meeting were of altogether too popular a cast to require their printing."[53] White supremacy was unspeakable and now unprintable. Racist language, gleeful claims to dominance, and new "facts" made for a heady brew. Agassiz's endorsement of polygenesis—multiple species of human—was itself newsworthy and scandalous. The scandal was that he denied the biblical account of the Creation from what he called "Theological Naturalists," not his intellectual support for slavery and segregation.[54]

After the meeting, Agassiz set off to make his now-infamous daguerreotypes of enslaved Africans, currently subject to a restitution lawsuit by Tamara Lanier, the lineal descendant of Renty and Delia, two of those photographed. Expecting to observe sharp distinctions in African "types," Agassiz commissioned the daguerreotypist J. T. Zealy to take a series of shots of enslaved Africans at a South Carolina plantation.[55] Stereotype was to be confirmed by daguerreotype to "demonstrate" the material existence of human type. Zealy posed his subjects as if for the slave market, stripped to the waist, in the manner used to advertise human beings for sale. Agassiz was not making images of the color line between white and Black. Rather, he expected to see in these bodies visual evidence of racial difference among Africans. It would never have occurred to him that the difference between people of African and European descent needed to be made visible. His goal was that a sophisticated (white) person would be able "to distinguish their [African] nations, without being told whence they came and even when they attempted to deceive him."[56] Like subsequent police, Agassiz saw photography as the perfect surveillance and detective tool.

Just as he did with the Ice Age, Agassiz had merely co-opted everyday practice into ethnology. In the slave market, one might observe as Joseph Holt Ingraham put it in 1835, "that singular look, peculiar to a buyer of slaves."[57] This "singular look" was concerned with both national origin in Africa and the degree of whiteness in the chattel body. Darker skin was preferred for outdoor work, whereas lighter-skinned women were picked for household labor. Close observation of the hands, arms, teeth, and face

was considered essential. In the parallel racializing vision of ethnography, the claim to see a person's origin at a glance was common. Morton also claimed to able to deduce ethnicity from skulls with "a single glance of his rapid eye."[58] This dissecting gaze was the Apollonian opposite of the supposedly diminished vision of the enslaved.

Just before the Civil War, Samuel Cartwright, a New Orleans–based doctor, went so far as to allege that "the field of vision is not so large in the negro's eye" because it was like that of apes.[59] His points of reference ran up and down Nott and George Gliddon's hierarchy, claiming that where the white person sees like a god, the African person sees like an ape. Cartwright went still further to assert that freedom created what he called "Dysaesthesia Aethiopis," or "Black dysaesthesia."[60] Black dysaesthesia was the opposite of the white aesthetic represented by the statue. His evidence, yet again, was Haiti. Freedom caused the refusal to obey or work. Cartwright shifted the field of racializing judgment from formal aesthetics to medicine with long-lasting consequences.

What did white people see when they looked at Zealy's daguerreotypes? Agassiz is known to have shown the daguerreotypes soon after they were made at a meeting of the Cambridge Scientific Club in Massachusetts on September 27, 1850. He concealed them only once it became clear that he would lose status with abolitionist white colleagues.[61] Douglass later speculated that "looking at the black man, the white man sees not himself but his dark opposite."[62] It was a Manichaean projection. Looking at enslaved people, the white person projected all evil onto them. It would not have been so simple in the case of daguerreotypes because the picture surface is shiny and reflects the viewer. A white person looking at them would have seen their reflected face hovering above the small likenesses of the Africans and African Americans. It was a visual analogy for Douglass's concept of "amalgamation," the inevitable interaction of people of different heritages. Racial typologists hated the possibility of such amalgamation, despite its palpable evidence all around. For Agassiz, even after the Emancipation Declaration, it was "as much a sin against nature as incest."[63]

It was Nott who combined the "evidence" offered by Agassiz and other polygenist ethnologists into an unreadable but highly influential eight-hundred-page compilation titled *Types of Man* (1854).[64] The whole book

Fia. 339. — Apollo Belvidere.

Fia. 340.

Greek.

comes down to this claim: "many primitive types of mankind were created."[65] Nott maintained that different "types" once created did not converge or assimilate but must remain systemically different. The visual type was perceptible above all in the dominant aspects of head shapes, skull sizes, and facial traits. He drew on his own observational evidence from ancient Egyptian monuments to find a distinct and permanent "Negro" type. Looking at a bas-relief said to date from the time of Ramses III, circa 1300 BCE, Nott observed that "anyone living in our Slave-States will see in this face a type which is frequently met with here" (249). This "evidence" was visually presented to readers in a set of amateur wood engravings made by Gliddon's wife. Once again, Apollo sat atop a hierarchy comprised of the African and a chimpanzee, complete with skulls (the African and chimpanzee have been redacted from the figure). Nott claimed that they depicted a "truthfulness . . . (viewed ethnographically)" (xlii). Such prints and photographs were the medium by which this "truth" moved from the narrow circuits of natural history into the cultural unconscious.

Mrs. Gliddon, "Apollo and His Skull," in Josiah Nott and George Gliddon, *Types of Mankind: Or, Ethnological Researches, Based upon the Ancient Monuments, Painting, Sculptures, and Crania of Races, and upon Their Natural, Geographical, Philological and Biblical History* (Philadelphia: Lippincott, 1854).

Nott described himself and other Europeans as Caucasian, entirely different from all other types of the human, being a "cosmopolite" (67), derived from many primitive races. The Caucasian was the only human to whom the book of Genesis could be applied (79). In this version of history, even the Garden of Eden was segregated with a whites-only sign. The Caucasian was God's imperialist, having the "mission of civilizing the earth . . . destined eventually to conquer and hold every foot of the globe, where climate does not interpose an impenetrable barrier" (77). In a spectacular example of having the cake and eating it, Nott said the Bible was wrong about human origins, but right about the dominance of Caucasians (a topic that it never mentions). Nott's ethnographic way of seeing provided a genealogical and biological justification for the permanence of slavery by means of its perception of visual type. Divorced from the mishmash of text, his visual stereotypes have had a life of their own, settling into the broad set of patterns that constitute the cultural unconscious where "race" reproduces itself.

PICTURES AND PROGRESS

In response to this visualizing of distinct human, abolitionists extended Haiti's antiracializing constitution into a visualizing democracy. Douglass, as mentioned above, called the connection "pictures and progress."[66] Abolition understood social life as tending toward progress, epitomized by the democratization of "pictures."[67] "Pictures" of course referred to photographs, engravings, daguerreotypes, and all kinds of mass-reproduced imagery. But it also referenced advertisements for fugitive slaves, antislavery picture books for children, James Presley Ball's Daguerrian Gallery of the West, and even lectures on beauty.[68] The "progress" Douglass touted was a very nineteenth-century term, implying steam, telegraph, and electricity.

"Pictures and progress" overturned the Apollonian image of white supremacy, right back to the Garden of Eden. Reframing slavery as the "original sin" of the United States, abolitionists updated Haiti's foundational unity of all humans to picture-making beings.[69] At the Ohio Women's Rights Convention of May 1851, Sojourner Truth set out a challenge: "I

cant read, but I can hear. I have heard the bible and have learned that Eve caused man to sin. Well if woman upset the world, do give her a chance to set it right side up again."[70] (She was later supposed to have asked, "Ain't I a woman?") Truth's "hearing" of scripture, discerning what Tina Campt has called its "frequency," undercut the idea of permanent visualized types.[71] A sinless Eve undid all manner of hierarchies.

Even after the Emancipation Proclamation, writer Harriet Beecher Stowe nonetheless could only see Truth as a racializing sculpture. In April 1863, Stowe published an essay in the *Atlantic Monthly* titled "Sojourner Truth, the Libyan Sibyl."[72] Stowe replaced Truth with a statue, whose white marble stood in for her "dusky" self. Truth was said to personify William Wetmore Story's (1819–1895) sculpture *Libyan Sibyl* (1860), shown at the 1862 World Exhibition. Symbolized by her Star of David, the Sibyl was a prophet, whom Story imagined foreseeing Atlantic slavery. When the sculpture was exhibited, the future of slavery was precisely what was in question in the United States as the Civil War unfolded. Story emphasized that the Sibyl was "thoroughly African—Libyan Africa of course, not Congo," meaning light-skinned, unlike Truth herself.[73] In the racial theory of the time, the Libyans were held to be the original Indigenous population of Egypt.[74] When Stowe mused on the Sibyl, she marveled nonetheless at her "unexplored depths of being and feeling, mighty and dark as the gigantic depths of tropical forests."[75] This was what she saw in Truth.

Such was Stowe's prestige that the label "Libyan statue" adhered to Truth from then on. Truth refused the link. Soon after Stowe's article appeared, Truth had a set of cartes de visite photographs made in Detroit in 1864. They became famous for her unusual printed caption: "I sell the shadow to support the substance."[76] The caption was there so white purchasers would know who they were looking at. The Platonic reference was a reversal of Stowe's effort to make Truth into a type. Perhaps the location of her studio project in Detroit was a contributing factor as well. Just across the river lay the freedom in Canada that Truth liked to sing about. Amhertsburg AME Church in Canada was the last stop on the Underground Railroad for many. Once free, many formerly enslaved had themselves photographed. Truth must have been aware of the ways in which free Black people were using photography as an expression of their

William Wetmore Story, *Libyan Sibyl*.
Metropolitan Museum of Art; gift of Erving
Wolf Foundation, in memory of Diane R. Wolf,
1979. Open Access Collection.

freedom.[77] Truth sold cartes de visite to sustain her substance: the practice of freedom.[78]

What W. E. B. Du Bois called "the general strike against slavery" enabled abolitionists to de-invisibilize the legacies of slavery and white supremacy. In this democratic frame, James McCune Smith, physician and abolitionist, defined abolitionism as following from the Haitian Revolution's proposition of "equal rights to all men."[79] In *Frederick Douglass' Paper*, he declared, "We are here for a purpose, to prove the human to be *one brotherhood*. We must work this out *here*, or for ages the chance may not come again."[80] The complete ending of slavery required that humanity be seen as one. Progress was not inevitable but the ground of a political battle to be won.

In a series of essays titled "Heads of the Colored People," also published in *Frederick Douglass' Paper*, Smith unbuilt the "types of man" argument.[81] In his account, people's "heads" did not depend on their "type" but on their circumstances. In 1852, two years after the Zealy daguerreotypes were taken, Smith described how a disabled, formerly enslaved newspaper seller in New York City was visibly descended from the "first families" of Virginia: "It is well known that Jefferson contradicted his philosophy of negro hate, by seeking the dalliance of black women as often as he could, and by leaving so many descendants of mixed blood, that they are to be found as widely scattered as his own writings throughout the world."[82] Smith used living people on the streets of New York to refute Nott's argument from ancient Egyptian monuments. The streets versus the statues: this conflict continues to the present day.

Douglass himself first engaged with ways of seeing in *My Bondage and Freedom*, his second autobiography published in 1855. He described Colonel Lloyd's plantation, where he grew up, in detail, observing that "a child cannot well look at such objects without *thinking*."[83] Smith pointed out in his insightful "Introduction" how Douglass developed a system of "observing, comparing and careful classifying." This classificatory method was, according to Smith, the basis of Douglass's capacity for systemic generalization and insight. It made Douglass into a "Representative American man—a type of his countrymen." Douglass's quality was not that he epitomized an unchanging essence but rather that he had passed through every "grade and type" from chattel to distinguished writer.[84] Douglass

I Sell the Shadow to Support the Substance.

SOJOURNER TRUTH.

himself understood the need to represent, making him the most photographed person in the nineteenth-century United States, if counted by the number of poses.[85] Of the 158 examples collected in a recent catalog, only 8 preceded *My Bondage and Freedom*. Douglass never let up thereafter on the representative task that Smith had assigned to him.

Lecturing in Boston on pictures and progress in 1861, Douglass called attention to the distinction between those white persons drawn from the highest seats of learning in the audience and himself, "summoned . . . from the plantation."[86] His opening highlighted that whiteness could not be thought of separately from Blackness. His own status in the preemancipation United States was as the "revenant," to use photographic historian Laura Wexler's insightful term, meaning the specter that returns—in this case, not from death, but from the social death of slavery.[87] There was another specter, which had been haunting Europe for a while: the commons and communism. For Douglass made the dramatic claim that pictures are the

fixed, certain and definite line separating the lowest man from the highest animal. . . . [M]an is everywhere a picture making animal. . . . The rule I believe is without exception and may be safely commended to the Notts and Gliddons who are just now puzzled with the question as to whether the African slave should be treated as a man or an ox. Rightly viewed, the whole soul of man is a sort of picture gallery.[88]

Douglass unified humans by virtue of their common tendency to make pictures. It was an effective rhetorical retort to Nott, Gliddon, and their "types of man" hierarchy, which was based on an interpretation of monuments. Humans were not fixed in permanent types, Douglass argued. It was rather the constant rate of change that indexed the human as a

Anonymous, Sojourner Truth: "I Sell the Shadow to Support the Substance," 1864. Gladstone Collection of African American Photographs, Library of Congress Prints and Photographs Division.

George Francis Schreiber, photo of Frederick
Douglass, 1870. Library of Congress Prints
and Photographs Division.

single yet constantly varied and "amalgamated" species, to use the term of the period.[89]

After emancipation, Douglass went even further. He saw cheap and widely available pictures as "social forces" that allow "moral and social influence" at the national level.[90] Pictures of present conditions should be contrasted with the ideal, alerting society to the possibility of progress. Like Truth, Douglass transformed the Platonic distinction of ideal and real that had upheld the type of whiteness into a common, amalgamated humanity.

REVENANT WHITENESS

After the Civil War, the specter of white supremacy returned, materialized in the form of Confederate monuments. In his influential study, historian Kirk Savage put it directly: "'Negro slavery is the South,' wrote one Georgia editor in 1862, 'and the South is negro slavery.' The business of Confederate commemoration after the war was to smash this equation."[91] The unlikely mission was to keep white supremacy, while forgetting its role in slavery. It found a way in 1890 with the immense equestrian monument of Lee created by French sculptor Antonin Mercié in Richmond, Virginia, the former capital of the Confederacy. Lee's statue launched the first great wave of Confederate monuments from 1892 to 1918, the period of Jim Crow. Richmond's was only the second Lee monument in the United States, but it became the avatar of white supremacy that "depoliticized the Confederacy after the fact."[92] The results are now familiar: the Confederate monument is claimed to represent "heritage, not hate." It is a perhaps unique achievement for the losing side in a civil war to be able to define national heritage, revealing that the nation is considered to be white.

In a two-step process, Lee took over the role formerly assigned to Apollo, while his horse stood in for racial hierarchy. Lee's status was attested to by none other than Jefferson Davis, former president of the Confederate States, in the year that the Richmond memorial was erected: "He was of the highest type of manly beauty, yet seemingly unconscious of it, and so respectful and unassuming as to make him a general favorite. . . . His mind led him to analytic rather perceptive methods for obtaining

results."[93] The queer attributes of Apollo were transferred to Lee in the implications of "manly beauty." Written just a few years after Francis Galton had coined the term "eugenics," Davis would mint the racializing formula for masculine whiteness: not too clever—a dangerously Jewish trait—yet gallant, dutiful, good at riding horses, physically prepossessing, and warlike.

The Richmond monument was truly monumental. Sixty feet high including the base, the statue of Lee himself was fourteen feet tall. Formally, the sculpture evoked that of the Roman. emperor Marcus Aurelius, whose *Meditations* was one of the books Lee was said to have taken with him to war. Accordingly, the 1895 US edition was dedicated to Lee by the English translator. The Roman bronze was in turn the model for the equestrian monument by Pietro Tacca, who created the Livorno monument to Ferdinando de' Medici with chained slaves at the base (see chapter 1). Iconographically and symbolically, all statues of Lee evoke settler slavery and should be imagined with enslaved people chained to their frequently massive pedestals.

While the Richmond monument was held to say nothing about race, Lee's horse, Traveler, was said to have refused to be ridden by an enslaved African American. The animal had learned racism from its white masters. Lee himself was said to have the horse under what one newspaper called "absolute control," in the manner of Marcus Aurelius, whose statue showed him riding without reins or stirrups.[94] The greatest debate among the judges for the memorial competition was, as a result, about the horse, the displaced work of racializing hierarchy. Mercié's assistant Patère, who sculpted the horse, did not, however, use Traveler as his model, using a more thoroughbred animal in keeping with the racializing displacement.

The statue form combined with Lee's carefully manicured reputation meant, as Savage argues, that "the commemoration of Lee thus provided a symbolic field in which to build a new image of popular unity and reconciliation under traditional white rule."[95] The "symbolic field" of whiteness was re-centered on sculpture as the means of restoring racializing hierarchy and erasing picture-making radical democracy. It was not until the George Floyd Uprising of 2020 that the statue became de-invisibilized,

Kevin Cranford, Jr., United Statues of
America project: Robert E. Lee statue in
Richmond, VA, 2020. Courtesy of the artist.

and the work it was doing to support white supremacy became legible to all. Local people tagged the immense pedestal with graffiti, hung banners and posters, and used it as the site for performance and photographs. The pedestal came to overshadow and symbolically overturn the statue on its top, long before it was removed in 2021. This extended sequence of actions made a tear in the fabric of white reality, opening a glimpse of another possible world in which, at a minimum, giant statues of white conquerors and racists do not dominate public space.

3

THE NATURAL HISTORY OF
WHITE SUPREMACY

May 25, 2020, the day on which George Floyd was murdered by Derek Chauvin in Minneapolis, began with what become known as the Central Park bird-watching incident. It demonstrated that it is still inconceivable for a white woman with a University of Chicago master's degree and career in finance to conceptualize bird-watching while Black. As types, Blackness and birds, in the worldview personified by the dog walker Amy Cooper, are the objects of white taxonomy, not its performing subjects. New York City Audubon Society board member Christian Cooper asked Amy (no relation) to leash her dog, as required to protect the wildlife. She did not see Christian as a person but instead as a type, "African American," as if it was her observing wildlife. Her racialized seeing transformed his spoken request into a violent assault. This kind of looking was known under Jim Crow as "reckless eyeballing," meaning to look a whiter person in the eye and thereby challenge their authority. This charge is supposed to have gone away, but it's very much active in the mass incarceration system. Amy called the New York Police Department. By the time the police arrived, Christian had left, yet he soon released the cell phone video he had made. Amy Cooper's racializing surveillance in Central Park was not an exception; it was constitutive of her role in finance capital. She had worked for a trifecta of 2008 financial crash companies: Lehman Brothers, AIG Insurance, and Citigroup. While many were ruined, Amy did just fine, ending up as a head of insurance portfolio management at Franklin

Templeton, a hedge fund managing $1.5 trillion in assets. The fund's web page devoted to "diversity top to bottom" at that time showed a white woman like Amy.

Police in Minneapolis viewed Floyd in related racializing terms. It was only seventeen-year-old Darnella Frazier's cell phone video that prevented Floyd from becoming just another statistic (see chapter 8). By the same token, Amy Cooper exemplified how white sight renders life into types within a racializing hierarchy and financializes the result. Meanwhile, the Audubon Society warned in 2019 of "a net loss approaching 3 billion birds, or 29% of 1970 abundance"—following from decades of such reports. What birds there are to see now are a fraction of a fraction of the preconquest populations. The de-birding of the settler colony is almost complete. The result is not the anticipated white paradise but rather what scientists have called "an ecosystem collapse."[1]

In short, white supremacy has a natural history. It is the history of how white dominance was made natural and in turn claimed nature as part of its domain. That claim was the counterpart to the formation of white as a more-than-human type, epitomized by the statue of Apollo (see chapter 2). To be divine, as Apollo, is to have dominion over nature, understand its processes, and make them valuable by extraction. Over the course of the long nineteenth century (1791–1914), a white way of seeing nature through the lens of extinction was formed in transnational exchange across the Atlantic and around the circuits of European settler colonies.[2] In the present moment—comprising the sixth mass extinction, climate crisis, and global heating—attention should be paid as to how nature was made white.

If the statue had become the "type" of whiteness, the naturalist's gaze was preternaturally static. This gaze captured past catastrophe and extinction in minute traces found on rocks or fossils. It paused ongoing extermination to record the transient forms of birds, bison, and other indigenous species, including humans. New visual media were created to preserve these records, from hyperreal lithographs to dramatic bird drawings in the style of history paintings and wildlife dioramas in natural history museums. As extermination continued, a network of institutions, including natural history museums, wildlife refuges, and zoos, was created in the Gilded Age to sustain white dominion and its consequent exterminations

as natural. Like the famous dioramas at the American Museum of Natural History (founded in 1869), this network had to be viewed from a specific place in a particular way, which was that of the state.

These static museum aesthetics were added to the statue, and created a direct visual education for and about "the great race" of white people, using slides, films, and monuments. By combining the state, statue, statute, and static, whiteness moved beyond local dominance to a national and international network. At its hub was the world museum, of which the first was the American Museum of Natural History. It is no accident that there has been a debate over national museums, the state, and its statues in recent years (see chapters 7–8). Far from being separate issues, these are all pathways into the network of whiteness. But while statues can be removed, extinction cannot be reversed. The lasting monument to white settler colonialism will be the permanent shift in global ecology.

we can't separate contemporary politics of looking from this historic context.

EXTRACTION AND EXTINCTION

One of the foundational mythologies of settler colonialism has been white people's claim to dominion over all the flora and fauna of the planet as an inexhaustible resource. Moving beyond the divine dominion given to Adam in Genesis, philosopher John Locke's *Second Treatise* claimed that "subduing or cultivating the earth and having dominion, we see are joined together."[3] Land could be taken, according to Locke, if it was not being cultivated—that is, if it was seen as terra nullius, according to Roman legal doctrine. The metamorphosis of terra nullius, literally meaning "nothing land," into empire gave dominion over land and life alike. All subdued land was both empire and white nature. As decolonial studies scholar Macarena Gómez-Barris insightfully summarizes it, "European colonization throughout the world cast nature as the other and, through the gaze of *terra nullius*, represented Indigenous peoples as non-existent."[4] This gaze comprised the process whereby a settler arrives, looks at land, fails to see who and what is already there, and claims it for themselves. Gómez-Barris calls the result "the extractive zone." What was extracted was not only minerals and other raw materials but also birds, bison, fossils, archaeological traces, human remains, photographs, and moving

images. That extraction was then turned into value, whether financial or cultural.

After the Haitian Revolution, white sight added extinction to extraction. Formerly considered heretical or impossible, extinction—also known as catastrophe or revolution—transformed natural history into life science in the era of the revolutions of the enslaved and abolition (1791–1888). Based on observation and display, the white gaze of extinction, to adapt Gómez-Barris, claimed a superior capacity for visual analysis. Ornithologist John James Audubon asserted that his art depicted *nature as it existed.*[5] What geologist, comparative zoologist, and racial theorist Louis Agassiz called "the naturalist's gaze" included extinction as a past or present possibility. Twinned natural history and anthropological museums were formed in order to collect species and specimens, whether human or other-than-human, before they became extinct. Under the white gaze of extinction, those colonized should also be collected. Collection became the third leg of colonial administration, added to the long-standing imperatives of ordering and governing set by Barbados's slave law in 1660.[6] Such museums exemplified what was known in the period as the "New Museum Idea."[7] The very idea of "nature" had become inextricably entangled with race.

The white way of seeing natural history was static. The "naturalist's gaze" required the observer to be absolutely still, almost to the point of sedation or anesthesia. That is to say, it was the gaze of the white person whose perfect type was the statue. In the wake of extinction, the static acquired a specific meaning in the work of Herbert Spencer. What he labeled "social statics" dealt with the "equilibrium of a perfect society." While Spencer was obsessed with progress, his ideal was a perfect balance, which entailed human and nonhuman extinctions: "The forces which are working out the great scheme of perfect happiness, taking no account of incidental suffering, exterminate such sections of mankind as stand in their way, with the same sternness that they exterminate beasts of prey and herds of useless ruminants. Be he human being or be he brute, the hindrance must be got rid of."[8] Spencer imagined the extinction of Indigenous people and bison in the United States as both necessary and inevitable. Only then would the violence end. Genocide was the road to white utopia.

It was not far from here to Spencer's most infamous turn of phrase: "the survival of the fittest." Although many attribute this concept to Charles Darwin, the natural selection described in *The Origin of Species* (1859) was random rather than socially determined. For Spencer, the survival of the whitest required social intervention. These systems were the practical application of a belief in white dominion to other forms of life. Static aesthetics asked, what does life look like? With the intent of finding out, which kind of life will survive, and which will become extinct? Often the only way to answer these questions was to consider what death looks like—a much easier answer to find.[9]

EXTINCTION AND THE DEATH OF BIRDS

This story begins, like so many others in this book, with Haiti and its revolution. French natural historian Baron Georges Cuvier, usually credited with defining extinction, described it in 1807 as a form of revolution, immediately following the independence of Haiti. Cuvier reshaped natural history as the science of life. He argued that geological as well as human history were marked by a series of catastrophes. His detailed observation of a mammoth tooth allowed him to demonstrate that it was not from an elephant but from the now-extinct ancestor. In his study of the "conditions of existence" in what he called *The Animal Kingdom*, Cuvier defined life as a struggle against extinction: "Every organized being reproduces others that are similar to itself, otherwise, death being a necessary consequence of life, the species would become extinct."[10]

Having set out this paradigm, Cuvier at once developed his race theory, connecting race to life—and death. He divided humans into three varieties. Cuvier relegated the "Negro race" to "the most complete state of utter barbarism."[11] In the next sentence after this assertion, he continues, "The race from which we are descended has been called *Caucasian*," meaning white. Not only were Caucasians the most handsome, they had advanced "philosophy, the arts and sciences"—the persistent cultural defense of whiteness. Within life, there were two divides, one marking extinction, and the other barbarity. Barbarism would be used to justify separation and slavery, with extinction being the result, whether

[handwritten annotations:] the figures in Llyn-y-Can are depicted certainly as NOT Iowlonic refined, educated, white (telescope)

by human or "natural" processes. This notoriously led Cuvier to define Africans as "the most degraded of human races, whose form approaches that of the beast and whose intelligence is nowhere great enough to arrive at regular government."[12] This was despite the fact that a majority African population had just done that in Haiti, a former French colony, of which Cuvier could not possibly have been ignorant. For Cuvier, Black life was a variety of animal life, whose outcomes might be the subject of curiosity but not moral engagement.

If Cuvier showed how Haiti changed the theory of natural history, Jean-Jacques Audubon was the practical example. Audubon often had to decide who he was, indicated by his long list of names, such as John James Audubon, Jean-Jacques La Forêt, and John James La Forest.[13] Born in Saint-Domingue to a plantation and slave owner father, and a Jewish servant mother, Jeanne Rabin, he became a refugee in France from postindependence Haiti. Finding his way to the United States as an adult, Audubon was haunted by abolition along with the extinction of birds, the Indigenous population—which he saw as doomed—and indeed the US wilderness as such.[14]

In his magnum opus, *Birds of America*, a multivolume assemblage of enormous color plates and a separate text, mingling natural history with autobiography and travel narrative, Audubon drew full-size birds so that his picture frame on an immense sheet of paper was not so much a window onto the world but rather a window the birds had flown through. Nor did he use a formal system of perspective.[15] For these scenes were not drawn from life in the wild but made in his studio, using dead birds suspended by wires. These famous pictures were less original than most of us think. Their large format and "action" poses were standard at the time in French (if not North American) ornithology.[16] One of his most influential drawings was that of what he called the wild pigeon, usually now known as the passenger pigeon, because the bird became extinct in August 1914. Audubon's drawing now stands in for the absent birds. The unreal sharpness of line, sense that the body was assembled in geometric sections—which is to say, the body as a machine—and clarity of the white picture space used as the ground combined to give a paradoxical sense of both precision and abstraction. In a word: whiteness.

[handwritten note:] I dunno about this tbh. Sometimes the evidence is shaped to fit the argument (which itself I do agree with)

John James Audubon, *Passenger Pigeon*,
1828–1835. Photo: University of Pittsburgh
via Wikimedia Commons.

He claimed his technique was derived from the studio—a combination of art school and picture workshop—of neoclassical painter Jacques-Louis David.[17] While Audubon did have artistic training in France, there is no record of his having been part of David's extensive studio. By claiming the lineage of the great artist, he displayed the instinct of the showman that he certainly was. The "history" Audubon was painting in the manner of David was the acceleration of the de-birding and de-wilding of the Americas as an index of the formation of the modern United States after the 1803 Louisiana Purchase. His originality was to express the resulting tensions between race, colonization, and extinction in a nonhuman but evocative form of history: birds.

What is a bird?[18] For the planter and colonist, it was often a pest, eating seed or fruit. For the poor and enslaved, it was a significant source of food, made into a commodity by mass killing. In settler colonial practice, the bird was rendered into a viewpoint, the bird's-eye view that has now become fully automated and digitized. For those racializing surveillance intended to contain and segregate, the bird was a visible example of freedom. If for the colonist, birds were an index of whiteness as property within terra nullius, they were for the enslaved the sight of what historian Walter Johnson calls "freedom as a bodily practice."[19] The enslaved dreamed of flight, and envied the birds their movement, while slave owners feared that birds might convey ideas and practices of resistance.[20] Black studies scholar Christina Sharpe evokes the "air of freedom"—no metaphor to those incarcerated.[21] Bird-watching, by contrast, was a metonymy for settler colonialism. The settler sees the bird, kills it, classifies it, and has it stuffed. Alive, the bird embodies freedom. Dead, it was first an extractive commodity, and later it contained and expressed "higher" values of aesthetics when displayed as an attraction in museums of natural history. There are over 750 natural history museums in the United States, not to mention 2,400 zoos. Rendered into a commonplace extractive item of exchange, birds index the intersection of extinction, settler colonialism, and racializing capitalism.

Among the all-pervasive violence of colonialism, the persistent ecocide of bird populations does not grab the attention. Birds were slaughtered in totally disproportionate numbers to any need or market. Among the cheapest food in the settler economy, sold for pennies in local markets,

birds finally acquired some commercial and noncommercial value on the verge of extinction by virtue of scarcity. But the immense labor of causing extinction was itself a form of extraction. Audubon only turned to writing about birds after his debt-funded purchase of slaves to work at his Kentucky mill ended in bankruptcy in 1819. In his 1826 Mississippi River journal, written in his idiosyncratic Franglais, Audubon discovered a new means of accumulation through ornithology: "So Strong is my Anthusiast [*sic*] to Enlarge the Ornithological Knowledge of My Country that I felt as if I wish myself *Rich again*."[22] His last human property rowed him down the Mississippi to New Orleans, where he sold the two men.

Late in his life, Audubon sought to explain why he had become a bird artist in his autobiographical sketch *Myself*. He noted that his mother kept both a large monkey and birds as pets. One day a parrot was calling:

The man of the woods probably thought the bird presuming upon his rights in the scale of nature; be this as it may, he certainly showed his supremacy in strength over the denizen of the air, for, walking deliberately and uprightly toward the poor bird, he at once killed it, with unnatural composure. The sensations of my infant heart at this cruel sight were agony to me. I prayed the servant to beat the monkey, but he, who for some reason preferred the monkey to the parrot, refused.[23]

This is a primal scene of the white supremacist imagination, centering on the doubled figure of "the man of the woods" (*homme de la forêt*)—that is to say, the orangutan and Audubon himself, who also used the name La Forêt. The scene was a transposition of the slavers' view of the Haitian Revolution into the not-quite-human world. The French-speaking parrot loses its life to the ape claiming his rights, a racist evocation of Haiti.[24] The orangutan was not whipped, a slight transposition in the white mind of the desire for the whipping of an enslaved person (recall that the orangutan was a rank lower than the African in the racializing hierarchy of the period).

Fugitivity was a repeated motif in Audubon's work. In his *Ornithological Biography*, published as a textual accompaniment to the famous pictures, he had already concocted a similarly bizarre fantasy.[25] Lost in the Louisiana bayou, Audubon claimed to have encountered a maroon (whom he calls a runaway slave) living in a cane brake with his family.[26] Here is yet

another homme de la forêt, or as Audubon put it, mixing racialized metaphors, "a perfect Indian in his knowledge of the woods."[27] Developing his story, Audubon tells how this unnamed man had been resold following the bankruptcy of his first owner, separating his family. Memorizing the destination of his wife and children, he escaped, rescued them, and made a camp in the woods. The bankruptcy and family breakup again echoed Audubon's personal rather than ornithological biography. He devised a fantasy ending in which the maroons obeyed him because of their "long habit of submission" and returned with him to their original plantation. The pursuit and biography of birds led Audubon to imagine personal as well as political reconciliation within racial hierarchy and restored slavery, as if the Haitian Revolution had never happened. For him, the restoration of benevolent slavery was a happy ending.

DEAD BIRDS FLYING

Audubon's writing was no pastoral. It amounts to an account of how much killing is involved in making a settler colony and making pictures from the results. Audubon noted that a single blast from a shotgun killed 120 blue-winged teals in New Orleans.[28] He saw one man in Pennsylvania killing 500 dozen passenger pigeons in a single day, which is 6,000 pigeons, or a pigeon a minute for ten hours. While the passenger pigeon has become a somewhat notorious example, almost every bird that Audubon looked at came with a story of mass slaughter.

Take the golden plover. While in Louisiana, Audubon remarked, "The gunners had assembled in parties of from twenty to fifty at different places, where they knew from experience that the Plovers would pass." He estimated that 144,000 were killed. As a result, "the next morning the markets were amply supplied with Plovers at a very low price."[29] Cannier hunters might have brought fewer birds and made more profit. By removing birds from the wild, hunters deprived both the enslaved and Indigenous of a food resource, and forced the settler poor to buy versus hunt them.[30] For bird hunters, killing was part of the emotional wages of whiteness, where to be "master" as Audubon had been in the bayou, whether over nature or the enslaved, was itself the reward. Exterminating birds offered

a particular form of violent pleasure by confirming and making visible the capacity to colonize.

In *Birds of America*, Audubon drew birds in the frame of a naturalized plantation economy. In 1831, Audubon observed what he called the snowy heron, also known as egrets, near Charleston in South Carolina. In the background created by his assistants is a plantation called Rice Hope, in Moncks Corner, South Carolina, where the enslaved cultivated rice.[31] None are to be seen here. Instead, Audubon, masked like bird hunters do, is seen with his rifle, chasing fugitives, whether birds or people. The painting metonymically represented supremacy as the intersection of whiteness, settler colonialism, the Second Amendment, and the invisibility of enslaved African labor. You can buy originals and reproductions of it all over the internet, teaching racialized vision, one print at a time.

Audubon casually recorded how practices of enslavement affected even common songbirds. For instance, the blue jay was a prolific species with a habit of eating crops, so that in Louisiana, "the planters are in the habit of occasionally soaking some corn in a solution of arsenic, and scattering the seeds over the ground, in consequence of which many Jays are found dead about the fields and gardens."[32] He did not need to mention that in Louisiana, all planters of means used enslaved labor.

The white gaze of extinction, focused here on birds, indexed the modern form of racial capitalism. Far from being contained to North America, it was systemic to settler colonialism. On the other side of the world, George Bennet, a marsupial naturalist in Australia, was struck in 1860 by "the war of extermination recklessly waged against them" by the British colonizers.[33] By 1873, colonial naturalist Walter Lowry Buller noted in Aotearoa (New Zealand) that

under the changed physical conditions of the country, brought about by the operations of colonization, some of these remarkable forms have already become almost, if not quite, extinct, and others are fast expiring. It has been the author's desire to collect and place on record a complete history of these birds before their final extirpation shall have rendered such a task impossible.[34]

The conditions were different indeed. Buller correctly understood that extinction was the deliberate result of the operations of colonization.

PLATE CCC.

Golden Plover.
CHARADRIUS PLUVIALIS. L.
1 Summer plumage. 2 Water. 3 Variety in March.

John James Audubon, *Golden Plover,* 1828–
1835. Photo: University of Pittsburgh via
Wikimedia Commons.

John James Audubon, *Snowy Heron, or White Egret*, 1828–1835. Photo: University of Pittsburgh via Wikimedia Commons.

Indeed, some thirty-five species that he might have heard or seen have since become extinct.

EXTERMINATION NETWORKS

After the Civil War, the reunited United States created a network of extermination, the means of making extinction. It was anchored by the railroads, with new institutions of display—museums, wildlife refuges, zoos, and so on—for the species being exterminated. The flow went both ways from the killing fields to the institutions and back. This extermination was enabled from the visual platform provided by the train, involving the mass slaughter of human and other-than-human life. General Tecumseh Sherman told Ulysses S. Grant in 1866, "We must act with vindictive earnestness against the Sioux, even to their extermination, men, women and children."[35] And they did. Lower Brule Sioux tribe scholar Nick Estes estimates that even as "buffalo-hunting [Indian] nations on the Northern Plains from 1780 to 1877 experienced a 40 percent population decline," between ten and fifteen million buffalo were exterminated in the last two decades of that period.[36] What did that look like? In 1871, a hunter encountered a herd in Arkansas that was fifty miles long and twenty-five miles wide, for an estimated four million animals.[37] All the dead buffalo would by extension have occupied a space between three and five thousand square miles, roughly the size of Connecticut, presently home to 3.5 million people.

To supplement the work of the US Army in both of these genocides, the newly completed Transcontinental Railroad was used as a platform from which to kill. An article from *Harpers Weekly* in 1867 described how "the train is 'slowed' to a rate of speed about equal to that of the herd; the passengers get out fire-arms which are provided for the defense of the train against the Indians, and open from the windows and platforms of the cars, a fire that resembles a brisk skirmish."[38] The train has long been understood as a paradigm for industrial modernity. The first "moving image" was the view seen from the train.[39] These trains put themselves in synch with buffalo life in order to kill them, using weapons first supplied

to kill Indigenous peoples. The moving image was from the outset a racializing scene of extermination of human and other-than-human life.[40]

A vivid example of the intersection of the attraction with the elimination of the buffalo can be seen in a now-widely circulated photograph of a massive arrangement of buffalo skulls, taken in Rougeville, Michigan, by an unknown photographer in the mid-1870s. The skulls were collected to be rendered into fertilizer so that the death of indigenous animal life could enable settler agriculture. Two men stand at the top and bottom of the structure, allowing us to estimate that the pile is some twenty-five feet high. In total, some three hundred thousand tons of buffalo bones were made into fertilizer in this way.[41] The photograph depicts the settler colonial conquest and racial hierarchy in material form. It was also a stunt, making the viewer ask, How can the man on top stand on such a pile? Looking closely, the skulls appear to be below ground level, filling in a trench, possibly a railroad cutting by which they had been delivered. The feet of the man at the top cannot be seen, concealed by a skull he is carrying. Perhaps he is standing on the top of the cutting. Or is he standing on a stack of metal cages, like the one in the foreground in which the skulls might have been transported? The factory went to extravagant lengths to create the illusion of a freestanding mountain of skulls, making indigenous death into an attraction and spectacle.

By the late nineteenth century, these massacres had gone so far that new colonial institutions were created to preserve the remnants as specimens and display the past in museums. The real problem with the American Museum of Natural History is not its displays—as controversial as they are—but the fact that it had to be created at all. The institutionalization of nature through museums, zoos, wildlife refuges, national parks, and the definition of wilderness marked the peak of empire's exterminations. By consigning nature to an attraction to be looked at, empire claimed total dominion over life. The dead animals displayed in the dioramas of the American Museum of Natural History teach children both that the role of nonhuman life is to die and they are to be its killers. The museum's opening in 1877 was the corollary to the creation of anthropological museums in Europe, formed from the loot taken by colonial expeditions. Just as curator Dan Hicks sees the anthropological museum

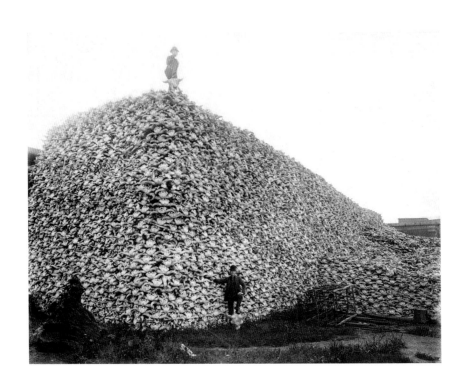

Anonymous, photo of men standing with pile
of buffalo skulls. Michigan Carbon Works,
Rougeville, Michigan, ca. 1872. Burton
Historical Collection, Detroit Public Library.
Used by permission.

as an "implement of . . . imperialism made in the final third of the 19th century," so too were museums of natural history, game reserves, and national parks tools of enshrining settler colonial dominion over nature and making it visible as extinction.[42]

The new American Museum of Natural History understood the importance of extinction. In his 1887 report to the trustees, curator J. A. Allen argued, "In view of the fact that the larger mammals of North America are being rapidly exterminated, the Elk, the Mountain Sheep, and several of the other larger species being as surely doomed as the Bison, now already practically extinct, it seems highly desirable that the friends of the Museum should provide the means for securing groups of these interesting animals . . . before it becomes too late to obtain them." The museum sent an expedition to Montana in 1888 to do so. While it scavenged skins, skeletons, and skulls, the small buffalo herd in the area had been "exterminated" before it arrived.[43]

White supremacist Madison Grant—later a board member at the American Museum of Natural History—became so concerned that the bison would disappear, reducing both opportunities for hunting and the "pure breeds" of the country, that he persuaded then president Theodore Roosevelt to create a game reserve for buffalo in Oklahoma. The Wichita Mountains National Wildlife Refuge was inaugurated on June 2, 1905. As there were by then no indigenous buffalo in the region, six bulls and nine cows were sent from the Bronx Zoo, which Grant had created ten years earlier, to Oklahoma by train. At each stop, people rushed up to see the rare animals.[44]

The very next year after the wildlife refuge was created, the Bronx Zoo went one step further with the now-notorious public display of Ota Benga in its Primate House. Ota Benga was Mbuti, from what is now the Democratic Republic of Congo. He had been purchased in a slave market after his village had been destroyed in 1903 by the Belgian Army, including the murder of his wife and children. By now it will be no surprise that the keepers added an orangutan and parrot, re-creating Audubon's primal scene and invoking racial hierarchy. The *New York Times* editorialized in support of this display over African American protests, holding that it was an "ethnological" display that demonstrated the theory of evolution and that "pygmies . . . are very low in the human scale."[45] It was entirely

consistent that in 1905, King Leopold II of Belgium, whose statues fell in 2020 because of his genocide in Congo, donated a vast range of objects from the-then Belgian Congo to the American Museum of Natural History. By 1932, the museum had expanded its footprint, especially its Africa Halls. A diorama of so-called pygmies, properly known as the Mbuti, Mbenga, or Twa peoples in the Congo region, was created and displayed in the Hall of Primates.

In New York City itself, the museum organized repeated excavations of Indian burial grounds.[46] Cases displaying "implements of stone, bone, shell and other materials" found on Staten Island and in Inwood were exhibited at the museum at one end of the Hall of the Plains Indians in 1909 as part of the citywide celebration of the three hundredth anniversary of Henry Hudson arriving to Manahatta. Described by the curator as dating from "prehistoric times," the exhibit guide nonetheless described Indigenous presence into at least the 1660s. To convey the effect of extinction, it included a photograph of Indigenous skeletons, still in their grave site on Tottenville, Staten Island, where the museum excavated them in 1895. Bone fragments were displayed alongside arrowheads placed at the point where they had been found embedded in the human remains. Material remains were organized by type rather than by people, using categories like polished stone or pottery. Along with every museum in the city, the Metropolitan Museum of Art participated in what was formally called the Hudson-Fulton celebration of 1909 with an exhibit of Golden Age Dutch painting, which remains a crowd-pleaser to the present; a show called In Praise of Painting: Dutch Masterpieces was on view when the pandemic shut the Met in March 2020 and when it reopened in 2021.

EUGENIC DIORAMAS

As part of this networked process of extinction, ornithology was distinguished from natural history and institutionalized with the formation of the American Ornithological Union in 1883.[47] Its function was to assert the primacy of other-than-exchange value for birds, and by extension, the natural world as a whole. In 1886, a special edition of *Science* noted the decline of bird species. American Museum of Natural History curator Allen

exhorted his readers that despite their still-limited financial value, "birds may be said to have a practical value of high importance and an aesthetic value not easily overestimated."[48] He blamed five groups for their decline: market gunners who hunted game birds; African Americans who trapped and sold small birds across the South for food; women who wore hats with feathers, named as "the dead bird wearing gender"; immigrants who trapped birds for food; and even small boys who hunted for eggs.

From this optic, ensuring the survival of birds was a blueprint for the eugenic survival of white supremacy in the uncertain conditions of modernity, which meant "reconfiguring the terms of being natural in culture."[49] The eugenic program developed by Francis Galton and enthusiastically received in the United States offered solutions to all the issues highlighted by Allen.[50] White women were to give up their monstrous display of feathers and return to breeding the "great race." Immigration was to cease, as the 1882 Chinese Exclusion Act prefigured, followed by ever more restrictive legislation. Jim Crow would reassert control of the South, and public schools would discipline children. The United States found many other ways for men to satisfy their desire to shoot. Ornithologists even characterized the birds themselves in eugenic terms. For New England naturalist Frank Bolles, "The English sparrow stands out to me as the feathered embodiment of those instincts and passions which belong to the lowest class of foreign immigrants. The Chicago anarchists, the New York rough, the Boston pugilist, can all be identified in his dirty and turbulent society."[51]

None of these eugenic policies much protected the birds. People in the United States continued to eat all kinds of bird in the period, including meadowlarks, blackbirds, sparrows, thrushes, warblers, vireos, waxwings, reedbirds, robins, and flickers. In 1897, William Hornaday of the New York Zoological Society concluded from two hundred questionnaires sent around the country that nearly half of all US birds had perished since 1882. As late as 1940, Eleanor Roosevelt wrote a column asking women to cut back on wearing feathers.

It was in this context of apparent extinction that the display of animals in habitat groups within dioramas in natural history museums came to the United States. It began in 1887 with the display of eighteen groups of nesting birds with accessories like foliage and flowers, created by British

Anonymous, photo of model wearing
"Chanticleer" hat of bird feathers, 1912.
Library of Congress.

museum modeler Mrs. E. S. Mogridge (d. 1903) at the American Museum of Natural History. She had previously worked for the British Museum and its Museum of Natural History with her brother H. Mintorn. Her work was seen by then president of the museum Morris K. Jessup, who raised funds to bring her to the United States. She worked for the Field Museum, Carnegie Museum, and Brooklyn Institute (now the Brooklyn Museum) as well as in New York City.[52] Using just a fraction of the American Museum of Natural History's forty thousand birds, Mogridge's models changed its practice dramatically and was credited for inspiring its famous habitat displays.[53]

In 1909, American Ornithologists Union president Frank Chapman created a group of the now-famous dioramas at the American Museum of Natural History.[54] In Allen's contemporary description, "The area of these groups ranges from 60 to 160 square feet, to which is added a panoramic background, which in most cases merges insensibly into the group itself. The backgrounds are painted by skillful artists, generally from studies made at the actual site represented."[55] The panorama depicting wading birds was based on Cuthbert Rookery in Florida, where a game warden had been killed by feather poachers in 1905 and the birds were believed to be at risk of local extinction. These panoramas were an attraction made by formerly living animals conveying the effect of life in death. Unlike Audubon's imaginary scenes, photographs were taken on-site and the birds were posed in imitation of them. Bird artists like Louis Agassiz Fuertes (no relation to Louis Agassiz) worked with taxidermists—including Herbert Lang, who would soon lead the museum expedition to the Belgian Congo—and photographers to create the illusion.

Chapman conceived of the panoramas as three-dimensional perspective paintings, noting "the background is curved [convex backward] with the front opening so reduced in size that at the proper distance, or 'correct view-point,' neither the ends nor the top of the group can be seen. By thus leaving the actual limits of the group to the imagination the illusion of space and distance is greatly heightened."[56] The ideal spectator would then stand at the proper viewpoint and be taken in by the illusion, just as Filippo Brunelleschi's mirror had created an illusion of reality in perspective painting. Care had to be taken to diffuse the lighting from above and avoid reflections in the glass so as not to disrupt the illusion. This

style prompted Allen to think about similar arrangements for mammals as both "pleasing to the eye and eminently instructive."[57] These dramatic groups remain a central attraction at the museum today.

WORLD VISION, WORLD MUSEUM

Under its charismatic, megalomaniac, racist director Henry Fairfield Osborn, the American Museum of Natural History aspired in the early twentieth century to become a "World Museum," setting the path for its pioneering claim to be a "universal museum" in 1962. The museum epitomized the "New Museum Idea" of the period that centered on public

Diorama of wading birds at the American Museum of Natural History, 1909. Photo: NComparato via Wikimedia Commons.

education via visually appealing displays.[58] By 1931, conservative writer G. K. Chesterton grumpily remarked, "We have passed from the age of monuments to the age of museums."[59] Visitors were to learn about the natural world, but also about eugenics, hygiene, public health, and "primitive" peoples to produce what New York City educators called "a more wholesome, more sanitary life."[60] The method to achieve these goals was what Osborn labeled "direct," meaning the visual observation of artistically arranged group displays. Just as the naturalist learned about racial hierarchy from static observation, reasoned Osborn, so could the public be imbued with its lessons by carefully curated imitations of nature. Beginning in the 1890s, objects were arranged in what were known as "life groups," including those posed by anthropologist Franz Boas in the Hall of Northwest Coast Indians (redesigned and reopened in 2022); they conveyed a "lifelike but no longer living" affect.[61] Osborn made the entire American Museum (as he called it) into a panorama that would depict the world for those who could not see it for themselves, and actively shape New York City via the dictates of racial hygiene and public health.

In 1909, Osborn amended the museum constitution so that it was recognized as an educational institution. In keeping with his belief that the museum was "the reincarnation of all the visual or direct education from Nature known to naturalists," he concentrated on visual media, inside and outside the institution. Osborn imagined cave dwellers as his model. In the urban context, the museum had to re-create their interactions with the natural world. As Osborn explained, "Its ideals are to present visually the laws of nature and of art in such a way as to both educate and to create a strong impression on the mind of the visitor."[62] From 1902, the museum lent out nature study collections to schools, centered on small groups of stuffed birds and later supplemented with an immense library of magic lantern slides, making close to a million loans by 1928. When its education building opened in 1926, it offered a range of slide lectures to schoolchildren in a vast new hall built for the purpose.

Osborn also oversaw the creation of a film unit that would document the museum's expeditions to Central Asia and other venues. The museum today continues to promote the Central Asia expeditions (1922–1928) for their exciting dinosaur discoveries, including a set of remarkable dinosaur eggs. Less prominently recalled is that Osborn organized the

expeditions intending to find a human ancestor for white people that had no connection to Africa.[63] In 1891, a set of early humanoid remains that became known as Java Man were located by Dutch colonist Eugène Dubois.[64] Inspired by this find, Osborn and others came to believe that human evolution had occurred in Asia, not Africa. The expeditions were intended to prove this theory. They failed.

Osborn saw himself as progressive in the sense of Theodore Roosevelt. That meant he was dedicated to limiting immigration and had a leading role in the 1924 Johnson-Reed Act that sharply curtailed immigration. He was a racist, strong proponent of eugenics, and admirer of both Benito Mussolini and Adolf Hitler.[65] There were public health exhibits at the museum, such as the 1909 International Tuberculosis Exhibition, because he and Grant believed that "Nordic" whites were particularly vulnerable to infectious disease that spread (in their view) from the slums. His book *Creative Education* concludes, "It is cruel to bring into the world a child predestined to disease and suffering—hence eugenics. It is cruel to bring into our country the kind of people who will produce people like this— cruel, I mean, to those already here—hence the Survey of immigration. It is cruel to bring up children in an unclean environment—hence this great campaign for a clean city."[66] The museum had become a machine to improve and protect whiteness.

Visitors to the museum today often note that there are no exhibits relating to European people. In Osborn's time, the Hall of the Ages of Man opened in 1924. Osborn's guide to the hall stated that humans came to prominence due to the extinction of the dinosaurs and would be "alone" by the 1950s because of the continuing extinction of mammals.[67] He continued to claim that the as yet undiscovered "Dawn Men" from Central Asia would show that apes and modern humans "were not directly related."[68] This theory of separate evolutions would have been congenial to nineteenth-century polygenists like Louis Agassiz or Josiah Nott. The skulls of gorillas and orangutans were placed in the same case as reconstructions of early human skulls to make the point directly, using Osborn's visual style: human skulls in this display had straight foreheads, while the apes had skulls that sloped.[69] A tree of skulls nearby had a US skull at the top, while the apes sat on the lowest branches, supposedly having branched off twenty-three million years ago. It is now thought that

apes and humans diverged around seven million years ago. The white "type" arrived with Cro-Magnons, who were imagined to be "a race of warriors, of hunters, of painters and of sculptors," dating from forty thousand years ago, and thus conveniently an older civilization than Egypt or Assyria.[70] While retaining the nineteenth-century notion of types, Osborn based this separation not only on skulls but also "the embodiment of an ancestral germ plasm," which supposedly never changed.[71]

The American Museum of Natural History taught this racist genealogy to New York City schoolchildren from 1923 until the civil rights era. In 1926, attendance at the museum was over 2 million. A further 138,000 schoolchildren attended lectures, and a remarkable 5.8 million children had "school service." Some ninety-one films, including *Nanook of the North* and Carl Akeley's gorilla films, were shown to 500,000 students.[72] Schools received a series of small busts of different human types, based on the Hall of the Ages of Man, including Java Man, a Neanderthal, and a Cro-Magnon. Osborn believed that Neanderthals were "darker" than the purportedly light-skinned Cro-Magnons, and the sculptures visibly depicted them as such. By 1940, 27 million schoolchildren were reached by education services including the loan of 8.5 million lantern slides and 5.8 million watching films.[73] If the museum defined itself as an educational institution, part of what it was teaching was how to racialize other people along with their cultures and histories. When the American Museum of Natural History announced in 1962 that it had advanced from being a world museum to a universal museum, it had taken this ambition to the highest level.[74]

In 1932, for the second time, the museum hosted the International Congress of Eugenics, designed to preserve the "Nordic" white race from contamination by those lower down the purported scale of the human—a project that would reach its height in Nazi Germany just a year later. Among the pieces in the accompanying exhibit was a dramatic chart showing the rise of the genealogy of the whiteness of President Roosevelt. Four years later, the museum opened its Roosevelt Memorial. No one misunderstood what it meant. It was the culmination of the museum project of direct visual education, impacting the visitor before they had even entered. Roosevelt, who has a whole chapter to himself in Nell Irvin Painter's *History of White People*, was not misrepresented here.[75]

The monument was sculpted by James Earle Fraser, who designed it after repeated studio visits by Osborn.[76] As late as 1935, Fraser was still working on the clay model.[77] Earlier versions did not have the African and Indian men carrying guns—the African was holding a gourd—and their faces were not so blatantly racialized caricatures.[78] In its final form, the fifteen-foot-high sculptural group, mounted on an eight-foot-high pedestal has multiple layers of racializing. As a dominant figure with two subalterns, the Roosevelt statue was the iconographic heir of the Livorno

International Congress of Eugenics, "The Near-Kin of Theodore Roosevelt: A Biological Study of Natural Inheritance in the Roosevelt Family," 1932. Laughlin Black Photo Album. Courtesy of Harry H. Laughlin Papers, Special Collections & Museums Department, Pickler Memorial Library, Truman State University.

statue of Ferdinando de' Medici with enslaved people at his feet (see chapter 1). As an equestrian monument, commissioned in 1924, the same year the Robert E. Lee statue was erected in Charlottesville, Virginia, it could not but evoke the Confederate monument.[79] Each figure was racially characterized—or caricatured—by means of the skull shape and size to conform to the long-standing US racial (stereo)types disseminated by those accepted as scientists in the nineteenth century like Nott and Gliddon (see chapter 2).

The idea that skull and brain sizes measured racial differences on a hierarchical scale had been enshrined in the museum, and from there

Roosevelt statue head by sculptor James Earle Fraser montaged with Greek skull. From Josiah Nott, with George R. Gliddon, Samuel George Morton, Louis Agassiz, William Usher, and Henry S. Patterson, *Types of Mankind: Or, Ethnological Researches* (Philadelphia: Lippincott, Grambo and Co., 1854).

entered into popular culture. While the museum argued after Osborn's departure that the statue was really about Roosevelt's interests in conserving nature, that did not stop it being about race too. As Osborn's biographer, Ronald Rainger, defined it, for men like Roosevelt and Osborn, conservation meant "keeping power in the hands of those whose ancestors had originally settled the New World" (with no concern for the Indigenous).[80] Osborn had determined that Fraser had to be the sculptor for the Roosevelt memorial after he saw the artists' *The End of the Trail*, an unsubtle evocation of the presumed inevitable extinction of the Indigenous in the form of a warrior on a horse, both of whom seem to be dying. Osborn had photos of it sent to the entire board of the museum.[81]

It's not surprising that the fifty years of protest about the statue began with young Indigenous activists Gus Grey Mountain, Gerald Crane, Raymond Sprang, Blanche Wahnee, Helene M. LaRaque, and Charmeine Lyons (identified in news reports of the period as Cherokee-Seneca, Navajo, and Comanche) spraying it with red paint and tagging it with graffiti in 1971.[82]

In a 2017 TED Talk archived on YouTube, African American artist Titus Kaphar describes how he came to investigate icons and monuments of US history after taking his children to the museum.[83] As they walked past the Roosevelt statue, the children called out that it was not fair. If one person had a horse, they all should. Even though the children did not directly perceive its racializing eugenics, they knew it created a hierarchy. And they could see who got to ride and who was made to walk. If the scene re-created one of Roosevelt's hunting expeditions, even that did not match reality. Like many other white visitors to Africa, Roosevelt had himself carried in a litter. In 2019, the museum staged a small exhibit called Addressing the Statue and once again a six-year-old African American New Yorker called out the unfairness of the riding arrangements. And finally, in the wake of the George Floyd Uprising, after fifty years of protests, the museum announced that the Roosevelt statue would be removed. A year later, in June 2021, New York City agreed. A destination for the statue was found in North Dakota, generating immediate protests from Indigenous people. In January 2022, the statue was quietly removed in the dead of night.

II

IMPERIAL VISIONS, ANTICOLONIAL WAYS OF SEEING

4

THE IMPERIAL SCREEN

Poet and prophet William Blake understood how imperial aesthetics work: "Empire follows Art, & not vice versa as Englishmen suppose."[1] White sight was changed in the influential teaching practice of nineteenth-century British art critic John Ruskin, a champion of both imperialism and painter J. M. W. Turner. In the wake of the First Indian War of Independence (1857), still known to the British as the Indian Mutiny, Ruskin reimagined perspective as a great glass screen between the colonizer and colonized.[2] His goal was to make the empire fully visible so that it could continue to expand.

Within this aesthetics of imperial war, there was a space of possibility for those at "home" whose ethnicity, gender, or sexual orientation put them at the margins of Englishness. Indian, Irish, Jewish, and queer persons of all genders for whom imperial England could not be "home" adopted the white mask as a disguise. This performance created a refraction within the great glass of empire so that these imperial subjects appeared to be in one place, but were actually somewhere else. Their goal, in the words of Oscar Wilde, was "to have no personality at all, but simply the possibility of many types."[3] In so doing, they avoided recognition and gained a certain freedom.

That freedom ended when the imperial state realized that it faced both rebellion abroad and sedition at home (to use its own language). It organized colonial violence into "small wars" in the colonies and carceral

institutions at home for deviant types within whiteness. The suffragettes saw the new situation for what it was, and launched a feminist strike to smash the screen by breaking windows and cutting paintings. At the height of the suffragettes' campaign in 1914, Europe blew up its own window in the collective deployment of its colonial techniques at home, now known as the First World War. Ever since, there has been a compulsive attempt to re-create that screen and its surrogates that continues to the present day.

"PLATE OF CRYSTAL"

The 1857 First Indian War of Independence was a moment of profound disillusionment for colonial whiteness. The projection of white superiority, so comforting to the colonizer, was revealed to have failed. Taken by surprise at the "very sudden" uprising, the London *Times* realized that it had "broken the spell of inviolability that seemed to attach to an English man as such."[4] British reaction was bewildered at what colonial lawyer John Bruce Norton called "a general antipathy to the European race."[5] India now appeared as what one procolonial historian of the uprising later portrayed as a "real wall, granite and immovable."[6] Inevitably, a statue of Sir Henry Havelock, a general involved in crushing the uprising with immense violence, was erected in Trafalgar Square in 1861. But something else was needed to make that wall once again transparent and restore the projective power of whiteness. It became a giant screen through which to keep imperial subjects under observation, just as Trump fantasized about building a transparent wall on the US–Mexico border. The labor of white imperial seeing was now beset by anxiety, aware of its past and possible future failure, and so was driven to constant expansion and repetition. The strategy helped sustain another ninety years of British rule on the subcontinent.

Two years after the uprising, Ruskin wrote a book to teach artists perspective. He disdained the "window on the world" technique of perspective drawing devised during the Renaissance (see chapter 1) as being too limited and restricting. Instead, he imagined "an unbroken plate of crystal" a mile high and a mile wide, but of no thickness.[7] In short, a

screen. It was crucial to Ruskin that the view through the screen not "be distorted by refraction," even though the crystal field was imaginary. In the same way, the American Museum of Natural History later went to great lengths to avoid causing reflections of spectators on the glass of its dioramas (see chapter 3). In making the opaque wall of mutiny transparent, empire became an immense diorama for British people, separating the imperial viewpoint from those people and places to be looked at. Those behind the glass were subject to observation and depiction, but had no claim to representation. More than that, they became targets.

Unlike the "vanishing point" of traditional perspective, Ruskin created what he called the "sight point." His diagram of how to align that point looks very much like a rifle sight. It was to be aligned directly opposite the viewer at whatever point on the crystal plate the artist chose. A circle drawn around this sight point allowed the artist to determine how lines should be produced in order to appear to converge at the distance where the viewer would be standing.[8] It was aimed at the seditious other at home and abroad. The imperial way of seeing was one where everything was crystal clear to the white English viewer through the square-mile window. And so they could shoot whatever there was to be seen with the impunity and clear conscience of separation. This all-seeing imperial perspective enabled Mr. Kurtz's chilling last words in Joseph Conrad's *Heart of Darkness* (1899): "Exterminate all the brutes."

Art historian Tim Barringer describes how Ruskin then wrote a series of articles during the American Civil War that were "strongly critical of the Northern states and endorse the Southern states because of their hierarchical social structures, including slavery."[9] Ruskin here followed reactionary historian Thomas Carlyle, who invented the English word "visuality" to mean the top-down view of history that is available only to those he called heroes, or great men. Both Ruskin and Carlyle publicly defended Governor Edward John Eyre of Jamaica when he violently repressed the Morant Bay uprising in 1865, killing over four hundred people. Writing in support of Eyre, Ruskin asserted it was clear "that white emancipation not only ought to precede, but must by the law of all fate, precede, black emancipation."[10] White freedom was one side of the great glass, and Black emancipation was on the other, postponed to an imprecise future.

These imperial doctrines came together in Ruskin's 1871 *Lectures on Art* at Oxford University. His declared goal was to help England find "supremacy among the nations."[11] He told his students that "the child of an educated race has an innate instinct for beauty" (28), meaning the white English, like him and them. Ruskin prescribed the study of English art in photographs, a condensation of the imperial screen into media form. From this collection, he perceived that one of the strengths of English art was its depiction of animals by artists like Edward Landseer, hoping that it would create an "almost perfect record of the present forms of animal life . . . of which many are on the point of being extinguished" (18) (see chapter 3). Otherwise, English art was to make portraits of its great men, past and present, and landscapes. The landscape was to be used as a "*memorial*" (29), creating a two-dimensional monument to be seen through the imperial screen. Thinking through screens and photographs, Ruskin was imagining a painted imperial Instagram, dominated by portraits, animals, and landscapes.

Addressing himself to imperial England, Ruskin drew intensely political consequences, being afraid of the "unemployed poor," yet proud

John Ruskin, "Sight Point," in *The Elements of Perspective* (London: Smith, Elder & Co., 1859).

of being "of the best northern blood" (27), meaning the Nordic whiteness of Anglo-Saxon, German, and Scandinavian descent, not the north of England. He defined what he called England's "manifest . . . destiny," a phrase that had been widely deployed in the United States: "And this is what she must either do, or perish: she must found colonies as fast and as far as she is able, formed of her most energetic and worthiest men;—seizing every piece of fruitful waste ground she can set her foot on" (29). In short, he advocated, colonize or become extinct, like the animals exterminated by empire. Imperialism was now a biological requirement. Following Blake, Ruskin intended art to lead to empire. While Britain was certainly not short of colonies in 1871, Queen Victoria was created Empress of India in 1877, as the nation moved to both take back direct control of its existing colonies and expand rapidly in Africa and Asia. Ruskin's cultural politics were ascendant.

STRANGE PERSPECTIVES, QUEER REFRACTION

And yet there was a flaw in the imperial glass. Writing two years after Ruskin had given his lectures, his Oxford colleague Walter Pater's *The Renaissance* (1873) took the whiteness of Greek sculpture exalted by Johann Winckelmann in a different direction. For Pater, classical sculpture's "white light" allowed art "a novel power of refraction"—exactly what Ruskin had been trying to avoid.[12] Pater identified "subtler threads of temperament" within Winckelmann's writing. His "romantic, fervent friendships with young men" when he had reached middle age "perfected his reconciliation to the spirit of Greek sculpture."[13] Living in this queer refraction created confusion between who you were and how you were seen.[14] It enabled what art historian Colin Cruise calls a "comparative morality."[15] The word used in the period was "strange," hinting at other-than-heterosexuality. By using refraction to make things strange, a space was created for "affective community" within and against whiteness.[16] Unwilling and unable to live in what Wilde called "the prison-house of realism," marginal groups used him as their own refracting white mask. Wilde was among the first to fall when the imperial state attached a single type to each person and punished those it considered deviant.

These white masks drew on the same sources as mainstream white supremacy, namely the Greek statue, especially that of Apollo. Greek art, affirmed Winckelmann, was about the "beauty of men." Pater quickly made this queer desire imperial by comparing Winckelmann to Christopher Columbus as discoverers of new worlds. Whiteness, Pater did not need to say, was always colonial. When Pater hailed the "Dorian worship of Apollo," it is apparent why Wilde gave his queer character that name in his 1890 novel *The Picture of Dorian Gray*.[17] Dorian Gray's "rose-white" blondness was part of his mystical attraction, even as Wilde indicated that the function of art was to conceal the artist. Indian poet Manmohan Ghose defended Wilde's use of masks: "You should know him as I do; and then you would feel what depth and sagacity there is behind his delightful mask of paradox and irony and perversity."[18]

In order for the strange to see each other behind their refracted white masks, they created what Wilde later termed "strange perspectives": "Modern life is complex and relative. Those are its two distinguishing notes. To render the first we require atmosphere with its subtlety of *nuances*, of suggestion, of strange perspectives: as for the second we require background."[19] Strange perspective was both the means by which those on the other side of Ruskin's imperial glass saw each other and that by which they evaded surveillance. Ruskin had worried about that glass reflecting and refracting for this reason. How could those looking through the crystal plate be sure where their others were if the view was refracted? It was and remains the classic problem of counterinsurgency. Later Mao Tse-tung would tell the insurgent to move among the people like fish in water. In the period, it was the problem formulated by Edgar Allen Poe in his short story "The Purloined Letter": How do the police find something—or someone—hidden in plain sight? But Wilde's meditation was written in prison. His 1895 two-year prison sentence with hard labor for "gross indecency" was one of the most powerful signals that his mask had been made visible and the refraction corrected. Wilde became prisoner C.3.3, the signatory of his most popular work in his lifetime, *The Ballad of Reading Gaol*.

Strange perspective was accessed by means of cultural, decorative, and sartorial codes that were temporarily illegible to the dominant. The color yellow was one such strange perspective. When Wilde first visited

the queer couple Charles Ricketts and Charles Shannon in their Chelsea house, he remarked on the yellow painted walls. At this time, Wilde's own study was also painted yellow, echoing both Pater's Oxford study and US painter James Abbott McNeill Whistler's famous yellow room.[20] Wilde had on his wall a drawing of Eros, the Greek god of love and a gently coded sign of queer desire, by Simeon Solomon, a queer Jewish member of the Pre-Raphaelite brotherhood.[21] When Ricketts designed a stage set for Wilde's decadent play *Salome*, he colored the Jews yellow, just as Aubrey Beardsley would call his notorious aesthetic journal the *Yellow Book*. Although it was dubbed "the Oscar Wilde of periodicals" by the *Critic*, Wilde dismissed it as "not being yellow at all."[22] In *The Picture of Dorian Gray*, Basil Hallward sent Gray a fateful yellow book and rumor incorrectly asserted that Wilde himself was carrying a yellow book at the time of his arrest in 1895. Yellow was a strange perspective refracting between the style of the aesthetic movement and mainstream imperial culture. Read one way, it indicated the strange affinities between Jewish and queer cultures in London. Or it was just a color. Or once decoded, it signaled what became known as "decadence," which needed to be purged from the imperial body politic.

Wilde had let his readers in on his tactics in the preface to *Dorian Gray*: "The nineteenth century dislike of Realism is the rage of Caliban seeing his own face in a glass."[23] This glass was Ruskin's wall reflecting despite itself. Caliban, Prospero's enslaved servant in Shakespeare's play *The Tempest*, has been taken as an image of the colonized in a range of twentieth-century writing by Aimé Césaire, George Lamming, and countless others. In the nineteenth century, Caliban was played as a "savage," defined as the missing link "between the true brute and man" in 1873 by one Daniel Wilson, previously known for his equally fantastic studies of prehistoric Scotland.[24] Wilde was probably thinking of the 1890s' performances of the role by F. R. Benson, who "spent many hours watching monkeys and baboons in the Zoo in order to get the movements and postures in keeping with his 'make-up.'"[25] To cast respectable middle-class people as Caliban was to place them on the wrong side of Ruskin's crystal. When they saw themselves realistically depicted, they were all the more enraged as their weaknesses became apparent. It carries the name "white fragility" now because the response is simply to break the glass. Wilde pushed his

middle-class critics into a racialized position, taking over by implication the place of whiteness at the apex of culture. It was not simply an anti-imperial position but also the claim to an "aesthetic empire."[26]

Strange perspective was, to use one of Wilde's favorite words, always a "paradoxical" viewpoint. In written, spoken, and visual form, it posed questions and questioned the pose: Is this the artist speaking and see-ing? Or is it the creation? Or both? Art, declared Wilde, is falsehood. At the same time, he added, if a mask is worn, the truth will be told. The white mask concealed certain truths behind its assertion of superiority. Wilde and his circle had arrived at the paradox to resolve their equivocal position within whiteness. On his 1882 lecture tour to the United States, Wilde at first claimed to be a member of "a race once the most aristocratic in Europe," meaning the Irish.[27] He soon discovered that to be Irish was not necessarily to be white in the United States.[28] Whiteness had a hierar-chy, and the Irish were not at the top of it. After the Irish famine brought over a million refugees to the United States, it was not enough to be light skinned. To be fully "white" you had to be "Anglo-Saxon," an idea that persists.[29] By contrast, "Irishism" was in some contexts close to Blackness, portrayed as "simian" and as having a "black tint of the skin."[30] Without the protection of whiteness, Wilde's gender nonconformity became visi-ble in the United States.

All of these prejudices quickly found visual expression in newspaper cartoons. First the *Washington Post* invited its readers of January 22, 1882, to consider "How Far Is It from This to This?," captioning two drawings: the top one claiming to show a Wild Man of Borneo, and the other below of Wilde. The Wild Men of Borneo were in fact two performers called Hiram W. and Barney Davis, who had just started working with P. T. Bar-num's circus. The "attraction" they offered was that although both were around 3.5 feet tall, they were unusually strong. Said at the time to be "idiots" in the eugenic terminology of deficiency, the two had no connec-tion with Indonesia at all. Wilde was recognizably drawn in the great-coat seen in photographs of the time with a handkerchief in one hand and the other holding a sunflower. In other cartoons, he was depicted as Chinese.[31] In the hierarchy of whiteness, his failure to perform what we would now call heteronormativity led to a racialized demotion. This pseudo-Darwinian reverse evolution became a composite visual symbol

just a week later, when *Harper's Weekly* portrayed Wilde as a monkey admiring a sunflower.[32]

To understand Wilde's response, it is only necessary to compare the photographs he had taken on the US tour and a portrait he had painted on his return. In Napoleon Sarony's Union Square studio in New York City, Wilde posed for a set of carte de visite photographs, in a large coat decorated with fur at the cuffs and collar. Removing the coat, Wilde then dressed in knee breeches, silk stockings, and patent leather slippers decorated with bows. Back in London, Wilde posed for a full-length portrait with Robert Goodloe Harper Pennington (1854–1920).[33] Here, Wilde was standing, dressed in sober brown, carrying a silver-topped cane against a neutral background. The portrait situated him within the aristocratic elite. Wilde looks down on the spectator from the position of authority, whereas the photographs have him looking into the camera or up and away. Wilde had become a dandy.

During his US tour, Wilde had read the complete works of Benjamin Disraeli, the Sephardi Jewish convert who became a Tory prime minister and ennobled as Lord Beaconsfield. Reflecting on his experience, Wilde remarked, "Lord Beaconsfield played a brilliant comedy to a 'pit full of kings' and was immensely pleased at his own performance."[34] Thinking of Disraeli as a dandy and performer as much as a politician, Wilde imagined Disraeli watching himself. To be a dandy was not, as in the Sarony photographs, to claim attention by extravagance but rather to offer little well-chosen details to the discerning eye—perhaps the cane, gloves, or narrow coat collar in the Pennington portrait.

STRANGE AFFINITIES

As queer Jewish writer Ada Leverson (1862–1933) later described the moment, "Where, in those days, was the strong silent man? Nowhere! Something weaker and more loquacious was required; and all these exuberant modes were certainly inaugurated by the poet-wit-dramatist Oscar Wilde."[35] By contrast, Lord Cromer, British governor of Egypt, praised in 1910 "the undemonstrative, shy Englishman, with his social exclusiveness and insular habits."[36] The imperial masculinity that is now a cliché of

Napoleon Sarony, photo of Oscar Wilde,
1882. Metropolitan Museum of Art, Gilman
Collection, Purchase, Ann Tenenbaum and
Thomas H. Lee Gift, 2005. Open Access
Collection.

Englishness was invented as a form of counterinsurgency, foreign and domestic. On the one side, Wilde. On the other, the absurdly heteronormative Marquess of Queensbury, whose twin claims to fame are lending his name to a set of rules for boxing and defeating Wilde in court.

Before the straight knockout of performative whiteness, women, queers, and Jews found refuge as well as resource in the refracted spaces behind the imperial screen within its own capital. Queer Jewish poet and novelist Amy Levy (1861–1889) looked to the possibilities for the "wanderer [who] goes down into the city."[37] In her 1888 novel *The Romance of a Shop*, Levy imagined four orphaned sisters running a photographic studio, situated at 20B Upper Baker Street, just up the street from the fictional Sherlock Holmes at 221B Baker Street.[38] Poet and writer Michael Field was a persona created by Katherine Bradley and Edith Cooper. These two Gentile women were aunt and niece, creating a striking form of sexual dissidence.[39] As a translator, Field was the first to give the Greek poetry of Sappho female pronouns and make it visibly queer. Field also had a long and significant friendship with Bernard Berenson, an art historian of Jewish descent, whose influential theory of "tactile values" perhaps reads a little differently in this light.[40]

I have been using the term "queer" following recent scholarly practice. If what was being said, written, and done in the 1890s now feels ahead of its time, that is only a measure of the success of subsequent imperial counterinsurgency. In 1896, art critic More Adey (1858–1942) tried to organize a petition to the home secretary for Wilde's release from prison. His surviving notes show something of the internal thinking of Wilde's circle at the time. Adey provocatively asked "whether the sin of indecency among males is a greater crime than the sin of intentionally unproductive intercourse between married persons." Or "whether the practise between males of the sexual aberrations referred to are productive of greater evils to society than the marriage of diseased persons and the transmission of their maladies among the next generation."[41] Public figures, even those once close to Wilde, refused to sign his petition.

British Jews were negotiating their relationship to each other and white Englishness. When Lucien Pissarro—son of the Impressionist painter of that name—wanted to marry fellow artist Esther Bensusan, a New Woman with a traditional Jewish father, a melodrama unfolded.

J. S. L. Bensusan demanded Pissarro be circumcised and that Esther be allowed to celebrate the Jewish holidays. Pissarro told his own family that he would not agree, even as he told his fiancée's family that he would. Finally, he told Esther's father that he was a "freethinker" and would not be circumcised.[42] The couple married anyway, with Ricketts and Shannon as the witnesses, carrying yellow roses. Esther and her Jewish friends called themselves the Werewolves.[43] These Werewolves—Eleanor Brickdale, Bertha Ohlensehlagen, Margaret Rust, and Edith Struben—were to be found at socialist meetings at William Morris's house, or the latest exhibitions and concerts. Together, they took photographs and studied drawing and engraving. They read *The Picture of Dorian Gray* together, and Rust provided a translation from old French for Ricketts's version of the *Queen of the Fishes*.[44] For these women, empire was an intimate threat because they might find themselves married to men posted into colonial service, like Struben, who struggled to maintain her artistic practice in South Africa.[45]

Artists visualized this refracted community as a set of intersecting circles and tendrils. Leverson was known to Wilde as the Sphinx. In 1894, Wilde wrote a poem called *The Sphinx*, which was published in a limited edition of two hundred copies, printed in red, green, and black ink, and bound in white leather with gilt decoration, with illustrations by Ricketts. The frontispiece showed two figures connected by intertwined tendrils. At the left was Melancholia, connecting her to Albrecht Dürer's famous print of that name. Dürer drew a brooding winged woman, surrounded by the tools of measurement and construction. Rickett's Melancholia is a slender nymph, eating grapes from a vine, while treading a mound of the fruit into wine. She directs her gaze at the Sphinx, half human, half animal, also winged and reaching to eat another bunch of grapes. Where Dürer saw melancholy as one of the four bodily humors, Ricketts envisaged it as a form of paradoxically connected separation, whether within one person or between two, or both. Most of the white page within the white-covered book was taken up with connective tendrils, circling around each other, connecting and separating. This ambivalently gendered white space of desire and connection visualized the affective community of strange perspective.

DREAM CITY

These decorated books are the remaining material trace of the interstitial modern city as lived by this circle of Jews, queers, radicals, and New Women in their "dream city that melted and faded into the sunset"—to quote Levy, published by Wilde in the magazine *Women's World*.[46] It was intended to be invisible to those looking through the glass screen of empire, visible only to its marginal participants. The dream city connected a set of double-edged locations in the existing "gray" city, creating a network composed of certain streets, from Piccadilly, which was the haunt

Charles Ricketts, "Melancholia" design for the frontispiece of Oscar Wilde, *The Sphinx without a Secret* (London: Elkin Mathews and John Lane, 1894). Photo: Wikimedia Commons.

of the rent boys, or Holywell Street, the location of pornographers of all kinds, to the Jewish East End, Limehouse's opium dens and sailors' bars, the music hall, certain houses of assignation (political or sexual), and even the museum as a place of romantic liaison.[47] On its outer edge, physically and conceptually, were prisons like Pentonville and Wandsworth, where Wilde was imprisoned, or Holloway, where the suffragettes would be force-fed.

In her collection of poems, *A London Plane-Tree*, published after her suicide in 1889, Levy mapped what would later be called the "psychogeography" of this dream city of outcasts. While other trees suffer in the polluted air, "the plane-tree loves the town." The central section "Love, Dreams and Death" showed how this city offered a chance of love, but at a high risk. Despite the harsh policed regime, especially for women, there was an urban place of possibility that Levy evocatively dubbed the "borderland." She imagined it as the space between waking and sleeping, in which she reclaimed the window from Ruskin: "Thro' the pane, I am aware / Of an unseen presence hovering." Neither the window-on-the-world of perspective or crystal imperial view, this was a strange perspective, revealing dramatically that "*it is she*." But death was all around, and soon her lover's house has only a "shuttered casement"—a window closed up with shutters, indicating that "she" has died.[48] It was a visual metaphor of exclusion for those being watched through the imperial glass. Levy gave directions as to where the "borderland" was to be found in her poem "In the Mile End Road." Mile End was located in London's East End, newly home to the immigrant Jewish population. Historian Gareth Stedman Jones highlights how for the middle and upper classes, heading into the area from the West End, it was "terra incognita"—that is to say, a region in need of colonizing and subjugating, where "small wars" of punitive colonization might become necessary.[49]

PRISON WORLDS

Wilde's downfall was a signature event in forming a hierarchy within whiteness—one that was distinguished into types and separated across a new carceral geography of imperial whiteness. New institutions confined

the "habitual drunkard" or "mentally defective" alongside an expanded world of prisons and the exclusion of immigrants. The Marquis of Queensbury, father to Wilde's lover, Lord Alfred Douglas, left him a card in 1895 with the text "posing as a somdomite" [*sic*]. Queensbury had outplayed Wilde because when he sued for libel, it was not possible to disprove that he had been "posing." The pose was intended as a paradox. Reduced to being one thing or the other, it failed. Incarcerated, Wilde reflected to Douglas on this "booby-trap as your father calls it to the present day."[50] Far from raging incoherently as legend has it, Queensbury had acted like a counterinsurgent: he had set a trap and drew his opponent out into the open. Once Wilde had withdrawn the libel suit, he was indicted and convicted for "gross indecency with another male person" under Section 11 of the 1885 Criminal Law Amendment Act, often referred to as the Labouchere Amendment. Following the Prison Reform Acts of 1865 and 1877, Britain had created a regime that prison historian Sean McConville has called "scarcely veiled torture."[51] Released, Wilde documented within days that "it is not the prisoners who need reformation. It is the prisons."[52]

Despite the widespread idea today that Victorian prisons were panopticons, where each prisoner was fully visible to the central guards, British prisons from 1867 served up punishment by means of silence. There was no light at all in Reading Gaol, Wilde recorded, noting, "Outside, the day may be blue and gold but the light that creeps down the thickly-muffled glass of the small iron-barred window . . . is grey and niggard."[53] Prisoners were kept in their cells twenty-three hours a day, with one hour for exercise in the yard. Jailers even wore felt slippers to avoid creating the slightest sound. In the spaces where the prisoners did gather, like the chapel, warders insisted on "eyes forward," or "eyes down" when exercising in the yard. The regime was a total subjugation of the body's movements with corporal punishment being administered for breaking the endless rules established, it seemed, only to generate reasons for punishment.

Wilde was aware that other prisoners were photographed in Reading Gaol using the then-new anthropometric method, taken in the glass-roofed shed otherwise used for executions.[54] It is hard to imagine the psychological effect of such "shooting" at the site of death. The goal of this photography was to make recidivist criminals visible to the police by means of data that could not be disguised. In Reading Gaol, some

prisoners had been fingerprinted for this purpose before being photographed, with the ink still visible on their fingers. Each prisoner was photographed looking more or less directly at the camera with a mirror placed so as to reflect the other side of their head. In the manner approved by its inventor Alphonse Bertillon, prisoners were made to raise their hands for the camera, these being supposedly impossible to conceal or disguise.[55] Researchers have subsequently used the archive to locate visibly Black prisoners, like Francis Branco, sentenced in 1880 for theft to serve three to five years in Pentonville.[56] Nonetheless, those imprisoned were overwhelmingly white, working class, and almost always poor, forming the "dangerous classes" at the heart of empire.[57] Prisons controlled and deployed this hierarchy within whiteness.

For as art historian and curator Nicole Fleetwood argues, "Prisons and museums emerge as late eighteenth- and early nineteenth-century institutions that were created as technologies of state power to manage and order populations, and to cultivate a notion of the citizen subject who would assent or be disciplined."[58] Wilde called this process "humanity's machine."[59] Prisons and museums both produced imperial subjects who had to learn to consent or be punished. This carceral regime created an extended series of deviant "types" from those on the margins of whiteness that were then housed in separate institutions. The Prison Act (1898), Inebriates Act (1898), Prevention of Crime Act (1908), and Mental Deficiency Act (1913) established institutions for the "extended training or segregation of 'habitual drunkards,' 'habitual criminals,' and the 'mentally defective.'"[60] Such institutions produced and segregated types of whiteness at home, while counterinsurgency controlled and punished other racialized types in the colonies. To be identifiable as such a type was to be visible as potentially deviant.

In 1905, the British state advanced this work by passing the Aliens Act (5 Edw. 7. CH. 13), "the first administrative structure to control immigration."[61] Although the unspoken intent of the act was to exclude Jewish immigrants, the designated categories of exclusion were criminals and those without means as well as anyone identified as a "lunatic or an idiot, or owing to any disease or infirmity appears likely to become a charge upon the rates or otherwise a detriment to the public."[62] These categories closely followed the eugenic concepts of the "unfit," in which poverty and

disease were moral as well as physical failings, requiring punishment and elimination. As has become all too familiar since, the act vested great power in the immigration official, who was held to be capable of diagnosing these various mental, physical, and social deficiencies at a glance. Levy's borderland had gone, replaced by the material border of imperial territory that still operates today as "border control."

British Jewish artist William Rothenstein (1872–1945), a friend of Wilde's, defiantly began painting East End Jews in response. In his memoirs, Rothenstein described his visit to the Machzike Hadass Synagogue on Brick Lane: "Here were subjects Rembrandt would have painted—had indeed, painted—the like of which I never thought to have seen in London. I was very much excited; why had no one told me of this wonderful place?"[63] But he must have seen it. Rothenstein had already worked in Jewish East London. In 1888, he taught in Whitechapel at the Whittington Club on Leman Street, less than half a mile from the synagogue.[64] Everything looked different after Wilde's imprisonment and the Aliens Act. Changed white sight had materially changed white reality, the lived experience of the city.

Rothenstein's 1906 painting *Aliens at Prayer* was an attempt to counter this new reality. In an interview with the *Jewish Chronicle*, he explained, "It is not the picturesque possibilities of Tallis and phylacteries that appeal to me. I have even left them out where I should have painted them. What appeals to me is the devotion of the Jew."[65] Rather than paint visible differences, Rothenstein attempted to depict the invisible similarity now incarnated in the peculiar term "Judeo-Christian." Posed against a neutral background, the three worshippers are static, as if to restrain the back-and-forth motion of Orthodox prayer, trying to become statues, which is to say white. They remained too clearly "Jews," at once a racial type and the target of the new immigration law. The painting was itself soon deported to Australia, where it now graces the basement of the National Gallery of Victoria. That same year, Rothenstein completed *Jews Mourning in the Synagogue* (Tate Gallery, 1906). If they were mourning the end of the free admission of Jews, it was sufficiently coded for the painting to pass into the national collection.

When noted art critic Roger Fry wrote about Rothenstein's "Jew pictures" for the *Nation* in 1910, he saw them as evidence that the artist

William Rothenstein, *Aliens at Prayer*,
1906. Photo: Courtesy of National Gallery
of Victoria.

had been "converted . . . from Yellow-Bookishness," meaning his affiliation with queer subversion. Such seditious qualities were set aside for "the effect of what is enduring, monumental and resistant in common things . . . , [and] a greater purity."[66] Moving away from yellow created a racial purity, and return to the monument and its whiteness. The imperial type had been effectively reconfigured. The journal *Truth* created by Henry Labouchère, author of the amendment under which Wilde was convicted, also wrote of the paintings, describing two local Whitechapel residents looking at *Carrying the Law*:

They were both very old men, they were both, truth to tell, extremely dirty, with bent backs and lack-lustre eyes, and each looked as though he might have suffered half a century of persecution in a Russian ghetto, as very probably they had. They were standing silently, side by side, in front of the painting, not interchanging a word. . . . Only the elder of them cast a half-stealthy glance of understanding at his companion that spoke volumes.[67]

The Jews saw themselves in the painting, but there was nothing to say. Rather than the dazzle and oscillation of strange perspectives, this "stealthy glance" evoked modes of communication in the silent prison regime, yet was all too visible. Rothenstein soon abandoned his Jewish subjects because "I was tired of painting the greasy clothes and shawls of East-End Jews."[68] He turned instead to painting portraits of famous men in the imperial manner approved by Ruskin.

MILITANT SUFFRAGETTES

If it seemed that the emancipatory possibilities of the 1880s and 1890s had been defeated, the suffragettes found the counter. Bringing together militant artists, Jewish activists, and women across the social scale, the suffragettes became what elite British culture had feared: an insurgency. From 1908 onward, the suffragettes realized that their claim to the right to vote for women had to be carried out both inside and outside the carceral state by refusing to accept the right of the state to punish. Their direct

actions in and around art, consumer culture, and museums literally and metaphorically broke Ruskin's plate glass window. It was a feminist strike.

Sylvia Pankhurst, one of the suffrage movement leaders, was herself an artist who finally had an exhibit at Tate Britain in 2014. Writing in 1913 about the force-feeding of women activists in prison, Pankhurst quoted Wilde's 1898 letter to the *Daily Chronicle*, where he defined the "three permanent punishments authorised by law in English prisons," namely hunger, insomnia, and disease.[69] His experience contributed to the suffragettes having no illusions about the criminal justice system. There were direct personal connections between the suffrage movement and Wilde circle. Inez Bensusan, an Australia-born suffragette activist and actor, was a cousin of Esther Bensusan. She began her activism in the theater as part of the Actresses' Franchise League, and in 1912, cofounded the Jewish League for Woman Suffrage, which disrupted synagogue services in London from 1913 to the outbreak of war.[70]

In 1908, the Women's Social and Political Union began to break the windows of shops, museums, and other institutions as a visible sign of support for women's suffrage. Emmeline Pankhurst, Sylvia's mother, declared, "The argument of the broken pane of glass is the most valuable argument in modern politics."[71] It broke the imperial way of seeing and created a visible resistance. The studio of sculptor Edith Downing was a meeting place for window breakers; there, they were assigned targets and given stones to throw.[72] A woman named Lillian Ball described how she went to the Gardenia restaurant and was given a hammer labeled "Better Broken Windows Than Broken Promises." She went from there to the United Services Museum and broke a small window, commensurate with her willingness to serve a short prison sentence: the larger the window, the longer the sentence. Today's museum activism has rarely taken such direct action.[73]

The tactic expanded rapidly. On March 1, 1912, four hundred shops were targeted in London's West End with 124 women being arrested, including Emmeline Pankhurst.[74] In February 1913, Sylvia Pankhurst, who had begun to organize in the East End, was also arrested in Bow along with four others for throwing a brick through an undertaker's window, supported by a crowd of locals. As she wrote later, "The Magistrate interrupted: 'What can you expect from East End people like that?' . . . 'If you

behave like common riffraff you must be treated like common riffraff,' he said, in sentencing my companions to one month and myself to two months with hard labour."[75] Pankhurst received Wilde's punishment for doing what Rothenstein could not bring himself to do: act in a way the state recognized only as criminal and of the "lowest" class. Pankhurst, like Wilde, was demoted within the hierarchy of whiteness.

Pankhurst made the hierarchy of the city's space visible by refusing to acknowledge it. In prison, in accord with the Women's Social and Political Union hunger strike, she refused food and was forcibly fed: "Infinitely worse than any pain was the sense of degradation, the sense that the very fight that one made against the repeated outrage was shattering one's nerves and breaking down one's self-control."[76] But Pankhurst was not alone. Eight solidarity marches came the six miles from Bow to Holloway Prison to support her at her "shuttered casement" while she was imprisoned.[77] The imagined borderland of freedom had been closely confined to the East End. These marches traversed the city and made its divides visible. In all great cities, there is a militant city. Often, like Karl Marx's old mole of revolution, it is underground, out of sight, and easily policed. And then there are the other times. A wave of militant suffragette direct action from that militant city began in 1912 and was only ended by the onset of war.

The suffragettes' strike undertook a coordinated set of attacks on museum artworks around the country. Years before Dada, these suffragette actions refused and cut into imperial heteropatriarchy, creating readymades. Perhaps the best known was Mary Richardson's attack on painter Diego Velázquez's *Rokeby Venus* in London's National Gallery. Most of the women that attacked art did so using butcher's cleavers, as a symbolic gesture. It emphasized the violence of the imperial worldview that the women were cutting. Like plate glass or Ruskin's window, the art gave way, allowing the constitutive violence of the British state to be seen.

Not even making the government's top-ten list of art attackers was Margaret Gibb, who used the alias Anne Hunt in her attack on John Everett Millais's portrait of Thomas Carlyle in the National Portrait Gallery. Despite later assertions that paintings were attacked at random, the National Portrait Gallery warden reported on July 16, 1914, that when he "asked which the picture was . . . the woman answered 'Oh, it's the Millais

Carlyle.'"[78] She knew exactly what she was doing. It made perfect sense to cut into Carlyle's patriarchal and racist worldview. At her trial, Gibb declared, "This picture will have an added value and be of great historical interest, because it has been honored by the attention of a militant."[79] For me at least that's true. I've been to see the painting to look at the cut that Gibb made, not because I like Millais.

What you might call Gibb's *Slashed Carlyle* is a more intense undoing of patriarchy than Marcel Duchamp's graffiti on the *Mona Lisa* in *L.H.H.O.Q* (1919). Gibb and the other slashing women made visible apertures in imperial white reality, gendered masculine. It created a moral panic, leading to women being banned from the National Portrait Gallery and other institutions. Even when readmitted, they had to leave their bags or parcels in the cloakroom in case they were concealing weapons, and were required to be accompanied by a man who would accept responsibility for their actions.

These cuts into white conceptual reality were sustained with attacks on the material infrastructure of imperial male whiteness. Women set mailboxes on fire, and bombed cricket pavilions and country houses. The houses of government ministers were particular targets, as befits an insurgency. In 1913, there were 213 such attacks, and 1914 was on a pace to match that number before war broke out.[80] In 1913, police raided the studio of suffragette artist Olive Hickin, who trained at the elite Slade art school, and was number two on the government's list of "known militant suffragettes" after her attacks on the Roehampton Golf Club and a house belonging to Prime Minister Lloyd George.[81] These items were found in her studio: wire cutters, fire lighters, hammers, bottles of corrosive fluids, five false automobile license plates, and strips of ribbon bearing the slogans "No votes—No telegraph connections" and "No security by post or wire until justice is done to women."[82] That's quite a list. Where Ruskin had seen art as the means to expand empire, the suffragettes' art strike targeted the imperial infrastructure of culture and communications to unbuild heteropatriarchy.[83] This suffragette militancy is a radical future that has not yet been fully lived.

The First World War ended this insurgency. On July 30, 1914, antiwar socialist Rosa Luxemburg, the theorist of the general strike, sat on the platform of a rally organized by the Second International in Brussels. Her

Sir John Everett Millais, 1st Baronet, *Thomas Carlyle*, 1877. Photograph of damaged canvas after attack by the suffragette Anne Hunt with a butcher's cleaver on July 17, 1914. © National Portrait Gallery, London.

head in her hands, she was unable to speak, despite being repeatedly called on by French socialist Jean Jaurès. Luxemburg could already see how decades of planning to resist the call to war were about to be demolished by a wave of patriotic fervor.[84] Perhaps she had a premonition of her own murder in 1919. The war's end created a new wave of monument building, reinforcing the shattered imperial worldview with an infrastructure of statues.

Police photograph of Olive Hickin, 1914.
National Archives AR1/528, UK.

To manage colonial populations, the British Empire had waged "small wars" throughout the nineteenth century. Fought every year from 1837 to 1914, small wars were undertaken against rebellion or sedition, often as punitive expeditions. In 1896, during Wilde's imprisonment, the British Army had issued the *Small Wars* manual for its officers. A small war was defined as "expeditions against savages and semi-civilised races by disciplined soldiers, it comprises campaigns undertaken to suppress rebellions and guerilla warfare in all parts of the world where organized armies are struggling against opponents who will not meet them in the open field."[85] The imperial screen wanted to see the empire as an open field, and the colonized resisted. The goal of imperial counterinsurgency was simple: to find a means by stealth, deceit, or brutality to use overwhelming force in that open field. Curator and scholar Dan Hicks has shown that this logic was "a central building-block in the transition from the . . . ideology of racial slavery to the early 20th-century militarist practice of state racism."[86] Hicks's insight shows that imperial wars were a racializing technology, changing whiteness at home and imposing empire abroad.

These wars were deliberately brutal. Military doctrine held that "uncivilized races attribute leniency to timidity." As Colonel C. E. Callwell, author of the *Small Wars* manual, coyly put it, "The [small] war assumes an aspect which may shock the humanitarian," involving "village burning" and "the capture of whatever they prize most."[87] The first reference echoes in the context of the United States with the infamous, if contested, 1968 statement that the US Army had to burn a village in Vietnam in order to save it. It was not a coincidence. Callwell's work influenced the 1940 *Small Wars* manual used by the US Marines and was referenced in the 2006 *Counterinsurgency* field manual FM 3–24. The second point can be understood by a visit to any museum in a former colonial power. The sheer quantity of materials, like the thirty-six thousand African objects in the American Museum of Natural History, were a military tactic, the taking of what was valued. Repatriating cultural property today is part of ending the 175-years-long history of small wars.

In 1915, W. E. B. Du Bois was clear that the roots of the war lay in Africa: "The present world war is, then, the result of jealousies engendered by the

recent rise of armed national associations of labor and capital whose aim is the exploitation of the wealth of the world mainly outside the European circle of nations."[88] For Du Bois, racial hierarchy was the direct cause of the European war. Just as later thinkers understood fascism as the application of colonial techniques to Europe, so did the First World War bring "home" all the "murder, assassination, mutilation, rape, and torture" that Du Bois knew were used as "small war" tactics.[89]

It was even a matter of arms. The Maxim machine gun that killed so many in Africa was repurposed by its new owners, Vickers, for extensive use on the western front. Marx had recorded Vickers's use of child labor in steel mills working night shifts at temperatures of ninety degrees during the Industrial Revolution.[90] Such cruelty paved the way to Passchendaele, where British casualties alone were at least 250,000. By the same token, the fascist "symbolic vision of total order" with its "armored bodies" was first made in the colonies, especially in extreme violence like the Namibian genocide of 1904.[91]

The war that had been waged through Ruskin's crystal plate ended up smashing it. It also generated a shift in the cultural unconscious, spotted by the founder of psychoanalysis, Sigmund Freud. Writing first in 1914 and then in 1918, Freud identified what he called a "compulsion to repeat." He saw it in shell-shocked patients and the general population, transformed by mass slaughter. His grandson played a game, throwing away a toy and reclaiming it. Aged two and a half, the child threw his toy, "exclaiming 'Go the fwont.'"[92] His father had been called up, and the child understood that this was tantamount to a death sentence. And he would repeat that process over and again. Freud's recognition of this compulsion to repeat identified the process whereby the imperial screen was compulsively reconstructed, only to meet with repeated destruction. Trump's call for a transparent border wall was one widely noticed recent example of this projected fantasy of white dominion. There is, then, no point in calling for that screen to be broken again because it will just get rebuilt. Following Du Bois's insights, to end racism and oppose militarism is to decolonize. It is to the decolonizing way of seeing that I turn next.

5

THE ANTICOLONIAL WAY OF SEEING

In November 2021, the island of Barbados became a republic. A year before the colonial statue of Admiral Horatio Nelson had been removed from the capital Bridgetown. So ended the dominion of the British monarchy that had begun in 1625. The return of the formal ceremonies of handover, as one flag was raised and the other lowered, was a reminder of postwar decolonization and the long shift to independence in the Caribbean that started with Haiti in 1801. It made visible again the aperture in white sight created by decolonization. This time period has become known as the contemporary—a time of being with other times and being with others. Barbadian poet and writer George Lamming named the contemporary practice of the "way of seeing" as anticolonial resistance in what he called his "exile" in 1950s' London. It was a way to see himself by seeing how others excluded from English whiteness were seen. It was at once reflexive and deeply empathetic to others. For although Britain formally declared a "hostile environment" to migrants and those deemed not British in 2012, it had been there all along, known as the "color bar," a means of informal segregation.

Racist and antisemitic violence, connected to sexual assault, marked postwar white nationalism. For self-identified British people, decolonization has meant shifting their sense of self-worth from their association with empire into the practices of whiteness. Its simple slogan was and remains "Keep Britain White," endorsed by Winston Churchill and the

fascist Oswald Mosley alike. The anticolonial way of seeing was a means of detecting the networks of white violence and creating a structure of immigrant feeling in this persistently hostile environment. Yet by the time John Berger used "ways of seeing" for his television series and now-classic accompanying book in 1972, the anticolonial and decolonial affects of the phrase had subsided.[1] It is time to revive it.

Lamming himself first perceived the way of seeing when reflecting back on his 1951 encounter with Jewish East End poet Emanuel Litvinoff and T. S. Eliot in the new Institute for Contemporary Arts (ICA) by way of Notting Hill. The ICA was part of the effort to revive British postwar culture. Housed in a Georgian terrace in Piccadilly, where Admiral Nelson had once lived, the ICA sought to imagine a post-imperial "contemporary" that was nonetheless every bit a plantation future. Notting Hill, a central London district where many Caribbean migrants lived, was the site of spectacular racist white violence in 1958–1959. As the hub of a new visual politics, Notting Hill was photographed by Roger Mayne (1929–2014), fictionalized by Colin MacInnes, and analyzed by then young cultural theorist Stuart Hall, all within the pages of the founding New Left journal *Universities and Left Review*.

Whether in the everyday life encounters of a declining empire or high culture spaces, Lamming's anticolonial "way of seeing" offered an empathetic seeing via, and by means of identification with, other others. In this seeing, I see how others see you, and that tells me how I am seen because of the affinities between us. The way of seeing cut across the shattered imperial screen and newly reinforced British color bar alike. The way of seeing did not attempt to evade racializing surveillance. Instead, it mapped nationalist whiteness to see how space was formed inside and outside the white imaginary. Lamming triangulated his position by means of relation with the immigrant Jewish minority so as to understand how West Indians were being seen. Fifty years later, Hall commented, "Looking back at these years I'm struck by the prominence of *sight* in the operations and theorizations of race. For me the visual components of these memories are potent."[2] Hall had grown up in a system of "racial classification in Jamaica [which] organized a highly calibrated system of thought" (175). In Jamaica, Hall considered himself to be "coloured" (99) by virtue of his typically Jamaican diverse background. It was through the intersecting

Roger Mayne, photo of Stuart McPhail Hall,
1958. © Roger Mayne Archive / Mary Evans
Picture Library.

experiences of the Notting Hill riots and US civil rights movement that he came to claim "black as a personal identity" (15). Implied was the counterpoint of a single "white" mode of dominion.

In this experience of migration from the still-colonized Jamaica to the "mother country," the colonial hierarchy "binding see-er and seen in a mutual but acutely unequal relation" (175) no longer existed:

The field of vision shifted. In the metropole the underlying syntax was reassembled and the disposition of the racial other was thrown more sharply into relief. New modes of looking emerged—had done from the time we boarded the boat out. They did so day by day in our new lives: in the street, at work and in the neighbourhood. And they entered the feelings we took home with us at night to our rooms, free from the immediate gaze which—intentionally or not—worked to position us as outside the shared habitus of England. (175)

Hall reshaped here Raymond Williams's contemporary concept of the "structure of feeling," often understood through class, into racializing practices of looking, seeing, and being seen every day in everyday life. Hall was not insisting on some primacy of vision but rather "that race/colour really does work as the principle of articulation across the society as a whole: as the means by which multiple forms of oppression interconnect and take on meaning" (103). This was obvious to Hall and Lamming alike as young immigrants in the 1950s.

By contrast, the emerging "white" viewpoint in postwar Britain, at once conscious of the loss of imperial power and arrival of visibly distinct minorities from the Caribbean, was both reactionary and conservative. A color line emerged in everyday life, known in the United Kingdom as a "colour bar."[3] It predated the arrival of Caribbean immigrants. A 1930 report argued for the exclusion of "colored" sailors from the merchant navy. Black soldiers from the Caribbean and United States experienced racialized hostility and segregation in the United Kingdom during the Second World War.[4] In 1944, the Pan-African Congress in Manchester decorated its platform with posters denouncing the color bar and antisemitism alike. After the war, right-wing politicians adopted the street slogan "Keep Britain White."[5] As the empire retreated physically, the shattered

imperial screen of the past century was replaced by this formal, physical segregation.

In 1948, a technical change in passport rules, designed to allow newly independent Commonwealth citizens to retain British passports, also extended full British citizenship to Caribbean peoples. The first boat bringing Caribbean citizens migrating to the United Kingdom in response to appeals for labor was called the *Windrush Empire*, and so the migrants have collectively become known as the Windrush generation. Even as the *Windrush* was at sea in 1948, Labour prime minister Clement Attlee inquired whether the ship could be diverted to East Africa. Calls for immigration controls preceded the arrival of any new immigrants. On the day the *Windrush* arrived, eleven Labour members of Parliament requested that the government impose such controls, fearing "an influx of coloured people domiciled here is likely to impact the harmony, strength and cohesion of our people and social life."[6] It did not need to be said who "our people" were. And this was at the height of the post-1945 socialist transformation.

Tory Member of Parliament Enoch Powell argued in Parliament in 1953 that immigration under the British Nationality Act (1948) had "brought about an immense constitutional revolution," which he called "the divisibility of the crown." Using this sophistry concerning the formation of the Commonwealth, in which the Crown was head of state in otherwise independent countries, and refusing to accept decolonization, Powell claimed his views were motivated by concern for the "future of the British empire." His speech articulated his belief in "the abject desire to eliminate the expression 'British,'" meaning a reduction in privilege of white people.[7] In response, the BBC broadcast an investigation called "Has Britain a Colour Bar?" in 1955—a question expecting the answer "yes" if ever there was one.[8] This speaking out loud of racist commonplaces in Parliament and on television enabled both the violence in Notting Hill and Nottingham of 1958–1959, and Powell's own later calls (thinly masked as warnings) for such violence. By 1979, Hall would grimly conclude that "Powellism won."[9]

US sociologist Ruth Glass, who studied the effects of immigration in London during this period, called Notting Hill a "zone of transition" for internal and external migrants, marked by "visual diversity," meaning

visible difference in skin tone.[10] All press and official reports of the period agreed that poor housing and rack rents charged by landlords were key elements to making the "zone" into a trouble spot. Powell's work as housing minister brought about the end of rent control in 1956, enabling the rack renting that caused so much tension.[11] Glass surveyed housing advertisements locally and found hundreds to be openly discriminatory.[12] Many stated "no coloured," while the greatest number stipulated "Europeans only." A subset specified "English only," which Glass learned meant "no Jews." The transition of "Notting Hill" came to mean that of the contested postimperial metropole as a whole from imperial capital to global financial center. The color bar accelerated this process that Glass was the first to call "gentrification" in 1964, dividing affluent white areas from the new zones of transition. Her term has come to convey the takeover of central cities worldwide by wealthy elites.

Those wanting to "keep Britain white" used racist street violence that spread in August and September 1958 from Nottingham to Notting Hill. Fighting was allegedly sparked when those specifically "looking for trouble" caught sight of Majbritt Morrison, a Swedish woman married to a Jamaican named Raymond Morrison.[13] It culminated in the 1959 murder of Kelso Cochrane of Antigua in the neighborhood. This murder was never formally solved, although the culprit's identity was known to the police at the time.[14] The killing of a West Indian perversely prompted anti-immigration legislation and regulations. By 1961, opinion polls recorded 67 percent support for immigration control.[15] As the empire declined, certain British people came to see themselves first and foremost as "white" in a binary distinction to "Black." Lamming's "way of seeing" emerged from the experience of that change in an identification between human beings who were equal in their exclusion from the racializing hierarchy of the contemporary metropole.

THE ICA

A poet and novelist, Lamming published *Pleasures of Exile* in 1960, reflecting back on his experience as an immigrant in postwar London. While it was "a report on one man's way of seeing," Lamming knew that no seeing

takes place in isolation. Rather it was "a dialogue between you and me. I am the whole world of my accumulated emotional experience, vast areas of which probably remain unexplored. You are the other, according to your way of seeing me in relation to yourself."[16] In the context of the Ceremony of Souls, a Haitian ritual in which the dead make demands of the living and with which Lamming opened his book, that encounter was also between the living and dead. The way of seeing is, then, a visible relation, as Édouard Glissant later put it, containing multiple layers of time-space. Imagining himself as Caliban bringing the anticolonial warning to Prospero that "his privilege of absolute ownership is over," Lamming unfolded the hierarchical, colonial way of seeing into its constituent layers. He was inevitably aware of the everyday distinctions experienced by migrants in London, describing an incident where he tried to retrieve a misdirected letter only to be told no "BLACK stamps" had been seen on envelopes at that address.[17] The emphasis in the reported speech conveyed its two meanings: no stamps from overseas countries considered Black, and the conceptual impossibility of mail addressed to Black people within Britain. Lamming nonetheless preferred to situate his exploration of the way of seeing in the realms of "high" culture, knowing that such gradations map directly onto racializing hierarchy.

His transformational scene was a poetry reading organized in February 1951 by Herbert Read, then director of the ICA.[18] The ICA played a significant role later that year in the Festival of Britain, explicitly designed to help the country redefine its identity after the war and the loss of empire. It held the survey exhibit Ten Decades: A Review of British Taste, 1851–1951, which served to connect the festival to the Great Exhibition of 1851 at the height of imperialism and set it within the context of "taste," meaning elite distinction among high cultural forms.[19] It also became the site of an intense debate on monuments and modern sculpture when it organized a competition for a monument to the unknown political prisoner, to be placed in West Berlin. The young John Berger denounced the never constructed winning entry by Reg Butler as demonstrating that "the official modern art of the West is now bankrupt."[20] In short, the ICA was, as it was intended to be, the key arena of contemporary British high culture, with acknowledged and unacknowledged debts and connections to imperialism.

Lamming's entrance to read his poetry in this overdetermined space was greeted with oddly loud applause that he took to be an indication that his Blackness had been seen.[21] Lamming was found worthy of outstanding applause simply for disproving Thomas Jefferson's old attack that no person of African descent had ever been a poet.[22] It followed that Lamming was spared the usual "painful test" of "examination questions" after he read. At this point, looking back from 1960 on these 1951 events, Lamming observed that "the ICA is a neighbor of Notting Hill. In spite of our differences in fortunes, the West Indian [Cochrane] who was murdered in Notting Hill is an eternal part of the writing Caliban who has, at least, warned Prospero that his privilege of absolute ownership is over. . . . There may be more murders; but Caliban is here to stay."[23] In geography, Notting Hill is four miles away from the ICA, and these events were separated by eight years. In the psychogeography of the contemporary formed by the way of seeing, the locations were neighbors and the events were contiguous. Writing after "Notting Hill," Lamming condensed time to remap contemporary London across the color bar.

The next poet to read was Litvinoff. Read had noticed Litvinoff's poems during the war and published his collection *The Untried Soldier* in the Routledge New Poets series. He invited Litvinoff to the reading in order to demonstrate the metamorphosis of the radical working-class Jew into white poetry. Litvinoff was incensed that Eliot had republished prewar antisemitic poems like "Burbank with a Baedeker, Bleistein with a Cigar" in his Penguin Poetry paperback *Selected Poems* (1948). Looking back, Litvinoff recalled, "I could forgive him for writing them at that time. But to publish them again after Auschwitz was an appalling thing for him to do."[24] His thought takes philosopher Theodor W. Adorno's well-known refusal of lyric poetry after Auschwitz a step further, rejecting modernist poetry that included lines such as "the jew is underneath the lot."

Antisemitism was still common in Britain, despite present-day assumptions that the Holocaust changed everything. Just before the publication of Lamming's book, Marxist historian Isaac Deutscher observed, "It is an indubitable fact that the Nazi massacre of six million European Jews has not made any deep impression on the nations of Europe. It has not truly shocked their conscience. It has left them almost cold."[25] There

were antisemitic riots in 1947, following the killing of two British sergeants in Palestine, prefiguring the violence in Notting Hill.[26]

Litvinoff's scathing poem in response was titled "To T. S. Eliot," attacking Eliot for antisemitism in the context of the Holocaust. It was the poem that he chose to read in the ICA:

Yet walking with Cohen when the sun exploded
and darkness choked our nostrils,
and the smoke drifting over Treblinka
reeked of the smouldering ashes of children,
I thought what an angry poem
you would have made of it, given the pity.[27]

And then there was an uproar. Lamming now saw how "the place really started to get like Notting Hill, except that there were no knives," referring to Cochrane's murder. Violence was underway in the ICA, using words as weapons. It was the violence of segregation, separation, and classification. Litvinoff had broken what Lamming called English high culture's "common assumption of outlook" by raising "questions of Race," turning him back into a Jew, not a poet. Lamming realized that there was still a "colonial situation among English poets."[28] The Notting Hill "riots" were a racist contestation of belonging, and Lamming understood the ICA to be a high culture instance of the color bar.

At the ICA, poet Stephen Spender immediately defended Eliot, first noting his own (partly) Jewish descent. With one Jewish grandfather, Spender declared, "As a poet almost as Jewish as Mr. Litvinoff, I protest at the reading of this poem."[29] Can one be a "fractional Jew," Lamming later wondered?[30] From the Nazi point of view, certainly, but otherwise a person is or is not Jewish, whether by formal religious standards or self-identification. Spender then argued that Litvinoff had misunderstood. British critics had similarly panned Lamming's work and indeed that of all Caribbean writers, as evidenced in a 1962 *Times Literary Supplement* review: "No West Indian writer, viewed from the highest standards, has yet contributed much to the English language."[31] Eliot's writing on Jews was, claimed Spender, to be understood as criticism: "There is always a certain resentment between races and although it is important that this

should not be expressed vindictively, it is also unwise for it to be inhibited altogether."[32] At this point, Spender reentered contemporary whiteness, while leaving Litvinoff very much outside. For Spender, racism was certain, only to be condemned when vindictive. If a minority group is judged to have behaved badly by the majority, then resentment against it would not be vindictive. Deutscher recognized that Jews remained identified with "trade and jobbing, money lending and money," allowing their extermination to be experienced as a "half-hearted and half-witted" anticapitalism.[33] Such were the sentiments that Spender felt it "unwise" to inhibit.

As Spender spoke, it became known that Eliot himself was in the room. Lamming saw how Eliot was seen as the "great man," or hero as Thomas Carlyle had put it, that no colonized subject could ever be, African or Jewish. Now, he noted, "the exercises in seeing and wanting to see had begun" among the white men. Within the white contemporary of the ICA, the colonial poets saw each other by, first, differentiating themselves from the person of African descent, then separating the Jew as intellectual inferior, and finally, claiming association with the latter-day hero, who alone can grasp history by means of visualizing tradition. As Lamming understood, these were culturally violent acts, analogous to the street violence racism of Notting Hill, because they were all "expressions of a similar deficiency in the national life of the country," meaning its unequal allocation of citizenship.[34]

Watching this high cultural violence engendered the anticolonial way of seeing. Lamming in exile from Barbados, an island that he had noted was (still) subject to four hundred years of colonial ordering and governing, watched Litvinoff from the bomb-damaged impoverished East End of London, newly traumatized by the Holocaust, become visible to the English elite only as a disruption to be excluded. In 1951, with India independent, and violence unfolding in Kenya, Malaya, and elsewhere, it looked as if there was little future for imperial Englishness. Litvinoff's refusal of deference made visible another way of seeing, producing both his own understanding that "I identified with the exile" and Lamming's engagement with exile as becoming.[35]

Lamming understood "culture" as everything from workplace banter to Eliot. Setting out an account of women factory workers demanding to see the "tails" of West Indian men, he made reference to Freudian

displacement, but then returned to what he saw as the "other example," the ICA. And he pointed out that the West Indians were at a disadvantage because they simply could not believe what they were now seeing every day: "I am walking up the street, and three men are walking towards me. I do not think that they are the enemy from Notting Hill; nor do I think they are not. I simply do not know, for there is no way of telling. It is my particular way of seeing which creates this doubt, in spite of all I have read about what was happening." And he concluded that "the West Indians who lived through the terror of Notting Hill have lost their confidence in the police."[36] That meant they had rejected contemporary Britain as home or even a place of refuge. It became exile. When the "police," who were also the white public, were no longer trusted, it meant that West Indians had rejected the entire system of governance, social custom, and manners.

But the other party to the anticolonial way of seeing missed it. Litvinoff talked about the incident with Eliot for the rest of his life and never once mentioned that Lamming was there. Perhaps he was too traumatized by the repeated attacks to remember. It's unlikely he didn't notice given the racialized dynamics of 1950s' London. Lamming's novels and criticism brought him considerable attention in the small circles of intellectual life in London, so even if Litvinoff had understandably been distracted at the time, it might have occurred to him later. But it didn't. Litvinoff was part of the radical Jewish tradition, shifting from his father's anarchism in and out of the Communist Party and other leftist factions. His East End was one of fish and chips, pubs, and street fashion where "crowds skirmished around the picture palaces trailing peanut shells."[37] This consumerist, urban Jewishness is less well remembered now than the Orthodox religious community that fascinates present-day writers, just as it had William Rothenstein (see chapter 4).

The separation was not so neat. A famous anecdote from the early twentieth century tells how Jewish anarchists would stand outside the Brick Lane synagogue on Yom Kippur—the holiest day of the religious calendar—eating ham sandwiches.[38] And a fight ensued. The point is that each side of Jewish life mattered enough to the other for direct conflict. The Holocaust scattered that sense of communal possibility. By 1951, thanks to wartime bombing, the East End haunts of Jews like Litvinoff had already mostly disappeared.

Litvinoff grew up on the northern edge of the Jewish East End on Fuller Street in the Bethnal Green working class.[39] Italian writer Elias Canneti described him as a "schizophrenic artist."[40] It was not so much clinical schizophrenia as a form of double consciousness in which his questions "What was I but English and what else was I but Jewish" met with the collective response "Not Quite British Enough."[41] Here British meant white, as it did in the ICA. In 1941, some eight hundred Jews escaped from eastern Europe on a leaky freighter named *Struma*. Reaching Istanbul, they requested permission to disembark and travel on to Palestine. The British government refused, designating them "illegal immigrants," as if the present hostile environment were already in action.[42] The *Struma* was towed out to sea, where it sank with the loss of all but one passenger. "Never again," wrote Litvinoff, "would I be able to think of myself as an Englishman." Although he attacked colonial prejudices in his 1968 novel *The Man Next Door*, Litvinoff did not see how others were seen in England or affiliate with them.[43] If no collective anticolonial way of seeing came out of the ICA, afterward both Lamming and Litvinoff stopped being poets and turned to prose, fiction, and criticism. Poetry remained too colonized.

TO SEE NOTTING HILL

The anticolonial way of seeing did not, then, simply arise from a specific place and time but rather from a reflection on place and time over time. It condensed a long series of struggles into "Notting Hill" as the site of the contemporary. For historians Camilla Schofield and Ben Jones, "Notting Hill" was a set of events that generated a "defining set of political questions about 'community' through which a new politics of race emerged."[44] In this view, the postwar fragmentation of community in Britain became the key organizing point for both racist and antiracist politics. For white politicians and social scientists, Notting Hill demonstrated the impossibility of a multicultural community.[45] From the anticolonial position, community was a goal to be achieved in the future, while the present was still structurally and systemically divided.

Hall responded as a teacher, activist, and editor of *Universities and Left Review* to Notting Hill. These experiences shaped him into the now-revered thinker on race, class, and culture. When the racist violence broke out in 1958, Hall was teaching "right at the bottom of the pile" in Kennington, South London. He followed some of his white students to Notting Hill after school. They wanted to witness what they described as "a bit of argy-bargy," meaning low-intensity street violence. He watched them on street corners, shouting abuse at Black women walking home, in chorus with older white men sitting inside pubs. Back in school, he asked them why, and the response was, "They're taking our women"—this from fourteen-year-olds—or "They're taking our things." When Hall asked if this "they" included himself or the Black children in the class, they denied it. He saw that violence among the young was "not willful callousness, but a part of their predicament. It is a successful surrogate, a release—*for the [f]ew*."[46] All that school had really taught them was prejudice that found a socially sanctioned release in "Notting Hill."

Hall used these local experiences to analyze the new contemporary. First he asserted directly and bluntly, "Notting Hill is London."[47] Notting Hill was not an isolated "zone" within a largely stable metropolis; the entire city was in transition. The prejudices and violence among the self-identified white population were, second, "the unmistakable profile of Britain's colonial policy over the last century." Far from being somehow provoked by the postwar migration of Caribbean workers, these were learned interpretations of imperial dominance since the Indian uprising in 1857—an imperial violence that has not stopped. This anticolonial way of seeing Notting Hill led him to commit to "direct action . . . of a socialist kind," perhaps to distinguish it from anarchist direct action. With some forty to fifty others, he created a Universities Left Review club in Notting Hill with the assistance of Donald Chesworth, London County councillor and Labour Party stalwart.[48] The Notting Hill club kept a Youth Club open during August when the state-organized youth facilities were closed, although school was out of session. It created a "fact-finding and working study group," for despite the creation of the welfare state, there was little reliable information about deprived areas like Notting Hill.[49] Finally, it established the Powis and Colville Residents Association, which quickly

rose to 160 members, and campaigned for fair rent, better garbage collection, improved street cleaning and lighting, provision of social clubs, and the upkeep of squares.[50]

Hall later remembered that while organizing the Notting Hill club, he met Michael de Freitas, later known as Michael X. De Freitas had migrated from Trinidad, the child of a Portuguese (perhaps Jewish) father and Barbadian woman of African descent. Like Hall, he was educated to believe "white is pretty; black is ugly" by his Black mother.[51] In Notting Hill, he came to work for the notorious Jewish rack landlord Peter Rachman, while also running blues dances and organizing sex work. He was arrested in the 1958 violence and served fourteen days for obstructing the police (which he claimed was false).

All kinds of outside researchers then descended into the area and gave de Freitas his own way of seeing. Jewish sociologist Richard Hauser and his wife, Hepzibah Menuhin, daughter of violinist Yehudi Menuhin, came to a party organized "so that they could learn something about us." But the researchers refused at first to participate, "standing spiritual miles off and scanning the surface." A young Jamaican accused them of treating the partygoers "like we're zoo animals." With the white visitors forced to participate, "the party went like a rocket and we had a great time observing their natural behaviour."[52] While the Jewish sociologists had intended to observe the West Indian party, their being seen doing so allowed the way of seeing to be reversed.

In a similar fashion, Hall continued to use Notting Hill as a lens to analyze the postimperial culture of Britain. Realizing that teenagers (a term then used to refer to people between twelve and twenty-five years of age) were all shaped in the postwar period, Hall addressed the difficulties of growing up in a climate of conformity, overweening bureaucracy, anti-intellectual education, and repetitive jobs. Their only outlet was what he called "mass entertainment" and consumerism on the US model, much to the disdain of their elders. Hall understood that culture (broadly defined) was to play a key role that was not present in standard left analysis of the economy. As a former Henry James scholar, Hall had tried without much success to interest his school students in Shakespeare. His writing shows detailed awareness of trends in fashion, music, slang, and what would come to be called subcultures among teenagers. After Notting Hill,

Hall argued that it was the absence of a "common culture" that prevented the possibility of a democracy worth the name.[53] He was already in transition to studying contemporary culture as the space of political possibility.

SOUTHAM STREET AND THE WAY OF SEEING

As editor of *Universities and Left Review*, Hall explored these interactions by publishing photographs and writings by his friend Roger Mayne. Mayne's pictures were controversially used to convey the ongoing transition in Notting Hill and emergence of teenagers.[54] Originally a chemist, Mayne had had some initial success as a photographer in the mode of Henri Cartier-Bresson's project to capture the "decisive moment." Now something of a photographic cliché, this idea was then new in England. Indeed, the Victoria and Albert Museum responded to his request that it collect photography by dismissing it as "a mechanical process into which the artist does not enter."[55] Mayne's work concentrated on catching decisive moments of modern British life. He already had work in the Museum of Modern Art's collection, and in 1956 had an exhibit at none other than the ICA.

That same year, Mayne began a six-year project photographing Southam Street in Notting Hill, one of the most impoverished streets in the area. The once-elegant town houses on Southam Street were dilapidated and run-down by 1956. Subdivided into multiple flats with just cold water and toilets only available communally on landings, these properties were rented to the urban dispossessed, including single parents, Irish people, and Caribbean migrants. Violence was part and parcel of life. It was on the corner of Southam Street that Cochrane was killed and a year later Mosley held a rally of his fascist Union Movement on the same spot. Nonetheless, Mayne found a dynamism there that contrasted with the apathy of postwar Britain:

My reason for photographing the poor streets is that I love them, and the life on them. . . . Empty, the streets have their own kind of beauty, a kind of decaying splendour, and always great atmosphere—whether romantic, on a hazy winter day, or listless when the summer is hot; sometimes it is forbidding; or it may be

warm and friendly on a sunny spring week-end when the street is swarming with children playing, and adults walking through or standing gossiping. I remember my excitement when I turned a corner into Southam Street, a street I have since returned to again and again.[56]

Mayne's photographs captured moments of street life that were unusually active because cars were banned from Southam Street as a "play street," making it into an informal playground and youth center.[57] Mayne lived locally in a classic two-up, two-down terraced house, which he had, in his own words, "'modernised' by the division of a first-floor room into kitchen and bathroom, and I had the two top-floor rooms knocked into one." Mayne, too, was part of the transition—as a gentrifier.

He moved there because he thought of himself as an artist, and Notting Hill was an artists' area. Painter Lucian Freud, grandson of the psychoanalyst, had a flat on Delamare Terrace, just a mile from Southam Street. The street faced the Regent's Canal, and as Freud put it, "Delamere was extreme and I was conscious of this. A completely nonresidential area with violent neighbors. There was a sort of anarchic element of no one working for anyone."[58] He painted a young local man called Charlie Lumley in 1950–1951. Titled *Boy Smoking* (Tate), the small painting has a close focus on Lumley's face, dominated by his blue eyes and full lips. Although he's said to be smoking, his cigarette has gone out. Lumley's look directly engages the artist/viewer with an affect that is at once vacant and queer. Freud used Lumley as an optic into working-class life, remarking, "Sometimes things that I didn't understand Charlie would explain to me: the harsh ways and laws of the life [in Paddington], such as the things people were respected and despised for."[59] In 1956, Freud repeated the work from the other end of the social scale, with a close-up portrait called *Head of a Boy* of the Honorable Garech Browne, wealthy from Guinness and sixteen years old at the time. The painting captures the same blond hair, blue eyes, and full lips, but this time the "boy" is looking demurely down.

Unusually for Freud, the frame cuts into both boys' heads.[60] Mayne appropriated both his subject matter of underclass London and this compositional technique. His photographs similarly let the frame cut through people or events. His focus is sometimes a little off, and his depth of field is sometimes forced. It is the uncertain dynamic of class and ethnic

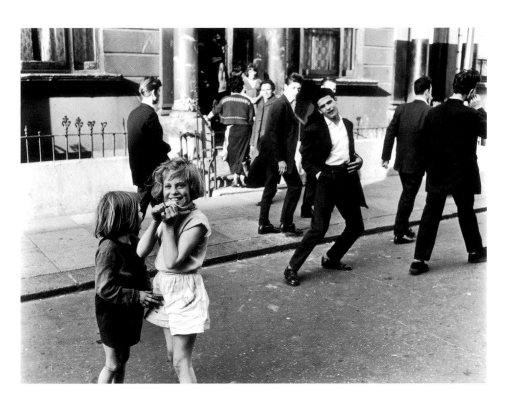

Roger Mayne, photo of children and Teddy
Boys playing and hanging out in the streets
of North Kensington, London, 1956. © Roger
Mayne Archive / Mary Evans Picture Library.

Lucian Freud, *Boy Smoking*, 1950–1951. Oil
on copper. © The Lucian Freud Archive /
Bridgeman Images.

relation that gives his photographs their energy. Despite many formal differences between Freud and Mayne, there was a common concern with the question as to how humans might connect as well as communicate across class, gender, and racial divides in the postwar, decolonial moment.

Mayne's Notting Hill photographs depict predominantly white-appearing teenagers, mothers, and children, but few adult men. Mixed unevenly and unequally among them were a minority of Caribbean people of all ages. Some recent commentaries have sought to interpret Mayne's work as addressing class to the extent that it even "transcends race."[61] To the contrary, Mayne's photographs perhaps unwittingly illuminate Hall's signature insight, derived from his own experience as a migrant: "Race is the modality in which class is lived. It is also the medium in which class relations are experienced."[62] None of the invented tradition of working-class belonging can be seen here—flat caps, football support, going to pubs, and the labor movement—except the respectably dressed young children, who are nevertheless out on the street.

In the transitional time-space of Notting Hill, English, Scottish, and Welsh working-class people came to see themselves first and foremost as "white," or more precisely, to be British was to be white. Their Caribbean counterparts came to understand, as Hall himself had done, that they were seen first and foremost as "Black," a category that made any claim on Britishness partial at best in white eyes. At the intersection of these processes was the making of "life," as postwar austerity transitioned to the consumer society. For the young, it was music, dance, clothing, fashion, and sport that made up a life worth living, while the jobs or black economy work that enabled those moments were "anti-life," to use Hall's term.[63]

Mayne was certainly aware of the sociological possibilities of photography for he had stayed with urban ethnographer Judith Stephen and her photographer husband, Nigel Henderson, in Bethnal Green.[64] His photographs also accompanied Iona Opie and Peter Opie's pioneering studies of childhood and nursery rhymes. But he wanted his work to be understood as "art," which like Oscar Wilde before him, he saw as the expression of a paradox. Unlike Wilde, he articulated it directly in relation to sex: "In sex the paradox is that what may start as pleasure, as a kind of game, can grow into love and a lasting relationship. . . . [T]he paradox of art is that the spiritual is expressed by physical means." Mayne regretted

that the "coldness I find in my pictures, and which I don't want there, is a reflection of my own deep pessimism." He avoided the label "social realist" for its association with Soviet Communism and so was left with a search for a "socialism as a way of life," but he did not, or could not, speak of how racializing happened in his photographs.[65] Like Litvinoff, he simply did not see it.

Looking at his work now, the way of seeing in Lamming's sense was everywhere in Notting Hill. In a 1956 photograph, Mayne recorded four smartly dressed West Indian men walking down Southam Street. The landscape format of the picture evoked what he called the "atmosphere" and "beauty" of this urban space from which the eye has no exit; even the windows are impenetrable, thanks to thick net curtains. The even grayness of Mayne's work unconsciously records the permanent London smog of those coal-fired days. The men pass among four visibly white boys, each of whom is staring fixedly at them, as if in illustration of Frantz Fanon's "Look! A Negro" scene.[66] None of the men pay them any attention. One looks over at the photographer, his glance mingling caution and good humor. But the three men in front are all looking carefully and fixedly at what lies ahead of them.

Labour politician Alan Johnson grew up on Southam Street, and in his childhood memoir, he observed how the men in Mayne's photograph are "on the look-out for trouble as they head towards a group of young guys gathered around the steps leading up to a front door. Youths with grey pinched faces who don't yet seem to have noticed the quartet ambling towards them." Looking was confrontational, as Johnson described: "When to look, when not to look and indeed how to look was a complex skill, acquired through trial and error. It was important to appear 'hard.'" If the youths on the stoop were to meet the look of the walking men, they would then be required to challenge them: "Oi 'Oo you screwin'?" where "screwing" means to look.[67] Screwing could not but have a sexualized connotation as well—as does the required "hard," meaning capable of violence—especially in the encounter of racialized bodies. All accounts of racialized tension talk of cross-ethnic relationships as central, including the beginnings of the Notting Hill riots in 1958.

In Mayne's photograph, the four white youths studiously ignored the Caribbean men, who had successfully performed being "hard." Whether

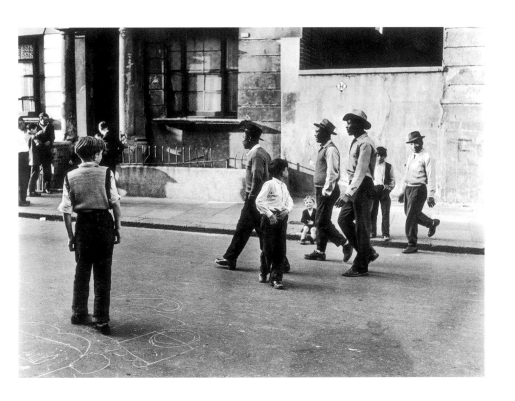

Roger Mayne, photo of West Indians in
Southam Street, 1956. © Roger Mayne
Archive / Mary Evans Picture Library.

or not such performance was required on their home islands, the combination of broad-brimmed hats, thousand-yard stares, and hands-in-pockets casualness won this encounter of class belonging for the Caribbean men. This photograph captured the means by which the transition of racializing was in turn producing and produced by a modality of class relations in Notting Hill. Here was Mayne's "way of life" as a way of seeing.

These photographs stand as uncertain eyewitnesses to the process of racialized change. Another photograph of Southam Street from 1956 has groups of children, young men, and women. All are white, and all have one member engaging the camera directly. Where the space felt dangerously enclosed when the Caribbean men were seen marching through it, here there is a palpable humorous performance for the camera. That sense of safety was not only produced by racialized homogeneity. During 1956, Mayne repeatedly photographed two young boys who appear to be Caribbean. Sometimes they are seen together and sometimes separately. They look as if they might be related, perhaps even brothers. In one scene, they appear together at the right foreground of the image, with the frame cutting off one of their feet. Despite a vacant space in the middle of the picture, it is clear they are making eye contact with different people out of the frame. A young white girl, who is often seen in Mayne's photographs, appears at the far left, watching over the boys.

On one occasion, one of the boys appears holding onto the handle of a pram, pushed by a young white woman, with a white baby inside. Both he and the young woman are looking away to the viewer's left at someone or something we can't see. The effect is one of young people being supervised—one that is reinforced by a photograph of a Caribbean woman on the step of a house, surveying the street, while another woman sits calmly on the stairs. The standing woman is looking for someone, certainly, perhaps one of the boys, but she does not appear concerned. In yet another picture, an older white woman is caring for one of the boys with a young white boy about his size. In another, only children are seen with one of the boys at the center of the group. No one minds. Everyone feels calm. It took the presence of "hard" white masculinity to undo that.

In a photograph taken after the 1959 murder of Cochrane at the end of Southam Street, a young Caribbean-appearing man stares directly at Mayne's camera. His hand rests casually on the shoulder of a white boy

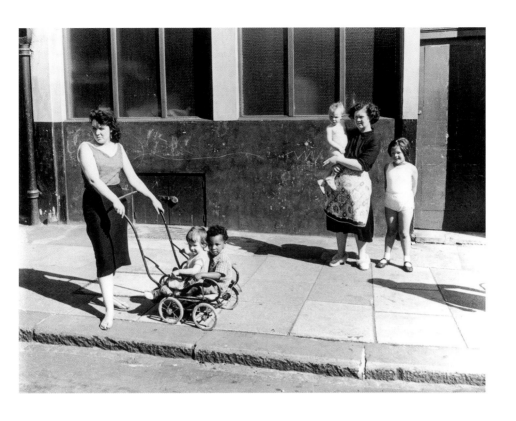

Roger Mayne, photo of Black and white
children together in Southam Street, London,
1956. © Roger Mayne Archive / Mary Evans
Picture Library.

next to him, and his ring suggests that he may not be as young as he looks. But his look is fully alert, sure to take in the middle distance as well as those around him. There's a group of young white men behind him, and another completes the trio in the left foreground. Two smaller boys are only partially visible in the right foreground. Who is protecting whom in this photograph? How has the changed political dynamic affected the street? Johnson says that his mother witnessed Cochrane's murder (while carefully not naming the assailant). She detested Mosley—her hero was suffragette Emmeline Pankhurst—and forbade her children from going anywhere near his rallies. Yet Johnson has a memory that he went nonetheless and has a visual picture of Mosley speaking.[68]

Writing in 1959, Hall assessed that Mosley's "support is far higher than the voting figures suggest."[69] The masculine fascination with fascism, to borrow from Susan Sontag, went much further than the ballot box, as our own time has sadly borne out. The street became a place of danger, accordingly, when men performed racialized masculinity in it. Mayne photographed a line of Teds (or Teddy Boys, a white subculture that wore dark jackets, white shirts, and crepe-soled shoes) blocking off Southam Street. As one of them gestures at the camera with a long stick, this potential violence becomes visible. Litvinoff remembered similar tactics in the 1930s when he and a friend ventured into neighboring Hoxton hoping to impress local young women: "Instead of attracting female attention, we ran into a gang of youths who spread themselves across the pavement, and told us to get back to Palestine."[70]

This informal color bar was reinforced by the police, occasionally seen in Mayne's photographs. The police then and now were reluctant to get involved in "domestics," meaning violence or abuse within the home. What can't be seen in Mayne's photographs is the "drunk and violent" behavior of white men in their flats toward women and children.[71] Mayne believed it was "unhappiness, loneliness and lack of human contact that characterises the English." This unhappiness was registered obliquely in terms of sexuality, as he referred to the 1957 Wolfenden report that had recommended decriminalizing male homosexuality and prostitution. A new morality would require what Mayne termed an acceptance of "the less normal but inevitable sides to sexual behavior."[72] Assuming that he was referring here via Wolfenden to queer sexualities, the male sociality

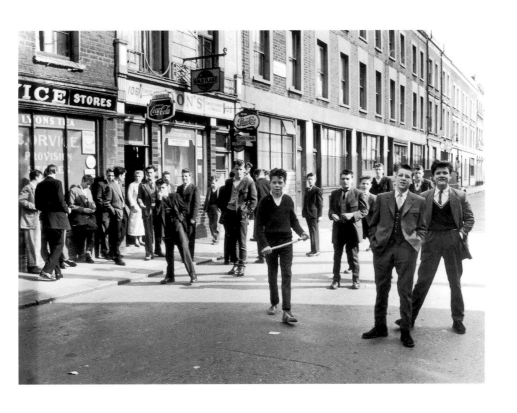

Roger Mayne, photo of a large gang of
youthful "Teds" in North Kensington, 1956.
© Roger Mayne Archive / Mary Evans
Picture Library.

on view in his street photography has another unspoken set of connotations. Was Mayne outing himself? Or acknowledging cross-class queer desire and sex work, as represented in Freud's painting?

These dynamics were directly addressed in Colin MacInnes's 1959 novel about Notting Hill, *Absolute Beginners*. Under Hall's editorship, MacInnes published insightful essays in *Universities and Left Review*, alongside his fictional *London Trilogy*, of which *Absolute Beginners* is the middle segment. The original cover of the novel featured a Mayne photograph that Hall had already published in *Universities and Left Review* showing a fashionably dressed young man waiting for a young woman coming toward him in a pose of deference and anxiety. The presumed heterosexual dynamic within a single couple was an unusual theme in Mayne's work. Her head is tilted to one side, and her face and gaze are directed down to the ground, perhaps in response to what seems to be his fixed gaze on her. The feeling is uneasy, as if this is the prelude to an argument or violence rather than a date. Alongside the photograph, Hall's essay explored the "frustration arising from the apparent impossibility to 'know other people,' from the anonymity of human society and its institutions, and from the lack of care." He traced a connection between the crisis of personal relationships and "deep social disturbances of which racial riots, juvenile delinquency and petty crimes are merely unpleasant forerunners."[73] The perceived decline in the value of whiteness and its social wage found expression in violence.

At first, *Absolute Beginners* has none of this foreboding, depicting a fast-moving youth culture, where drug use and a range of sexual expression were common. It narrated the life of migrants, subcultures, media professionals and part-timers (a key source of revenue for many migrant writers), and the new "teenagers" in a postwar London, then as now clinging to delusions of imperial grandeur. The anonymous teenager who narrates was a photographer, Jewish by descent through his mother. He has Jewish friends, and observes that if the Jews were to leave London, so would he. His photographic work is commercial, mostly fashion and some TV, but backed up by a lucrative line in pornography. The photographer really wants to be an artist, like Mayne, Freud, or many other Notting Hill bohemians. His friends include Big Jill, a lesbian organizer of sex work; Mr. Cool, a "mixed-race" teenager; and Hoplite, a queer media

personality and party organizer. In short, this was not the standard character group of the 1950s' literary English novel. In search of becoming an artist, the narrator nonetheless poses young models in scenes said to be evocative of Englishness, such as on a rowing boat.

Born in London in 1914, MacInnes was raised in Australia. Far from being Jewish, he was related to such eminent Victorians as the writer Rudyard Kipling and painter Edward Burne-Jones on his mother's side. In 1959, he was forty-five, no teenager. MacInnes was one of the first of the Notting Hill queer community to be publicly "out" and published a book on bisexuality in 1973.[74] Not all of his work has stood the test of time. His unabashed excitement at Black bodies would have been somewhat progressive in the 1950s, but reads awkwardly at best now.[75] The first of the trilogy was titled *City of Spades*, using a then colloquial racist term for people of African descent.[76] That said, when de Freitas became Michael X and formed the Racial Adjustment Action Society, he noted that "Colin comes as near to being colour-less as anyone I know."[77]

Absolute Beginners is rightly remembered for its concluding depiction of the violence in Notting Hill. Suddenly an altogether different tone appears in the writing, which the narrator tries to explain, while still referring to Notting Hill as Napoli, for the active street life that Mayne had photographed: "Because there in Napoli you could feel a *hole:* as if some kind of life were draining out of it, leaving a sort of vacuum in the streets and terraces. And what made it somehow worse was that, as you looked around, you could see the people hadn't yet noticed the alteration, even though it was so startling to you."[78] Here, finally, was the "Jewish" counterpart to Lamming's way of seeing that had opened up in the ICA as a neighbor to Notting Hill. In Notting Hill, as MacInnes imagined it, the Jewish photographer seeing white violence directed at Caribbean residents can no longer sustain the illusion that Notting Hill enabled a "disjointed form of communal sociality."[79] The racist violence opened a hole in white reality. What happened to Black people in Notting Hill allowed the narrator to see how he was seen and feel the "alteration" that had always been there from their point of view. This tear in white reality was shocking and "startling," for white people at least.

Seen from the radical perspectives of the 1960s and 1970s, this rupture in whiteness would have seemed like a small harbinger of what

was to come. Then again, the resurgence of white racism from Margaret Thatcher to Brexit and its now-routine expression on social media suggests that the reaction, at first slow in the making, has been even more forceful. Seen from the 2020s, when the term "decolonizing" has again entered wide circulation, the way of seeing shows how decolonization's uneven temporalities unfold uncertainly. Trinidadian activist Claudia Jones, who had been deported from New York City for her radical politics, started the Notting Hill Carnival in 1959 in response to the racist violence. In 1976, Carnival became a major uprising against the police and white supremacy, and the memory of that led police to shut it down altogether in 2020.[80] In 1982, as Britain sent a neo-imperial fleet thousands of miles to the Falkland Islands in the South Atlantic, Hall would observe, "Empires come and go. But the imagery of the British Empire seems destined to go on forever. The imperial flag has been hauled down in a hundred different corners of the global. But it is still flying in the collective unconscious."[81] White sight is and was never simply about what is physically seen by one person. It is a collective psychic projection onto reality from the cultural unconscious. To see how this persistence sustains itself, it is necessary to look from both sides of the broken imperial screen in the moment of decolonizing.

6

THE CULTURAL UNCONSCIOUS AND THE DISPOSSESSED

George Lamming's way of seeing between groups placed at the margins of white seeing in the age of mass media had a general application in the decolonial contemporary. It went by way of the Caribbean, to Algeria during its decolonial revolution (1954–1962), the Black Panthers in the United States, and the Birmingham Center for Contemporary Cultural Studies under Stuart Hall's direction.[1] Such transnational networks of seeing should not be surprising. They were, after all, constitutive of modern art, to say nothing of imperialism. Global media made such networks material and instant, connecting the world's population in unprecedented ways. Old ideas were splintering under the new social conditions produced by the end of empire with uneven effects. Even as empire receded, ideas of racializing hierarchy surged. Tracing this line of thought makes visible the unexpected resurgence of whiteness in Euro-American politics since 1979.

With the formal decolonization of most of Europe's empires by 1975, for people identifying as white who had once called themselves working class first and foremost, it was being white that now mattered. Building on his insights from Frantz Fanon, Hall saw how the "great moving right show," which he called Thatcherism, drew its energy from this fragmentation of what had once been known as "the class."[2] For all of his pessimism of the intellect, even Hall could not then have foreseen how far right this move would go and how long. In the final section of the book, I'll consider

how it has created the general crisis of whiteness. First, we need to think about how it got started.

Let's begin with Lamming's meeting with decolonial thinker Fanon in 1956 at the International Congress of Black Writers and Artists in Paris, where Fanon also used the expression "way of seeing." Like Lamming's moment of clarity in the ICA, the intersection of Blacks and Jews was central to Fanon's understanding of visual encounter under colonial domination: "Anti-Jewish prejudice is no different from anti-Negro prejudice. A society has race prejudice or it has not."[3] Fanon grew up on Martinique, alongside an old Jewish community and soon found another in Algiers, where he worked as a psychiatrist. Following French-Jewish psychologist Henri Baruk, Fanon examined the cultural history of the scapegoat to analyze antisemitism. He understood both racism and antisemitism as forms of scapegoating. How could they be challenged? Rejecting Baruk's vague concept of the "moral conscience," Fanon framed seeing as a collective cultural process, drawing on shared knowledges. He came to realize that mass media culture was now the collective unconscious of racialization.

Who could change such global collective thinking? Fanon's radical answer was that it would be the global dispossessed, whom he saw as the most revolutionary sector of society. Here he overturned the Marxist applecart again because it was held to be only the industrial working class or proletariat that would create any revolution. In Algiers, there were hardly any such proletarians. Instead, the city's shantytowns were filled with marginal and dispossessed people, known to Marxists as the *lumpenproletariat*. These were people coming from rural areas to the city in search of work and ending up unemployed in its margins, often turning to what is now called the "black economy," or petty crime, to survive. Many experienced a profound alienation, diagnosed as mental illness. Fanon had treated them in his clinic before the Algerian Revolution. Looking at them again through the lens of revolution, Fanon realized that social transformation in the new global cities being formed as part of decolonization could only come from those with nothing to lose. In the 1970s, Fanon's lumpenproletariat theory of revolution electrified two different groups: the Black Panthers, who kept it short as lumpen, and Hall's Center for Contemporary Cultural Studies. Both saw the lumpen as a different road to revolutionary change. But a key section of the white working class

followed Margaret Thatcher's populism—a process that culminated with the 2016 transatlantic votes for Brexit and Donald Trump.

BLACK-JEWISH RELATION

Fanon was rarely discussed when I was a student in the 1980s, but has now become an indispensable reference for Rhodes Must Fall (RMF), Black Lives Matter, and scholars of race worldwide. In itself, this history tells a story about the folded nature of decolonial time. Less frequently discussed is what Fanon had to say about the encounter between Blacks and Jews. In his 1952 classic *Black Skin, White Masks*, Fanon worked with an implied theory of visual culture as the collective repository of racializing practices, in which he turned to the Black-Jewish interface time and again. Although the title suggests a simple face-off between people of European and African descent, the Jew—as Fanon put it—constantly appears to disrupt the binary and ask harder questions. Fanon had fought in the Second World War, so this is perhaps not so surprising. But the deeper connection came from the long history of Black-Jewish interaction on his native Martinique.

Jews arrived on Martinique around 1650 from Brazil, which they left to escape the Spanish Inquisition. By 1683, there were around a hundred Jews on the island, much to the distaste of the Jesuits, who denounced their houses as "places of debauch and scandal." The Jesuits demanded that they should wear "some visible exterior mark" to make it clear to all who was a Jew.[4] Jews were a key minority in the Caribbean, just as they would be in Algeria. Their history in the Caribbean was challenging. For example, in 1739, white Barbadians drove the Jews out of Bridgetown and burned down their synagogue after a quarrel over money led to a white person being struck by a Jew.[5] In 1767, Dutch planters forced Jews to live in a ghetto in Paramaribo, the capital of Surinam, accusing them of engineering a financial crisis.[6] Against mythologies of Jewish wealth, nearly all Jews in eighteenth-century Curaçao were poor.[7] And so on.

It was not surprising, then, that Jews sought other ways to defend themselves. A Jamaican Jew called Abraham Sanchez claimed the right to vote in 1750, but was denied by the returning officers and later the

Jamaica Assembly.[8] A section of Caribbean Jews lived outside the Jewish and colonial laws alike, marrying Christians, supporting African uprisings against slavery, or having African partners. In Surinam, a Jewish man lived with an African woman. Their children were brought up in the Dutch Reformed Church, but the eldest daughter married a Catholic. This new son-in-law already had a Greek Orthodox child, born in Russia.[9] In Barbados, a corner of the graveyard known as the Nook was set aside for those "infamous" Jews who were not supposed to be buried in Jewish cemeteries, such as actors, felons, prostitutes, bastards, pugilists, and suicides.[10] A late eighteenth-century rabbi asserted that many Caribbean Jews thought "nothing could be believed which was not seen and understood."[11]

One such was David de Isaac Cohen Nassy, a Jewish philosophe who lived in Surinam and published a two-volume history of the colony's Jews. Beyond local languages, he had studied Arabic, Chaldean, and Hebrew, and yet wrote a contemporary, "He employs himself, as the meanest of his countrymen, in buying and selling old cloaths. He has composed a Dictionary in the Indian Calibi [Carib] language."[12] Such people were known around the Atlantic world as *Smouse*, meaning old clothes or rags, which was perhaps the source of this assertion. Smouse would have resonated with Fanon, if he had known the word, since lumpen means "rags." If C. L. R. James was right that the first modern proletariat came into being in the plantations, that proletariat also had its accompanying lumpenproletariat, the dangerous class, as Friedrich Engels later called them. It was precisely this class that Fanon would come to see as the most revolutionary of all.

The Black-Jewish relation first arises in *Black Skin, White Masks* when Fanon recalls the parallel drawn between colonialism and fascism. This connection was broadly understood across the imperial world. In 1937, the Sierra Leone–born trade unionist I. T. A. Wallace-Johnson declared that Britain's imperial policies "turned the whole land into one large concentration camp." In the same year, Indian independence leader Jawaharlal Nehru asserted that the British official in India "wears a fascist uniform."[13] In 1938, Trinidadian Pan-African activist George Padmore described the repression of the Caribbean-wide uprising of the time as "Colonial Fascism."[14] For Jewish intellectual Simone Weil writing in 1943 amid the Second World War, "Hitlerism consists in the application by

Germany to the European continent . . . [of] colonial methods of conquest and domination."[15] When Aimé Césaire insisted in 1950 that Adolf Hitler "applied to Europe colonialist procedures which until then had been reserved for the Arabs of Algeria, the 'coolies' of India, and the 'n******' of Africa," he was voicing a decolonial consensus among African, Caribbean, and Jewish thinkers.[16] For Fanon to quote this passage from Césaire in *Black Skin, White Masks* was for him to affiliate with this transnational, anticolonial antifascism. Fanon would later record how this affiliation continued with Algerian Jews supporting the decolonial revolution, precisely because they remembered how colonizers had been ready to see "the total extermination of the Jews as a salutary step in the evolution of humanity."[17]

HUMANIZING

Fanon explored themes across his books, expecting the reader to follow along as he opened up points of tension. He acknowledged that it was the Jew who allowed him to humanize himself.[18] An Antillean (a person born in the French Caribbean colonies) was seen by a Jew and vice versa, forming a moment of mutual self-recognition. It broke the Black-white binary and allowed for a comparative way of seeing each other. As the book unfolds, Fanon thinks of two modes of being Jewish. The first was Jean-Paul Sartre's *salaud*—a person of bad faith—and the other was the Jew as *semblable*, or fellow. In Sartre's 1944 *Anti-Semite and Jew*, it was famously the antisemite who made the Jew.[19] In the postwar years, Sartre was the dominant figure in the French intellectual world and a key supporter of Fanon's. Nonetheless, Fanon believed that "man is propelled toward the world and his kind [semblable]" (24)—or in my literal translation, "To be human is movement toward the world and the semblable." To be static is (as we have seen) the form of racialization. Breaking through the imperial screen of "race" requires movement—a movement toward the semblable.

It was hard to define exactly who was a semblable and who was not. The semblable had been a crucial concept in French nineteenth-century writing. For Alexis de Tocqueville, the semblable was the fellow human of liberal constitutions. For poet Charles Baudelaire, famously, it was a form

of address at the conclusion of his poem "To the Reader": "—Hypocrite lecteur,—mon semblable,—mon frère!" (—you hypocrite reader—my fellow—my brother). The "fellow" here was less morally simple, as it would be even more when refracted across the color line. Fanon understood it in philosopher Karl Jaspers's terms as the "solidarity among men" that results from us being "co-responsible" (semblable) for each other (69n9).

Fanon detoured from this literary and philosophical heritage into the psychiatric definition of antisemitism, offered by Baruk, the head of the Charenton mental hospital in Paris. Himself Jewish, Baruk had worked under the occupation wearing a yellow star. He wrote at length after the war to try to make sense of the experience. In 1950, Baruk considered antisemitism to be part of what he called "moral and social psychiatry." In this field, a person may have their reason, but their "social adaptation is disturbed." Noting the difficulty of making such distinctions, Baruk insisted that a person must be understood in their "social and individual totality." As a result, there were also collective problems of character, among which he ranked antisemitism as a "psychosis of hate." Baruk gave examples from the occupation: a man believing himself to be the dictator of France broke into the room next door to his in a hotel, thinking its occupant to be a Jew, and attacked him; a patient in the Charenton was horrified to be in the charge of a "syndicalist staff" directed by a "Jew," while a Jewish patient saw Baruk's star and shouted disdainfully, "Well, I, sir, I am French."[20] Even the profoundly ill, barely able to speak, insisted on pointing out all the Jews.

Baruk surprisingly asserted that the wearing of the yellow star in some ways undid the repression usually associated with antisemitism, although he says nothing about the exterminations that followed. In a wide-ranging summary, Baruk then labeled the Jews as "a people placed in the *conditions of living death*." In ethnographic style, he argued that Jews were taken to be the "scapegoat . . . a victim to be sacrificed for the good of all."[21] The concept of the "scapegoat" was derived from anthropologist James Frazer's *Golden Bough*. Frazer described how in ancient Greece and Rome, an enslaved or poor person would be driven out of a town, supposedly taking all of their evil with them or ridding the city of a plague.[22] Behind these rituals, contended Baruk, was the structural principle that every fault must be paid for. Against this complex, Baruk claimed that the

"moral conscience" should be applied, following the principles of the Ten Commandments.[23]

From his reading of these ideas, Fanon drew several conclusions. First, he recognized that "the Jew, be he authentic or inauthentic, is labelled a *salaud*" (158). In other words, to be called a Jew by a Gentile was itself an act of bad faith, with no function other than to allow racialization. And as a result, he maintained that the Jew must be his semblable: "What others have said about the Jew applies perfectly to the Black man" (160)— just as his professor on Martinique had said. But what the professor did not say was that the scapegoat was the result of "transgression, guilt, denial of guilt, paranoia: we are back in homosexual territory" (160). The scapegoat must be expelled to ensure that the white man can deny being queer. That was not so simple because, as writers from Johann Winckelmann to Walter Pater and Oscar Wilde had made clear, the "white statue" form of whiteness was also an expression of queer desire. Today, any Black Lives Matter marcher will be abused in homophobic terms by white nationalists. Scapegoating remains all too visible. It is an expression of the cultural unconscious formed, on the one hand, by misogyny intersecting with the repression of queer affiliation and desire, and on the other, by racializing stereotypes.

It was painfully obvious that Baruk's concept of moral conscience had no possible use against racism, antisemitism, or any other mode of scapegoating in the era of the Holocaust and segregation. Fanon shared Baruk's concern that the social was not part of Sigmund Freud's analysis (at least in French circles at the time), rightly asserting that "the historical and economic realities must be taken into account" (139n25). In a fast-moving passage, Fanon adapted psychoanalyst Carl Jung's concept of the collective unconscious by transferring it to popular culture in all of its forms from the rumor to the cartoon and Hollywood films: "The Tarzan stories, the tales of young explorers, the adventures of Mickey Mouse, and all the illustrated comics aim at releasing a collective aggressiveness" (123–124). In short, there was and remains a cultural unconscious, formed out of mediated types and stereotypes, from the statue to the cartoon, which is where whiteness lives and persists.

In his documentary *Exterminate All the Brutes* (2021), filmmaker Raoul Peck put together a montage of related clips from the spectacular racism

of a film like *On the Town* (1949), which might have been on Fanon's mind, to 2016 film versions of Tarzan (*The Legend of Tarzan*, dir. David Yates) and repeated clips from cartoons. Watching it, I remembered seeing my daughter looking at a cartoon on TV around 2001 in which "primitive" Black characters placed a missionary in a pot to cook him. That is how the racializing cultural unconscious works. Its stereotypes are stored, forgotten but retrievable if and when the right prompt appears. How often has a white person suddenly uttered a racializing slur, apparently out of character, when under pressure?

While it might once have been thought that the days of comics were past, the Marvel and DC comics domination of the multiplex has become a given fact for a decade or more. The Marvel Cinematic Universe dominates the cultural unconscious today in the way that comics did in the 1950s and 1960s. When a collective of Black and minority British writers addressed its country's collapse as "empire's endgame" in 2021, it did so with reference to *Avengers: Endgame* (2019), not the Samuel Beckett play of the same name.[24] As Fanon had argued, these popular formats still structure the villain as Black or Indigenous so that the viewer desires to be white. Even radical playwright Bertolt Brecht admitted he wanted to be a cowboy when he watched Westerns. By the same token, Fanon said the young in the Caribbean identified with Tarzan—but not in Europe because the white audience there associated all Blacks with "the savages on screen" (131n15). To end scapegoating as a historical practice, it was and is necessary to change the collective cultural unconscious. That means not just changing the instantly recognizable figures of good and evil but also moving away from the simple alternative of good and evil altogether.

When Fanon came to work with radical François Tosquelles in his clinic at Saint-Alban in central France in 1953, he was at once absorbed into the institutional psychotherapy movement, whose goal was "to fight every day against that which can turn the collective whole towards a concentrationist or segregationist structure."[25] The experiences of living under occupation—fascist or colonial—led Tosquelles to espouse "decentralization, self-management and solidarity" within the clinic "to cure the institution." During the Spanish Revolution and Civil War (1936–1939), Tosquelles found a decolonial focus on the "disoccupation" of the mind.[26] For Tosquelles, the self was not singular but instead, as poet Walt

Whitman famously put it in his *Song of Myself* (1855), "I contain multitudes." For Tosquelles, "the personality doesn't consist of a bloc. If it did it would be a statue."[27] The white mind is that statue and vice versa. Outside its mask, and on the other side of its screen, it imagines the wild or "savage" world to be kept out.

This practical effort at what Fanon later called disalienation attracted a remarkable range of thinkers to Saint-Alban including Michel Foucault, Félix Guattari, and Georges Canguilhem as well as artists like Paul Éluard and Tristan Tzara. To be alienated is to be estranged or foreign. In French, it also means insane (*aliené*). Tosquelles imagined the institution as a place of exchange in which each person found their identity by means of "de-depersonalization." Fanon would have heard Césaire's "dehumanization" in that term and came to see institutional psychotherapy as a means to de-dehumanize those he would call "the wretched of the earth." As Camille Robcis puts it, Fanon understood from personal experience that "colonialism had a direct psychic effect."[28]

At the first International Congress of Black Writers and Artists, held in Paris in 1956, Fanon and Lamming argued for the way of seeing as a means of making decolonial change. For Lamming, as we have seen, "the image of the Other is always present in our conception of ourselves." This doubling was both specific and universal, such that the "Negro" was understood as exemplifying "that gap, that distance which may separate one man from another, and in the case of an acutely self-consciousness, may separate a man from himself."[29] That separation produced what Lamming later called the "limited sovereignty" that a person can obtain from the way of seeing.

For Fanon, speaking at the same event, this process was simply called "alienation," which Kenyan writer Ngũgĩ wa Thiong'o later identified as also being characteristic of Lamming's thought.[30] In a passionate address titled "Racism and Culture," Fanon emphasized the centrality of culture to antiracist work, describing how "the oppressor, through the inclusive and frightening character of his authority, manages to impose on the native a new *way of seeing* [*façon de voir*], and in particular a pejorative judgment with respect to his original forms of existing."[31] On Martinique, it was said of the *béké* (white man), "The blue of his eyes burned the eyes of the negro in slavetime."[32] Disalienation meant undoing that colonial way of seeing within the cultural unconscious.

The preferred avenue at the time was to change the politics of representation. The famous demonstration that year at *Brown v. Board of Education* (1956) by psychologists Kenneth Clark and Mamie Clark that Black children chose white dolls over Black was instrumental in the desegregation decision. But Fanon did not think the cultural form was so important. It was just the means to produce and release systemic aggression. His solution was far-reaching: create a new kind of human altogether. Fanon argued that racializing had already created varieties of an inauthentic human. The task now was to accomplish disalienation, not by somehow rendering racial types authentic, but by creating humans for whom those categories made no sense. That meant refusing to adhere to past ways of acting, even as memory. The first step was to show solidarity with the semblable. This work required directing all attention to the present and future.

Lamming later acknowledged meeting Fanon at the event and presumably he heard the address. Whether or not he adopted the expression "way of seeing" from Fanon, the two were thinking in related anticolonial and decolonial fashion. The colonial way of seeing its others as inferior had produced an antithetical way of seeing, which was not going to produce a neat synthesis. The goal was a different kind of culture altogether. Jamaican writer David Scott later identified Lamming as one of those that Guyanese poet and activist Martin Carter defined in a 1974 speech to the University of Guyana as "the riskers who go forward boldly to participate in the building of a free community of valid persons."[33] Carter's careful phrase tries to imagine people after racism. Ngũgĩ likewise acclaimed Lamming's work as creating "the aesthetic of resistance and human liberation."[34] It need hardly be added that Fanon was one of these persons as well. To bring these various phrases together, the Black-Jewish, anticolonial way of seeing aspires to, and prefigures, the aesthetic of resistance and human liberation for a free community of fully human persons.

THE LUMPEN REVOLUTION

Fanon imagined the way to create a new, fully human human being from his experiences in Algeria as a psychiatrist and revolutionary. Taking a position in Algeria in 1954, Fanon found himself working in a large

psychiatric hospital at Blida-Joinville. The hospital, like all colonial facilities, was segregated. More pertinent, the Algerian "school" of psychiatry founded by Antoine Porot held that the North African was a primitive, with a less developed brain and tendencies to criminal activity. Porot did not envisage this as a temporary stage but rather as "a social condition that has reached the end of its evolution."[35] While the vocabulary was a little different, the racializing hierarchy was exactly that proposed by Julien-Joseph Virey in 1801, and disseminated in the United States by Josiah Nott and George Gliddon (see chapter 2). Yet Fanon was contesting it in the era of space exploration.

The end of the French occupation of Algeria did not bring an end to this long reign of prejudice. South African psychiatrist J. C. Carothers attempted to explain the Mau Mau revolt in Kenya by claiming the African mind was at the level of a European child.[36] Fanon's work reminds us how biased science lives on in everyday life long after it has been discredited. You don't have to spend long on a New York City street to hear someone described as a "moron," a term of quasi-scientific origin in early twentieth-century eugenics and psychology. Tens of thousands of would-be immigrants to the United States were rejected as "morons."

Considering such legacies, Fanon envisaged a new form of humanity altogether emerging out of the decolonial movement. His inspiration came from his clinical practice in Algiers, and that in turn brought about new insights into the practices of whiteness. He opened the space following Tosquelles's principles, bringing films, newspapers, and collective meetings into everyday use. While the European women on Fanon's ward responded positively to the theatrical evenings and readings, it made no difference for the Muslim men. Fanon came to understand "a revolutionary attitude was essential, because it was necessary to go from a position in which the supremacy of Western culture was self-evident, to one of cultural relativism."

At the same time, the experience of these men was itself new. Driven off the land by the adoption of modern farm machinery, they came in search of work to the city. There were few factories in Algiers, so it was not possible to find a trade or specialization. Fifty-eight of the 220 Muslim men on Fanon's ward came from this new sector, living in shantytowns and uniformly illiterate. They had no response to the social therapy, so

the staff continued to tie up "agitated" patients using belts and other restraints. Thinking collectively, Fanon saw how this unstable element was nonetheless "breaking the domestic, economic and political frameworks" of the country.[37] This statement was published in October 1954, just days before the revolution he had foreseen broke out.

Writing after the victory of the Algerian Revolution in *Wretched of the Earth* (1961), Fanon produced an unexpected and dynamic theory of global social change from his clinical and political experience. Fanon turned to those whom traditional Marxism wrote off as the lumpenproletariat as the last best chance for transformative change. Karl Marx himself had dismissed the marginal poor as "specters," invisible to and outside of politics. The wretched and criminal were known only to the punitive aspects of the state, like the judge, bailiff, or doctor.[38] Fanon recalled the shantytown residents that he had treated precisely in one of those punitive institutions and drew a dramatically different conclusion: "The lumpenproletariat, this cohort of starving men, divorced from tribe and clan, constitutes one of the most spontaneously and radically revolutionary forces of a colonized people."[39] Think here of the character Ali La Pointe in Gillo Pontecorvo's *Battle of Algiers* (1966), a film made in the same locations that the events it depicted took place. A street hustler turned revolutionary, this character represented resistance leader Amar Ali, who had let himself be killed rather than surrender. Played by another lumpen, Brahim Hadjadj, Ali's confrontational analysis was proved right by the end of the film as the success of the general strike during the Battle of Algiers won no meaningful international support and allows the French Army to obliterate the organization.[40]

Fanon thought of this revolutionary force as one made on the margins of urban spaces, not found:

The lumpenproletariat. Once it is constituted, brings all its force to endanger the "security" of the town, and is the sign of the irrevocable decay, the gangrene ever-present at the heart of colonial domination. So the pimps, the hooligans, the unemployed, and the petty criminals throw themselves into the struggle. . . . The prostitutes too, and the maids who are paid two pounds a month, all who turn in circles between suicide and madness, will recover their balance, once more go forward, and march proudly in the great procession of the awakened nation.[41]

Fanon's experience in the clinic and as a revolutionary combined to create this picture of a newly disalienated class, awakening transformed, no longer threatened with insanity and no longer on the margins of society. Cultural critic Ranjana Khanna understands the appearance of this lumpenproletariat to create "the political as a zone of indeterminacy . . . [for] those who fail to fit the category of the political subject."[42] This was a new unfixed space, a space in revolt, a space invisible to white sight, in which those excluded from being fully human—the people without title, those who have no part—can finally appear, see, and be seen as people.

For Khanna, the lumpen are "perhaps the nongovernable."[43] That does not mean they are out of control. Rather it means they are not willing to give up control over themselves to others.[44] These groups have had many names: fugitives, Maroons, pirates, Communards, Zapatistas, Indignados, and so on. Governments detest them for obvious reasons. In the present era, the form of control that is among the most resented is surveillance, whether CCTV, face ID, swipe card entry, or keystroke monitoring at work. In his 1959 lectures at the University of Tunis, Fanon addressed this crisis of what he called "perpetual surveillance" as a new mode of alienation.[45] By extension, Fanon saw that those outside the zone of surveillance—at that time, predominantly the workplace and sites of consumption—were the future. Nongoverned, outside surveillance, they would form a new kind of human, no longer a type and no longer arranged in hierarchies. It was less a position in political economy than the insight of a political visionary. Fanon saw how life chances for the dispossessed veered between death, suicide, and madness, but that there was still an exit: revolutionary transformation. Unlike many versions of Marxism, Fanon did not pretend that this moment was inevitable, produced by unchanging laws of history. But his visionary moment resonated around the Atlantic.

THE LUMPENPROLETARIAT AND THE PUNITIVE STATE

In the United States, the Black Panthers were electrified. They shared Fanon's skepticism about technology, which they saw affecting Black

workers first. In the Detroit auto factories, there was already ample evidence of that, presaging the long shut down of the Black regions of the city.[46] Huey Newton foresaw an inevitable decline of the industrial working class in the face of automation.[47] What to do? For George Jackson in 1971, "There must be a collective redirection of the old guard—the factory and union agitator—with the campus activist who can counter the ill effects of fascism at its training site, and with the lumpenproletariat intellectuals, who possess revolutionary scientific-socialist attitudes to deal with the masses of street people already living outside the system."[48] The lumpen and nongovernable were already outside the system so they knew how to live otherwise. They needed to work with student organizers and organized labor in a new direction.

Eldridge Cleaver took the insight a step further:

We are Lumpen. . . . The Lumpenproletariat are all those who have no secure relationship or vested interest in the means of production and the institutions of capitalist society. That part . . . who have never worked and never will; who can't find a job, who are unskilled or unfit, who have been displaced by machines, automation, and cybernation. . . . Also the so-called "Criminal Element," those who live by their wits. . . . [T]hose who don't even want a job. . . . [I]n short all those who simply have been locked out of the economy and robbed of their rightful social heritage.

Cleaver used this insight to remap US society into what he called the "Mother Country," meaning white America, and "Black Country." Both countries had a traditional proletariat and the new lumpenproletariat.

For Cleaver, this new division also created a new politics. In both countries, the "working class is the right wing . . . and the lumpenproletariat is the left wing."[49] Union-supported labor was now an elite. Certainly, as is so often lamented today, union jobs for those predominantly white people lucky enough to get one supported a comfortable life in the 1970s before the oil crash recession of 1973. Automation and digitization created disposable, lumpen populations that have increasingly been confined in prisons.[50] The shift in class produced a change in the state. The imperial state that had organized punitive expeditions in its colonies

metamorphosed into the financialized, punitive state that has now become standard.

All of this resonated intensely in the United Kingdom. In *Policing the Crisis*, a long collective study of the formation of Thatcherism as a punitive state, Hall drew on both the Panthers and Fanon. He agreed with the Panthers' designation of inner cities as "resource-starved enclaves," making them into "internal colonies." Adopting Fanon's politics, argued Hall, the Panthers came to understand self-organization as key to creating the possibility of revolutionary transformation. Drawing on the work of British sociologist Peter Worsley, who had met Fanon in 1960 in Accra, Ghana, Hall endorsed the new understanding of the lumpenproletariat as the agent of change. Like Fanon and the Panthers, Hall charged that traditional Left class analysis had failed to account for the transnational politics of control and expulsion, which deliberately produced what Marx had called "pauperism." Working through this shift, Hall realized that "race" is how "the class-structured mode of capitalist production 'appears' . . . in the 'theatre of politics.'"[51] This sentence places the visual politics of the present as a drama of appearance within and without the space of politics claimed by whiteness. Hall continued to reflect on the question of the lumpenproletariat in relation to race until the end of his life. It appears in one of his last essays on artist Isaac Julien, whose work recurs across this book.[52]

Writing in the late 1970s, Hall could already see that both the Algerian Revolution and Black Panthers had not produced the anticipated transformation. Soon after independence, the Algerian Army took control. The once-liberating Front de Libération Nationale became a corrupt bureaucracy. The Panthers had been met with state violence on a spectacular scale. Despite Angela Davis's famous court victory in 1972, Jackson and Newton had been murdered, and Cleaver was in exile in Algeria. Hall could see coming to pass Worsley's 1972 prediction that the splintering of the working class might produce "shock troops of Right-wing populism."[53] These troops were rallied in Britain as a collective resistance to a purported crime wave, allegedly carried out by Black youth against white people. In this formation, the Black "mugger"—a word that crossed the Atlantic from the United States to the United Kingdom—

became the scapegoat identified by Fanon via Baruk. In Britain, the term "folk devil" was preferred by the sociologists, defined as "visible reminders of what we should not be."[54] These reminders were obtained without fail from the mass media, particularly Britain's lurid tabloid newspapers.

Against the folk devils or scapegoats, a "moral panic" was directed, comprising a collective media-generated anxiety that this form of crime was undermining traditional, meaning white, morality. Sociologist Stanley Cohen, who coined the term, later suggested that it had come to him by reading Marshall McLuhan's *Understanding Media* (1964).[55] Here, then, was a powerful, mutually reinforcing network of race, class, and media. The division of working people into fractions differentiated by status (proletarian or lumpen) and race (usually collapsed into a binary of Black and white) was exacerbated and justified by the moral panic over crime.

The decolonial revolution of the lumpen that Fanon had observed and the Panthers had tried to create instead became grounds for further racializing. To be against crime was to be for Britain and against Black people. The desired change for these white shock troops was an end to immigration and the expulsion of those already arrived. In 1978, Conservative leader Thatcher had shared with a TV interviewer her belief that "people are really rather afraid that this country might be rather swamped by people with a different culture," referring specifically to people from the Commonwealth (the former British colonies). Welcomed by Enoch Powell, these remarks produced an immediate dramatic swing in the opinion polls to the Conservatives, leading to their election victory in 1979 and an eighteen-year term in office.[56] Brexit and the politics of white resentment have been equally successful in generating a continuing twelve-year government since 2010.

The question for those of us looking back at such defeats snatched from the jaws of victory is, What time is it in relation to these events? The decolonial movement has spurred a sequel in the decolonial "war against statues" that spread from South Africa's RMF movement in 2015 to the United States in 2017, and across the former colonizing world in 2020 after the George Floyd Uprising. Was that a continued reckoning with infrastructures of racializing white space? Or the end of a long historic

moment? By the same token, it is not difficult to see Worsley's "shock troops" as the far right populism associated with Trump, epitomized by the Capitol insurgency of 2021. While the coup was frustrated in terms of the presidency, its media dominance has pushed the far right to still further aggression, as Fanon might have diagnosed it. While this book has all been about the contemporary, its final part will, then, need to pay close attention to the unfolding of the new conjuncture.

III

THE CRISIS OF WHITENESS

7

THE STRIKE AGAINST STATUES

The struggle of the dispossessed to unbuild whiteness has spread since Frantz Fanon's untimely death in 1962 from the global South to global North. In January 1960, the then British prime minister Harold MacMillan gave a speech in both independent Ghana and apartheid South Africa declaring "a wind of change is blowing through this continent."[1] It signaled that Britain would no longer attempt to prevent that change. State power changed hands from colonizer to formerly colonized, as did the means by which that power was symbolically stored, recognized, and distributed. From the north to the south of Africa over fifty years, there was a strike against the colonial world of statues, removing one statue at a time. It began on the shores of the Mediterranean in newly independent Algeria in 1962, reaching the southern tip of the continent at Cape Town in 2015.

The strike then reverberated back across the Atlantic, shaking statues across the Americas. Striking the monument means first removing its physical structures. Next the strike must disrupt and unbuild the infrastructure of white reality and patriarchy, of which the statues are a central part. And it must refuse racialized "common sense" about what is contemporary and what counts as history. The strike knows that all such monuments must fall so that there can be another way to constitute symbolic power, not as colonial and patriarchal domination, but so as "to become visionaries and to imagine the practices of freedom."[2]

Long-established circuits of circulation, first formed amid the brutality of slavery, have become visible and active in the continuing strike against statues. This movement makes visible all the politics of gender, memory, and time contained in the monument. It refuses to allow real or symbolic violence to be transformed into value. To take a well-known example, when activists in Bristol threw the statue of slaver Edward Colston into the sea in June 2020, their gesture refused all value to the carving. Far from erasing history, it reasserted poet Derek Walcott's maxim, "the sea is history." To jettison means to throw something from a ship. There is a terrible history of slavers throwing Africans, alive and dead, into the sea, whether to claim insurance or repress an insurrection. And that history met a certain response in summer 2020 as others from Baltimore to New Orleans threw other statues into the abyss where so many thousands had gone, including Christopher Columbus, the symbol of settler slavery. In 2021, Nuu Chah Nulth young people and their allies jettisoned Captain Cook, British colonist, into the waters off Victoria Island, British Colombia. In January 2022, a Bristol jury acquitted four of those who admitted to having overturned the Colston statue on all charges. They preferred not to convict and accepted the defense that the racist statue did harm. This strike against violence and for history has found a way to unbuild whiteness.

DECOLONIAL STRIKE: FROM ALGERIA TO ANGOLA (1962–2013)

This strike against whiteness began on the first day after the formal end of French colonial rule in Algeria in 1962. Colonial statues started to be removed in what became known as the "war of statues," both by the victorious Front de Libération Nationale and retreating French forces. After a protracted and vicious eight-year war (1954–1962), Algeria had achieved independence in a struggle watched around the world. It was immediately apparent to forces on both sides that a war of memory had just begun that is still being waged today. In the main square of Algiers stood the 1845 equestrian statue of the Duc d'Orléans, who had led the colonial war of conquest in 1830. The monument was made from captured Algerian cannons by sculptor Carlo Marochetti.[3] In July 1962, the statue

was accessorized with an Algerian flag and tagged with graffiti. It was the "most powerful symbol of French rule in Algiers," and France did not want to see it overturned in a symbolic moment. French engineers rushed to remove it, together with other French statues on July 4, 1962, just days after the Algerians had approved the peace agreement in a referendum. It now stands once again de-noticed in a suburban park outside Paris. Other statues were treated as the French had feared, like that of former prime minister René Viviani, torn from its pedestal and decapitated, with the head then posted outside Air France offices as a warning. The Algerian War continues to be a touchstone across French politics. In Algiers itself, the city has not replaced most of the statues but instead has cultivated decolonial memory by renaming over three hundred streets after fallen combatants in the long war of liberation.[4]

The removal of colonial statues was a revolutionary and liberatory action in the African independence struggle. When the Belgian Congo, turned Republic of Congo, became Zaire (now the Democratic Republic of Congo) in 1971, incoming leader Mobutu Sese Sokou launched an "authenticity" campaign. It included cutting down a statue of explorer Henry Morton Stanley in the capital Kinshasa, where it still lies in the grass. Mobutu created a national museum, now "silent and deserted," in its place.[5] The war of statues soon spread to Angola and its fellow Portuguese colony of Mozambique, which both achieved independence from Portugal in 1974 after almost four hundred years of colonization and a long, brutal war of decolonization. From the late nineteenth century on, monuments had been placed as anchors of Portuguese settler colonial reality. Accordingly, in revolutionary Mozambique, a statue of Portuguese dictator Antonio de Oliveira Salazar (1933–1968) was turned to face the wall as a form of shaming in 1975, while many others were destroyed.[6] The immense equestrian statue of General Mouzinho de Albuquerque (1855–1902), who brutally repressed an Indigenous uprising in 1894–1895, was unceremoniously torn down at night and removed in pieces. Victorious Frelimo forces made sure to film the event so that the colonizer's fall was archived.[7]

In Angola, even as the war was still being fought, liberators removed statues of the colonizers around the capital, Luanda. Monuments installed by Salazar were taken to the Museum of the Armed Forces, where

Statue of the Duc d'Orléans, anonymous
photographer, Algiers (July 2, 1962).
Getty Images.

they are still displayed. This left behind a series of empty pedestals. Art historian Nadine Siegert describes how "the most radical toppling took place on Kinaxixi Square, then called Largo Maria da Fonte, when the Victory monument by Portuguese artist Henrique Moreira dating from 1937 was dynamited in 1974 and replaced by a Soviet tanker."[8] This tanker had carried Angola's first president, Agostinho Neto, into the city. It was later replaced by a statue of Queen Njinga (1582–1663), who had resisted colonialism. That statue was itself later displaced to make way for a shopping mall.

Luanda was once a small coastal settlement that became Angola's capital in 1575 and is now a fragmented city of eighteen million people, intensely divided by wealth and access to infrastructure. The elites are supported by oil-derived wealth, while 80 percent of Luanda's people live in informal housing known as *musseques*.[9] Studying the new urban formation, sociologists Susan Parnell and Jennifer Robinson noted that "the creation of a whole new gated city outside of Luanda, Angola, which concentrates services for the wealthy few and excludes the poor majority . . . may reflect the new urban form of an absent and utterly incapacitated state."[10] This form is as visible in former colonial capitals like Lisbon as it is in the former colonies. Before the pandemic, Luanda was the most expensive city in the world for non-Indigenous people to live in.[11] In this way, the independent state was able to contain and dispel the threat posed by the dispossessed.

Under these divided and contested circumstances, Angolan artist Kiluanji Kia Henda returned to the pedestals of the fallen statues in 2011, ten years after the end of the long civil war. Familiar with the removed statues, Kia Henda decided to create a series of photographs titled *Redefining the Power*, depicting his "cultural heroes" on top of their vacated pedestals. As he put it in an interview, "The emptiness of those pedestals was also a metaphor of the absence of a reflection about the history and the society we were living in during the turbulent years of the civil war."[12] In the third of the series, *Redefining the Power III (with Miguel Prince)*, Kia Henda created a triptych that epitomized the decolonial dynamic. On the left was a colonial postcard depicting the monument to Pedro Alexandrino, a nineteenth-century governor of Luanda. The monument dominates what can be seen of the low-rise colony around it, with a single gaslight

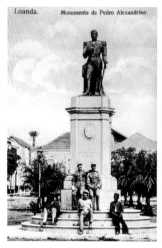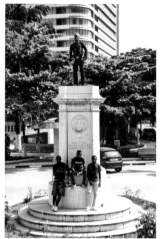

adjacent as a visible sign of the so-called civilizing process. At the base of the statue, three colonial soldiers pose, smiling for the camera and exuding confidence. Two Africans sit quietly to either side of the main group, as if to provide visible evidence of racial hierarchy and colonial domination. These postcards and stereographic views circulated around the world, depicting and sustaining the colonial imaginary.

The center of Kia Henda's triptych shows the pedestal in 2011 with the statue removed as it had been since 1975. Weeds can be seen growing out of the pavement. The saplings visible in the colonial postcard are now full-grown trees. Notably, the monument is no longer the high point of the urban space, seeming tiny by comparison with the steel-and-glass skyscraper behind it that could come from any global city. In the final photo, Miguel Prince stands on the monument in a pose that echoes the formal

Kiluanji Kia Henda, *Redefining the Power III (with Miguel Prince)*, 2011. Triptych, photographic print mounted on aluminium, 120 × 80 cm. Photo supplied by Goodman Gallery.

statue. Rather than a sword or other emblem of conquest, he holds a hieroglyph created by the musician Prince to set off his stylish yet military-themed outfit. Below, three young Angolan men replace the soldiers in the colonial scene, dressed in the uniform of global youths—T-shirts, ripped jeans, and sneakers.

This sequence transforms the power of the title, meaning oppression, into what Argentinean activist-scholar Verónica Gago calls *potencia*, meaning capacity, or "the desire to change everything."[13] Looking at the empty pedestal is to be reminded of Fanon's dictum that decolonization requires a tabula rasa. Colonists believed themselves to exemplify Thomas Carlyle's "great man," the agent of history, surrounded by others who could not even be aware of that history. Siegert notes that the photograph is "part of the series *Homem Novo* (New Man), which is a reference to the Angolan national anthem."[14] Created during the decolonial and socialist period, it also references Fanon's concept of the new human. For there to be a new human would require a new form of history, even as the supposed history of great men is extolled every day in endless biographies. In 2007, then president Nicolas Sarkozy of France went to Senegal, and in a speech intended to be part of a reconciliation, told students that "the tragedy of Africa is that the African has not fully entered into history."[15] Alexandrino's statue had materialized that worldview, as part of Fanon's "world of statues." But as Fanon knew, "the colonized always dream of taking the colonist's place."[16] In the third photo, that is exactly what has happened. Now Prince stands where Alexandrino once did, queering colonial power and releasing their own *potencia*.

The dreamlike effect in the photo evokes the continuing displacement by which the cultural unconscious might be changed. The multiframe format depicts change over time, but also evokes the gaps in between each image and the future that is yet to come. These temporal gaps make visible "an aperture, an opening, a possibility" in settler colonial reality through which a different future may be accessed.[17] To use Fanon's terms, the performance was rendered aesthetic, as something other than the established order. Queer and trans bodies claimed a redefined constituent power (*potencia*) to imagine the global. While the skyscraper makes it clear that the global city world continues to constrain and compartmentalize life for the majority, the triptych suggests that maybe the queer

African can de-dehumanize the world (see chapter 6). The three young Africans sitting below could be the foot soldiers of that transformation, just as the Portuguese soldiers in the first panel were for imperialism.[18]

RHODES MUST FALL

It was the 2015 Rhodes Must Fall (RMF) movement in neighboring South Africa that set in motion a possible undoing of white reality. The name of former imperial governor Cecil John Rhodes resonates in his native Britain and the United States alike, so when this statue fell, it was felt around the Atlantic world. It was, as activist Sandile Ndelu put it, a moment "worth rioting and writing at once. When it is documented through images, it speaks in the way that writing would speak, but is also incredibly disruptive in the same way that a protest would be disruptive."[19] Once Rhodes fell, the intense energies of the white cultural unconscious that it condensed and contained became visible from gender hierarchy to infrastructure, colonial history and colonized time. RMF opened up what the South African student activist journal *Publica[c]tion* called in 2016 "a decolonial moment," in which "fallism" resonated as the disruptive alternative to colonial aesthetics.[20] It continues to drive movements around the world, making it worth studying in some detail.

The African National Congress had come to power peacefully in 1994, an achievement for which Nelson Mandela and his peers have been rightly celebrated. One consequence, however, was that the "world of statues" built by colonialism remained in place. In her 2014 *Memoirs of a Born Free* (meaning the generation born after the fall of legalized apartheid in South Africa), activist Malaika Wa Azania (a nom de guerre) did not feel that anything had changed: "The South Africa we see today is but a different version of yesterday's South Africa. It is a South Africa where racialism and racism are no longer imposed through violence . . . [they] are now institutionalized." Raised in the Meadowlands informal housing west of Johannesburg, Malaika decided to attend Stellenbosch University, formerly a hub of white supremacist thinking, to study nuclear physics. Arriving on campus in January 2010, Malaika encountered an Afrikaner-dominated locale for the first time: "I first felt the magnitude of the contempt that

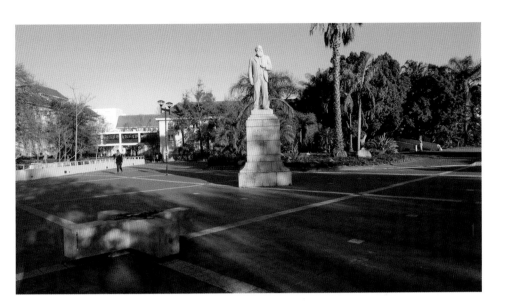

Afrikaners have for us, a contempt that can be expressed in as minute a gesture as a glance."[21] The instant of racializing visual encounter made it clear that she did not "belong," twenty years after the fall of apartheid, and Malaika dropped out. The Stellenbosch campus continues to exude colonial domination, and a statue of its founder, Jan Marais, a mining magnate, dominates its central square.

In 2015, University of Cape Town (UCT) students took action against the Rhodes statue, engendering a global pushback against the stone colonialists. RMF was the intersection of protests against the continuing dispossession of the majority since the fall of apartheid and the decolonial war on statues. For Black South Africans, the protests "fall within the context of hundreds, if not thousands of service delivery strikes, miners' protests and countless corruption scandals."[22] Service delivery refers to protests concerning the supply of services like electricity, sewage, and water to the

Statue of Jan Marais, Stellenbosch University, South Africa. Photo by the author.

townships and urban areas in which the Black majority mostly live. Often inadequate or nonexistent, the lack of services symbolized to the "born-free" generation the lack of meaningful change since the fall of apartheid. In the academic literature on RMF, however, these issues rarely appear.[23] Thinking of the student protest only in terms of art history, activist art, or memory studies understates its crucial intersection with infrastructure and service delivery.[24] RMF connected local service delivery protests to the continuing war on statues and broader struggle for decolonization.

For the born frees, the statue epitomized the failures of the postapartheid state. Why, they asked, was the statue of a person who believed that "the native is to be treated as a child and denied the franchise" still standing in a dominant position on UCT's beautiful campus?[25] Noting Rhodes's deep racism, renowned academic Achille Mbembe suggested in 2016,

The debate therefore should have never been about whether or not it should be brought down. All along, the debate should have been about why did it take so long to do so. To bring Rhodes' statue down is far from erasing history. . . . Bringing Rhodes' statue down is one of the many legitimate ways in which we can, today in South Africa, demythologize that history and put it to rest.[26]

The first protest against the Rhodes statue was carefully organized by a group of students and carried out by Chumani Maxwele on March 9, 2015.[27] Planning began after the statue issue was dismissed by Vice-Chancellor Max Price at a public meeting in October 2014. The date was strategically chosen because it was the opening day of a performance festival called Infecting the City—a title that is not likely to be reused—so that the action could be (mis)understood as performance art. The action decided on was to throw human waste at the statue, following long-standing protests by Black South Africans living in the townships without toilet facilities. Photographer Maxisole Feni, who lives in the Mfuleni settlement near Khayelitsha, had photographed activists throwing their waste at Western Cape premier Helen Zille's vehicle in a 2014 protest, so the tactic was in people's minds.[28] As Maxwele tells it,

[Wandile Kasibe] suggested that we use human excrement that runs exposed through Khayelitsha so that we could speak to the urgent need for human dignity

for the black people living in shacks in Khayelitsha in inhumane conditions and indignity. Kasibe said that, by throwing poo at the statue of Rhodes, we would symbolise the filthy way in which Rhodes mistreated our people in the past. Equally, we would show disgust at the manner in which UCT, as a leading South African institution of learning, celebrates the genocidal Rhodes. In short, the poo would be an institutional appraisal of UCT.[29]

Throwing human waste, brought from Khayelitsha where Maxwele lived, at the statue was a bringing of the world of the dispossessed into and onto the world of statues. It was intensely in the spirit of Fanon, as a strike into public space by the dispossessed (see chapter 6).

Khayelitsha means "new home" in isiXhosa. The township was a re-location point under apartheid for those who had been forcibly removed from their homes.[30] It has a fast-growing population of around one million, 99 percent Black South African, with many lacking in basic services. In suitably Manichaean fashion, a mass march in 2010 from the township of Gugulethu to Khayelitsha was called Welcome to Hell.[31] In Khayelitsha, 75 percent of the people share chemical toilets supplied by a private company.[32] "Portable toilet containers" were also supplied—a euphemism for a white plastic box into which people could relieve themselves—for those without access to even the portaloos. In a series of 2011 protests, these containers were thrown in the Cape Town airport, on the main N2 high-way, and on the steps of the provincial legislature.[33] Feni has documented the degrading labor involved in collecting, emptying, and cleaning these containers, inevitably performed by Black South Africans. The containers provided Maxwele with raw materials for his action.

Maxwele did his best to appear like a performance artist on the day. He was naked from the waist up, wearing only running shoes and tights, topped with a pink construction hat. He carried a whistle and drum, while sporting placards designed by artist Dathini Mzayiya reading "Exhibit White @ Arrogance U.C.T." and "Exhibit Black Assimilation @ UCT." As Maxwele recalled, "This had to be a true performance. . . . Campus se-curity arrived and asked what was happening. I told them it was perfor-mance art, and they let me continue." Whether or not he was pretending, it had become a performance. Throwing excrement broke the aesthetic of respect that sustained the world of statues. The sheer, unavoidable force

of the smell shattered any illusion that the statue had a good reason to be there. The performative action revealed the Rhodes statue as what it was: an integral part of the material operations of colonial infrastructure.

In retrospect, it was remarkable how quickly this performance led to the permanent removal of the statue. In October 2014, the idea of removing the statue had been dismissed. Even in March 2015, the UCT administration tried the time-honored delaying tactics of calling for debate and a referendum. The statue was removed a month later. No doubt the hope was to stop the strike at one monument and no more. But the throwing of human waste had rendered visible how unbuilding the infrastructures of white supremacy was the precursor to fair infrastructure provision for all, understood in the broadest sense. As the RMF Collective itself put it, "The removal of the statue will not be the end of this movement, but rather the beginning of the decolonisation of the university."[34] Whether that turns out to be the case is still open to question.

For the colonizer, the Rhodes statue had materialized, networked, and visualized domination and hierarchy. Even as it was being removed, new possibilities opened up. Black South African performance artist Sethembile Msezane, who grew up in Soweto, offered an embodied counterpoint. Throughout the four-hour removal process of the statue, she performed a countermonument in a costume of woven hair as the Great Bird of Zimbabwe, dressed in a leotard while standing on a plinth in six-inch heels. For Msezane, the task was not to fall so that Rhodes might fall. In the now-iconic photographs as the statue was lifted from its base, she was almost the only person visible not taking a photograph. Her performance evoked ancestral African accomplishment and raised questions about the visibility of gender, for as she said later, "The absence of my body as a black woman within public memorialised spaces muted my existence."[35] Note that she felt "muted," not made invisible. In colonial conditions, epidermal difference is always visible. Falling resonates with those who have always been there but muted. Rhodes's fall opened the way for further countermonuments, whether temporary like Msezane's performance or more permanent.

Not yet addressed was the infrastructure of informal housing that the first action had put into question. These issues remain acute. To stay with the issue of toilet facilities, even universities do not always have decent

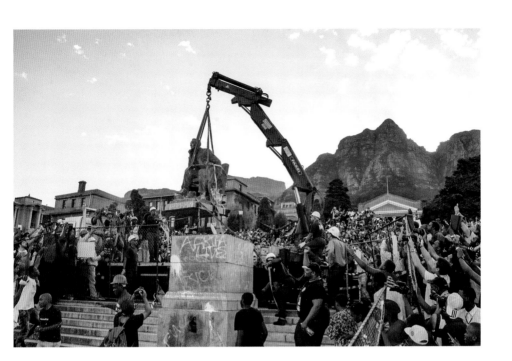

service. According to student activist Luvo Jaza, Walter Sisulu University, serving "the most economically underdeveloped communities," experienced "blockages and sewage leaks. Sewage water running between residences. The scent is unbearable." Photos graphically documented that excrement was not just a metaphoric problem for South African students.[36] Across the country, just a third of Black South African households had flush toilets, according to the 2016 census, but 42 percent of the toilets were in the yard rather than the house. White households had almost universal indoor flush toilets.[37]

Wandile Kasibe, Untitled (removal of the Rhodes statue), University of Cape Town, South Africa, 2015. Courtesy of Wandile Kasibe.

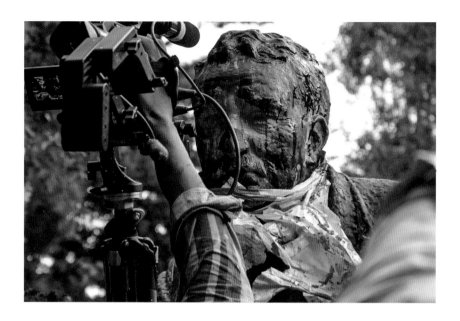

FEES MUST FALL

Poverty researcher Sarah Bracking, while noting the difficulty of obtaining accurate figures, has calculated that "it would cost R10.2 billion per annum to remove all South Africans from poverty"—a cost that she contrasts with the R250 billion Special Infrastructure Project, on the one hand, and R4 billion cost of not increasing university tuition in 2016, on the other.[38] Small wonder, then, that campaigns against statues perceived as symbols of such inequality continued after the removal of the Rhodes statue. The Economic Freedom Fighters, a breakaway radical grouping from the African National Congress, had called for a removal of colonial and apartheid monuments when it had taken parliamentary seats in 2014.

Wandile Kasibe, Untitled (the head of the removed Rhodes statue being filmed), University of Cape Town, South Africa, 2015. Courtesy of Wandile Kasibe.

After RMF, the group renewed that call, and took actions against statues of Boer hero Paul Kruger and a war memorial.[39]

The decolonizing campaigns in South Africa moved on from RMF to Fees Must Fall and then simply fallism. In 2016, student activist GamEdze declared that "the fight for free education fits into the larger struggle for structural change that includes basic human rights like land, healthcare, food, electricity, safety and sanitation."[40] Fallism sought to undo all the long legacies of colonial hierarchy. According to RMF activist Kealeboga Ramaru, "When we say 'Rhodes Must Fall' we mean that patriarchy must fall, that white supremacy must fall, that all systematic oppression based on any power relations of difference must be destroyed at all costs."[41] In the space opened up by the fall of the Rhodes statue, fallist counter-aesthetics cut into white reality, as the militant suffragettes had done a century earlier, by burning paintings, placing countermonuments in public space, challenging gender-based violence, and making the lack of infrastructure for human waste visible and smellable.

In the subsequent #FeesMustFall campaign in October 2015, provoked by the decision of the University of Witwatersrand to raise student tuition by 10 percent, the fragile consensus between students, academics, and administrators quickly collapsed. UCT and other South African universities remained largely white and overpriced. In 2013, only 3 percent of the UCT faculty were Black South Africans, although they were 79 percent of the population as a whole.[42] More than two-thirds of the students were also white. Median Black South African household income in 2015 was R2,900 per month, while 2019 student fees at UCT were around R60,000 a year for an undergraduate degree (the 2019 exchange rate was about R8 to the US dollar).[43] Only 53 percent of Black South African students graduated six years after beginning their degree.[44]

Students and administrators held totally different views of the situation. As universities sought to close budget shortfalls by tuition increases, students saw this move as hostile to Black students. In 2018, the *New South Africa Review* published an analysis by Stephanie Allais that rejected the student model of state-funded institutions for fear of "substantial weakening of our top institutions."[45] Notably absent from her discussion was student debt, even when highlighting the 50 percent dropout rate of South African students, driven primarily by financial hardship. Students

with "historic debt" are not allowed to register for classes in the South African system and are forced to drop out.

Student activists Kelly Gillespie and Leigh-Ann Naidoo saw the universities very differently: "The quality of teaching and infrastructure of institutions of higher learning is deteriorating because of long-term austerity. This has been accompanied by a submission to privatization and debt."[46] Central to #FeesMustFall was a campaign to end outsourcing at universities in order to generate better pay and conditions for the (almost entirely) Black staff. #FeesMustFall looked at the university from below, where concerns about student debt, staff conditions, student housing, and food were paramount. Looked at from "above," what mattered were global rankings and research outputs. The students won this round, and the fees were not increased.

SHACKVILLE

These approaches clashed in the Shackville controversy. On February 15, 2016, student activists created a countermonument titled Shackville on the UCT campus. A re-created "shack" made from wood and corrugated iron, complete with a portaloo, Shackville was a performative installation of township conditions and protest against inadequate housing for students, especially poor and Black students. The university could only offer sixty-six hundred beds to its twenty-seven thousand students, and a crisis of homeless students resulted. The shack was placed in the middle of a campus roadway in order to disrupt everyday circulation and call attention to the continued exclusion of the majority of students from their own universities.

Organizer Zola Shokane accounted for the action in terms of the townships: "The agenda is emancipation at all costs. . . . [T]he cure for cancer could be in the brain of a child in Khayelitsha."[47] In the activists' own words,

Shackville is a *representation* of Black dispossession, of those who have been removed from land and dignity by settler colonialism, forced to live in squalor. . . . It is necessary, therefore, to impose this *image* onto our campus where there is a

purposeful attempt by UCT to hide away from its complicity in the violence experienced by those in shacks and townships throughout the country.[48]

In this view, Shackville was a countermonument, a confrontational follow-up to RMF, continuing to collide the world of the townships with that of continued white privilege, but now with regard to the unequal present, not the colonial past.

The next day, February 16, 2016, Shackville activists went into a student dining hall to eat without paying. For many Black students, food services at historically white universities are too expensive so this was a step into the unfamiliar. Shackville activists saw colonial and apartheid

Ashraf Hendricks, photograph of the Shackville protest, 2015. Courtesy of Ashraf Hendricks.

era paintings hanging in the dining hall and elsewhere in the university buildings as an affront. They took them off the walls, piled them up outside, and set them on fire. Photographs from the scene show perhaps twenty paintings being burned. It was a direct challenge to the university, asking what mattered more, Black lives or art made under apartheid.

This opposition was widely refused. The action seemed to unite "South Africa in a sudden, bristling defense of oil paintings."[49] The university responded first by forcibly evicting the protesters using private security firms, and then suspending or expelling the activists, including Maxwele.[50] Whether sincerely or otherwise, particular attention was paid to the fact that two paintings by Keresemose Richard Baholo, a Black South African artist, were destroyed. But for RMF organizer Wanelise Albert, "It is curious to me that people are more concerned about the paintings of white racist serial killers than the lives of poor Black students."[51] For all the repetition of James Baldwin's phrase "the fire next time," when it actually came, the comparison was to the Nazis, not the civil rights movement. Yet for a student activist like Suren Pillay, "the fire this time . . . [is] where African is not the name for a black hole, where everything including time, futurity, possibility, achievement, seem to drain into a vortex."[52]

TRANS*

Just a few weeks later, on March 9, 2016, the questions of gender violence that were inherent to the colonialist monument became visible in the wake of Rhodes's fall. An exhibition of RMF photographs at UCT on the first anniversary of the movement was also the site of a performative intervention by a group called the Trans Collective. At first concerned that images of trans people were being used without their consent, the collective then discovered that only three of the one thousand photographs depicted trans individuals. In its account, published in *Publica[c]tion*, the collective recalled that "we replaced the images with placards that told a truer story of RMF. A story of trans erasure, trans antagonism, unabated sexual assault and complicity." Nonetheless, the collective stated "unequivocally" its continued commitment to RMF and decolonization as "the fallist space of our dreams."[53] Collective members blocked the way

into the show with their (naked) bodies so that in their own words, "Anyone who would enter through the blockaded doors to see the exhibition would be stepping over trans bodies and that they would have to reconcile themselves with the implication that they valued the content of the exhibition more than the trans bodies on the floor."[54] The counteraesthetic that motivated Shackville offered respect to people, not art exhibitions.

Inside, collective members wrote the word "Rapist" in red paint on a photograph of Maxwele throwing human waste as a means of "speaking back to RMF and keeping it accountable to its commitment to intersectionality precisely because it is positioned as a black decolonial space."[55] Maxwele had become a specific target after some intense controversies during the #FeesMustFall campaign.[56] The action was again not well received or understood. Photographs showed Paul Weinberg, the white curator of the exhibition, protesting with arms held wide in evident disbelief as a nude trans activist wrote on the photograph of Maxwele. Journalistic accounts described the Trans Collective as having "smeared" paint rather than writing on the glass.

TIME AND STRUGGLE

In the aftermath, the time of the settler colony became visibly out of joint. While the "world of statues" had ensured the successful repetition of plantation futures, after Rhodes fell many born-free student activists perceived a temporal disjuncture between themselves and older antiapartheid activists, known as the "struggle generation." Black and white, this group did not see 2015 as a time of revolution. RMF academic and activist Leigh-Ann Naidoo responded in her 2016 Ruth First Memorial Lecture that "in relation to the question of rage and violence—we are living in different times." She described the student movement as "time travelers," intent on abolishing "the fantasy of the rainbow, the nonracial." Naidoo's decolonial imaginary challenged some of the most cherished beliefs of the struggle generation—not to mention the US civil rights movement—that had brought about the end of apartheid. Rejecting the characterization of fallist movements as violent, Naidoo countered, "Many in the anti-apartheid generation have become anesthetized to the possibility of

another kind of society, another kind of future. . . . *The conduit for rage is awareness of another possible world in which that violence does not exist.*"[57] Fallist counteraesthetics sought to de-anesthetize the senses in order to reclaim the future from the plantation and end the repetition of violence.

CHARLOTTESVILLE

In 2015, the war on statues recrossed the Atlantic to the United States. South Africa was directly connected to the events in Charlottesville, Virginia, and the resurgent strike against Confederate and racist monuments. White supremacists in the United States have consistently followed events in South Africa via racist websites like Afriforum. On June 15, 2015, terrorist Dylann Roof murdered nine people in Charleston, South Carolina. He had posed in the uniform of apartheid Rhodesia and used the rhetoric of white replacement. Roof's murderous rampage enabled the de-invisibilizing of the nationwide network of Confederate flags and monuments. The sheer numbers are astonishing. In 2015, there were over thirteen thousand Civil War memorials, markers, and monuments, including seven hundred Confederate monuments on public land. These monuments could be found at Arlington National Cemetery and the US Capitol in Washington, DC, not to mention statues of Robert E. Lee at universities like City College of New York and Duke. In short, it was an extended infrastructure of white supremacy hiding in plain sight. This network was historically and culturally connected to South Africa, from the support given by Ronald Reagan and Margaret Thatcher to the apartheid regime to present-day white supremacy. RMF again broke that imperial screen, and let's hope for good.

In that charged moment, South African visual activist Zanele Muholi held a 2015 exhibition in Charlottesville in which their photographs were printed on banners and displayed outside. To quote their biographical statement online, "Responding to the continuing discrimination and violence faced by the LGBTI community, in 2006 Muholi embarked on an ongoing project, *Faces and Phases*, in which they depict black lesbian and transgender individuals."[58] Working together with the collective Inkanyiso, of which they were a cofounder, Muholi has documented and

mourned violence against these communities, while affirming that "all things are possible." For while the South African constitution guarantees all manner of rights, daily life in the townships is marked by homophobic and heteronormative violence. Muholi's success has taken them abroad on many occasions, and they have developed a practice of self-portraiture, with the pieces being named after their destination.

One such photograph is titled *Bona, Charlottesville, Virginia* (2015). In Zulu and Xhosa, bona means "they," the artist's preferred pronoun. It also means "see." The title might be translated as "they/see." As they often do, Muholi has rendered themselves darker in the portrait than they are so that the work is, in their words, "confronting the politics of race and pigment in the photographic archive."[59] For a US viewer, it evokes Zora Neale Hurston's saying, "I feel most colored when I am thrown against a sharp white background." The white linens and needlework that enclose the space are not neutral but infrastructures of settler colonialism, just yards from where Sally Hemmings, the enslaved woman who was a forced sexual partner to President Thomas Jefferson, once lived. Muholi holds up a mirror to themselves twice: once as the subject of the photograph, "they," and once as its photographer—in order to "see." What those who see the photograph see is not what they saw, in either role: double consciousness doubled.

On June 13, 2015, Muholi did a public event for their exhibit. Two weeks later, on the day their exhibit closed, activists tagged the statue of Confederate general Lee in Charlottesville with "Black Lives Matter" on June 30, 2015 (see chapter 2). Perhaps Muholi's public display of Black beauty and pride made the Lee statue all the more hateful, creating a chord with RMF. Up until that point, statues had not been a significant part of Black Lives Matter, so whatever the cause, the shift in Charlottesville was significant and ultimately momentous.[60] The 2015 action set in motion the strike against statues in North America and then across the world. It began when the young African American vice mayor of Charlottesville, Wes Bellamy, led a movement to remove the Lee statue in 2016. He then encountered a persistent campaign of harassment led by Justin Kessler, who later organized the Unite the Right rally there in 2017.

The Charlottesville equestrian monument to Lee was one of four racializing monuments put up by Confederate veterans in the 1920s. On

the day it was unveiled by Lee's great-granddaughter, Klansmen lined the streets and held a torchlight parade after dark. Klan posters in the city had claimed, "The eye of the unknown has been and is constantly observing. . . . We See All, We Hear All, We Know All."[61] Confederate monuments embodied that racializing surveillance for the next century. The Lee monument was designed by Henry Merwin Shrady and finished by Leo Lentelli. Shrady, a New Yorker, had designed the Washington, DC, memorial for Ulysses S. Grant. In the 1996 application to place the Lee statue on the National Register of Historic Places, no historical claim relating to the Civil War was made. Rather, the work was held to be an "important art object that exhibits the figurative style of outdoor sculpture produced by members of the National Sculpture Society."[62] Which is to say, it's not that important as a sculpture. Lee sits stolidly on his horse, hat in hand. The horse is clearly derived from Antonin Mercié's statue of Lee in Richmond (see chapter 2). The Charlottesville statue has no historical value relating to its subject because it was not made in the period when Lee was alive and the artists never met him. As a work of art, it was derivative and in poor condition. As a key node in the infrastructure of white reality, it remained active until its removal in 2021. It is now set to be melted down and made into a new artwork, despite the inevitable lawsuit.

The Charlottesville Lee statue was dedicated in the same year that Virginia passed a law for the "Preservation of Racial Integrity." This 1924 law defined "white" as a person with "no trace whatsoever of any blood other than Caucasian," with the supplementary exception of one-sixteenth Indian descent.[63] The legal definition of "white" that began in the eighteenth century had reached its most aggressive point, visualized by the Lee statue. It condensed into symbolic form the related arguments that whiteness contained the highest forms of nature, civilization, and art. It was this projection of "racial integrity," the Manichaean belief that one "race" contains all that is good, that continued to "unite the right" in 2017.

Zanele Muholi, *Bona, Charlottesville, Virginia*, 2015. Courtesy of the artist and Goodman Gallery.

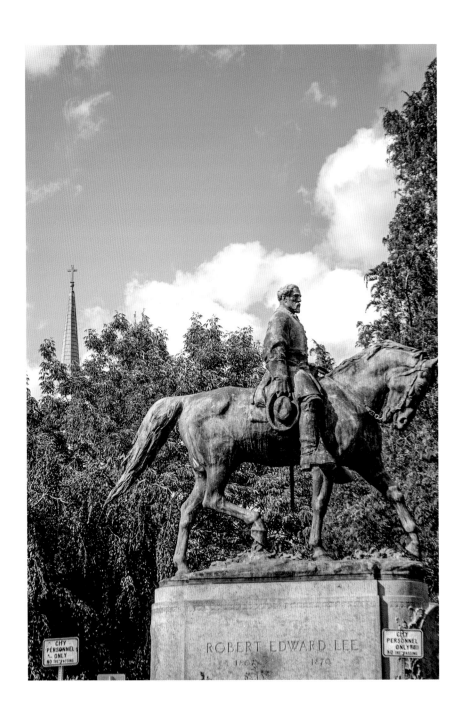

Lee Wilson, *Statue of Robert E. Lee,*
Charlottesville, VA, 2020. Courtesy of
the artist.

The statues were always watching, defending white supremacy. In a *Vice* documentary on Charlottesville, African American local activist Tanesha Hudson called attention to the "reality of Charlottesville [that] the master sitting on top of Monticello . . . looks down on us."[64] Hudson's lived experience described the fabric of white claim to reality, supported by the white sight embodied not only the Lee statue but also in the unavoidable legacy of slave owner and former president Jefferson. It was around the Jefferson statue at the University of Virginia that Unite the Right had held its torchlight rally, chanting Nazi slogans like "Blood and Soil" together with "You Will Not Replace Us." It will be around statues like Jefferson's that the next wave of unbuilding white sight will center. In October 2021, the New York City Council voted to remove a statue of Jefferson from its chambers.

The sense that the Confederate or other white supremacist statues seemed to watch Black people was a repeated theme in local reporting and social media accounts from 2016 to the George Floyd Uprising. African American civil rights activist Karl Adkins recalled desegregating restaurants in Chapel Hill in 1968 and then returning to the campus of the University of North Carolina to see the generic Confederate monument, known as Silent Sam: "And there he is looking over you. I remember him very well. I'm glad it's gone and I hope to never hear about it anywhere."[65] The monuments placed those designated "not white" on notice that white supremacy was always watching. For white-identified people, this infrastructural function remained invisible until it was directly challenged.

MONUMENTAL VIOLENCE

Confederate and other racist statues materialized the mystical power and violence of white sight, as part of segregated public space. But the monuments did not just imply violence. Nationally, there was a clear correlation between the number of lynchings and the creation of Confederate monuments. Both peaked in the decade after 1890, as Jim Crow became fully established in the South, with an upturn again in the 1920s with the revival of the Ku Klux Klan. The monuments did not cause lynchings or vice versa. Rather, they were interactive instruments of violence in the

infrastructure and practices of white supremacy. Often, as in the case of Emmett Till, white violence was motivated by the reported look of a Black person at a white woman, decoded as signifying sexual intent. The monuments acted as media infrastructure by conveying a message. White sight was both surrogated through the monument, and expressed as the power to remain visible (in the case of the monument) and unseeable (in that of white women). The metamorphosis of violence, embodied in the monument, sustained the wages of whiteness, "paid" as the right to commit violence with impunity.

Lynchings took place at the site of Confederate monuments, such as in Brooksville, Florida, and Hot Springs, Arkansas.[66] Caddo Parish, in Shreveport, Louisiana, was one of the largest sites of lynchings nationwide.[67] On November 30, 1903, Phil Davis, Walter Carter, and Clint Thomas had been lynched from the tree that is now adjacent to the Confederate monument, watched by a crowd of twelve hundred people. The men were accused of the murder of a businessman, and the case was reported by the *New York Times*.[68] In 1905, the United Daughters of the Confederacy put up the thirty-foot-high monument at the site, adjacent to the courthouse. At the time that the monument was dedicated, Caddo Parish was 62 percent Black, but had only two registered "colored" voters.[69]

It was not an isolated incident locally or nationally. Nearly five hundred African Americans were killed in Caddo Parish during Reconstruction.[70] The Caddo Parish monument is a typical mass-produced "Silent Sentinel" monument with a statue in front to represent Clio, the muse of history. The inscription reads "Lest We Forget." The charge of "erasing history" was, then, literally built into the Confederate monument. In 2017, Caddo Parish authorities voted to take down the monument, but it remained in place due to legal action by the United Daughters of the

Caddo Parish Confederate monument, Shreveport, Louisiana. Photo by Renelibrary via Wikimedia Commons. Creative Commons license CC BY-SA 4.0. https://commons .wikimedia.org/wiki/File:Caddo_Confederate _Monument_(1_of_1).jpg.

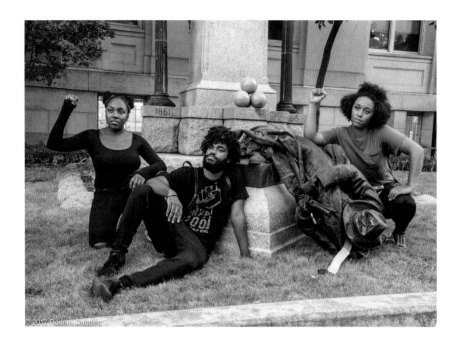

Confederacy.[71] When the Parish Commission threatened to cover it up, the United Daughters of the Confederacy finally agreed to move it to a Civil War battlefield site.[72] Although the monument remains listed on the National Register of Historic Places, a contract was finally signed for its removal in March 2022.[73]

Realizing that mere outrage was not enough against such infrastructure, activists from BYP100, the Workers World Party, and others took to the streets of Durham, North Carolina, on August 14, 2017, and pulled down a statue of Silent Sam. The statue brought down in Durham was dedicated in 1924, like the Lee statue in Charlottesville, at a time of "unprecedented growth" for the Ku Klux Klan in the state, sparking a second

Rodney Dunning, *Fallen Silent Sam*, Durham North Carolina, August 14, 2017. Creative Commons license CC BY-NC-ND 2.0. https://www.rodneydunning.com/#/workers-world-party-protest-durham-august-14-2017.

wave of such memorials between 1921 and 1941. The generic Durham statue was far more interesting fallen than it ever was on its pedestal. As so frequently happens, the fallist movement did not erase history but instead revealed it. If these statues are not "just" in defense of the Confederacy but in active support of the Klan, then even from the mainstream point of view that exalts "balance," there can be no case that they should continue to stand. It was not until the George Floyd Uprising of 2020 that it suddenly became obvious they should not.

In 2019, the city of Charlottesville sued to use the Fourteenth Amendment equal protection clause to justify removing its Confederate statues, including that of Lee. Giving judgment, Judge Richard E. Moore rejected the claim: "Though the statues may represent a history that many do not like, they do not speak of hatred, but people do." It was not difficult to recognize here the assertion of the National Rifle Association that guns don't kill, people do. Moore further granted a permanent injunction, preventing the removal, disturbance, violation, or encroachment of the statues. He argued that the statues provided "political voice" to those who would otherwise lack it, presumably referring to those who were waving Confederate flags outside.[74]

A few days later, the statues were again tagged with a graffito reading "1619," referencing the date on which enslaved Africans were first landed in Virginia, exactly four hundred years prior. The intent of the tag was to say that 1619 is now. It condensed an entire political theory that, to quote Paolo Virno speaking presciently in 2005, the present is a "new seventeenth century." By this parallel, Virno did not intend a simple repetition but instead "an epoch of terrible uprisings in which all the categories of public life are newly redefined."[75] Those would all become visible in 2020, resulting in the final removal of the Lee statue from Charlottesville in 2021.[76]

8

THE GENERAL CRISIS
OF WHITENESS

In 2020, everything happened at once. The COVID-19 pandemic un-
leashed the furious violence contained in the cultural unconscious of
whiteness. It made the visual politics and practices of white sight and
white reality starkly visible in the United States, expressed in a chaotic mix
of police, political, and viral immunities.[1] A general crisis of whiteness
has ensued whose outcomes remain in the making. One symptom of this
crisis was that majorities of white people were first for Black Lives Mat-
ter and then voted for Donald Trump. The strike against whiteness took
down statues as a means of culturally defunding white infrastructures,
accelerating and disseminating the decolonial strike against statues. As
unprecedented millions marched under the banners of Black Lives Mat-
ter, the police became the form of white identification, taking the place
of the statue and screen. The condensed slogan for this set of reversals
became "Back the Blue." The existing state, its statues and its statutes had
failed to defend whiteness, leading the supporters of white supremacy to
launch an ongoing insurrection on January 6, 2021. The power that this
insurrection constituted has since been mobilized against reproductive
rights, voting rights and the very notion of the right to autonomy.

By the same token, striking against whiteness is no longer a utopian
position. It is a conceivable future that would, finally, not be a plantation
future. The means of undoing whiteness are clearer now. It requires mov-
ing away from the heroic individual emblematized by the memorial statue

toward communities centered on protection. This movement combines repair, reparations, and restitution. It is both symbolic and material at once, an always changing social formation, which I will imagine here as a murmuration, the collective movement of birds.

Another possible outcome of the crisis is an intensified return to a plantation future, perhaps as a neo-Confederacy in the United States. In plantation futures, as Black studies scholar Rinaldo Walcott puts it, "the Americas institutionalize terror and death as a mode of being."[2] Nationally and internationally, the visual politics and practices of whiteness now frame whiteness as the fear of being "replaced." This whiteness also claims immunity, both biologically and politically. That is to say, white persons were imagined to be immune to COVID-19 and to have legal immunity for their actions, especially as police. Statue removal came to symbolize white replacement in the "white racial frame."[3] The intense dramas around masking and vaccination made visible the claim to biological immunity. The claim to political immunity was acted out all too visibly by former police officer Derek Chauvin as he murdered George Floyd in Minneapolis on May 25, 2020.

THE CRISIS OF WHITE REALITY

The symbolic order of white reality was directly challenged by the widespread strike against statues in 2020 and the simple claim that Black life mattered. If public space has long been white police space in the settler colony, the pandemic tested and made visible its boundaries. Patrick Henry, one of the so-called founding fathers whose "Liberty or Death" saying was everywhere in 2020, would have understood; boundaries and landmarks, he claimed, made settler colonies (see the introduction). The uprising following George Floyd's murder actively contested boundaries by marching across every city in the United States and declaring autonomous "police-free" zones. And it took down "landmarks" in the form of statues across the country.

Hitherto unsayable ideas like defunding the police were not only discussed but also in some places, briefly put into practice. More limited reforms, like bans on choke holds or access to police disciplinary records,

happened surprisingly quickly. By July 4, a variety of media estimates suggested that between fifteen and twenty-six million people, many of them white, had participated in Black Lives Matter marches. According to the *New York Times*, "nearly 95 percent of counties that had a protest [by July 3, 2020] are majority white, and nearly three-quarters of the counties are more than 75 percent white."[4] In June 2020, there were an average of 140 protests a day across the country. Since the Charleston massacre in 2015, 142 Confederate monuments and markers had been removed by 2020. In the five months following Floyd's murder, over 100 more were taken down, along with those representing Christopher Columbus, conquistadors, and other colonists. Statues were taken down across the Atlantic world, including the toppling of two statues of Victor Schoelcher, a French abolitionist, and Empress Josephine on Martinique on May 22, preceding Floyd's murder.

In 2020, it became apparent that maintaining white reality was the absolute priority for those identifying with white supremacy, above the survival of any individual in the pandemic or that of the republic as presently constituted. Sometimes keeping that power required Black and Brown labor to continue "essential" work; sometimes it demanded statues be defended; sometimes it deployed violence by police or the National Guard; and sometimes it demanded deference to its icons like the flag or national anthem. In each case, the opposite was said to be "anarchy," meaning the imagined alternative to white constituent power was "nasty, brutish, and short" existences in "savage" conditions, such as those of the preconquest Americas (see chapter 1).

People strongly identifying as white began to claim that whiteness conveyed immunity to the virus, using #naturalimmunity on signs and social media. There was a double meaning. If asked, antivaxxers would say they had acquired immunity by having COVID-19. But the implication was that being white made people immune. Before it described resistance to disease, immunity meant an exemption from service, obligation, or duty. States have absolute or sovereign immunity from prosecution.[5] The police have a similar qualified immunity, which is especially powerful when related to violence against Black, Indigenous, People of Color (BIPOC) people.[6] By emotional implication and the empirical observation of infection rates, as reported in the media, white people came to believe

they had immunity. What followed was the working out of these politics of immunity, or immunopolitics, as the result of the intense interaction of these different senses of immunity.

NEW YORK CITY: DYING OF GLOBALIZATION (MARCH 2020)

In this chapter, I write about this crisis from the places that I was in, using my perspectives, and my politics. I was in New York City and on Long Island, fifty miles apart yet culturally vastly distinct locations. The city marched for Black Lives Matter, while Long Island rallied for Trump. Going from one to the other felt like being in different countries. At first the city was ravaged by COVID-19, and then Long Island was hit hard. But while the city changed in response, the suburbs resisted all accommodations. Like everyone else, I was experiencing social life through social media, which allowed me to map those local responses onto a wider scale, using what media scholar Sean Cubitt calls "anecdotal evidence." These are necessary tactics to respond to the immensity of what Cubitt describes as the "mass image" created by digital networks.[7] This chapter is my report on that experience, as seen on the digital devices that are the splintered screens of imperial globalization.

On March 30, 2020, there had been 1,218 deaths from COVID-19 in New York State, 253 of which came on the previous day. Almost 200 of those deaths were in New York City. The shock of these numbers finally made it emotionally real to me: the predicted catastrophe was now underway. These numbers seemed almost trivial only a year later, by which time there had been 795,000 cases in New York City alone, where over 34,000 people had died. By Halloween 2021, 1,300 or more people were still dying every day nationwide, all but ignored until the Omicron variant dramatically transformed the politics of immunity.

It was endlessly said that the virus was invisible, even as its magnified image was equally endlessly circulated. The intrusion of sudden death in New York City created a new relation to visibility and invisibility. Empty city streets were described as eerie or spooky. They resembled an updated version of the *Ideal City* paintings with which I began this book. The anxiety was not whether the city would survive but rather who would still

be there to see it. There were a series of visual shocks, from the Federal Emergency Management Agency's refrigerated trucks for bodies, to universities being converted into emergency hospitals, and the navy hospital ship *Comfort* moored in the Hudson River, intended to take the overflow of non-COVID-19 patients. As they have long done, prisoners dug graves for those who could not afford a funeral on Hart Island off the Bronx on the Long Island Sound, but now wearing personal protective equipment and getting $6 an hour rather than the usual pennies. When a journalist photographed the burial space using a drone, it caused tremendous shock. It appeared that there were mass graves being dug. In fact, these were not COVID-19 patients; this is how the impoverished dead invisibly go to rest in New York. And the pandemic was audible in the new urban soundscape, composed of ambulance sirens cutting into the unaccustomed quiet.

Pre-pandemic global New York was above all a so-called world city, one of those cities more connected to each other than to their nation-states. New York has always been ranked first among such cities in the United States, leading inexorably to its status as most infected. New York was literally dying of globalization. But not all of New York. It quickly became clear that the virus acted like a tracer dye for inequality. The epidemic spread fastest in the invisibilized structures built to warehouse people, above all institutions for older people and prisons. By the end of March 2021, just under 400,000 cases of COVID-19 had been reported in prisons nationwide, including over 6,000 in New York State. Only 35 died in New York in prisons from the virus, but over 2,500 nationwide.[8] While Rikers Island and other jails were the subject of long-standing protests, there were no sit-ins or occupations to protest senior living facilities or nursing homes, where 1.5 million people live in the United States. By March 2021, over 15,000 people had died in nursing homes and other care facilities.[9]

More dramatically still, BIPOC people became disproportionately sick in the first days. Even in COVID-ravaged New York City, the worst affected areas were densely populated minority neighborhoods where many people could not work remotely. While case rates for Black and "Hispanic-Latino" (to use the government's outdated classification) populations in New York were comparable to cases among Asians and whites, the rates

of hospitalization and death were far worse for Black and especially Hispanic-Latino groups.[10] The city may have been empty at the street level, but it continued to function as a globalized machine of inequality.

RACIALIZING THE VIRUS (APRIL 2020)

National awareness of this racial disparity created the possibility for the mainstream reemergence of the far right, last seen in 2017 in Charlottesville, Virginia. In one week in April 2020, the virus became racialized. This far right activism followed from a perverse and reverse act of self-recognition. Those white people inclined to make an overt declaration of white supremacy became aware that Black, Brown, and Indigenous people were being disproportionately affected. They concluded that they were immune in both the political and biological senses. Claiming to be sovereign, they demanded liberty. Imagining themselves to be immune from the virus, they demanded to be exempt from protective measures from masks to social distancing and vaccines.

When these "protesters" against lockdown measures were asked if they thought the epidemic was real, they often agreed that it was, but claimed that they were protected by a "higher power." Soon phrases like "Jesus is my face mask" could be found all over the internet. The concept of "higher power" comes as much from the rhetoric of Alcoholics Anonymous and other twelve-step groups as from Christianity. It carried a double meaning in the familiar dog whistle locutions of US white supremacy: the higher power is God, manifested as whiteness. For these white groups, the "invisible enemy" constantly evoked by Trump in the first weeks of the pandemic had de-invisibilized into visibly nonwhite people. Across a ten-day span in April 2020, the virus became racialized domestically, engendering the ongoing violent xenophobia attached to the disease as being "Chinese."

Forbes magazine predicted in March 2020 that minorities would suffer disproportionate economic loss.[11] But it was not until April that media began to report on the disproportionate rates of death and infection in these communities. A wave of national media reports started on April 7, following a White House briefing. *USA Today* correspondent Deborah

Barfield Barry ran a piece giving some of the first precise numbers, such as the fact that 70 percent of the COVID-19 deaths in Louisiana were among African Americans.[12] On that day, Los Angeles County also released its first data on the pandemic giving racial and ethnic numbers. The next day, the *LA Times* ran a critical editorial on the disproportionate deaths in minority communities.[13] By April 17, the Centers for Disease Control was reporting that of those cases where racial and ethnic identity was known, 30 percent of COVID-19 patients were African American and 18 percent were "Hispanic/Latino." That gap had closed by October, but the damage was done.

White people responded by claiming the newly empty streets. Just a week after this media wave broke, the first white "protest" against stay-at-home measures took place in Lansing, Michigan, on April 15. Organized by Trump front groups like the Michigan Conservative Coalition (MCC), the event was quickly co-opted by the far right. The MCC had called for people to stay in their cars to participate in a motorcade protest, first devised by leftist activist Saul Alinsky. Instead, maskless rifle-carrying men in combat gear posed on the steps of the state Capitol, claiming public space as white space policed by white men. This unpermitted, armed action was allowed to continue and garnered wall-to-wall media coverage. Photo ops arranged white men carrying automatic rifles and wearing tactical vests into clusters on the statehouse steps. US flags were prominent, alongside yellow "Don't Tread on Me" Tea Party flags. The ubiquitous Trump merchandise seen at all later events had yet to make an appearance. Some of the men were wearing masks or bandannas, although the majority were not. The primary talking point was the assertion that the US Constitution invalidated all the state stay-at-home orders—a reversal of the standard white supremacist "state's rights" argument.

This white immunopolitics allowed an emotional surge from the cultural unconscious, a volatile mix of anger, resentment, and fear of failure, combined with rhetorics of violence, especially against women. The 2016 slogan "Lock Her Up" against Hillary Clinton was again used at the Michigan protest, directed against state governor Gretchen Whitmer. Guns were the iconographic form of this action. Its vocabulary was selectively drawn from the 1776 settler colonial American Revolution. Looking back, this first pro-Trump lockdown protest prefigured the January 6, 2021,

insurgency in all areas, except that by January, white nationalists were ready to be violent.

No sooner had a *Fox News* segment on April 17 covered the event than Trump sent out a "LIBERATE MICHIGAN" tweet, among similar exhortations to other potentially important states in the presidential election, like Minnesota and Virginia.[14] As in Charlottesville, the far right received a presidential endorsement, although the MCC Facebook page urged its followers not to attend the follow-up Operation Gridlock events later that month. But the Betsy Devos–funded Michigan Freedom Fund, a co-organizer of the event, was still all in, calling the stay-at-home order "arbitrary and capricious."[15] In other words, the president and a leading cabinet member had begun to conspire against the policies of their own administration. This paradoxical claim to be outside politics while holding the very offices being criticized was the strategy of Trump's immuno-politics right up to January 6.

If Michigan was a display of assault rifles, two days later on April 19, 2020, Denver, Colorado, saw a white woman in a top-end Dodge RAM 1500 confronting one of two medical workers in masks and scrubs who were blocking an antirestrictions motorcade with their bodies. The moment was widely seen on social media, depicted in a photograph by freelancer Alyson McClaran that became the number one Reuters Photo of the Month for April 2020.[16] Amid a barrage of honking, the woman leaned right out of her vehicle in order to tell the nurse to "go to China." She did so not because he was Chinese but rather because—in the white nationalist worldview—social distancing is Communism and the virus "is" Chinese. It followed, from this perspective, that any person supporting stay-at-home or masking policies should be deported to Communist China. Given the size and immaculate condition of her expensive vehicle, her new USA T-shirt, and carefully maintained blond hair, it seems unlikely that this woman was suffering personally. While she felt herself to be a brave anti-Communist, she did not in fact dare to walk the streets.

There was a range of class and political positions among the white activists. What they shared was the long-standing fear that whiteness was being undone, or "replaced" as the far right puts it, in the emergency created by the pandemic. When they said—as they all did—that they would

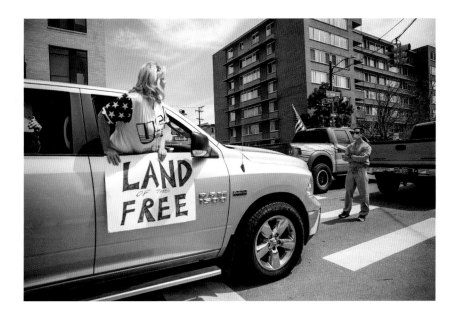

rather work than receive a government "handout," it expressed the long-standing belief that welfare is only for people of color and so-called white trash.[17] So much of the policed white public space is and has been about the prevention of so-called idleness that it undoes the logics of whiteness to support people not working. Being required to stay home and receive government funds provoked a furious backlash at being designated a dependent person, which in the rhetoric of white nationalism can only mean a person of color as opposed to a "free" person, meaning white.

Believing themselves to be free of the risk of infection, this new immunopolitics of white supremacy manifested in the symptomatic refusal to wear face coverings. To put on a material mask veils the whiteness of

Alyson McClaran, Health care workers stand in the street in counter-protest to hundreds of people who gathered at the State Capitol to demand the stay-at-home order be lifted in Denver, Colorado, April 19, 2020. Photo courtesy of Reuters.

the white masks that are white bodies. If whiteness conveys immunity, then to wear a mask is to be identified as nonwhite. In the worldview of the neo-Confederate politics of 2020, masking was itself form of "white slavery" by impeding absolute liberty of action. Mask wearing further evoked the veil and the long history of Orientalist unveiling, intersecting with post-9/11 Islamophobia whereby a face covering is itself perceived as a terrorist act. The mask cathected misogynist and homophobic fears of concealed embodiment and identity from the white cultural unconscious. Even the concept of mutual protection (your mask protects me, and my mask protects you) was against the strict anti-Communism of white settler colonialism 2020 style.

All of this quickly had an effect across the country. On April 9, *Newsweek* reported a Quinnipiac poll showing that 81 percent of people in the United States supported the stay-at-home policies, including 68 percent of Republicans.[18] A week later on April 16, 2020, Pew Research found that 66 percent were concerned that the country would reopen too quickly.[19] By April 19, NBC found that support had dropped to 58 percent, with less than 40 percent of Republicans in support.[20] Polling numbers varied thereafter, but after April 17, 2020, there was always a disparity in the numbers, with majorities of self-declared Republicans against all measures to contain the virus. By November 2021, counties that voted for Trump had a markedly higher rate of death from COVID-19, following low rates of vaccination—a pattern that was already set by April 2020.

IMMUNOPOLITICAL PROTEST (MAY 2020)

Immunopolitics in 2020 centered around claims to public space. A series of Long Island white antiregulatory protests by white conservatives happened in May 2020, close by where I was living. Organized by a pro-Trump group called Setauket Patriots, maskless people verbally hounded and intimidated a local TV news reporter, Kevin Vessey.[21] When he posted a video to Twitter, Trump reposted it—twice—celebrating those targeting the journalist, with each post getting over a hundred thousand retweets (now unavailable). These actions claimed that stay-at-home policies were Nazism, whose implementation was Communism. In Illinois, a person

wanting to see reopening challenged the Jewish state governor with a sign reading "Arbeit Macht Frei," the notorious statement above the gates of the Auschwitz concentration camp in Poland.[22] The sign maker was arguing that her freedom required that she be allowed to work, but the Nazi slogan was a sarcastic misdirection at an extermination site. It did not seem to matter that far right protesters were the ones calling state officials Nazis. Her "message" that any restriction on white freedom of action was totalitarian was widely received.

A similar action followed on May 16, 2020, in Eureka, California, linking two of the most reliably Democratic states in the country. Signs claimed that "crisis does not excuse Communism." The event at Humboldt County Courthouse became notorious because of drama teacher Gretha Stenger's sign, seen in a widely circulated photograph. I chose not to reproduce it in order to break the chain of circulation. There's nothing in the sign that cannot be described. It comprised a text on the left side claiming that "muzzles are for dogs and slaves, I am a free human being."[23] Although Stenger was photographed wearing a bandana, presumably as a face covering, her sign equated masks with such muzzles. Her parallel of restraints on animals with those on human beings was appallingly visualized by her use of the then top search return on Google images for "mask + slavery." It depicted an enslaved African woman in Brazil wearing a metal muzzle across the mouth with a spiked iron collar. This toxic image was an illustration to Jacques Arago's *Memoirs of a Blind Man* (1839), a travel narrative written when the author had become blind, making it a far from reliable source. It is said to show Escrava Anastàcia, a young woman healer and resistance leader among the Brazilian enslaved, who is now a popular folk saint, although the Catholic church has denied she even existed.

Several copies of the sign had been made using an office printer or photocopier to place two A4 sheets next to each other. Another woman called Larkin Small was also photographed carrying one. But it was a cropped photograph of Stenger by local journalist Kym Kemp that went viral on social media.[24] Stenger tried to claim that she had only held the sign because she did not bring one of her own, even though her folded homemade sign can be clearly seen under her arm and in another one of Kemp's photographs. She seems perfectly content to be photographed,

although she probably did not expect so many to see the results. These small-scale actions across the country, combined with mass online discussion, had created a toxic and volatile white immunopolitics. On May 27, even after the murder of Floyd, Trump retweeted conservative columnist Lee Smith's argument that masks represent a "culture of silence, slavery, and social death."[25] Given that social death is best known as sociologist Orlando Patterson's definition of enslavement, the white claim was to have been enslaved twice by culture.

THE GEORGE FLOYD UPRISING

On May 25, 2020, police officer Derek Chauvin murdered George Floyd in Minneapolis. But for the happenstance that Darnella Frazier was a bystander with the presence of mind to record the brutal event, and had both a smartphone with the capacity to record nine minutes, twenty-nine seconds of video, and a data plan sufficient to allow her to post that footage, Floyd might be just another statistic. Frazier rightly won a 2021 Pulitzer Special Award for her actions.[26] Yet for Eric Garner, Tamir Rice, and many others, similar visibility had not been enough to have police even indicted. Frazier's video condensed the racializing politics of 2020 into one unbearable extended sequence. Chauvin remained static, kneeling on Floyd's neck. His pose evoked his role as an agent of the state, a statue-figure, while Floyd's martyrdom made the scene resemble a statue. In many other instances, video has served the claim of self-defense when movement creates ambiguity. Chauvin's stillness was what convicted him.

The killing took place in a public square, in broad daylight, witnessed and recorded by many. Chauvin remained utterly unconcerned, convinced he had immunity for his actions. He had obviously done similar things before. It did not occur to him that police action against a visibly Black man in a Black neighborhood could be made visible as a crime, even though he knew it was being recorded. Had Floyd been capable of any movement at all, he might have been right because his defense would have been "fear for his life." Chauvin's mistake was that Frazier's video could not be questioned. Even then, it took an uprising to have police testify against Chauvin at his May 2021 trial.

After weeks of far right white supremacist claims to freedom and public space, Floyd's senseless killing sparked a nationwide uprising that spread across the world. The uprising understood his death and that of other victims both before and after him to be systemically related. Despite the risks of the pandemic, protesters challenged the long-standing demarcation and equivalence of public space as policed white space. In Minneapolis, community artists Cadex Herrera, Greta McLain, and Xena Goldman created a mural with a portrait of Floyd, his name, and a halo of other names of those killed by police.[27] The artists were not Black. But the family used their design at Floyd's funeral. Local people turned the surrounding area into a memorial, leaving flowers by the thousands, creating artwork and reclaiming the space as "George Floyd Square." Like other autonomous spaces, this was temporary. Minneapolis city workers arrived at dawn in June 2021 to remove everything except the mural and a clenched fist statue.

In May 2020, it was immediately to clear to the protesters that the symbolic order of whiteness had to be removed. The toppling of Confederate and other racist monuments became a vital act of contemporary redress and repair. Under the conditions that colonial power has long designated as a riot—the tumultuous assembly of those not authorized to assemble in public space—white reality shattered and splintered. Removing the statues created a sustained tear in the fabric of that reality. Striking statues was the feminist strike against racism and sexism, making visible the material infrastructure of whiteness, one of the key means by which it reproduces and sustains itself. It does not "erase" history, as is so often claimed, but rather reveals a different understanding of history.

Images of the strike flew across social media. Four days after the murder on May 29, in Louisville, Kentucky, a protester removed the right hand of the statue of French king Louis XVI, after whom the city is named. That night, someone tagged the plinth with "All Cops Uphold White Supremacy" (not visible in the later photograph reproduced here). The action and tag condensed the historical understanding of sovereignty in settler slavery into a single image. It demonstrates that the analysis offered in this book made sense to people because of their own experience of white reality and its cultural unconscious. The king's surrogate in the plantation was the overseer, whose hand could be raised to punish or kill.

Like the king, the overseer had two bodies: his own, and a second one that never died and never slept. This second body embodied what was known in the period as the plantation machine (see chapter 1). It became the emblem of white supremacy, a statue that sustained the racialized surveillance of the plantation. Although Louis XVI was executed in the French Revolution, in Louisville, he remained standing as the symbolic order of white supremacy to defend the "plantation future." The tag on Louis's base understood that the cop and prison guard are the plantation futures of the sovereign-overseer. Removing the hand of the king was an act of what Christina Sharpe calls "redaction," a gesture that erases in order to make it fully clear what there is to see.[28] In September 2020, the entire statue was removed.

MOURNING AND MILITANCY (JUNE 2020)

The static white statue was replaced by the largest mass movement ever, a seemingly unstoppable march into and across all forms of public space. The marches were safe and felt mandatory. In June, there were around nineteen thousand new cases of COVID-19 per day, down from the April peak of thirty-four thousand. This pause within the pandemic allowed people to protest in public space without undue fear of infection. Many had time because they were furloughed or unemployed. The marches were notable for maintaining social distancing, mask wearing, and ubiquitous hand sanitizing. No increase in cases was traced to the immense wave of protests. The sheer number of protesters was remarkable. One June afternoon, I realized that as we were marching up Sixth Avenue from Washington Square Park in New York City, another march was coming down Fifth Avenue parallel to us, both with many thousands of people. It seemed that for an entire generation of young people, participating in this movement was required. Opinion polls in June showed majorities of white people supporting the goals of Black Lives Matter to end the war on Black people (which is not to say that this was the most important aspect of the moment).

Over the Juneteenth weekend, there were around fifty Black Lives Matter events in New York City alone, according to the Instagram feed

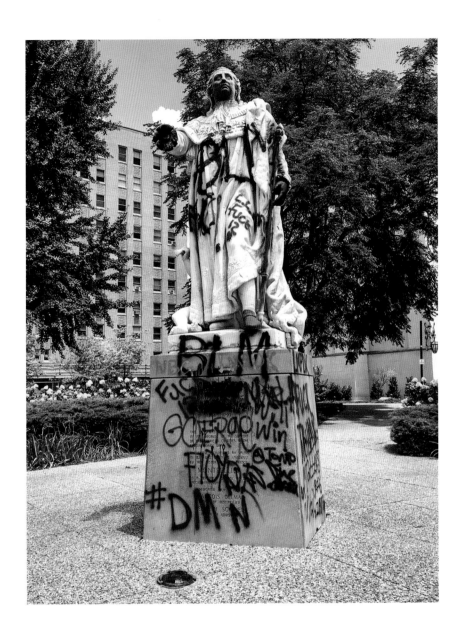

Maiza L. Hixson, *Statue of Louis XVI,
Louisville, Kentucky*, 2020. Courtesy of
the artist.

@JusticeForGeorgeNYC. This intensely curated social media project listed each event every day with live updates as to where each specific march was located if you had missed the start. Photos and videos were offered to those who couldn't make it. Bicycles were used to block intersections so marchers could walk through safely. Ten years of activism from the time of Occupy Wall Street in 2011 had clearly paid off, as organizing was horizontal and decentered, making it hard for police to stop. After the first highly contested days in the streets, the New York Police Department apparently decided to withdraw, allowing marches to self-organize, without even sending the usual escorts.

On June 20, as part of Juneteenth—which has since become a federal holiday—the Movement for Black Lives organized a march in which I took part as it went from the African Burial Ground downtown via the AIDS Memorial in Greenwich Village to the Hudson River. Shortly after the Pittsburgh synagogue massacre in November 2018, someone took it on themselves to graffiti the African Burial Ground "Kill the N*****s." As Walter Benjamin realized in 1940, when fascism is active, "even the dead will not be safe from the enemy if he wins."[29] The remains of some fifteen thousand enslaved Africans still lie under the Wall Street area, quite literally an infrastructure of whiteness.

Mourners wore white in the African tradition. BIPOC marchers were at the front, with a New Orleans–style brass marching band, while allies were asked to bring up the rear. African flags were much in evidence at the Burial Ground. Homemade signs read "Silence = Death, Black Lives Matter," merging the two most powerful slogans from either end of neoliberalism. The route of the march went past the first places where the "Silence = Death" poster had been put up in 1987 to raise awareness of the AIDS epidemic.[30] It then paused at the AIDS Memorial in a moment of remembrance. When the march reached the river, participants who had been carrying flowers the entire march gently threw them into the water. The gesture echoed the St. Ann's mourning ritual during New Orleans Mardi Gras, as did the marching band. This one march incorporated a set of histories, memories, and actions into a contemporary assemblage that rewrote public space into a different history. The masked march recognized individual histories, intersections, and memories too. It found the means to integrate "mourning and militancy," as ACT UP had named

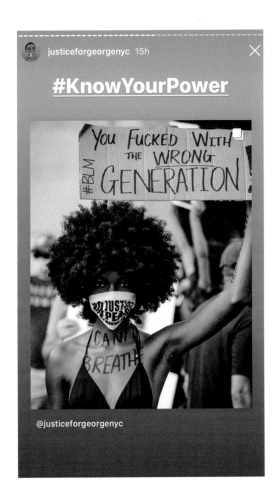

Screengrab of @JusticeForGeorgeNYC
Instagram post.

Almost forgot one

Sex Workers Speak Out Against Police Brutality
NEW TIME
7/9/20 6pm
Stone Wall Inn

policing_our_bodies POST PONED DUE TO WEATHER!
See you on Thursday everyone 🖤

Screengrab of @JusticeForGeorgeNYC
Instagram post.

it in the same space.[31] Theory emerged out of action, not just on a single day, but across the uprising.

WHITE TO BLUE (JUNE–NOVEMBER 2020)

In response to this new energy, far from pulling back or looking to compromise, white reality metamorphosed again. It became blue. The white-to-blue shift moved the axis of personal and political identity from ancestry to affiliation with law enforcement as the state. It shifted the equivalence of the (white) public as police to the police, pure and simple.

Movement for Black Lives Juneteenth march,
African Burial Ground, New York City, June
2020. Photo by the author.

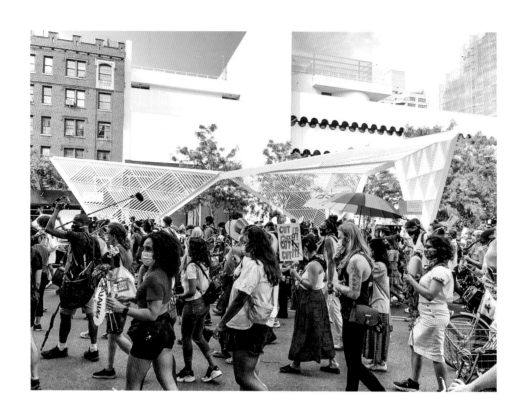

Movement for Black Lives Juneteenth
march, AIDS Memorial, June 2020. Photo by
the author.

At the same time, all white-identified white people became police. To be "white-to-blue" was now to bring together all the tangled desires and frustrations contained by the cultural unconscious of whiteness into becoming the police. Back the Blue was the resulting slogan, condensing all of these energies. In the white-to-blue imaginary, the former demarcation of public policed white space now extends across the entire country. The result was a new form of nationalism. Like the nation-state, it has flags, demands violence, and exults in its own presumed superiority. It was visibly performed in the presidential election campaign by Trump's followers, with their trucks, flags, guns, and banners. And it led to an insurrection to constitute the power of the new white-to-blue nation.

Since the civil rights movement, policing has presented itself as a "thin blue line" against disorder—a dog whistle evoking white fears about the loss of a permanent, racialized social hierarchy.[32] Unspoken but understood was that the areas that the blue line protects are white spaces, the largely segregated districts where white people mostly live. Taking over from the financial restrictions known as redlining, the white-to-blue shift expanded the thin blue line nationwide. It did not form a coherent geographic space but rather a new configuration of what George Lipsitz calls the "white spatial imaginary."[33] In 2016, this imaginary had gone "Make America Great Again" with the substitution of a wall for the thin blue line. Now, instead of there being one single divider, a screen marking both geographic and racialized borders, the entire white spatial imaginary had gone blue. The resulting white-to-blue space connects white supremacy to those domains of the state most directly involved in the war on Black lives from immigration enforcement to border patrol and the apparatus of mass incarceration.

The now-ubiquitous Back the Blue flag had its origins in the white resistance to the 2014–2016 Black Lives Matter movement and its "Blue Lives Matter" slogan. Back the Blue reproduces the US flag in black and white with one blue line across it.[34] For its designer, Andrew Jacob, the black space below the blue represents "criminals."[35] That is to say, it spatializes in visual form the "color line" between Black and white that W. E. B. Du Bois identified as the great American "problem." The flag visualizes the claim that "blue," the police in all senses, is what prevents chaos. Above the line is now the white-to-blue space, the modern Leviathan. As

a segregationist emblem, Back the Blue has become the flag of an imagined neo-Confederacy, which takes the gated community as the model for a nation. It contains a visualized reference to slavery. A blue line can be a simple designation of the sea. The below-the-line "criminals" are, then, those in the hold of the slave ship, while the white people above are slavers. Unsurprisingly, the Back the Blue flag had appeared in Charlottesville in 2017. After the George Floyd Uprising, it became visible almost everywhere, attracting mainstream media coverage from June 2020 on.

White-to-blue space was formed and claimed by its own set of public performances. The fallen statues were replaced by the "Trump caravans," formed by long lines of F-150 trucks, SUVs, and other cars taking over the roadways. These caravans, which I saw all over Long Island, first appeared during the resistance to COVID-19 shutdowns in April 2020. The caravans deployed a battery of flags, ranging from Trump merchandise to Back the Blue flags and Tea Party banners. None were homemade. There was even an inflatable Trump on one occasion, as if to say, "We know he's a cartoon and we don't care." The motorcades flaunted fossil-fuel intensive vehicles in yet another summer of climate-change driven wildfires. Driving slowly, like biker gangs, the caravans filled all lanes of traffic on converging roads so that it was impossible to avoid them. They went on routes designed to reinforce white reality. Locally, that meant driving from a 9/11 memorial to a Revolutionary War battleground and a pizzeria that Trump had tweeted about. In becoming "blue," whiteness restored its projection of reality.

CLAIMING WHITE POWER (JANUARY 2021)

The insurgency at the US Capitol on January 6, 2021, was a monumental act with multiple intents. The Capitol is, after all, a monument, perhaps the monument of monuments, combining historic significance and the seat of legislative power. The January 6 insurgency formed a capstone to the long histories of whiteness, screens, the state, statues, and statutes in this book. White nationalists responded to the removal of racist statues with a mediated and visible affirmation of the white-to-blue claim to state power. Like the US Army in Vietnam, this self-appointed counterinsurgency had to destroy the Capitol in order to save it. Those who

had insisted on "broken windows" policing in Black neighborhoods now broke the windows of the Capitol using police shields to do so. Insurgents even attacked police with Back the Blue flags because in their view, such police were defending the now-discredited existing order. Even the "blue" had to follow Back the Blue. The single imperial screen was reconstituted as many distributed devices, streaming video and downloading images that reconstructed white reality.[36]

In 2017, the Unite the Right rally in Charlottesville had been a defense of Confederate statues as the symbolic infrastructure of white supremacy. Four years later, the Capitol insurgency was a digitally mediated claim to state power for the white-to-blue nation. "Storming the Capitol," as the insurgents called January 6, as if it were a performance (and there will, of course, be a movie) was a self-conscious reenactment of the American Revolution. While many saw affiliations with the live action role-playing

Trump caravan, "Back the Blue," 2020. Photo by the author.

craze, its roots lay in Civil War reenactments. At such events, the insurgents had long practiced the overturning of history.

The action had two primary levels. Most spectacular was the violent effort by paramilitaries like the Proud Boys and Oath Keepers, many of whom were past or present military or police, to create a formal coup by compelling then vice president Mike Pence to invalidate the electoral college votes. Far more important in the long run was the media action. For the insurgency was endorsed by its watching audience online and on television, in the same way that the invited audience and spectators endorse a coronation or inauguration. In this segment of the insurgency, often created by the so-called normal protesters, the much-derided selfies and livestreaming were the point, not a sideshow. These media created consent for the insurrection that continues to unfold. After many compulsive repetitions, the single expanded imperial screen was replaced here with multiple streaming video feeds, playing on device screens via social media apps.

In a photograph taken by Ahmed Gabar in the Rotunda, one insurgent is using the statue of Abraham Lincoln to get a better viewpoint for his smartphone filming, while hovering above a professional standard video camera and an insurgent with a GoPro camera mounted on his helmet. This livestreamed "people" streamed themselves to themselves and their audience as the newly and properly constituted form of the United States. No less than 147 elected representatives voted later that day to endorse this white-to-blue reconstitution of the state and the States. It has since become "common sense" across the right, reiterated daily on social media and cable news.

These dramas were condensed into the simple slogan "1776," chanted inside and outside the Capitol that day. This "1776" transformed the narrative already monumentalized at the Capitol into a new revolution to constitute white power. Consider the widely photographed scenes of insurgents in the tear-gassed Rotunda. Through the sfumato of the gas, John Trumbull's oversized paintings of the American Revolution can be seen hovering in the background, as in Mostafa Bassim's photograph. Two scenes of British surrender emphasize US military dominion. Facing paintings of the Declaration of Independence and George Washington resigning his commission showed how this power was then formally

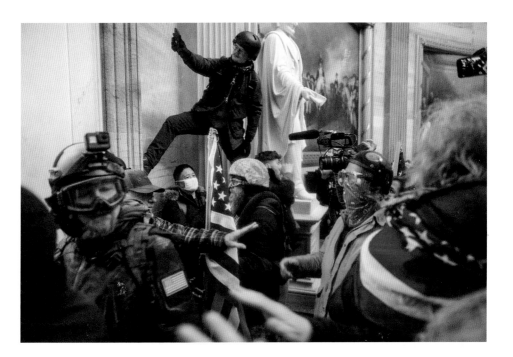

constituted. Military dominion supplies the constituent power to write a constitution. The insurgents ignored all of these painted and sculpted scenes of past white supremacy.[37] That version of the republic required reconfiguring into one where white supremacy could never be challenged.

While many journalists stayed outside, Bassim's experience in Tahrir Square gave him the skills to be in the middle of what his photograph shows to be a violent confrontation between protesters and police with phones and cameras recording all the action. Trump flags, hats, and signs are prominent, with the US flag disregarded on the wall. Men in bicycle helmets and goggles had come prepared for a fight. Police outside the Capitol unusually allowed them to carry metal flag poles and wooden

Ahmed Gabar, US Capitol, January 6, 2021.
Courtesy of Ahmed Gabar and Magnum
Foundation.

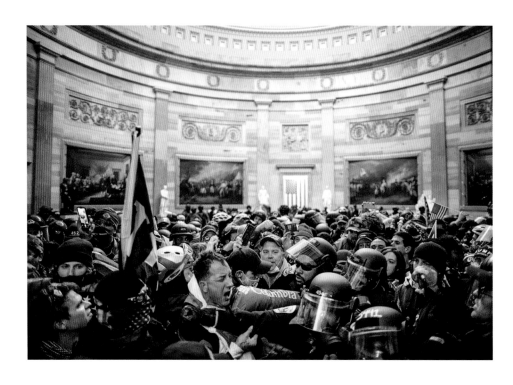

Mostafa Bassim, US Capitol Rotunda,
January 6, 2021. Courtesy of Mostafa Bassim
and Magnum Foundation.

supports for signs that they then turned into weapons. These photographs make it very clear that this was an insurrection.

When the tear gas cleared, there were several possible destinations for white-identified people. The insurrection allowed white-to-blue nationalism to connect hostility to "defund the police," statue removal and critical race theory into the ground for a resurgent and reactive white supremacy. Like other hegemonic projects, this white nationalism connected disparate elements into a structure of feeling, which articulated (meaning both to make intelligible and to connect) the fear of replacement in the white cultural unconscious. This "strong" nationalism was countered by the "soft" affiliation to the "United States" as an ever "more perfect union," to quote the phrase from the Constitution that is central to the Obama-Biden political project. Finally, there was and is the renewed possibility to ally with BIPOC abolitionists and strike against whiteness, a transnational movement facing forward to a decolonial future intensely threatened by the climate catastrophe.

In this transition, blue must become simply blue. I visited only one exhibit in 2020, the transformational Museum of Modern Art / P.S. 1 project Marking Time: Art in the Age of Mass Incarceration, curated by Nicole Fleetwood. Toward the end of this revelatory show was Sable Elyse Smith's *Landscape V* from her series *Blue Is Ubiquitous and Forbidden*. It is a neon sculpture, spelling out a text that describes the silence after a police officer's radio is smashed. Smith evoked the possibility of what she calls "black language" and concludes, "And blue in a decade where it finally means sky." Below this revolutionary aspiration is a thin blue line in neon. It first underlines that last sentence and then it also evokes the police. This double possibility is the contemporary after 2020: maybe a blue line is just a line, or maybe it's a militarized police force. When blue means sky another metamorphosis will have happened—one in which life is not transformed into value by violence but rather exists in and for itself and for others.

Fleetwood evocatively suggests that Smith's use of "carceral blue is not only the blue of depression or emotional lows. It connects with the history of 'prison blues' as emotion and art-making, and with the larger tradition of blues music."[38] Blue is a clothing color forbidden to prison visitors and one that may render people subject to arrest for gang

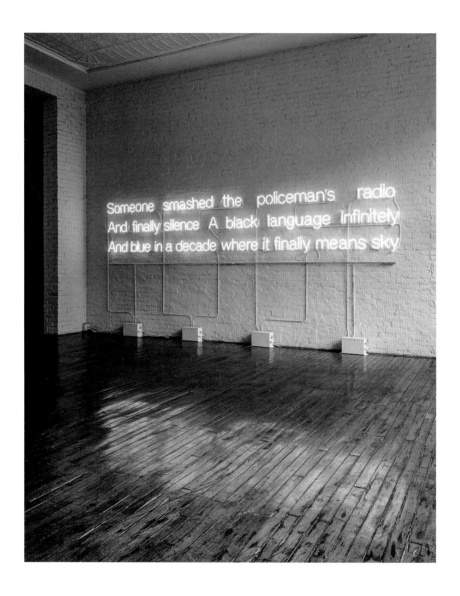

Sable Elyse Smith, *Landscape V*, 2020. Photo:
MoMA/PS1.

membership. I think, too, of the relation of black, blue, and beauty evoked in Barry Jenkins's 2016 film *Moonlight*. Again, I think of the blue of the sky when the Vendôme Column fell during the Paris Commune in 1871 that surrealist André Breton said he saw in all of Gustave Courbet's paintings. To claim these blues and more for whiteness is a violent effort to erase such possibilities.

In the midst of the ongoing violence of white-to-blue identification, despite all the worsening of the "weather" of antiblackness, as Christina Sharpe has it,[39] there is nonetheless the possibility to undo its nationalism. If white can become blue, can white become what happens when all colors are mixed together, the composite of composites, as opposed to the single marker of the hierarchy of the human? This white would be the mark of what Stuart Hall often called the "impure," to whom the future belonged.[40] White-to-blue nationalism wants the past. The future remains open. When Kazimir Malevich created *Suprematist Composition: White on White* (1918), it was possible to imagine the work had "overcome the lining of the colored sky," as Smith again hopes to do.[41] The strike against whiteness imagines that possibility. Let blue just be the sky and what happens next?

EPILOGUE: THE MURMURATION OF STARES

When blue is just the sky, then it will again be time to see the birds. Not as examples of species, not as avatars of extinction, not as indexes of whiteness, but otherwise, as ways to see and think after whiteness. The first New York City gallery exhibit I saw in a long time was John Akomfrah's *Five Murmurations* (2021), a three-screen film projection in black and white.[42] Shot in 2020, *Five Murmurations* visualized the intersection of the pandemic, George Floyd Uprising, and continued climate catastrophe through the lens of the personal within the collective unconscious. Colonial images, Renaissance paintings, police violence, Black Lives Matter marches, the death of Che Guevara, and moments of everyday life in 2020 when all these histories were present flowed across the screens, connected by the murmurations of birds. Unlike much of Akomfrah's recent work, rendered in vivid color and high resolution, the visual form

was a layered black and white, creating montages within the single screen as well as in between the three screens. *Five Murmurations* visualizes the "multiplicitous, polyphonic, collective and diasporic" reality that results when the imperial screen is broken.[43] Which is to say, a murmuration.

Following the lead of Saidiya Hartman, activist-scholars Fred Moten and Stephano Harney discussed in 2021 how to be in the collective, and proposed the murmur, the "conference of birds," murmurations, and the "shift in social formation" that results.[44] A murmuration occurs when a flock of birds, often starlings, moves together to create fractal patterns in the sky. These moments are mesmerizing. The murmuration embodies consent not to be a single being. It is what the strike against whiteness looks like. It is spontaneous. It exists in three dimensions, not the two produced by perspective. It is composed of as many ways to see as there are birds in the murmuration. Each bird sees topologically, meaning in

Still from John Akomfrah, *Five Murmurations,* 2021. Three channel HD black and white video installation, 7:1 sound. 54 min, 39 secs (AKOM210009).

the space around it. Each observes patterns of light caused by sky, and the dark made by other birds, and flies accordingly.

Creating form in space, the birds are making a "drawing" using light and dark, like an artist using pencil on paper. Simultaneously, their use of light and dark is a modality of data, zeros and ones, without projecting good and evil, to create what scientists call a "hybrid projection."[45] This projection preceded and may outlast white projection. It creates "marginal opacity," an avian tweak on the right to opacity. The birds do not combine data with colonialism but with their own "embodiment as the dynamic movement between inner and outer, subject and object, inside and outside." It's still not really known why they do this. Perhaps it does

George Clerk, large murmuration of starlings at dusk. Licensed from iStock photos.

distract predators as is often suggested. Frequently, though, I've seen birds murmuring when there was no predator around or over water where surprise attacks would be unlikely. It's hard not to believe that they are doing it for pleasure, to create a community in which "the community moved through the body, as much as the body through the community."[46] This commons is not the dull, grounded, premodern formation of caricature. It is a flying in formation, in a changing social formation, in which information is produced but is not the only reason to have a body, collective or otherwise.

Imagine a murmuration with millions of birds in it, the flocks of birds that were commonplace before settler colonists systematically killed them all. John James Audubon described the "angles, curves and undulations" in the "multitudes of Wild Pigeons" as tactics designed to repel hawks.[47] He estimated that there were no less than a billion of the now-extinct birds in the murmuration. Now you have a sense of what colonial de-birding has wrought. The starling was an apparent exception to this decline. All North American starlings stem from the release of eighty birds in Central Park in 1890 by a group that wanted to see all the birds mentioned in Shakespeare in New York City. Starlings were wildly successful immigrants, reaching an estimated population of 166 million in 1970.[48] Often seen congregating on telephone and electric cables, starlings are modern birds, still listed as an "invasive species." The loss of habitat and the climate crisis nonetheless affects all species, and the starling population had declined by half to 85 million in 2021.[49]

The settlers are not yet finished with the birds. Murmurations are becoming "governance applications" for data in workplace monitoring techniques and elsewhere.[50] Inevitably, a digital art studio called DRIFT, based in the Netherlands, has taken the algorithm that produces a simplified digital murmuration and used it to program drone flights. The result was a 2017 performance called *Franchise Freedom* in which hundreds of illuminated drones flew around at night. In the documentation video, Dutch artists Lonneke Gordijn (b. 1980) and Ralph Nauta (b. 1978) envisage the swarm as a relation between personal freedom and social systems, or a "natural" disciplinary structure. As if to riposte, a parody disinformation campaign called Birds Aren't Real has claimed that birds are in fact drones engaged in surveillance.[51]

To murmur was to voice a grievance, and a murmuration was an instance of such complaint. Murmuration became the collective noun for the starlings, or stares as they were known to poet John Dryden and artist William Morris. A murmuration of stares resonates as a multisensory, multispecies, and multidimensional alternative to white projection of white reality. In his journalistic account of slavery, published in 1856, Frederick Law Olmsted, the architect of Central Park where starlings were released and the 2020 bird-watching encounter took place, used the term "murmur" to mean conspire or revolt.[52] A murmuration in that sense is the revolution. That turn can be made in other ways, I know.[53] But in 2020, I spent time with blue jays, cardinals, crows, finches, ospreys, owls, sparrows, starlings, and wild turkeys. The birds assembled me.

The conference of birds is the past future that still awaits. In seventeenth-century Europe, as colonialism became both state policy and a central theme in art, the *Assembly of Birds* became a popular artistic subject, often treated by Dutch artist Frans Snyders (1579–1657). The parrot and toucan in one Synders version of the theme make it clear that it was always a colonial imaginary. The owl at the center is either conducting the song or warning the birds of human hunters, as in Aesop's fable. Or both. I like to think of it as an actual assembly, a democracy in which predators and songbirds have an equal say. Unlike humans, except in opera, there's no need for them to speak one at a time. There's a *Concert of Birds* (ca. 1630) by Snyders in the Prado museum without the owl, which is to say, an assembly without a visible leader, a direct democracy of other-than-human life. Some have suggested that the owl was cut out at some point, but no matter. Someone wanted it to look like that.

Such assemblies have existed and do exist. In the remarkable paintings of Aotearoa New Zealand artist Bill Hammond, who sadly passed in February 2021, zoomorphic birds dominate the land. Hammond's work radically changed when he visited Motu Maha, or the Auckland Islands, an archipelago to the south of Aotearoa that is designated as an "area outside territorial authority." It's not terra nullius. It's land outside white reality. Early Polynesian settlement gave way to a nineteenth-century British whaling and sealing station, until the relentless massacre of the seals made the labor of extermination unprofitable around 1894. The islands are now a National Nature Reserve whose staff members are attempting

to remove all introduced mammals, like feral cats, rabbits, and pigs. This work is what Juno Salazar Parreñas calls "decolonizing extinction. Care is not necessarily affection, but for me it is a concern about the treatment and welfare of others."[54] It might mean rehabilitating animals to the wild, as Parreñas describes in the case of orangutans born in captivity and raised "semi-wild." This gesture topples the monument of species hierarchy from the other end. As the white statues are removed, after two centuries of putting orangutans at the bottom of their hierarchy, the apes gain equal standing and deserve reparations.

Or it might mean rehabilitating the wild to animals, as is taking place on Motu Maha. On his visit, Hammond was struck by the way the birds on the island stood upright staring out to sea. It reminded him that prior to the arrival of humans around 1300 CE, birds were the dominant species in the archipelago now known as Aotearoa. There were no predators, other

Frans Snyders, *Concert of Birds*, 1630.
Museo del Prado, Madrid. Photo: Wikimedia
Commons.

CHAPTER 8

than the *pouakai* (Haast's eagle), a giant eagle. The most populous species were moa, large bipedal flightless birds, which were quickly made extinct by the first human colonists, now known as the Māori. The Māori simply ate them all, in about two hundred years. Archaeologists have identified three hundred moa-hunting sites in Aotearoa. Remains suggest that twenty to ninety thousand birds were eaten at the Waitaki River bone midden alone.[55]

In 1873, British naturalist Walter Lowry Buller had defined the ornithologist's task as being "useful to his fellow colonists" as birds became extinct alongside the Indigenous (see chapter 3). The Māoris, he noted, said of the *kākāpō* (owl parrot), "In winter they assemble in large numbers, as if for business; for after confabulating together for some time with great uproar, they march off in bands in different directions." Buller recognized the sound of this assembly in the dawn chorus, comprising bellbirds, tui, whiteheads, and *piopio*, observing that "shortly after daylight a number of birds of various kinds join their voices in a wild jubilee of song."[56] The jubilee is the moment of freedom, a celebration of the end of slavery in nature, which colonialism sought to exterminate.

Musing on all of this, after reading Buller, Hammond created a massive painting called *Fall of Icarus* (1995), in which the birds watch the human flight of Icarus end in failure. The space is a deep metallic blue, mingled with drips of black-and-white paint throughout. One of those drips, perhaps the white streaky column in the center-right, marks Icarus falling from his overambitious flight. Icarus would have been the first white colonist in Aotearoa had he been able to land. It would have been a hard place to fly because there are two distinct horizons, marked by smoking volcanic islands. Hammond tore white reality in half. Pieter Brueghel the Elder's painting of Icarus (ca. 1560) evoked the Fall of Man caused by the actions of Adam, who as we have seen, became Apollo, the very type of whiteness (chapter 2). The birds know that whiteness is coming. In the other space visible in Hammond's painting, perhaps it is now going. As the birds stand in trees to the left and right from top to bottom, the space nonetheless "works" visually, depicting the murmuration of stares.

In one space, the land is new, there are not yet human words to describe it, and the birds sing it into being. In the other, they are watching humans disappear for a second time, falling in the rising waters. The two

Bill Hammond, *The Fall of Icarus (after
Brueghel)*, 1995. Acrylic on canvas. 2005 ×
2165 × 36 mm. Collection of Christchurch
Art Gallery Te Puna o Waiwhetū, purchased
1996.

spaces are colonial and Indigenous, human and avian, forming a double vision of space, not yet colonized as space, not subject to the "laws" of perspective. Can you fly drones here? The birds look out from the trees, bipedal, wingéd, armed in the sense that they have arms, long beaked, wearing one-piece costumes like superheroes. The stillness of their looking watches over this doubled space to live, and keeps it possible, where whiteness insists on the single, the screen, and the singular. Some stand on branches, and others hang by their "arms." What are the birds actively doing? They murmur to create community, strike against whiteness and the invasion of humans, and imagine the future. They are waiting, not for Godot, but for the end of whiteness.

ACKNOWLEDGMENTS

This book was written in the particular circumstances of the COVID-19 pandemic, which eliminated the possibility of travel, but opened up the digital commons. The ideas in this book were profoundly shaped by my participation in autonomous learning spaces online, especially Testing Assembly and the Center for Convivial Research and Autonomy. In particular, I want to acknowledge the importance of the thinking I have been able to do together with Manolo Callahan, Fulvia Carnevale, Jesal Kepadia, MPA, and Annie Paradise. Special thanks to Claire Fontaine for the amazing cover art. I very much want to thank the museums, galleries, and universities that invited me to speak on or around this topic; I learned much from each audience.

I had the time to write thanks to the Mellon-ACLS Scholars and Society award of a 2020–2021 residential fellowship in New York City at the Magnum Foundation, which was also remote physically yet not intellectually. Many thanks to Kristen Lubben, Noelle Flores Theard, Emma Raynes, Africia Heiderhoff, and everyone at the Magnum Foundation. I spent the pandemic with Kathleen Wilson, and she was as ever brilliant and supportive in equal measures; her thought is everywhere in this book.

Among my academic colleagues, I've been profoundly inspired by Dan Hicks's work on Benin and British imperialism; Sarah Elizabeth Lewis's Vision and Justice Project; Rachel Nelson and Gina Dent's 2020–2021 Visualizing Abolition series, with its accompanying exhibition, Barring Freedom; and my colleague Nicole Fleetwood's transformative engagement with art in the age of mass incarceration.[1] Each has set out to use their scholarship to make social change, and on a good day, I hope this book can follow in these footsteps.

Some sections of this book appeared elsewhere in different forms, including "Artificial Vision, White Space and Racial Surveillance Capitalism," *AI and Society* (2020); "The Whiteness of Birds," *Liquid Blackness* (April, 2022); and "An Anti-Colonial Way of Seeing: Race, Violence and

Photography in Notting Hill (1951–1960)," *Interventions* 22 (March 2022). I want to acknowledge the online magazine *Hyperallergic*, and my editor there, Seph Rodney, who graciously hosted my first thoughts on many of the ideas developed here, especially in "Watching Whiteness Shift to Blue via Nationalist Aesthetics," *Hyperallergic* (November 30, 2020). Similarly, *Monument Bulletin* carried my first response to the January 6 insurrection as "The Capitol Insurgency and the Monument," *Monument Bulletin* (February 15, 2021), with special thanks to Patricia Kim. While I can trace the origin of sections of this book back to these pieces, everything here has been revised and updated. Finally, my thanks to all at the MIT Press, where my editor Victoria Hindley believed in this book before I did, and the anonymous reviewers were enormously instructive. The production team, including Deborah Cantor-Adams, and Gabriela Bueno Gibbs, did an excellent job, as did copy editor Cindy Milstein. All the remaining errors and oversights are, of course, no one's but my own.

NOTES

ACKNOWLEDGED

1. Carby, *Imperial Intimacies*, 13.
2. See Akomfrah, *The Unfinished Conversation*.
3. https://veralistcenter.org/exhibitions/imaria-thereza-alves-seeds-of-change-new-yorkmdasha-botany-of-colonizationi.
4. Lewis, "Groundwork."
5. Halley, Eshleman, and Mahadevan, *Seeing White*; Blight, *Image of Whiteness*, 20.
6. Barker, *Native Acts*, 5.
7. Veracini, *Settler Colonial Present*, 2.
8. Sharpe, *In the Wake*, 110.
9. Campt, *Black Gaze*, 7.
10. Wolfe, "Settler Colonialism"; Couldry and Mejias, "Data Colonialism"; Downey, "Algorithmic Apparatus of Neo-Colonialism"; Beller, *World Computer*, 6–10.
11. Mirzoeff, *Appearance of Black Lives*.
12. To refer to just some of their work, see Dyer, *White*; Harris, "Whiteness as Property"; Jacobson, *Whiteness of a Different Color*; Jacobson and Roediger, *Working toward Whiteness*; Painter, *History of White People*.
13. Lipsitz, *How Racism Takes Place*, 3.
14. Dyer, *White*, 9.
15. Bouteldja, *Whites, Jews, and Us*; Lentin, *Why Race Still Matters*; Moreton-Robinson, *White Possessive*; Rodríguez, *White Reconstruction*; Wolfe, *Traces of History*.
16. Berger, *Ways of Seeing*; Berger, *White Lies*; Berger, *Sight Unseen*; Smith, *American Archives*.
17. Blight, *Image of Whiteness*; Casid, *Scenes of Projection*; D'Souza, *Whitewalling*; Smith, *American Archives*; Wexler, "More Perfect Likeness."

INTRODUCTION

1. Wynter, "The Ceremony Found," 199n22.
2. Merleau-Ponty, *Visible and the Invisible*.

3. Mirzoeff, "Striking"; Precarias a la Deriva, "A Very Careful Strike"; Draper, "Strike as Process"; Claire Fontaine, *Human Strike*; Gago, *Feminist International*.

4. See Federici, *Caliban and the Witch*, 11; Robinson, *Black Marxism*, 100–120; Browne, *Dark Matters*, 15–16.

5. Robinson, *Forgeries of Memory*, 10.

6. Roy, "The Pandemic Is a Portal."

7. Anderson and Wilson, "Introduction," 16.

8. Painter, *History of White People*.

9. Moten and Harney *All Incomplete*, 16.

10. Marx, *Economic and Philosophic Manuscripts*, 108.

11. Browne, *Dark Matters*, 15; Georgakas and Surkin, *Detroit*, 18; Graeber, *Utopia of Rules*, 3–5.

12. Antonio Gramsci, *Prison Notebooks*, quoted in Hall, *Cultural Studies*, 160.

13. Hall, *Cultural Studies*, 107–108.

14. Campt, *Listening to Images*, 6.

15. Sell, *Trouble of the World*, 3ff.

16. McTighe, "Abraham Bosse."

17. Hicks, *Brutish Museums*, 37–48, esp. 41.

18. Du Bois, "Souls of White Folk," 29.

19. Moten and Harney, *All Incomplete*, 14.

20. Couldry and Meijas, "Data Colonialism," 337 ff.

21. Mignolo, "Crossing Gazes," 178.

22. See Rowland, *3 & 4 Will. IV c. 73*; McKittrick, *Dear Science*, 140–145.

23. Ruskin, *Elements of Perspective*, 8–12.

24. Hilton, *John Ruskin*, 253–254.

25. Hicks, *Brutish Museums*.

26. Gordon, "Viewing Violence in the British Empire," 70.

27. Grant, *Passing of the Great Race*, 50.

28. Graeber, *Fragments of an Anarchist Anthropology*, 23.

29. Rodríguez, *White Reconstruction*, 8.

30. Downey, "Algorithmic Apparatus of Neo-Colonialism," 79.

31. Robinson, "Surveillance Integration Pivotal in Israeli Successes," 16. I first learned about this drawing from Lee, "Commodified (In)Security," 142–144. I am grateful for her permission to reference it. The permission fees were too exorbitant to allow for a reproduction.

32. Parks, "Vertical Mediation," 135.

33. Cubitt, *Anecdotal Evidence*, 229.

34. Larkin, "The Politics and Poetics of Infrastructure," 328–239.

35. Quoted in Wolfe, "*Corpus nullius*, 144.

36. Hobbes, *Leviathan*, 84.

37. Ruppert, "Statue of George III."

38. Fanon, *Wretched of the Earth*, 15.

39. Thompson, *Smashing Statues,* 184–185.

40. Quoted and translated in Warner, *Monuments and Maidens*, 21.

41. Quoted in Roediger, *Wages of Whiteness*, 14.

42. Wekker, *White Innocence*, 3.

43. Fanon, *Toward the African Revolution*, 32, 37.

44. Hall, *Fateful Triangle*, 33.

45. Gilmore, *Golden Gulag*, 28.

46. Robinson, *Black Marxism*, 26.

47. Browne, *Dark Matters*, 16, 128.

48. Zuboff, *Age of Surveillance Capitalism*, ix; Nemser, *Infrastructures of Race*, 1–26; Estes, *Our History Is the Future*, 115.

49. Pugliese, "Biometrics"; Taylor, "Technoaesthetics"; Benjamin, "Discriminatory Design."

50. Gómez-Barris, *Extractive Zone*, 5–9.

51. Sylvia Wynter has defined a related "Black metamorphosis." See McKittrick, *Dear Science*, 154–167.

52. Johnson, *River of Dark Dreams*, 244.

53. Johnson, *River of Dark Dreams*, 248.

54. Moore, "Madeira, Sugar, and the Conquest of Nature," 353.

55. Marx, *Capital*, 352.

56. McKittrick, "Plantation Futures," 2; Casid, *Scenes of Projection*.

57. Marx, *Capital*, 353, 377.

58. Glissant, *Poetics*, 144.

59. Moten, *Black and Blur*, xv.

60. Luxemburg, *Rosa Luxemburg Reader*, 181.

61. Moten and Harney, *Undercommons*, 28; Scott, *Art of Not Being Governed*.

62. Claire Fontaine, *Human Strike*, 49.

63. Keeling, *Queer Times, Black Futures*, 45–47; Claire Fontaine, *Human Strike*, 49, 195.

64. Nkrumah, "From Now on We Are No Longer a Colonial."

65. See Claire Fontaine, *Human Strike*; Gago, *Feminist International*, 188, 3.

66. Gago, *Feminist International*, 13.

67. Simpson, "State Is a Man."

68. Ovid, *Metamorphoses*, 86–91. See Butterfield-Rosen, "Men are Dogs."

69. Deer, *Beginning and End of Rape*, xvii, quoted in Estes, *Our History Is the Future*, 81.

70. Equiano, *Interesting Narrative of the Life of Olaudah Equiano*, chapter 5.

71. Morgan, "*Partus sequitur ventrem*," 5. See also Sharpe, *In the Wake*, 15ff.

72. Roediger, *Wages of Whiteness*.

73. Du Bois, *Black Reconstruction in America*, 700.

74. Du Bois, *Black Reconstruction*.

75. Bouteldja, *Whites, Jews, and Us*, 34.

76. Claire Fontaine, *Human Strike*, 114.

77. Taylor, *How We Get Free*, 19.

78. Gago, *Feminist International*, 193.

79. See brown, *Emergent Strategy*.

80. Anderson and Wilson, "Introduction," 16.

81. Dubrovsky and Graeber, "Another Art World."

82. See Rosemont and Kelley, *Black, Brown, and Beige*.

83. Long Soldier, *Whereas*, 8.

84. Glissant, *Poetics*, 193.

85. Claire Fontaine, *Human Strike*, 121.

86. Shukaitis and Graeber, "Introduction," 9.

87. Graeber, *Utopia of Rules*, 219.

88. Keeling, *Queer Times, Black Futures*, 12–15.

89. brown, *Emergent Strategy*, 17.

90. Hicks, *Brutish Museums*, 17 (emphasis in original).

CHAPTER 1

1. Sorkin, "Freddy Grays' Death."

2. Julien, *Baltimore*.

3. Damisch, *Origin of Perspective*, 168ff. Subsequent references are in the text.

4. Mignolo and Walsh, *On Decoloniality*, 141–145.

5. Vazquez, *Vistas of Modernity*, 25.

6. Panofksy, *Perspective*, 72.

7. Yusoff, *Billion Black Anthropocenes*.

8. Lepenies, *Art, Politics, and Development*, 43.

9. Damisch, *Origin of Perspective*, 192.

10. Robinson, *Black Marxism*, 104.

11. Robinson, *Black Marxism*, 105.

12. Rosen, "Pietro Tacca's *Quattro Mori*," 37.

13. Incorrectly spelled as Capria in the US translation of Damisch, *Origin of Perspective*, 383.

14. Markey, *Imagining the Americas*, 159.

15. Markey, "Stradano's Allegorical Invention of the Americas," 399.

16. Markey, "Istoria," 202.

17. Markey, "Istoria," 200–201.

18. Markey, *Imagining the Americas*, 134.

19. Nadalo, "Negotiating Slavery," 276.

20. Markey, *Imagining the Americas*, 151.

21. Nadalo, "Negotiating slavery," 289.

22. Nadalo, "Negotiating Slavery," 283.

23. Quoted in Nadalo, "Negotiating Slavery," 287.

24. Rosen, "Pietro Tacca's *Quattro Mori*," 40–41.

25. Nadalo, "Negotiating Slavery," 278.

26. Nadalo, "Negotiating Slavery," 296.

27. Rosen, "Pietro Tacca's *Quattro Mori*," 34.

28. Rosen, "Pietro Tacca's *Quattro Mori*," 43.

29. See Kaplan, "Italy, 1490–1700," 182–183; Ostrow, "Pietro Tacca and His Quattro Mori."

30. Rosen, "Pietro Tacca's *Quattro Mori*," 44.

31. Ostrow, "Pietro Tacca and His Quattro Mori," 156, 158.

32. Mukhtar Dar, *Priti Patel; Colonisers Clone* (poster), 2020. Text by Raj Pal.

33. Ovid, *Metamorphoses*, 15.

34. For a survey of the literature on this statue, see Cordova, "Apollo and Daphne."

35. Pollock, *After-Affects/After-Images*, 52 (emphasis in original). For a feminist analysis of the myth, see Pollock, *After-Affects/After-Images*, 55–59.

36. Sharpe, *In the Wake*, 30–31.

37. Wark, "Editorial."

38. Gilroy, *The Black Atlantic*, 72–110.

39. Quoted in Skinner, *From Humanism to Hobbes*, 284.

40. Hobbes, *Leviathan*, chapter 17.

41. See McGaffey and Harris, *Astonishment and Power*.

42. Berger, *Art of Philosophy*, 188.

43. Hobbes, *Leviathan*, xviii.

44. Hardt and Negri, *Assembly*, 26.

45. See Toscano, "Images of the State." For a full exegesis, see Skinner, *From Humanism to Hobbes*, 222–315.

46. Skinner, *From Humanism to Hobbes*, 264.
47. See Mitchell, *Iconology*.
48. See Hill, *Milton*, 171–181.
49. Reinhardt, "Vision's Unseen," 181–184.
50. Bredekamp, "Thomas Hobbes's Visual Strategies," 33.
51. Quoted in Tralau, "Leviathan, the Beast of Myth," 65–69.
52. Sharpe, *In the Wake*, 27; Moten and Harney, *Undercommons*, 93.
53. Rediker, *Slave Ship*, 70.
54. Gordon, *Principles of Naval Architecture*, 23; Rediker, *Slave Ship*, 41.
55. Gordon, *Principles of Naval Architecture*, 83.
56. Casid, *Scenes of Projection*, 15.
57. Mirzoeff, *Right to Look*, 48–76.
58. Ginzburg, "Fear, Reverence, Terror," 9.
59. Quoted in Johnson, *River of Dark Dreams*, 167.
60. Johnson, *River of Dark Dreams*, 246.
61. Handler and Wallman, "Production Activities," 446.
62. Johnson, *River of Dark Dreams*, 157.
63. Johnson, *River of Dark Dreams*, 227.
64. Burnard and Garrigus, *Plantation Machine*, 12–13.
65. Bouton, *Relation de l'Establissement des Francois*, 121.
66. Johnson, *River of Dark Dreams*, 222–224.
67. Quoted in Burnard and Garrigus, *Plantation Machine*, 5.
68. Quoted in Burnard and Garrigus, *Plantation Machine*, 42.
69. James, *Black Jacobins*, 85–86.
70. Johnson, *River of Dark Dreams*, 31–40.
71. Harris, "Whiteness as Property."
72. Linebaugh and Rediker, *Many-Headed Hydra*, 124, 134.
73. Reprinted in Engerman, Drescher, and Paquette, *Slavery*, 106–113.
74. Browne, *Dark Matters*, 78.
75. McCord, *Statutes at Large of South Carolina*, 397.
76. Browne, *Dark Matters*, 79.

CHAPTER 2

1. Morse, "Classics and the Alt-Right."
2. "SP-4402 Origins of NASA Names," 99. *History of NASA*, 99, https://history.nasa.gov/SP-4402/ch4.htm.

3. Casimir, *Haitians*, 306–351.
4. Douglass, "Pictures and Progress," 161.
5. See Gates, *Stony the Road.*
6. Smith "Dürer and Sculpture," 81.
7. Bond, "Why We Need to Start Seeing the Classical World in Color."
8. Greenblatt, *Rise and Fall of Adam and Eve*, 152–162.
9. Milton, *Paradise Lost*, 4:300.
10. Milton, *Paradise Lost*, 92n258–263.
11. Milton, *Paradise Lost*, 9:1115.
12. Milton, *Paradise Lost*, 9:1115–1118.
13. Quilligan, "Theodor De Bry's Voyages," 6.
14. Mignolo, "Crossing Gazes," 179.
15. Adorno, *Guaman Poma*, xvii, xxviii.
16. Mignolo, "Crossing Gazes," 209.
17. Hill, *Milton*, 346.
18. Hill, *Milton*, 127, 346.
19. Hill, *World Turned Upside Down*, 156.
20. Painter, *History of White People.*
21. Rancière, *Politics of Aesthetics.*
22. Winckelmann, *Winckelmann*, 93.
23. Winckelmann, *Winckelmann*, 93.
24. Winckelmann, *Winckelmann*, 107.
25. Michaud, *Barbarian Invasions*, 51, 52.
26. Potts, "Ideal Bodies, in *Flesh and the Ideal,* 162.
27. Brown, *Tacky's Revolt.*
28. See esp. Weheliye, *Habeas Viscus*, 1–17.
29. Meijer, "Bones, Law and Order in Amsterdam," 192.
30. Meijer, "Bones, Law and Order in Amsterdam," 203.
31. Wolfe, *Traces of History*, 8n21.
32. Bindman, *Ape to Apollo*, 211.
33. Hartman, "Venus in Two Acts," 1.
34. Browne, *Dark Matters*, 32.
35. Rediker, *Slave Ship*, 288.
36. Mignolo, *Darker Side*, 183–211.
37. Spillers, *Black and White and in Color*, 206.
38. Scott, *Common Wind.*

39. C. L. R. James, "The Making of the Caribbean People," quoted in Bouteldja, *Whites, Jews, and Us*, 50.

40. Gould, "Geometer of Race."

41. Gould, "Geometer of Race." See Painter, *History of White People*, 43–58.

42. Virey, *Histoire naturelle du genre humain*, 1:146.

43. Virey, *Histoire naturelle du genre humain*, 1:134.

44. Virey, *Histoire naturelle du genre humain, Nouvelle edition*, 1:249.

45. Morton, *Crania Americana*, 12.

46. Nott, "Physical History of the Jews," 106.

47. Quoted in Irmscher, "Agassiz on Evolution," 205.

48. Agassiz, *Etudes sur les glaciers*, 19, 241.

49. Desor, *Excursions et séjours dans les glaciers*, 10.

50. Agassiz, "Discours," xxxi.

51. Agassiz, *Etudes sur les glaciers*, 241.

52. Nott, "Physical History of the Jews," 107.

53. Rogers, *Delia's Tears*, 205; Stauffer, "Not Suitable for Public Notice."

54. Nott et al., *Types of Mankind*, 62.

55. Wallis, "Black Bodies, White Science"; Barbash, Rogers, and Willis, *To Make Their Way in the World*.

56. Rogers, *Delia's Tears*, 281.

57. Quoted in Johnson, *Soul by Soul*, 135.

58. Rogers, *Delia's Tears*, 219.

59. Cartwright, "Report," 693.

60. Cartwright, "Report," 709.

61. Stauffer, "Not Suitable for Public Notice."

62. Quoted in Sheehan, "In a New Light," 12.

63. Stepan, *Picturing Tropical Nature*, 109n67.

64. Dain, *Hideous Monster of the Mind*, 231–237.

65. Nott et al., *Types of Mankind*, 186. Subsequent references are in the text.

66. Douglass, "Pictures and Progress."

67. See Wallace and Smith, *Pictures and Progress*.

68. On slave advertisements, see "A Pretty Pair of Pictures," *Frederick Douglass' Paper*, December 25, 1851. On photography, see "Anecdote Of Daguerre," *Frederick Douglass' Paper*, February 26, 1852. On antislavery picture books, see "Indoctrinate the Children, and When They Grow to Be Men and Women Their Principles Will Be Correct!," *Frederick Douglass' Paper*, September 22, 1854. On J. P. Ball, see "Daguerrian Gallery of the West," *Frederick Douglass' Paper*, May 5, 1854. On beauty, see "The Ministry of the Beautiful," *Frederick Douglass' Paper*, March 16, 1855.

69. See Davis, "Emergence of Immediatism." On modern Christianity, see Wallis, "America's Original Sin."

70. Quoted in the original orthography in Painter, *Sojourner Truth*, 124.

71. Campt, *Black Gaze*, 10, 77–108.

72. Stowe, "Sojourner Truth, the Libyan Sibyl."

73. Quoted in Painter, *Sojourner Truth*, 138.

74. Nott et al., *Types of Man*, 208–209.

75. Quoted in Painter, *Sojourner Truth*, 159.

76. Grigsby, *Enduring Truths*, 63.

77. LaRoche, *Free Black Communities and the Underground Railroad*.

78. Vartanian, "How Do We Photograph Freedom?"

79. Smith, *Works of James McCune Smith*, 25–47.

80. Smith, "Letter from Communipaw."

81. On Smith, see Dain, *Hideous Monster of the Mind*, 239–249; Crane, "Razed to the Knees"; Sinha, "Scientific Racists and Black Abolitionists," 245–247.

82. Smith, "Heads of the Colored People."

83. Douglass, *My Bondage and Freedom*, 161.

84. Smith, "Introduction," in Douglass, *My Bondage and Freedom*, 134, 132.

85. Stauffer, Trodd, and Bernier, *Picturing Frederick Douglass*, 1.

86. Douglass, "Lecture on Pictures," 126.

87. Wexler, "More Perfect Likeness," 37.

88. Douglass, "Lecture on Pictures," 131.

89. N'yongo, *Amalgamation Waltz*, chapter 2.

90. Douglass, "Lecture on Pictures," 129.

91. Savage, *Standing Soldiers, Kneeling Slaves*, 129.

92. Savage, *Standing Soldiers, Kneeling Slaves*, 131.

93. Davis, "Robert E. Lee," 55.

94. Savage, *Standing Soldiers, Kneeling Slaves*, 133–134.

95. Savage, *Standing Soldiers, Kneeling Slaves*, 139.

CHAPTER 3

1. Axelson, "Nearly 30% of Birds in the US, Canada Have Vanished since 1970."

2. See Heise, *Imagining Extinction*; Grusin, *After Extinction*, vii–xx.

3. Locke, *Works of John Locke*, chapter 25 sec. 36, 358.

4. Gómez-Barris, *Extractive Zone*, 6.

5. Audubon, *Writings*, 754 (emphasis in original).

6. Bennett et al., *Collecting, Ordering, Governing*, 9–51.

7. Rader and Cain, *Life on Display*, 8–11.

8. Spencer, *Social Statics*, 409, 416.

9. See Demos, *Beyond the World's End*.

10. Cuvier, *Animal Kingdom*, 17.

11. Cuvier, *Animal Kingdom*, 50.

12. Cuvier, *Recherches sur les ossemens fossiles*, quoted in Gould, *Mismeasure of Man*, 69.

13. Rhodes, *John James Audubon*, 4–5.

14. Audubon, *Writings*, 522.

15. Roberts, *Transporting Visions*, 78–79, 92–93.

16. Partridge, "By the Book."

17. Audubon, *Prospectus*, 8.

18. Despret, *Living as a Bird*.

19. Johnson, *River of Dark Dreams*, 210.

20. Johnson, *River of Dark Dreams*, 209–210.

21. Sharpe, *In the Wake*, 104–112; Fleetwood, *Marking Time*, 34–35, 52–53.

22. Audubon, *Writings*, 47.

23. Audubon, *Writings*, 261.

24. Iannini, *Fatal Revolutions*, 261.

25. Audubon, *Ornithological Biography*, 2:27–32.

26. Diouf, *Slavery's Exiles*, 87.

27. Audubon, *Ornithological Biography*, 2:29.

28. Audubon, *Writings*, 476.

29. Audubon, *Ornithological Biography*, 5:575.

30. For example, Audubon (*Writings*, 455) described how Africans in Louisiana would make "gombo soup" from brown pelicans, of which "they kill all they can find."

31. Roberts, *Transporting Visions*, 186n73.

32. Audubon, *Ornithological Biography*, 2:11.

33. Ritko, *Platypus and the Mermaid*, 11.

34. Buller, *History of the Birds of New Zealand*, 2.

35. Quoted in King, "Where the Buffalo No Longer Roamed."

36. Estes, *Our History Is the Future*, 86, 110.

37. Spiro, *Defending the Master Race*, 62.

38. Quoted in King, "Where The Buffalo No Longer Roamed."

39. See Schivelbusch, *Railway Journey*. See also Mirzoeff, *How to See the World*, 125–141.

40. Maurice, *Cinema and Its Shadow*.

41. Spiro, *Defending the Master Race*, 63.

42. Hicks, *Brutish Museums*, 9.

43. Allen, "Department of Mammals and Birds," 12.

44. Spiro, *Defending the Master Race*, 63–64.

45. Spiro, *Defending the Master Race*, 44–48.

46. Skinner, "Indians of Manhattan Island."

47. See Taylor, *Rise of the American Conservation Movement*, 190–223.

48. Allen, "Present Wholesale Destruction of Bird-Life."

49. Gephart and Ross, "How to Wear the Feather," 200.

50. See Kevles, *In the Name of Eugenics*.

51. Bolles, "Bird Traits," 96. See also Coates, *American Perceptions*.

52. "Notes and News." Her first name is not reported.

53. Osborn, *Creative Education*, 235.

54. Quinn, "Windows on Nature," 88–89.

55. Allen, "Habitat Groups," 166.

56. Quoted in Allen, "Habitat Groups," 174.

57. Allen, "Department of Mammals and Birds," 13.

58. Rader and Cain, *Life on Display*, 8–11.

59. Quoted in Rader and Cain, *Life on Display*, 1.

60. Quoted in Rader and Cain, *Life on Display*, 17.

61. Bennett et al., *Collecting, Ordering, Governing*, 15.

62. Osborn, *Creative Education*, 230.

63. Osborn argued that "the human stock branched off from the common stock, known as the Anthropoides or human-like animals, long before the specialized habits of the man-like apes had profoundly modified their anatomy." Henry Fairfield Osborn Papers, March 2, 1928, box 44, folder 7.

64. Regal, *Henry Fairfield Osborn*, 97.

65. Osborn wrote to Grant that "the aliens are driving the native Americans out of house and home by violation of the prohibition laws. They are becoming enormously rich, buying up property and land all around us, while the Americans are being starved out." Henry Fairfield Osborn Papers, June 27, 1928, box 9, folder 1. In an exchange of letters over a pro-Nazi editorial in *Eugenical News* (January–February 1935), Osborn railed against Jews and claimed "the metempsychosis of Germany is one of the most extraordinary phenomena of modern times." Henry Fairfield Osborn Papers, May 28, 1935, box 44, folder 7.

66. Osborn, *Creative Education*, 268.

67. Osborn, *Hall of the Ages of Man*, i.

68. Regal, *Henry Fairfield Osborn*, 153.

69. Osborn, *Hall of the Ages of Man*, 7.

70. Osborn, *Hall of the Ages of Man*, 19.

71. Rainger, *Agenda for Antiquity*, 147.

72. American Museum of Natural History, *Report of the Trustees for the Year 1926*, 3, 19–20.

73. American Museum of Natural History, *American Museum of Natural History*, 26.

74. Hicks, *Brutish Museums*, 202.

75. Painter, *History of White People*, 245–256.

76. Osborn visited Fraser's studio in 1928, 1929, and 1930. Henry Fairfield Osborn Papers, box 37, folders 9–11.

77. H. C. Pindar memo, October 22, 1935, American Museum of Natural History Archive, box 38, folder 3.

78. See the photographs by Julius Kirchner in the American Museum of Natural History Archive, negative numbers 31490 and 314093.

79. Sullivan, "It's Hard to Get Rid of a Confederate Memorial."

80. Rainger, *Agenda for Antiquity*, 118.

81. Henry Fairfield Osborn Papers, September 14, 1928, box 37, folder 9.

82. Oelsner, "Six Indians."

83. Kaphar, "Can Art Amend History?"

CHAPTER 4

1. Quoted in Barringer, "Landscape Then and Now."

2. Chaudhary, *Afterimage of Empire*, chapter 2.

3. Wilde, "Decay of Lying," 44.

4. Callwell, *Small Wars*, 75; Gopal, *Insurgent Empire*, 48.

5. Quoted in Gopal, *Insurgent Empire*, 54.

6. Edward Thompson (1925), quoted in Gopal, *Insurgent Empire*, 42.

7. Ruskin, *Elements of Perspective*, 3.

8. Ruskin, *Elements of Perspective*, 8–12. For the sight point diagram, see Ruskin, *Elements of Perspective*, 7.

9. Barringer, "Introduction." x

10. Quoted in Gopal, *Insurgent Empire*, 111.

11. Ruskin, *Lectures on Art*, 5. Subsequent references are in the text.

12. Pater, *Renaissance*, 170. See also Pater, *Renaissance*, 169–173.

13. Pater, *Renaissance*, 152.

14. See Denisoff, *Aestheticism and Sexual Parody*, 97–119.

15. Pater, *Renaissance*, 176; Cruise, "Coded Desires," 27.

16. Gandhi, *Affective Communities*.

17. Pater, *Renaissance*, 162.

18. Quoted in Gandhi, *Affective Communities*, 170.

19. Oscar Wilde, *De Profundis*, cited in Frankel, *Annotated Prison Writings*, 153.

20. Gere with Hoskins, *House Beautiful*, 103.

21. Ricketts, *Oscar Wilde*, 33–34; Cruise, "Simeon Solomon."

22. Ricketts, *Oscar Wilde*, 53. The idea is sometimes attributed to Wilde himself. Tydeman and Price, *Wilde: Salome*, 21; Lambourne, *Aesthetic Movement*, 218–219.

23. Wilde, *Dorian Gray*, 1.

24. Vaughan and Vaughan, *Shakespeare's Caliban*, 110.

25. Vaughan and Vaughan, *Shakespeare's Caliban*, 185.

26. Marez, *Drug Wars*, 75.

27. Lewis and Smith, *Oscar Wilde Discovers*, 225.

28. See Ignatiev, *How the Irish Became White*; Carby, "What Is This 'Black' in Irish Popular Culture?"

29. Jacobson, *Whiteness of a Different Color*, 41–43.

30. Jacobson, *Whiteness of a Different Color*, 48–52.

31. Marez, *Drug Wars*, 85–86.

32. Blanchard *Oscar Wilde's America*, 33.

33. Bristow, "Oscar Wilde."

34. Weintraub, "Disraeli and Wilde's Dorian Gray," 22.

35. Quoted in Wyndham, *Sphinx and Her Circle*, 106.

36. Quoted in Said, *Orientalism*, 211.

37. Quoted in Goody, "Murder in Mile End," 463.

38. Evans, "We Are Photographers, Not Mountebanks!"

39. Mahoney, "Michael Field and Queer Community."

40. Vicinus, "Sister Souls."

41. More Adey, MS notes [1896], Clark Library, University of California at Los Angeles.

42. Lucien Pissarro to J. S. L. Bensusan, n.d. [August 4, 1892], Pissarro Family Archive (hereafter PFA).

43. Esther notes the formal creation of the Werewolf group in February. Esther Bensusan, diary for 1891, PFA.

44. Esther Bensusan, diary entry for December 2, 1891, PFA; Ricketts, *List of Books Issued by Messrs Hacon and Ricketts*.

45. Edith Struben to Esther Bensusan, July 12, 1891, PFA. Esther's sister Rica was also in South Africa.

46. Levy, *Reuben Sachs*, 146.

47. Nead, *Victorian Babylon*, 189–203.

48. Levy, *London Plane-Tree*, 36, 42, 48.

49. Gareth Stedman Jones, *Outcast London* (1971), 14, cited in Goody, "Murder in Mile End," 464. See also Walkowitz, *City of Dreadful Delight*.

50. Oscar Wilde, *De Profundis*, cited in Frankel, *Annotated Prison Writings*, 71.

51. McConville, *English Local Prisons*, 187. See also Frankel, *Annotated Prison Writings*, 1–4.

52. Oscar Wilde, "Letter to the Daily Chronicle, 27 May 1897," cited in Frankel, *Annotated Prison Writings*, 305.

53. Quoted in Frankel, *Annotated Prison Writings*, 344n54.

54. Frankel, *Annotated Prison Writings*, 326n15.

55. See Stoneley, "Looking at the Others." Peter Stoneley discovered these photographs in the Berkshire Record Office.

56. See Black Londoners 1800–1900, Equiano Centre, https://www.ucl.ac.uk/equiano -centre/projects/black-londoners-1800-1900.

57. Stoneley, "Looking at the Others," 474.

58. Fleetwood, *Marking Time*, 26.

59. Oscar Wilde, "Reading Gaol," cited in Frankel, *Annotated Prison Writings*, 365.

60. Bailey, "English Prisons," 291.

61. Wray, "Aliens Act 1905," 303.

62. Aliens Act 1905, https://www.legislation.gov.uk/ukpga/1905/13/pdfs/ukpga_1905 0013_en.pdf.

63. Rothenstein, *Men and Memories*, 2:35.

64. Rothenstein, *Men and Memories*, 1:30.

65. Speaight, *William Rothenstein*, 163.

66. Quoted in Speaight, *William Rothenstein*, 163–164.

67. Quoted in Speaight, *William Rothenstein*, 165.

68. Rothenstein, *Men and Memories*, 2:98.

69. Pankhurst, "Forcibly Fed."

70. Paxton, *Stage Rights!*, 151; Simkin, "Jewish League for Woman Suffrage."

71. Iglikowski-Broad, Fox, and Hillel, "Suffragettes, 2012."

72. Emily Davison Lodge, "Sylvia Pankhurst Memorial Lecture," 5.

73. "Window Smashing Campaign," National Archives, https://www.national archives.gov.uk/education/resources/suffragettes-on-file/window-smashing -campaign/.

74. Chapman, "Argument of the Broken Pane," 244.

75. Pankhurst, "Forcibly Fed."

76. Pankhurst, "Forcibly Fed."

77. Stewart, "East End Suffrage Map."

78. National Portrait Gallery, Votes for Women.

79. *Suffragette*, July 31, 1914, quoted in Emily Davison Lodge, "Sylvia Pankhurst Memorial Lecture," 25.

80. Bearman, "Examination of Suffragette Violence," 372.

81. National Archives, "Women to Watch."

82. Emily Davison Lodge, "Sylvia Pankhurst Memorial Lecture," 4.

83. Emily Davison Lodge, "Sylvia Pankhurst Memorial Lecture," 18.

84. Frölich, *Rosa Luxemburg*, 202.

85. Callwell, *Small Wars*, 21.

86. Hicks, *Brutish Museums*, 50.

87. Callwell, *Small Wars*, 148, 40.

88. Du Bois, "African Roots of the War," 711.

89. Du Bois, "African Roots of the War," 708.

90. Marx, *Capital*, 371.

91. Amidon and Krier, "Rereading Male Fantasies," 7; Theweleit, *Male Fantasies*.

92. Freud, *Beyond the Pleasure Principle*, 15.

CHAPTER 5

1. Berger, *Ways of Seeing*.

2. Hall with Schwarz, *Familiar Strangers*, 174 (emphasis in original). Subsequent references are in the text.

3. See Busby and Mason, *No Colour Bar*.

4. Carby, *Imperial Intimacies*, 65–87.

5. Kynaston, *Family Britain 1951–1957*, 100, 455.

6. Olusoga, *Black and British*, 495.

7. Quoted in Foot, *Rise of Enoch Powell*, 18, 1.

8. Kynaston, *Family Britain 1951–1957*, 448.

9. Hall, *Hard Road to Renewal*, 55.

10. Glass, assisted by Pollins, *London's Newcomers*, 51.

11. Foot, *Rise of Enoch Powell*, 27.

12. Glass, assisted by Pollins, *London's Newcomers*, 159.

13. Dawson, *Mongrel Nation*, 27; Green, *Rachman*, 96.

14. Olden, *Murder in Notting Hill*.

15. Olusoga, *Black and British*, 511.

16. Lamming, *Pleasures of Exile*, 12.

17. Lamming, *Pleasures of Exile*, 63, 57.

18. Whiteley, *Art and Pluralism*, 25–27.

19. Moffat, "Horror of Abstract Thought," 98.

20. Sperling, *John Berger*, 20.

21. Lamming, *Pleasures of Exile*, 60.

22. See Jefferson, *Notes on the State of Virginia*.

23. Lamming, *Pleasures of Exile*, 62, 63.

24. Quoted in Laity, "Identity in the East End."

25. Deutscher, "Wandering Jew," 12.

26. Kynaston, *Austerity Britain*, 270.

27. Cited in Lawson, *Passionate Renewal*, 236.

28. Lamming, *Pleasures of Exile*, 64, 74.

29. Quoted in "T. S. Eliot and the Jews."

30. Lamming, *Pleasures of Exile*, 64.

31. Brown, *Migrant Modernism*, 84.

32. Quoted in "T. S. Eliot and the Jews."

33. Deutscher, "Wandering Jew," 13.

34. Lamming, *Pleasures of Exile*, 64, 73.

35. Lamming, *Pleasures of Exile*, 12, 187.

36. Lamming, *Pleasures of Exile*, 81, 82.

37. Litvinoff, *Journey*, 170.

38. Lichtenstein, *Brick Lane*, 26.

39. Litvinoff, *Journey*, xvii.

40. Quoted in Litvinoff, *Journey*, xviii.

41. Litvinoff, *Journey*, 175, 176.

42. Patrick Wright, "Introduction," in Litvinoff, *Journey*, xxix.

43. Litvinoff, *Journey*, 183, xxxii.

44. Schofield and Jones, "Whatever Community Is, This Is Not It," 143.

45. Waters, "Dark Strangers."

46. Hall, "Politics of Adolescence," 3 (emphasis in original).

47. Hall, "Habit of Violence," 4.

48. Hall, "ULR Club," 71.

49. Hall, "ULR Club," 72; Glass, assisted by Pollins, *London's Newcomers*, 213–217.

50. Glass, assisted by Pollins, *London's Newcomers*, 56n11, 196; Hall, "ULR Club," 72.

51. Malik, *Michael de Freitas*, 1.

52. Quoted in Malik, *Michael de Freitas*, 81.

53. Hall, "Politics of Adolescence," 20.

54. Brooke, "Revisiting Southam Street," 465–467.
55. Haworth-Booth, "Where We've Come From," 8.
56. Mayne, "Photography and Realism," 43.
57. Johnson, *This Boy*, 13.
58. Quoted in Feaver, *Lucian Freud*, 21.
59. Quoted in Tóibín, "Falling in Love with Lucian."
60. Johnson, *This Boy*, 13.
61. Brooke, "Revisiting Southam Street," 493.
62. Hall, with et al., *Policing the Crisis*, 386.
63. Hall, "Absolute Beginnings," 23.
64. Moran, "Imagining the Street in Post-War Britain," 169.
65. Mayne, "Photography and Realism," 44.
66. Fanon, *Black Skin*, 91–92.
67. Johnson, *This Boy*, 76, 65.
68. Johnson, *This Boy*, 93–94.
69. Hall, "ULR Club," 72.
70. Litvinoff, *Journey*, 172.
71. Johnson, *This Boy*, 15; Olden, *Murder in Notting Hill*, 121–123.
72. Mayne, "Photography and Realism," 43.
73. Hall, "Absolute Beginnings," 21.
74. MacInnes, *Loving Them Both.*
75. Matera, *Black London*, 215–216.
76. MacInnes, *City of Spades.*
77. Malik, *Michael de Freitas*, 163.
78. MacInnes, *Absolute Beginners*, 242.
79. Hornsey, *Spiv and the Architect*, 257.
80. White, "Police, Press and Race in the Notting Hill Carnival."
81. Hall, *Selected Political Writings*, 200.

CHAPTER 6

1. Barrow, "Bribed Tool of Reactionary Intrigue."
2. Hall, *Hard Road to Renewal*, 39–56.
3. Fanon, *Toward the African Revolution*, 41.
4. Cahen, "Les juifs de la Martinique."
5. *New York Gazette.*
6. Nassy, *Essai Historique*, 2:159–160.

7. Goslinga, *Dutch in the Caribbean*, 236–237.

8. Cundall, *Governors of Jamaica*, 198.

9. Nassy, *Essai Historique*, 2:28.

10. Samuel, *Review of the Jewish Colonists*, 29–33.

11. Da Costa, *Reason and Faith*, 27.

12. Adams, *History of the Jews*, 2:208.

13. James, "What Lessons on Fascism Can We Learn from Africa's Colonial Past?"

14. Padmore, "Fascism in the Colonies."

15. Wilder, *Freedom Time*, 82.

16. Césaire, *Discourse on Colonialism*, 36. Text amended to avoid unnecessary offense.

17. Fanon, *Dying Colonialism*, 157.

18. Fanon, *Black Skin*, 101. Subsequent references are in the text.

19. Sartre, *Anti-Semite and Jew*.

20. Baruk, *Précis de la psychiatrie*, 355, 356, 370, 371–372.

21. Baruk, *Précis de la psychiatrie*, 374, 375 (emphasis in original).

22. Frazer, *Golden Bough*, chapters 57–58.

23. Baruk, *Précis de la psychiatrie*, 376–381.

24. Bhattacharyya et al., *Empire's Endgame*, x.

25. Jean Oury, quoted in Robcis, "François Tosquelles," 212.

26. Robcis, "François Tosquelles," 214–215, 212–214.

27. Invisible Committee, *Coming Insurrection*, 50.

28. Robcis, "Frantz Fanon," 48.

29. Lamming, "Negro Writer and His World," 321, 323.

30. Ngũgĩ, "Freeing the Imagination," 168.

31. Fanon, *Toward the African Revolution*, 38 (translation modified).

32. Quoted in Macey, *Frantz Fanon*, 166.

33. Scott, "Sovereignty of the Imagination," 73.

34. Ngũgĩ, "Freeing the Imagination," 169.

35. Antoine Porot (1939), quoted in Fanon, *Alienation and Freedom*, 407.

36. McCulloch, *Colonial Psychiatry*, 64–76.

37. Frantz Fanon and Jacques Azoulay, "Social Therapy in a Ward of Muslim Men" (1954), in Fanon, *Alienation and Freedom*, 353–371.

38. Marx defined the lumpenproletariat in 1844 as "the rascal, swindler, beggar, the unemployed, the starving, wretched and criminal workingmen—these are figures who do not exist for political economy but only *for other eyes*, those of the doctor, the judge, the grave-digger, and bum-bailiff, etc.; such figures are *spectres* outside its domain." Quoted in Denning "Wageless Life," 1.

39. Fanon, *Wretched of the Earth*, 81.

40. See Mirzoeff, *Right to Look*, 252–256.

41. Fanon, *Wretched of the Earth*, 81, 130.

42. Khanna, "Lumpenproletariat," 135.

43. Khanna, "Lumpenproletariat," 140.

44. Scott, *Art of Not Being Governed*.

45. Fanon, *Alienation and Freedom*, 524.

46. Georgakas and Surkin, *Detroit*, 85–106.

47. See Wang, *Carceral Capitalism*, 56–65.

48. Jackson, "Toward the United Front," 143.

49. Quoted in Worsley, "Frantz Fanon," 222.

50. Fleetwood, *Marking Time*, 15.

51. Hall, with Chritcher et al., *Policing the Crisis*, 370.

52. Hall, "Isaac Julien's Workshop," 227.

53. Worsley, "Frantz Fanon," 224.

54. Cohen, *Folk Devils and Moral Panics*, 10.

55. Cohen, "Moral Panics as Cultural Politics."

56. See https://www.runnymedetrust.org/blog/what-does-it-mean-to-be-british.

CHAPTER 7

1. See https://www.sahistory.org.za/article/wind-change-speech.

2. Claire Fontaine, *Human Strike*, 121.

3. See Sessions, "Entangled Politics."

4. Grabar, "Reclaiming the City," 395.

5. De Boeck and Baloji, *Suturing the City*, 10.

6. de Sousa, "Memory as an Interculturality Booster."

7. See https://arquivos.rtp.pt/conteudos/derrube-estatua-de-mouzinho-de-albuquerque.

8. Siegert, "Art Topples Monuments," 157.

9. Power, "Angola 2025."

10. Parnell and Robinson, "(Re)theorizing Cities," 601.

11. See https://borgenproject.org/cost-of-living-in-angola.

12. Knoppers, "Interview with Kiluanji Kia Henda." https://www.reuters.com/article/uk-africa-sarkozy/africans-still-seething-over-sarkozy-speech-idUKL0513034620070905.

13. Gago, *Feminist International*, 2.

14. Siegert, "Art Topples Monuments," 159.
15. See https://www.reuters.com/article/uk-africa-sarkozy/africans-still-seething-over -sarkozy-speech-idUKL0513034620070905.
16. Fanon, *Wretched of the Earth*, 15 (translation modified).
17. De Boeck and Baloji, *Suturing the City*, 16.
18. Cobb, "Luanda's Monuments," 64.
19. Dlakavu, Ndelu, and Matandela "Writing and Rioting," 105.
20. Publica[c]tion Collective, *Publica[c]tion*, 3.
21. Malaika, *Memoirs of a Born Free*, 4, 113.
22. Kamazi, "Securitization," 9.
23. Francis B. Nyamnjoh's *#RhodesMustFall* is the notable exception.
24. For the student movement perspective, see Gillespie and Naidoo, "Against the Day." To understand the issues within the University of Cape Town, see Mangcu, "Shattering the Myth." For a decolonial account, see Evans, "Unsettled Matters, Falling Flight." For an art historical account of the statue arguing for interventions rather than removal, see Schmahmann, "Fall of Rhodes."
25. Quoted in Nyamnjoh, *#RhodesMustFall*, 40.
26. Transcribed and quoted in van der Wal, "Killing Rhodes," 6.
27. Bester, "Protesters Throw Poo on Rhodes Statue."
28. Feni, *Drain on Our Dignity*.
29. Maxwele, "Black Pain Led Me to Throw Rhodes Poo."
30. Taghavi, "Exploring Fallism."
31. Nkopo, "Of Air. Running. Out," 160.
32. Babe, "There's a Message for City Planners."
33. Nyamnjoh, *#RhodesMustFall*, 77.
34. "Rhodes Must Fall UCT."
35. Pinto, "Creative Women."
36. Jaza, "Our Story to the World."
37. Makgetia, "Inequality in South Africa," 36.
38. Bracking, "Politics of Poverty and Inequality," 79.
39. See Nyamnjoh, *#RhodesMustFall*, 99.
40. GamEdze, "Concerning Shutdowns."
41. Quoted in Pather, "Rhodes Must Fall."
42. Nyamnjoh, *#RhodesMustFall*, 87.
43. Makgetia, "Inequality in South Africa," 15.
44. "FACTSHEET."
45. Allais, "Analysis Must Rise," 152.

46. Gillespie and Naidoo, "#MustFall," 192.

47. Furlong, "Rhodes Must Fall Protestors."

48. "Rhodes Must Fall Statement" (emphasis added).

49. Burnett, "Appreciating #Shackville."

50. Charlie and Duggan, "Shackville Two Years On"; Furlong, "UCT Shackville Protestors."

51. Petersen and Albert, "How Shackville Started a War."

52. Suren Pillay, "Fires This Time."

53. UCT Trans Collective, "Trans Capture Status."

54. "Disrupting the Silencing of Voices."

55. Hendricks, "Rhodes Must Fall Exhibition."

56. "UCT's Maxwele."

57. Naidoo, "Hallucinations." See Gillespie and Naidoo, "Between the Cold War and the Fire," 232.

58. https://www.yanceyrichardson.com/artists/zanele-muholi/featured-workds?view=thumbnails.

59. Muholi, *Somnyama Ngonyama*, 5.

60. Thompson, *Smashing Statues*, 133-136.

61. Nelson and Harold, *Charlottesville 2017*, 22.

62. The relevant page has been removed from the Virginia Department of Historic Resources website, and the National Register of Historic Places has only an outline: https://npgallery.nps.gov/NRHP/AssetDetail?assetID=7f3b2b20-29de-4b29-800d-2a2a806c69e7.

63. Wolfe, *Traces of History*, 77.

64. "Charlottesville: Race and Terror."

65. Quoted in Levenson, "Toppled, but Silent Sam Still Looms."

66. Lancaster, "Lynchings Hidden in the History."

67. Equal Justice Initiative, *Lynching in America*, 41.

68. "Three Negroes Lynched."

69. Ratcliff, "Caddo Confederate Monument."

70. Vandal, "Bloody Caddo."

71. Hill, "History and Enduring Legacy of Bloody Caddo."

72. Patterson, "Caddo's Confederate Statue."

73. https://www.ksla.com/2022/03/31/crews-begin-removal-caddo-confederate-monument-2022.

74. Hammel, "Judge Rejects 14th Amendment Claim."

75. Virno, "Interview with Brandon W. Joseph," 34.

76. Waller, "Charlottesville Can Remove Confederate Statues."

CHAPTER 8

1. Cohen, *Body Worth Defending*.
2. Walcott, *Long Emancipation*, 19.
3. See Feagin, *The White Racial Frame*.
4. Buchanan, Bui, and Patel, "Black Lives Matter."
5. Cohen, *Body Worth Defending*.
6. Neocleous, *Critical Theory of Police Power*, 73.
7. Cubitt, *Anecdotal Evidence*, 223–247.
8. Marshall Project, "State-by-State Look."
9. Long Term Care Community Coalition, "New York COVID-19 Fatality Data."
10. New York City, "COVID-19 Data."
11. Hale, "Economic Impact of COVID-19."
12. Barry, "Black people Dying from Coronavirus."
13. Times Editorial Board, "Editorial."
14. Mauger and LeBlanc, "Trump Tweets 'Liberate Michigan.'"
15. Pickford, "Leadership by Insult."
16. "Photos of the Month: April."
17. On the colonial origins of these prejudices, see Wray, *Not Quite White*, 25–26.
18. Walker, "More Than 80 Percent Support National Stay-at-Home Order."
19. Pew Research Center. "Most Americans Say Trump Was Too Slow."
20. Murray, "In New Poll."
21. Vessey, News 12.
22. Mack, "Woman at an Anti-Lockdown Protest."
23. Mukherjee, "Humboldt County Coronavirus."
24. Kemp, "At the Courthouse."
25. Relman, "Trump Shares Tweet."
26. Pulitzer Prizes, "Darnella Frazier."
27. See George Floyd Global Memorial, https://www.georgefloydglobalmemorial.org.
28. Sharpe, *In the Wake*, 117.
29. Benjamin, "Concept of History."
30. Schulman, *Let the Record Show*, 319–323.
31. Crimp, "Mourning and Militancy."
32. Vitale, *End of Policing*, xx.
33. Lipsitz, *How Racism Takes Place*, 3.
34. Chammah and Aspinwall, "Short, Fraught History."
35. Lavin, "Behind the 'Thin Blue Line' Flag."

36. Cubitt, *Anecdotal Evidence*, 265.

37. For details, see Fryd, *Art and Empire*.

38. Fleetwood, *Marking Time*, 260.

39. Sharpe, *In the Wake*, 106.

40. Hall, *Selected Writings on Race and Difference*, 338

41. "Kazimir Malevich."

42. Akomfrah, *Five Murmurations*.

43. Enwezor, "Wreck of Utopia," 86.

44. Hartman, *Wayward Girls,* 231, 348; Moten, Harney, and Shukaitis, "Refusing Completion."

45. Pearce et al., "Role of Projection," 10423.

46. Vallee, "Animal, Body, Data," 87, 86.

47. Audubon, *Writings*, 263, 262.

48. Coates, *American Perceptions*, 62–64.

49. Leonard, "Starling Success."

50. Vallee, "Animal, Body, Data," 94.

51. See http://birdsarentreal.com.

52. Olmsted, *Journey*, 191–194.

53. See Parikka, *Insect Media*; Tsing, *Mushroom*.

54. Parreñas, *Decolonizing Extinction*, 6.

55. Wolfe, *Moa*, 181.

56. Buller, *History of the Birds of New Zealand*, 2, 34, 136.

ACKNOWLEDGMENTS

1. Lewis, "Vision and Justice"; Hicks, *Brutish Museums*; Fleetwood, *Marking Time*.

BIBLIOGRAPHY

Adams, Hannah. *A History of the Jews.* 2 vols. Boston: John Elliot Jr., 1812.

Adorno, Rolena. *Guaman Poma: Writing and Resistance in Colonial Peru.* Austin: University of Texas Press, 2000.

Agassiz, Louis. "Discours." *Actes de la Société helvétique des sciences naturelles.* Neuchâtel, Switzerland: Imprimerie de Petitpierre, 1837.

Agassiz, Louis. *Études sur les glaciers.* Neuchâtel, Switzerland: Ol. Petitpierre, 1840.

Akomfrah, John. *Five Murmurations.* Lisson Gallery, 2021. https://www.lissongallery.com/exhibitions/john-akomfrah-84102347-34ef-491a-84fc-46a5e071d352.

Akomfrah, John. *The Unfinished Conversation.* Smoking Dogs Films, 2012.

Allais, Stephanie. "Analysis Must Rise: A Political Economy of Falling Fees." In *New South Africa Review 6: The Crisis of Inequality*, edited by Gilbert M. Khadiagala, Sarah Mosoetsa, Devan Pillay, and Roger Southall, 152–166. Johannesburg: Wits University Press, 2018.

Allen, J. A. "Department of Mammals and Birds." *American Museum of Natural History Annual Report of the Trustees, Act of Incorporation, Constitution, By-Laws and Lists of Members for the Year 1887–88.* New York: American Museum of Natural History, 1888.

Allen, J. A. "The Habitat Groups of North American Birds in the American Museum of Natural History." *Auk* 26, no. 2 (April 1909): 165–174.

Allen, J. A. "The Present Wholesale Destruction of Bird-Life in the United States." *Science* 7, no. 160 (1886): 191–195.

American Museum of Natural History. *American Museum of Natural History: Seventy-Second Annual Report for the Year 1939.* New York: American Museum of Natural History, 1940.

American Museum of Natural History. *Fifty Eighth Annual Report of the Trustees for the Year 1926—The American Museum of Natural History.* New York: American Museum of Natural History, 1927.

Amidon, Kevin S., and Daniel A. Krier. "Rereading Male Fantasies." *Men and Masculinities* 11, no. 4 (2009): 488–496.

Anderson, Sean, and Mabel O. Wilson, "Introduction." In *Reconstructions: Architecture and Blackness in America*, edited by Sean Anderson and Mabel O. Wilson, 14–23. New York: Museum of Modern Art, 2021.

Attar, Farid Ud-Din. *The Conference of Birds*. New York: Penguin, 2011.

Audubon, John James. *Ornithological Biography: Or, an Account of the Habits of the Birds of the United States of America*. 5 vols. Edinburgh: Adam and Charles Black, 1843.

Audubon, John James. *Prospectus: Birds of America*. Edinburgh: Adam Black, 1831.

Audubon, John James. *Writings and Drawings*. Edited by Christopher Irmscher. New York: Library of America, 1999.

Axelson, Gustave. "Nearly 30% of Birds in the US, Canada Have Vanished since 1970." September 19, 2019. https://news.cornell.edu/stories/2019/09/nearly-30-birds-us-canada -have-vanished-1970.

Babe, Ann. "There's a Message for City Planners in Cape Town Plumbing Poll." *Next City*, September 26, 2016. https://nextcity.org/features/view/khayelitsha-cape-town -toilets-plumbing-poverty-data-collection.

Bailey, Victor. "English Prisons, Penal Culture, and the Abatement of Imprisonment, 1895–1922." *Journal of British Studies* 36, no. 3 (1997): 285–324.

Baldwin, James. *Collected Essays*. New York: Library of America, 2008.

Barbash, Ilisa, Molly Rogers, and Deborah Willis, eds. *To Make Their Own Way in the World: The Enduring Legacy of the Zealy Daguerreotypes*. Cambridge, MA: Peabody Museum Press, 2020.

Barker, Joanne. *Native Acts: Law, Recognition, and Cultural Authority*. Durham, NC: Duke University Press, 2011.

Barlow, Clare, ed. *Queer British Art: 1861–1967*. London: Tate, 2017.

Barringer, Tim. "Introduction—John Ruskin: Seer of the Storm-Cloud." In *Unto This Last: Two Hundred Years of John Ruskin*, edited by Tim Barringer, with Tara Contractor, Victoria Hepburn, Judith Stapleton, and Courtney Skipton Long, 13–29. New Haven, CT: Yale Center for British Art, 2019.

Barringer, Tim. "Landscape Then and Now." *British Art Studies* 10 (September 2018). https://dx.doi.org/10.17658/issn.2058-5462/issue-10/tbarringer.

Barrow, Clyde W. "A Bribed Tool of Reactionary Intrigue: Black Panther Ideology and the Rise of a White Lumpenproletariat." *New Political Science* 42, no. 3 (2020): 435–442.

Barry, Judith Barfield. "Black People Dying from Coronavirus at Much Higher Rates in Cities across the USA." *USA Today*, April 7, 2020. https://www.usatoday.com /story/news/nation/2020/04/07/who-dying-coronavirus-more-black-people-die-major -cities/2961323001.

Baruk, Henri. *Précis de la psychiatrie*. Paris: Masson, 1950.

Baur, Erwin, Eugen Fischer, and Fritz Lenz. *Human Heredity*. Translated by Eden and Cedar Paul. 3rd ed. New York: Macmillan, 1931.

Bearman, C. J. "An Examination of Suffragette Violence." *English Historical Review* 120, no. 486 (April 2005): 365–397.

Beckert, Sven, and Seth Rockman, eds. *Slavery's Capitalism: A New History of American Economic Development*. Philadelphia: University of Pennsylvania Press, 2016.

Beckles, Hilary McD. "Kalinago (Carib) Resistance to European Colonisation of the Caribbean." *Caribbean Quarterly* 54, no. 4 (December 2008): 77–94.

Beller, Jonathan. *The World Computer: Derivative Conditions of Racial Capitalism*. Durham, NC: Duke University Press, 2021.

Benjamin, Ruha. "Discriminatory Design, Liberating Imagination." In *Captivating Technology: Race, Carceral Technoscience, and Liberatory Imagination in Everyday Life*, edited by Ruha Benjamin, 1–24. Durham, NC: Duke University Press, 2019.

Benjamin, Walter. "On the Concept of History" (1940). Translated by Lloyd Spencer. https://www.sfu.ca/~andrewf/CONCEPT2.html.

Bennett, Tony, Fiona Cameron, Nélia Dias, Ben Dibley, Rodney Harrison, Ira Jacknis, and Conal McCarthy. *Collecting, Ordering, Governing: Anthropology, Museums, and Liberal Government*. Durham, NC: Duke University Press, 2017.

Berger, John. *Ways of Seeing*. Harmondsworth, UK: Pelican, 1972.

Berger, Martin A. *Sight Unseen: Whiteness and American Visual Culture*. Berkeley: University of California Press, 2005.

Berger, Maurice. *White Lies: Race and the Myths of Whiteness*. New York: Farrar, Straus and Giroux, 1999.

Berger, Maurice, and Thulani Davis. *For All the World to See: Visual Culture and the Struggle for Civil Rights*. New Haven, CT: Yale University Press, 2010.

Berger, Susanna. *Art of Philosophy: Visual Thinking in Europe from the Late Renaissance to the Early Enlightenment*. Princeton, NJ: Princeton University Press, 2017.

Bester, Junior. "Protesters Throw Poo on Rhodes Statue." *IOL*, March 10, 2015. https://www.iol.co.za/news/south-africa/western-cape/protesters-throw-poo-on-rhodes-statue-1829526#.VR4nLZTF_FJ.

Bhattacharyya, Gargi, Adam Elliott-Cooper, Sita Balani, Kerem Nişancıoğlu, Kojo Koram, Dalia Gebrial, Nadine El-Enany, and Luke De Noronha. *Empire's Endgame: Racism and the British State*. London: Pluto Press, 2021.

Bindman, David. *Ape to Apollo: Aesthetics and the Idea of Race in the 18th Century*. London: Reaktion Books, 2002.

Blanchard, Mary Warner. *Oscar Wilde's America: Counterculture in the Gilded Age*. New Haven, CT: Yale University Press, 1988.

Blight, Daniel. *The Image of Whiteness: Contemporary Photography and Racialization*. London: SPBH Editions, 2019.

Bolles, Frank. "Bird Traits." *New England Magazine* 13, no. 1 (September 1892): 93–96.

Bond, Sarah E. "Why We Need to Start Seeing the Classical World in Color." Hyperallergic, June 7, 2017. https://hyperallergic.com/383776/why-we-need-to-start-seeing-the-classical-world-in-color.

Bosse, Abraham. *Le peintre converty aux précises et universelles regles de son art: sentiments sur la distiction des diverses manières de peinture, dessin et gravure.* Edited by Roger-Armand Weigert. Paris: Hermann, 1964. First published 1663.

Bouteldja, Houria. *Whites, Jews, and Us: Toward a Politics of Revolutionary Love.* Los Angeles: Semiotext(e), 2015.

Bouton, Jacques. *Relation de l'Establissement des François depuis l'an 1635 en l'isle de la Martinique.* Paris: Sebastien Cramoisy, 1640.

Bracking, Sarah. "The Politics of Poverty and Inequality in South Africa: Connectivity, Abjections and the Problem of Measurement." In *New South Africa Review 6: The Crisis of Inequality*, edited by Gilbert M. Khadiagala, Sarah Mosoetsa, Devan Pillay, and Roger Southall, 66–83. Johannesburg: Wits University Press, 2018.

Bratton, William J., and George L. Kelling. "Why We Need Broken Windows Policing." *City Journal* (Winter 2015). https://www.city-journal.org/html/why-we-need-broken-windows-policing-13696.html.

Bredekamp, Horst. "Thomas Hobbes's Visual Strategies." In *The Cambridge Companion to Hobbes's* Leviathan, edited by Patricia Springborg, 29–60. Cambridge University Press, 2007.

Brege, Brian. 2017. "Renaissance Florentines in the Tropics: Brazil, the Grand Duchy of Tuscany, and the Limits of Empire." In *The New World in Early Modern Italy, 1492–1750*, edited by Elizabeth Horodowich and Lia Markey, 206–222. Cambridge: Cambridge University Press, 2017.

Bristow, Joseph. "Oscar Wilde: The Pennington Portrait." In *Queer British Art: 1867–1967*, edited by Clare Barlow, 60–61. London: Tate, 2017.

Bromwich, Jonah, and Ed Shanahan. "Amy Cooper, White Woman Who Called 911 on Black Birder, Sues over Firing." *New York Times*, May 26, 2021. https://www.nytimes.com/2021/05/26/nyregion/amy-cooper-suing-racial-discrimination.html.

Brooke, Stephen. "Revisiting Southam Street: Class, Generation, Gender, and Race in the Photography of Roger Mayne." *Journal of British Studies* 53, no. 2 (April 2014): 453–496.

brown, adrienne maree. *Emergent Strategy: Shaping Change, Shaping Worlds.* Chico, CA: AK Press, 2017.

Brown, J. Dillon. *Migrant Modernism: Postwar London and the West Indian Novel.* Charlottesville: University of Virginia Press, 2013.

Brown, Vincent. *Tacky's Revolt: The Story of an Atlantic Slave War.* Cambridge, MA: Harvard University Press, 2020.

Browne, Simone. *Dark Matters: On the Surveillance of Blackness*. Durham, NC: Duke University Press, 2016.

Buchanan, Larry, Quoctrung Bui, and Jugal K. Patel, "Black Lives Matter May Be the Largest Movement in US History." *New York Times*, July 3, 2020. https://www.nytimes .com/interactive/2020/07/03/us/george-floyd-protests-crowd-size.html.

Buck-Morss, Susan. *Hegel, Haiti, and Universal History*. Pittsburgh: University of Pittsburgh Press, 2009.

Buller, Walter Lowry. *A History of the Birds of New Zealand*. London: John van Voorst, 1873.

Burkhart, Charles. *Ada Leverson*. New York: Twayne, 1973.

Burnard, Trevor, and John Garrigus. *The Plantation Machine: Atlantic Capitalism in French Saint-Domingue and British Jamaica*. Philadelphia: University of Pennsylvania Press, 2016.

Burnett, Scott. "Appreciating #Shackville. *South African*, February 19, 2016. https:// www.thesouthafrican.com/opinion/appreciating-shackville/.

Busby, Margaret, and and Beverley Mason, eds. *No Colour Bar: Black British Art in Action 1960–1990*. London: Friends of the Huntley Archives at London Metropolitan Archives, 2018.

Butterfield-Rosen, Emmelyne. "Men Are Dogs: Titian's *Poésie* for Philip II," *Artforum* 60, no. 8 (April 2022).

Cahen, Abraham. "Les juifs de la Martinique au XVIIème siècle." In *Revue des Études Juives*, 114–121. Tome deuxième. Paris: A. Durlacher, 1881.

Callahan, Manolo, and Annie Paradise. "Fierce Care: Politics of Care in the Zapatista Conjuncture." December 2017. https://transversal.at/blog/Fierce-Care.

Callwell, C. E. *Small Wars*. 3rd ed. London: War Office, 1906.

Campt, Tina M. *A Black Gaze*. Cambridge, MA: MIT Press, 2021.

Campt, Tina M. *Listening to Images*. Durham, NC: Duke University Press, 2017.

Carby, Hazel V. *Imperial Intimacies: A Tale of Two Islands*. New York: Verso, 2019.

Carby, Hazel V. "What Is This 'Black' in Irish Popular Culture?" *European Journal of Cultural Studies* 4, no. 3 (2001): 325–349.

Cartwright, Samuel. "Report on the Diseases and Physical Peculiarities of the Negro Race." *New Orleans Medical and Surgical Journal* (May 1851): 693–709.

Casid, Jill. *Scenes of Projection: Recasting the Enlightenment Subject.* Minneapolis: University of Minnesota Press, 2015.

Casimir, Jean. *The Haitians: A Decolonial History*. Translated by Laurent Dubois. Chapel Hill: University of North Carolina Press, 2020.

Césaire, Aimé. *Discourse on Colonialism*. Translated by Joan Pinkham. Introduction by Robin D. G. Kelley. New York: Monthly Review Press, 2000.

Chamayou, Grégoire. *Drone Theory*. London: Penguin, 2015.

Chammah, Maurice, and Cary Aspinwall. "The Short, Fraught History of the 'Thin Blue Line' American Flag." *Politico*, June 9, 2020. https://www.politico.com/news /magazine/2020/06/09/the-short-fraught-history-of-the-thin-blue-line-american-flag -309767.

Chantiluke, Roseanne, Brian Kwoba, and Athinangamso Nkopo, eds. *Rhodes Must Fall: The Struggle to Decolonize the Racist Heart of Empire*. London: Zed Books, 2018.

Chapman, Jane. "Argument of the Broken Pane." *Media History* 21, no. 3 (2015): 238–251.

Charlie, Ayanda, and Leila Duggan. "Shackville Two Years On." *Daily Maverick*, February 22, 2018. https://www.dailymaverick.co.za/article/2018-02-28-no-filter-volume-4 -shackville-two-years-on-a-perspective-from-the-student-who-graduated.

"Charlottesville: Race and Terror—VICE News Tonight on HBO." YouTube, August 14, 2017. https://youtu.be/RIrcB1sAN8I.

Chaudhary, Zahid R. *Afterimage of Empire: Photography in Nineteenth-Century India*. Minneapolis: University of Minnesota Press, 2012.

Claire Fontaine. *Human Strike and the Art of Creating Freedom*. Los Angeles: Semiotext(e), 2020.

Coates, Peter. *American Perceptions of Immigrant and Invasive Species: Strangers on the Land*. Berkeley: University of California Press, 2007.

Cobb, Daniel. "Luanda's Monuments." In *The Johannesburg Salon*, edited by Achille Mbembe and Megan Jones, 58–66. Johannesburg: Johannesburg Workshop in Theory and Criticism, 2014.

Cohen, Ed. *A Body Worth Defending: Immunity, Biopolitics, and the Apotheosis of the Modern Body*. Durham, NC: Duke University Press, 2009.

Cohen, Stanley. *Folk Devils and Moral Panics*. 2nd ed. New York: St. Martin's, 1980.

Cohen, Stanley. "Moral Panics as Cultural Politics: Introduction to the Third Edition." *Folk Devils and Moral Panics*. 3rd ed. Abingdon, UK: Routledge, 2002.

Cordova, Ruben. "Apollo and Daphne: A Tale of Cupid's Revenge Told by Ovid and Bernini." Glasstire: Texas Visual Art, February 8, 2021. https://glasstire.com/2021/02/08 /cupids-revenge-apollo-and-daphne-by-ovid-and-bernini/.

Couldry, Nick, and Ulises A. Mejias. "Data Colonialism: Rethinking Big Data's Relation to the Contemporary Subject." *Television and New Media* 20, no. 4 (2019).

Crane, Jacob. "'Razed to the Knees': The Anti-Heroic Body in James McCune Smith's 'The Heads of Colored People.'" *African American Review* 51, no. 1 (Spring 2018): 7–21.

Crimp, Douglas. "Mourning and Militancy." *October* 51 (Winter 1989): 3–18.

Cruise, Colin. "Coded Desires." In *Queer British Art: 1867–1967*, edited by Clare Barlow, 24–47. London: Tate, 2017.

Cruise, Colin. "Simeon Solomon." In *Queer British Art: 1867–1967*, edited by Clare Barlow, 30–35. London: Tate, 2017.

Cubitt, Sean. *Anecdotal Evidence: Ecocritique from Hollywood to the Mass Image*. New York: Oxford University Press, 2020.

Cundall, Frank. *The Governors of Jamaica in the First Half of the Eighteenth Century*. London: West India Committee, 1937.

Cuvier, Georges. *Recherches sur les ossemens fossiles*. Vol. 1. Paris: Deterville, 1812.

Cuvier, Georges. *The Animal Kingdom: Arranged in Conformity with Its Organization*. Translated by H. M'Murtrie. New York: Carvill, 1832. First published 1816.

Da Costa, Joshua Hezekiah. *Reason and Faith: or, Philosophical Absurdities and the Necessity of Revelation*. Philadelphia: F. Bailey, 1791. First published 1788.

Dain, Bruce. *A Hideous Monster of the Mind: American Race Theory in the Early Republic*. Cambridge, MA: Harvard University Press, 2003.

Damisch, Hubert. *The Origin of Perspective*. Translated by John Goodman. Cambridge, MA: MIT Press, 1995.

Davis, David Brion. "The Emergence of Immediatism in British and American Antislavery Thought." *Mississippi Valley Historical Review* 49, no. 2 (September 1962): 209–230.

Davis, Jefferson. "Robert E. Lee." *North American Review* 150, no. 398 (January 1890): 55.

Davis, Mark, Paul Flowers, Davina Lohm, Emily Waller, and Niamh Stephenson. "Immunity, Biopolitics and Pandemics: Public and Individual Responses to the Threat to Life." *Body and Society* 22, no. 4 (2016): 130–154.

Dawson, Ashley. *Mongrel Nation: Diasporic Culture and the Making of Postcolonial Britain*. Ann Arbor: University of Michigan Press, 2007.

De Boeck, Filip, and Sammy Baloji. *Suturing the City: Living Together in Congo's Urban Worlds*. London: Autograph, 2016.

Deer, Sarah. *The Beginning and End of Rape: Confronting Sexual Violence in Native America*. Minneapolis: University of Minnesota Press, 2015.

Demos, T. J. *Beyond the World's End: Arts of Living at the Crossing*. Durham, NC: Duke University Press, 2020.

Denisoff, Dennis. *Aestheticism and Sexual Parody 1840–1940*. Cambridge: Cambridge University Press, 2001.

Denning, Michael. "Wageless Life." *New Left Review* 66 (November–December 2010): 79–97.

Desargues, Girard. *Exemple de l'une des manières universelles de S.G.D.L. touchant la pratique de perspective, sans employer aucun tiers point de distance ni d'autre nature qui sont hors du champ d'ouvrage*. Paris, 1636.

Desor, Édouard. *Excursions et séjours dans les glaciers et les hautes régions des Alpes de M. Agassiz*. Neuchâtel, Switzerland: J-J Kissling, 1844.

de Sousa, Vitor. "Memory as an Interculturality Booster in Maputo, through the Preservation of the Colonial Statuary." *Buala* (December 13, 2020). https://www.buala .org/en/city/memory-as-an-interculturality-booster-in-maputo-through-the-preserva tion-of-the-colonial-statua.

Despret, Vinciane. *Living as a Bird*. Cambridge, UK: Polity Press, 2022.

Deutscher, Isaac. "The Wandering Jew as Thinker and Revolutionary." *Universities and Left Review* no. 4 (Summer 1958): 12–13.

Diouf, Sylviane A. *Slavery's Exiles: The Story of the American Maroons*. New York: NYU Press, 2011.

"Disrupting the Silencing of Voices." *Journalist*, March 29, 2016. http://www.thejournal ist.org.za/art/disrupting-the-silencing-of-voices.

Dlakavu, Simamkele, Sandile Ndelu, and Mbali Matandela. "Writing and Rioting: Black Womxn in the Time of Fallism." *Agenda* 31, no. 3–4 (2017): 105–109.

Douglass, Frederick. "Lecture on Pictures" (1861). In *Picturing Frederick Douglass: An Illustrated Biography of the Nineteenth Century's Most Photographed American*, edited by John Stauffer, Zoe Trodd, and Celeste-Marie Bernier, 126–141. New York: W. W. Norton, 2015.

Douglass, Frederick. *My Bondage and Freedom* (1855). In *Frederick Douglass: Autobiographies*, edited by Henry Louis Gates Jr. New York: Library of America, 1994.

Douglass, Frederick. "Pictures and Progress" (1864–1865). In *Picturing Frederick Douglass: An Illustrated Biography of the Nineteenth Century's Most Photographed American*, edited by John Stauffer, Zoe Trodd, and Celeste-Marie Bernier, 161–173. New York: W. W. Norton, 2015.

Downey, Anthony. "The Algorithmic Apparatus of Neo-Colonialism: Or, Can We Hold 'Operational Images' to Account?" *Nordic Journal of Aesthetics* 30, no. 61–61 (2021): 78–82.

Draper, Susana. "Strike as Process: Building the Poetics of a New Feminism." *South Atlantic Quarterly* 117, no. 3 (July 2018): 682–691.

D'Souza, Aruna. *Whitewalling: Art, Race, and Protest in 3 Acts*. New York: Badlands Unlimited, 2018.

Du Bois, W. E. B. "The African Roots of the War." *Atlantic Monthly* 115, no. 5 (May 1915): 707–714.

Du Bois, W. E. B. *Black Reconstruction in America, 1860–1880*. New York: Russell, 1935.

Du Bois, W. E. B. "The Souls of White Folk." In *Darkwater: Voices from within the Veil*, 17–29. New York: Washington Square Press, 1920.

Dubrovsky, Nika, and David Graeber. "Another Art World, Part 3: Policing and Symbolic Order." *e-flux* 113 (November 2020). https://www.e-flux.com/journal/113/360192/another-art-world-part-3-policing-and-symbolic-order.

Du Tertre, Jean-Baptiste. *Histoire générale des Antilles habitées par les François*. 4 vols. Paris, 1667–1671.

Dyer, Richard. *White*. New York: Routledge, 1997.

Emily Davison Lodge. "Sylvia Pankhurst Memorial Lecture." Wortley Hall, August 2014. Edited transcript. http://sylviapankhurst.gn.apc.org/2014%20lecture%20for%20website.pdf.

Engerman, Stanley L., Seymour Drescher, and Robert L. Paquette, eds. *Slavery*. New York: Oxford University Press, 2001.

Enwezor, Okwui. "The Wreck of Utopia." In *John Akomfrah: Signs of Empire*, 82–91. New York: New Museum, 2018.

Equal Justice Initiative. *Lynching in America: Confronting the Legacy of Racial Terror*. 3rd ed. Montgomery, AL: Equal Justice Initiative, 2017.

Equiano, Olaudah. *The Interesting Narrative of the Life of Olaudah Equiano, or Gustavus Vassa, the African*. London, 1789. https://www.gutenberg.org/files/15399/15399-h/15399-h.htm#CHAP_V.

Estes, Nick. *Our History Is the Future: Standing Rock versus the Dakota Access Pipeline and the Long Tradition of Indigenous Resistance*. New York: Verso, 2019.

Evans, Elizabeth F. "'We Are Photographers, Not Mountebanks!' Spectacle, Commercial Space, and the New Public Woman." In *Amy Levy: Critical Essays*, edited by Naomi Hetherington and Nadia Valman, 25–46. Athens: Ohio University Press, 2010.

Evans, Joanna Ruth. "Unsettled Matters, Falling Flight: Decolonial Protest and the Becoming-Material of an Imperial Statue." *TDR: The Drama Review* 62, no. 3 (239) (September 1, 2018): 130–144.

"FACTSHEET: Funding and the Changing Face of South Africa's Public Universities." Africa Check, October 26, 2016. https://africacheck.org/factsheets/factsheet-funding-changing-face-sas-public-universities.

Fanon, Frantz. *Alienation and Freedom*. Edited by Jean Khalfa and Robert J. C. Young. Translated by Steven Corcoran. New York: Bloomsbury, 2018.

Fanon, Frantz. *Black Skin, White Masks*. Translated by Richard Philcox. New York: Grove, 2008.

Fanon, Frantz. *A Dying Colonialism*. Translated by Haakon Chevalier. New York: Grove, 1965.

Fanon, Frantz. "Racisme et culture." *Présence Africaine*, nouvelle série, no. 8–10 (June–November 1956): 122–131.

Fanon, Frantz. *Toward the African Revolution*. Translated by Haakon Chevalier. New York: Grove, 1967.

Fanon, Frantz. *The Wretched of the Earth*. Translated by Richard Philcox. New York: Grove, 2004.

Feagin, Joe. *The White Racial Frame: Centuries of Racial Framing and Counter-Framing*, 3rd ed. New York: Routledge, 2020.

Feaver, William. *Lucian Freud*. London: Tate, 2002.

Federici, Silvia. *Caliban and the Witch: Women, the Body and Primitive Accumulation*. 2nd ed. Brooklyn: Autonomedia, 2014.

Feeser, Andrea. *Red, White, and Black Make Blue: Indigo in the Fabric of Colonial South Carolina Life*. Athens: University of Georgia Press, 2013.

Feni, Maxisole. *A Drain on Our Dignity: A Perspective*. Auckland Park: Jacana Media, 2017.

Fischer, Eugen. "Racial Differences in Mankind." In *Human Heredity*, edited by Erwin Baur, Eugen Fischer, and Fritz Lenz. Translated by Eden and Cedar Paul. 3rd ed. New York: Macmillan, 1931.

Fitch, Andy. "Plural Experiments and Experiences: Talking to Michael Hardt." *BLARB*, March 30, 2018. https://blog.lareviewofbooks.org/interviews/plural-experiments-experiences-talking-michael-hardt.

Fleetwood, Nicole. *Marking Time: Art and Mass Incarceration*. Cambridge MA: Harvard University Press, 2020.

Foot, Paul. *The Rise of Enoch Powell*. Harmondsworth, UK: Penguin, 1969.

Foucault, Michel. *Security, Territory, Population: Lectures at the Collège de France 1977–1978*. Translated by Graham Burchell. New York: Palgrave Macmillan, 2007.

Frankel, Nicholas. *The Annotated Prison Writings of Oscar Wilde*. Cambridge, MA: Harvard University Press, 2018.

Frazer, Sir James. *The Golden Bough*. London: Penguin, 1996.

Freud, Sigmund. *Beyond the Pleasure Principle*. Translated by James Strachey. New York: W. W. Norton, 1961.

Friedberg, Anne. *The Virtual Window*. Cambridge MA: MIT Press, 2006.

Frölich, Paul. *Rosa Luxemburg*. Translated by Johana Hoornweg. Chicago: Haymarket Press, 2010.

Fryd, Vivien Green. *Art and Empire: The Politics of Ethnicity in the United States Capitol, 1815–1860*. New Haven, CT: Yale University Press, 1992.

Furlong, Ashleigh. "Rhodes Must Fall Protestors Burn UCT Art." *Ground Up*, February 17, 2016. https://www.groundup.org.za/article/rhodes-must-fall-protesters-destroy-uct-artworks.

Furlong, Ashleigh. "UCT Shackville Protestors Effectively Expelled." *Ground Up*, May 12, 2016. https://www.groundup.org.za/article/uct-shackville-protesters-effectively-expelled.

Gago, Verónica. *Feminist International: How to Change Everything*. Translated by Liz Mason-Deese. New York: Verso, 2020.

GamEdze. "Concerning Shutdowns." In *Publica[c]tion*, edited by Publica[c]tion Collective, 21. Johannesburg: Publica[c]tion Collective, 2016.

Gandhi, Leela. *Affective Communities: Anticolonial Thought, Fin-de-Siècle Radicalism, and the Politics of Friendship*. Durham, NC: Duke University Press, 2006.

Gates, Henry Louis, Jr. *Stony the Road: Reconstruction, White Supremacy, and the Rise of Jim Crow*. New York: Penguin, 2019.

Georgakas, Dan, and Marvin Surkin. *Detroit: I Do Mind Dying. A Study in Urban Revolution*. Chicago: Haymarket Books.

Gephart, Emily, and Michael Ross. "How to Wear the Feather: Bird Hats and Ecocritical Aesthetics." In *Ecocriticism and the Anthropocene in Nineteenth-Century Art and Visual Culture*, edited by Maura Coughlin and Emily Gephart, 192–207. New York: Taylor and Francis, 2019.

Gere, Charlotte, with Lesley Hoskins. *The House Beautiful: Oscar Wilde and the Aesthetic Interior*. London: Lund Humphries and the Geffrye Museum, 2000.

Gillespie, Kelly, and Leigh-Ann Naidoo, eds. "Against the Day." *South Atlantic Quarterly* 118, no. 1 (January 2019).

Gillespie, Kelly, and Leigh-Ann Naidoo. "Between the Cold War and the Fire: The Student Movement, Antiassimilation, and the Question of the Future in South Africa. *South Atlantic Quarterly* 118, no. 1 (January 2019): 226–239.

Gillespie, Kelly, and Leigh-Ann Naidoo. "#MustFall: The South African Student Movement and the Politics of Time." *South Atlantic Quarterly* 118, no. 1 (January 2019): 190–194.

Gilmore, Ruth Wilson. *Golden Gulag: Prisons, Surplus, Crisis, and Opposition in Globalizing California*. Berkeley: University of California Press, 2007.

Gilroy, Paul. *The Black Atlantic: Modernity and Double Consciousness*. Cambridge, MA: Harvard University Press, 1993.

Ginzburg, Carlo. "Fear, Reverence, Terror: Reading Hobbes Today." Lecture at the Max Weber Programme, European University Institute, Florence, 2008.

Glass, Ruth, assisted by Harold Pollins. *London's Newcomers: The West Indian Migrants*. Cambridge MA: Harvard University Press, 1961.

Glissant, Édouard. *Poetics of Relation*. Translated by Betsy Wing. Ann Arbor: University of Michigan Press, 1997.

Gómez-Barris, Macarena. *The Extractive Zone: Social Ecologies and Decolonial Perspectives*. Durham, NC: Duke University Press, 2017.

Goody, Alex. "Murder in Mile End: Amy Levy, Jewishness, and the City." *Victorian Literature and Culture* 34, no. 2 (2006): 461–479.

Gopal, Priyamvada. *Insurgent Empire: Anticolonial Resistance and British Dissent*. New York: Verso, 2019.

Gordon, Michelle. "Viewing Violence in the British Empire: Images of Atrocity from the Battle of Omdurman, 1898." *Journal of Perpetrator Research* 2, no. 2 (2019): 65–100.

Gordon, Thomas. *Principles of Naval Architecture*. London, 1779.

Goslinga, Cornelis Ch. *The Dutch in the Caribbean and in the Guianas, 1680–1791*. Assen, Netherlands: Van Gorcum, 1985.

Gould, Stephen Jay. "The Geometer of Race." *Discover*, November 1, 1994. https://www.discovermagazine.com/mind/the-geometer-of-race.

Gould, Stephen Jay. *The Mismeasure of Man*. 2nd ed. London: Penguin 1997.

Grabar, Henry S. "Reclaiming the City: Changing Urban Meaning in Algiers after 1962." *Cultural Geographies* 21, no. 3 (2014): 395–399.

Graeber, David. *Fragments of an Anarchist Anthropology*. Chicago: Prickly Pear, 2004.

Graeber, David. *Toward an Anthropological Theory of Value*. New York: Palgrave, 2001.

Graeber, David. *The Utopia of Rules: On Technology, Stupidity, and the Secret Joys of Bureaucracy*. Brooklyn: Melville House, 2016.

Grant, Madison. *The Passing of the Great Race*. New York: Scribner's, 1916.

Green, Shirley. *Rachman: The Slum Landlord Whose Name Became a Byword for Evil*. London: Hamlyn, 1981.

Greenblatt, Stephen. *The Rise and Fall of Adam and Eve*. New York: W. W. Norton, 2017.

Grigsby, Darcy Grimaldo. *Enduring Truths: Sojourner's Shadows and Substance*. Chicago: University of Chicago Press, 2015.

Grusin, Richard, ed. *After Extinction*. Minneapolis: University of Minnesota Press, 2018.

Hale, Kori. "The Economic Impact of COVID-19 Will Hit Minorities the Hardest." *Forbes*, March 17, 2020. https://www.forbes.com/sites/korihale/2020/03/17/the-economic-impact-of-covid-19-will-hit-minorities-the-hardest/?sh=77e73def10c0.

Hall, Stuart. "Absolute Beginnings." *Universities and Left Review* 7 (Autumn 1959): 16–25.

Hall, Stuart. *Cultural Studies 1983*. Edited by Jennifer Daryl Slack and Lawrence Grossberg. Durham, NC: Duke University Press, 2016.

Hall, Stuart. *The Fateful Triangle: Race, Ethnicity, Nation*. Cambridge, MA: Harvard University Press, 2017.

Hall, Stuart. "Gramsci and Us." Verso, February 10, 2017. https://www.versobooks.com/blogs/2448-stuart-hall-gramsci-and-us.

Hall, Stuart. "The Habit of Violence." *Universities and Left Review* 5 (Autumn 1958): 4–6.

Hall, Stuart. *The Hard Road to Renewal*. New York: Verso, 1988.

Hall, Stuart. "Isaac Julien's Workshop." In *Riot*, by Isaac Julien, 222–231. New York: Museum of Modern Art, 2013.

Hall, Stuart. "The Politics of Adolescence." *Universities and Left Review* 6 (Spring 1959): 3–20.

Hall, Stuart. *Selected Political Writings*. Durham, NC: Duke University Press, 2017.

Hall, Stuart. *Selected Writings on Race and Difference*. Edited by Paul Gilroy and Ruth Wilson Gilmore. Durham, NC: Duke University Press, 2021.

Hall, Stuart. "ULR Club in Notting Hill." *New Left Review* 1 (January–February 1960): 71–72.

Hall, Stuart, with Chas Chritcher, Tony Jefferson, John Clarke, and Brian Roberts. *Policing the Crisis: Mugging, the State and Law and Order*. New York: Palgrave Macmillan, 2013. First published 1978.

Hall, Stuart, with Bill Schwartz. *Familiar Stranger: A Life between Two Islands*. Durham, NC: Duke University Press, 2017.

Hall, Stuart, with Paddy Whalen. *The Popular Arts*. Durham, NC: Duke University Press, 2018. First published 1964.

Halley, Jean, Amy Eshleman, and Ramya Mahadevan. *Seeing White: An Introduction to White Privilege and Race*. London: Rowan and Littlefield, 2011.

Hammel, Tyler. "Judge Rejects 14th Amendment Claim in Confederate Statues Lawsuit." *Daily Progress*, September 11, 2019. https://www.dailyprogress.com/news/august12/judge-rejects-th-amendment-claim-in-confederate-statues-lawsuit/article_18d1e2e2-fb15-542f-a389-37d6be937b6e.html.

Handler, Jerome, and Diane Wallman. "Production Activities in the Household Economies of Plantation Slaves: Barbados and Martinique, Mid-1600s to Mid-1800s." *International Journal of Historical Archaeology* 18, no. 3 (September 2014): 441–466.

Hardt, Michael, and Antonio Negri. *Assembly*. New York: Oxford University Press, 2012.

Harris, Cheryl. "Whiteness as Property." *Harvard Law Review* 106, no. 8 (June 1993): 1707–1791.

Hartman, Saidiya. "Venus in Two Acts." *Small Axe* 12, no. 2 (June 2008): 1–14.

Hartman, Saidiya. *Wayward Lives, Beautiful Experiments: Intimate Histories of Riotous Black Girls, Troublesome Women, and Queer Radicals*. New York: W. W. Norton, 2020.

Haworth-Booth, Mark. "Where We've Come From: Aspects of Postwar British Photography." *Aperture* 113 (Winter 1988): 2–9.

Heise, Ursula. *Imagining Extinction: The Cultural Meaning of Endangered Species*. Chicago: University of Chicago Press, 2016.

Hendricks, Ashraf. "Rhodes Must Fall Exhibition Vandalised in UCT Protest." *Ground Up*, March 10, 2016. https://www.groundup.org.za/article/rhodes-must-fall-exhibition-vandalised-uct-protest.

Hicks, Dan. *The Brutish Museums: The Benin Bronzes, Colonial Violence and Cultural Restitution*. London: Pluto Press, 2020.

Hill, Christopher. *Milton and the English Revolution*. New York: Penguin, 1978.

Hill, Christopher. *The World Turned Upside Down: Radical Ideas in the English Revolution*. New York: Penguin, 1975.

Hill, Jennifer. "The History and Enduring Legacy of Bloody Caddo." *Bayou Brief*, December 13, 2017. https://www.bayoubrief.com/2017/12/13/the-history-and-enduring-legacy-of-bloody-caddo.

Hilton, Timothy. *John Ruskin*. New Haven, CT: Yale University Press, 2002.

Hobbes, Thomas. *Leviathan: Or, the Matter, Forme and Power of a Commonwealth, Ecclesiasticall and Civill*. Cambridge: Cambridge University Press, 1904.

Hornsey, Richard. *The Spiv and the Architect: Unruly Life in Postwar London*. Minneapolis: University of Minnesota Press, 2010.

Horodowich, Elizabeth, and Lia Markey. *The New World in Early Modern Italy, 1492–1750*. Cambridge: Cambridge University Press, 2017.

Iannini, Christopher. *Fatal Revolutions: Natural History, West Indian Slavery, and the Routes of American Literature*. Raleigh: University of North Carolina Press, 2012.

Iglikowski-Broad, Vicky, Katie Fox, and Rowena Hillel, "Suffragettes, 1912: 'Rather Broken Windows than Broken Promises," National Archives blog, May 18, 2018. https://blog.nationalarchives.gov.uk/rather-broken-windows-broken-promises.

Ignatiev, Noel. *How the Irish Became White*. New York: Routledge, 1995.

The Invisible Committee. *The Coming Insurrection*. Los Angeles: Semiotext(e), 2011.

Irmscher, Christoph. "Agassiz on Evolution." *Journal of the History of Biology* 37, no. 1 (Spring 2004): 205–207.

Jackson, George. "Toward the United Front." *The Black Panther Party Service to the People Programs*, edited and with an afterword by David Hilliard, 139–144. Foreword by Cornel West. Albuquerque: University of New Mexico Press, 2008.

Jacobson, Matthew Frye. *Whiteness of a Different Color: European Immigrants and the Alchemy of Race*. Cambridge, MA: Harvard University Press, 1998.

Jacobson, Matthew Frye, and David Roediger. *Working toward Whiteness: How America's Immigrants Became White: The Strange Journey from Ellis Island to the Suburbs*. New York: Basic Books, 2005.

James, C. L. R. *The Black Jacobins*. New York: Vintage, 1963.

James, Leslie. "What Lessons on Fascism Can We Learn from Africa's Colonial Past?" *Africa Is a Country*, January 24, 2017. https://africasacountry.com/2017/01/what -lessons-on-fascism-can-we-learn-from-africas-colonial-past.

Jaza, Luvo. "Our Story to the World." In *Publica[c]tion*, edited by Publica[c]tion Collective, 14. Johannesburg: Publica[c]tion Collective, 2016.

Jefferson, Thomas. *Notes on the State of Virginia* (1784). https://press-pubs.uchicago .edu/founders/documents/v1ch15s28.html.

Johnson, Alan. *This Boy*. London: Bantam Press, 2013.

Johnson, Walter. *River of Dark Dreams: Slavery and Empire in the Cotton Kingdom*. Cambridge, MA: Belknap Press of Harvard University Press, 2013.

Johnson, Walter. *Soul by Soul: Life Inside the Antebellum Slave Market*. Cambridge MA: Harvard University Press, 1999.

Julien, Isaac. *Baltimore*. 2003. https://www.isaacjulien.com/projects/baltimore.

Kamazi, Brian. "Securitization and the Public University." In *Publica[c]tion*, edited by Publica[c]tion Collective, 9. Johannesburg: Publica[c]tion Collective, 2016.

Kaphar, Titus. "Can Art Amend History?" TED Talk, YouTube, August 15, 2017. https:// youtu.be/DDaldVHUedI.

Kaplan, Paul. "Italy, 1490–1700." In *The Image of the Black in Western Art: From the "Age of Discovery" to the Age of Abolition, Part I: Artists of the Renaissance and Baroque*, edited by David Bindman and Henry Louis Gates Jr., 93–101. Cambridge, MA: Harvard University Press, 2010.

"Kazimir Malevich: Suprematist Composition: White on White, 1918." Museum of Modern Art. https://www.moma.org/collection/works/80385.

Keeling, Kara. *Queer Times, Black Futures*. New York: NYU Press, 2019.

Kelling, George L., and James Q. Wilson. "Broken Windows." *Atlantic*, March 1982. https://www.theatlantic.com/magazine/archive/1982/03/broken-windows/304465/.

Kemp, Kym. "At the Courthouse Friday, a Group Protested against Stay-at-Home Orders." *Redheaded Blackbelt*, May 16, 2020. https://kymkemp.com/2020/05/16/at-the -courthouse-friday-a-group-protested-against-stay-at-home-orders/.

Kevles, Daniel J. *In the Name of Eugenics: Genetics and the Uses of Human Heredity*. Cambridge, MA: Harvard University Press, 1995.

Khadiagala, Gilbert M., Sarah Mosoetsa, Devan Pillay, and Roger Southall, eds. *New South Africa Review 6: The Crisis of Inequality*. Johannesburg: Wits University Press, 2018.

Khanna, Ranjana. "The Lumpenproletariat, the Subaltern, the Mental Asylum." *South Atlantic Quarterly* 112, no. 1 (Winter 2013): 129–143.

King, Gilbert. "Where the Buffalo No Longer Roamed." *Smithsonian Magazine*, July 17, 2012. https://www.smithsonianmag.com/history/where-the-buffalo-no-longer -roamed-3067904.

Knoppers, Kim. "Interview with Kiluanji Kia Henda." *Foam*, May 20, 2015. https://www .foam.org/talent/spotlight/interview-with-kiluanji-kia-henda.

Kulman, Michael. "The Anticulture Born of Despair." *Universities and Left Review* 4 (Summer 1958): 51–54.

Kynaston, David. *Austerity Britain 1945–51*. New York: Bloomsbury, 2008.

Kynaston, David. *Family Britain 1951–1957*. New York: Walker and Co., 2009.

Laity, Paul. "Identity in the East End." *Guardian*, August 9, 2008. https://www.theguard ian.com/books/2008/aug/09/fiction7.

Lambourne, Lionel. *The Aesthetic Movement*. London: Phaidon, 1996.

Lamming, George. "The Negro Writer and His World." *Présence Africaine*, nouvelle série, no. 8–10 (June–November 1956): 318–325.

Lamming, George. *Pleasures of Exile*. Ann Arbor: University of Michigan Press, 1992. First published 1960.

Lancaster, Guy. "Lynchings Hidden in the History of the Hot Springs Confederate Monument." *Arkansas Times*, August 18, 2017. https://arktimes.com/arkansas -blog/2017/08/18/lynchings-hidden-in-the-history-of-the-hot-springs-confederate -monument.

Larkin, Brian. "The Politics and Poetics of Infrastructure." *Annual Review of Anthropology* 42, no. 1 (2013): 327–343.

LaRoche, Cheryl Janifer. *Free Black Communities and the Underground Railroad: The Geography of Freedom*. Champaign: University of Illinois Press, 2014.

Lavin, Talia. "Behind the 'Thin Blue Line' Flag: America's History of Police Violence." MSNBC, April 22, 2021. https://www.msnbc.com/opinion/behind-thin-blue-line-flag -america-s-history-police-violence-n1264866.

Lawson, Peter, ed. *Passionate Renewal: Jewish Poetry in Britain since 1945—An Anthology*. Nottingham: Five Leaves Publications, 2001.

Lee, Shimrit. "Commodified (In)Security: Visual Mediations of Violence in Israel, the United States, and Beyond." PhD diss., New York University, 2019.

Lentin, Alana. *Why Race Still Matters*. Cambridge, UK: Palgrave, 2020.

Leonard, Pat. "Starling Success Traced to Rapid Adaptation." *Cornell Chronicle*, February 9, 2021. https://news.cornell.edu/stories/2021/02/starling-success-traced-rapid -adaptation.

Lepenies, Philipp. *Art, Politics, and Development*. Philadelphia: Temple University Press, 2018.

Levenson, Michael. "Toppled, but Silent Sam Still Looms over U.N.C." *New York Times*, February 20, 2020, A23.

Levy, Amy. *A London Plane-Tree* (1889). Victorian Women Writers Project. http://web app1.dlib.indiana.edu/vwwp/view?docId=VAB7098;chunk.id=d1e1782;toc.depth=1;toc.id=d1e1782;brand=vwwp;doc.view=0;query=.

Levy, Amy. *Reuben Sachs*. London: Persephone Books, 2001. First published 1888.

Lewis, Lloyd, and Henry Justin Smith. *Oscar Wilde Discovers America (1882)*. New York: Harcourt Brace and Company, 1935.

Lewis, Sarah Elizabeth, ed. "Vision and Justice." Special issue, *Aperture*, no. 223 (2016).

Lewis, Sarah Elizabeth. "Groundwork: Race and Aesthetics in the Era of Stand Your Ground Law." *Art Journal* 79, no. 4 (2020): 92–113.

Lichtenstein, Rachel. *On Brick Lane*. London: Penguin, 2007.

Linebaugh, Peter, and Marcus Rediker. *The Many-Headed Hydra: Sailors, Slaves, Commoners, and the Hidden History of the Revolutionary Atlantic*. Boston: Beacon Press, 2000.

Lipsitz, George. *How Racism Takes Place*. Philadelphia: Temple University Press, 2011.

Litvinoff, Emmanuel. *Journey through a Small Planet*. Introduction by Patrick Wright. London: Penguin, 2008. First published 1972.

Locke, John. *The Works of John Locke . . . Two Treatises of Government*. London: C. and J. Rivington, 1824.

Long Soldier, Layli. *Whereas*. Minneapolis: Gray Wolf, 2017.

Long Term Care Community Coalition. "New York COVID-19 Fatality Data: Nursing Homes and Adult Care Facilities." https://nursinghome411.org/ny-nursinghome-covid-data/.

Lowe, Lisa. *The Intimacies of Four Continents*. Durham, NC: Duke University Press, 2015.

Lucian Freud Archive, http://lucianfreud.com/paintings.html (2019).

Luxemburg, Rosa. *The Rosa Luxemburg Reader*. Edited by Peter Hudis and Keven B. Anderson. New York: Monthly Review Press, 2004.

Macey, David. *Frantz Fanon: A Biography*. New York: Verso, 2012.

MacInnes, Colin. *Loving Them Both: Study of Bisexuality and Bisexuals*. London: Martin Brian and O'Keeffe, 1973.

MacInnes, Colin. *Absolute Beginners*. London: Allison and Busby, 2011. First published 1959.

MacInnes, Colin. *City of Spades*. London: Allison and Busby, 2012. First published 1957.

Mack, David. "A Woman at an Anti-Lockdown Protest Held a Sign from a Nazi Concentration Camp." *Buzzfeed*, May 2, 2020. https://www.buzzfeednews.com/article/david mack/auschwitz-condemns-nazi-coronavirus-protest-sign?bfsource=relatedmanual.

Mahoney, Kristin. "Michael Field and Queer Community at the Fin de Siècle." *Victorian Review* 41, no. 1 (Spring 2015): 35–40.

Makgetia, Neva. "Inequality in South Africa." In *New South Africa Review 6: The Crisis of Inequality*, edited by Gilbert M. Khadiagala, Sarah Mosoetsa, Devan Pillay, and Roger Southall, 14–43. Johannesburg: Wits University Press, 2018.

Malaika, Wa Azania. *Memoirs of a Born Free: Reflections on the Rainbow Nation*. Auckland Park, South Africa: Jacana Media, 2014.

Malik, Michael Abdul. *From Michael de Freitas to Michael X*. London: André Deutsch, 1968.

Mangcu, Xolela. "Shattering the Myth of a Post-Racial Consensus in South African Higher Education: 'Rhodes Must Fall' and the Struggle for Transformation at the University of Cape Town." *Critical Philosophy of Race* 5, no. 2 (2017): 243–266.

Marez, Curtis. *Drug Wars: The Political Economy of Narcotics*. Minneapolis: University of Minnesota Press, 2004.

Markey, Lia. *Imagining the Americas in Medici Florence*. Chicago: University of Chicago Press, 2016.

Markey, Lia. "'Istoria della terra chiamata la nuova spagna': The History and Reception of Sahagún's Codex at the Medici Court." In *Colors between Two Worlds: The Florentine Codex of Bernadinho de Sahagún*, edited by Gerhard Wolf, Joseph Connors, and Louis A. Waldman, 199–220. Milan: Villa I Tatti, 2011.

Markey, Lia. "Stradano's Allegorical Invention of the Americas in Late Sixteenth-Century Florence." *Renaissance Quarterly* 65, no. 2 (Summer 2012): 385–442.

Marshall Project. "A State-by-State Look at 15 Months of Coronavirus in Prisons." Marshall Project, July 1, 2021. https://www.themarshallproject.org/2020/05/01/a-state-by -state-look-at-coronavirus-in-prisons.

Marx, Karl. *Capital*. Vol. 1. Translated by Ben Fowkes. Harmondsworth, UK: Pelican Books, 1976.

Marx, Karl. *Economic and Philosophic Manuscripts of 1844*. Mineola, NY: Dover Publications, 2012.

Matera, Marc. *Black London: The Imperial Metropolis and Decolonization in the Twentieth Century*. Berkeley: University of California Press, 2015.

Mauger, Craig, and Beth LeBlanc. "Trump Tweets 'Liberate Michigan.'" *Detroit News*, April 17, 2020. https://www.detroitnews.com/story/news/politics/2020/04/17/trump -tweets-liberate-michigan-other-states-democratic-governors/5152037002.

Maurice, Alice. *Cinema and Its Shadow: Race and Technology in Early Cinema.* Minneapolis: University of Minnesota Press, 2013.

Maxwele, Chumani. "Black Pain Led Me to Throw Rhodes Poo." *Business Day*, March 16, 2016. https://www.businesslive.co.za/bd/opinion/2016-03-16-black-pain-led-me-to -throw-rhodes-poo.

Mayne, Roger. "Photography and Realism: A Statement." *Universities and Left Review* 6 (Spring 1959): 42–44.

McConville, Sean. *English Local Prisons 1860–1900: Next Only to Death.* London: Routledge, 1995.

McCord, David J., ed. *The Statutes at Large of South Carolina, Volume 7.* Columbia, SC: A. S. Johnston, 1840.

McCulloch, Jock. "Theory into Practice: Carothers and the Politics of Mau Mau." In *Colonial Psychiatry and "the African Mind,"* 64–76. Cambridge: Cambridge University Press, 1995.

McGaffey, Wyatt, and Michael D. Harris. *Astonishment and Power: Kongo Minkisi and the Art of Renee Stout.* Washington, DC: Smithsonian Institution Press, 1993.

McKittrick, Katherine. *Dear Science and Other Stories.* Durham, NC: Duke University Press, 2021.

McKittrick, Katherine. "Plantation Futures." *Small Axe* 17, no. 3 (42) (November 2013): 1–15.

McTighe, Shella. "Abraham Bosse and the Language of Artisans: Genre and Perspective in the Académie Royale de Peinture et de Sculpture, 1648–1670." *Oxford Art Journal* 21, no. 1 (1998): 1–26.

Meijer, Miriam Claude. "Bones, Law and Order in Amsterdam: Petrus Camper's Morphological Insights." In *Petrus Camper in Context: Science, the Arts, and Society in the Eighteenth-Century Dutch Republic*, edited by Klaas van Berkeley and Bart Ramakers, 187–213. Hilversum, Netherlands: Verloren, 2015.

Merleau-Ponty, Maurice. *The Visible and the Invisible.* Evanston, IL: Northwestern University Press, 1968.

Michaud, Eric. *The Barbarian Invasions: A Genealogy of the History of Art.* Translated by Nicholas Huckle. Cambridge, MA: MIT Press, 2019.

Mignolo, Walter. "Crossing Gazes and the Silence of the 'Indians': Theodor De Bry and Guaman Poma de Ayala." *Journal of Medieval and Early Modern Studies* 41, no. 1 (Winter 2011): 173–223.

Mignolo, Walter. *The Darker Side of Western Modernity: Global Futures, Decolonial Options.* Durham, NC: Duke University Press, 2011.

Mignolo, Walter, and Catherine E. Walsh. *On Decoloniality.* Durham, NC: Duke University Press, 2018.

Milton, John. *Paradise Lost*. New York: W. W. Norton, 1993.

Mirzoeff, Nicholas. *The Appearance of Black Lives Matter*. Miami: NAME Publications, 2017. https://namepublications.org/item/2017/the-appearance-of-black-lives-matter.

Mirzoeff, Nicholas. *Diaspora and Visual Culture: Representing Africans and Jews*. London: Routledge, 2000.

Mirzoeff, Nicholas, *How to See the World*. New York: Basic Books, 2016.

Mirzoeff, Nicholas. *The Right to Look: A Counterhistory of Visuality*. Durham, NC: Duke University Press, 2011.

Mirzoeff, Nicholas. "Striking: The Right to Strike / the Striking Image / Striking the Right." In *Identity Theft: The Cultural Colonization of Contemporary Art*, edited by Jonathan Harris, 197–220. Liverpool: Liverpool University Press, 2008.

Mitchell, W. J. T. *Iconology: Image, Text, Ideology*. Chicago: University of Chicago Press, 1986.

Moffat, Isabelle. "'A Horror of Abstract Thought': Postwar Britain and Hamilton's 1951 'Growth and Form' Exhibition." *October* 94 (2000): 89–112.

Moore, Jason W. "Madeira, Sugar, and the Conquest of Nature in the 'First' Sixteenth Century: Part I: From 'Island of Timber' to Sugar Revolution, 1420–1506." *Review* (Fernand Braudel Center) 32, no. 4 (2009): 345–390.

Moran, Joe. "Imagining the Street in Post-War Britain." *Urban History* 39, no. 1 (February 2012): 166–186.

Moreton-Robinson, Aileen. *The White Possessive: Property, Power, and Indigenous Sovereignty*. Minneapolis: University of Minnesota Press, 2015.

Morgan, Jennifer L. "*Partus sequitur ventrem*: Law, Race, and Reproduction in Colonial Slavery." *Small Axe* 22 (2018): 1–17.

Morley, David. "In a Viral Conjuncture: Locking Down Mobilities." *Cultural Politics* 17, no. 1 (2021): 17–28.

Morse, Heidi. "Classics and the Alt-Right: Historicizing Visual Rhetorics of White Supremacy." Learn Speak Act, February 18, 2018. https://sites.lsa.umich.edu/learn-speak-act/2018/02/15/classics-and-the-alt-right.

Morton, Samuel. *Crania Americana, or, a Comparative View of the Skulls of Various Aboriginal Nations of North and South America*. Philadelphia: J. Dobson, 1839.

Moten, Fred. *Black and Blur. Vol I: Consent Not to Be a Single Being*. Durham, NC: Duke University Press, 2017.

Moten, Fred, and Stephano Harney. *The Undercommons: Fugitive Planning and Black Study*. New York: Minor Compositions, 2013.

Moten, Fred, and Stephano Harney. *All Incomplete*. New York: Minor Compositions, 2021.

Moten, Fred, Stephano Harney, and Stevphen Shukaitis. "Refusing Completion: A Conversation." *e-flux* 116 (March 2021). https://www.e-flux.com/journal/116/379446 /refusing-completion-a-conversation.

Muholi, Zanele. *Somnyama Ngonyama*. Johannesburg: Stevenson, 2015.

Mukherjee, Shomik. "Humboldt County Coronavirus Protester's 'Slaves' Sign Goes Viral." *Time Standard*, May 18, 2020. https://www.times-standard.com/2020/05/18 /humboldt-county-coronavirus-protesters-slaves-sign-goes-viral.

Murray, Mark. "In New Poll, 60 Percent Support Keeping Stay-at-Home Restrictions to Fight Coronavirus. NBC News, April 19, 2020. https://www.nbcnews.com/politics /meet-the-press/poll-six-10-support-keeping-stay-home-restrictions-fight-coronavi rus-n1187011.

Nadalo, Stephanie. "Negotiating Slavery in a Tolerant Frontier: Livorno's Turkish *Bagno* (1547–1747)." *Mediaevalia* 32 (2011): 275–324. https://doi.org/10.1353/mdi.2011.0004.

Naidoo, Leigh-Ann. "Hallucinations: 2016 Ruth First Memorial Lecture Keynote Address." In *Publica[c]tion*, edited by Publica[c]tion Collective, 49. Johannesburg: Publica[c]tion Collective, 2016.

Nassy, David de Isaac Cohen. *Essai Historique sur la colonie de Surinam, avec L'Histoire de la Nation Juive Portugaise et Allemande y Etablie*. 2 vols. Paramaribo, 1788.

National Archives. "Window Smashing Campaign." https://www.nationalarchives.gov .uk/education/resources/suffragettes-on-file/window-smashing-campaign.

National Archives. "Women to Watch, File number AR1–528." https://www.nationalar chives.gov.uk/education/resources/suffragettes-on-file/women-to-watch.

National Portrait Gallery. Votes for Women, 2018. https://www.npg.org.uk/whatson /display/2018/votes-for-women.

Nead, Lynda. *Victorian Babylon: People, Streets and Images in Nineteenth-Century London*. New Haven, CT: Yale University Press, 2000.

Negri, Antonio. *Insurgencies: Constituent Power and the Modern State*. Minneapolis: University of Minnesota Press, 1999.

Nelson, Louis P., and Claudrena N. Harold. *Charlottesville 2017: The Legacy of Race and Inequity*. Charlottesville: University of Virginia Press, 2018.

Nemser, Daniel. *Infrastructures of Race: Concentration and Biopolitics in Colonial Mexico*. Austin: University of Texas Press, 2009.

Neocleous, Mark. *A Critical Theory of Police Power: The Fabrication of the Social Order*. New York: Verso, 2021,

New York City. "COVID-19 Data." https://www1.nyc.gov/site/doh/covid/covid-19-data -totals.page.

New York Gazette. October 1–8, 1739, no. 725.

Ngũgĩ wa Thiong'o. "Freeing the Imagination." *Transition* 100 (2000): 164–169.

Nkopo, Athinangamso. "Of Air. Running. Out." In *Rhodes Must Fall: The Struggle to Decolonize the Racist Heart of Empire*, edited by Roseanne Chantiluke, Brian Kwoba, and Athinangamso Nkopo, 158–167. London: Zed Books, 2018.

Nkrumah, Kwame. "From Now on We Are No Longer a Colonial but Free and Independent People." March 6, 1957. https://youtu.be/lTTdi8AjZg8.

"Notes and News." *Auk* 20, no. 3 (1903): 326–330.

Nott, Josiah. "The Physical History of the Jews." *Proceedings of the American Association for the Advancement of Science, Third Meeting*. Charleston: Walker and James, 1850.

Nott, Josiah, with George R. Gliddon, Samuel George Morton, Louis Agassiz, William Usher, and Henry S. Patterson. *Types of Mankind: Or, Ethnological Researches*. Philadelphia: Lippincott, Grambo and Co., 1854.

Nyamnjoh, Francis B. *#RhodesMustFall: Nibbling at Resilient Colonialism in South Africa*. Bamenda, Cameroon: Langaa Research and Publishing, 2016.

N'yongo, Tavia. *The Amalgamation Waltz: Race, Performance, and the Ruses of Memory*. Minneapolis: University of Minnesota Press, 2009.

Oelsner, Lesley. "Six Indians Accused of Defacing Theodore Roosevelt Statue." *New York Times*, June 15, 1971, 37.

Olden, Mark. *Murder in Notting Hill*. London: John Hunt Publishing, 2011.

Olmsted, Frederick Law. *A Journey in the Seaboard Slave States*. New York: Dix and Edwards, 1856.

Olusoga, David. *Black and British: A Forgotten History*. London: Macmillan, 2016.

Osborn, Henry Fairfield. *Creative Education in School, College, University and Museum. Personal Observation and Experience of the Half-Century 1877–1927*. New York: Charles Scribner's Sons, 1927.

Osborn, Henry Fairfield. *The Hall of the Ages of Man*. 6th ed. New York: American Museum of Natural History, 1932.

Osborn, Henry Fairfield. "Papers." American Museum of Natural History Archives, New York.

Ostrow, Steven F. "Pietro Tacca and His Quattro Mori: The Beauty and Identity of the Slaves." *Artibus et Historiae* 71 (2015): 145–180.

Ovid. *Metamorphoses*. Translated by Charles Martin. Introduction by Bernard Knox. New York: W. W. Norton, 2005.

Padmore, George. "Fascism in the Colonies." *Controversy* 2, no. 17 (February 1938). https://www.marxists.org/archive/padmore/1938/fascism-colonies.htm.

Painter, Nell Irvin. *The History of White People*. New York: W. W. Norton, 2010.

Painter, Nell Irvin. *Sojourner Truth: A Life, a Symbol*. New York: W. W. Norton, 1996.

Pankhurst, E. Sylvia. "Forcibly Fed." *McClure's Magazine*, August 1913, 87–93.

Panofsky, Erwin. *Perspective as a Symbolic Form*. Translated by Christopher S. Wood. New York: Zone Books, 1991.

Parikka, Jussi. *Insect Media: An Archaeology of Animals and Technology*. Minneapolis: University of Minnesota Press, 2010.

Parks, Lisa. "Vertical Mediation and the U.S. Drone War in the Horn of Africa." In *Life in the Age of Drone Warfare*, edited by Lisa Parks and Caren Kaplan, 134–158. Durham, NC: Duke University Press, 2017.

Parnell, Susan, and Jennifer Robinson. "(Re)theorizing Cities from the Global South: Looking beyond Neoliberalism." *Urban Geography* 33, no. 4 (2012): 593–617.

Parreñas, Juno Salazar. *Decolonizing Extinction*. Durham, NC: Duke University Press, 2018.

Partridge, Linda Dugan. "By the Book: Audubon and the Tradition of Ornithological Illustration." *Huntington Library Quarterly* 59, no. 2–3 (1996): 269–301.

Pater, Walter. *The Renaissance: Studies in Art and Poetry: The 1893 Text*. Edited by Donald L. Hill. Berkeley: University of California Press, 1980.

Pather, Ra'essa. "Rhodes Must Fall: The Movement after the Statue." *Daily Vox*, April 21, 2015. https://www.thedailyvox.co.za/rhodes-must-fall-the-movement-after-the-statue.

Patterson, Destinee. "Caddo's Confederate Statue to Be Moved to DeSoto Parish." KSLA News 12, September 12, 2020. https://www.ksla.com/2020/09/12/caddo-parish -confederate-monument-be-moved-desoto-parish.

Paxton, Naomi. *Stage Rights! The Actresses' Franchise League, Activism and Politics 1908– 58*. Manchester: Manchester University Press, 2018.

Pearce, Daniel J. G., Adam M. Miller, George Rowlands, and Matthew S. Turner. "Role of Projection in the Control of Bird Flocks." *Proceedings of the National Academy of Sciences of the United States of America* 111, no. 29 (2014): 10422–10426.

Petersen, Francis, and Wanelisa Albert. "How Shackville Started a War." *City Press*, February 21, 2016. https://www.news24.com/citypress/Voices/how-shackville-started -a-war-20160219.

Pew Research Center. "Most Americans Say Trump Was Too Slow in Initial Response to Virus Threat." April 16, 2020. https://www.people-press.org/wp-content/uploads /sites/4/2020/04/PP_2020.04.16_Trump-and-COVID-19_FINAL.pdf.

"Photos of the Month: April." Reuters, May 2, 2020. https://www.reuters.com/news /picture/photos-of-the-month-april-idUSRTX7GUMJ.

Pickford, Cameron. "Leadership by Insult." Michigan Freedom Fund, April 17, 2020. https://www.michiganfreedomfund.com/leadership_by_insult.

Pillay, Suren. "The Fires This Time." In *Publica[c]tion*, edited by Publica[c]tion Collective, 33. Johannesburg: Publica[c]tion Collective, 2016.

Pinto, Gabriella. "Creative Women: Sethembile Msezane on Black Women and Colonialist Ideologies." *10and5*, August 26, 2015. http://10and5.com/2015/08/26/creative-women-sethembile-msezane-black-women-colonialist-ideologies.

Pissarro Family Archive, Ashmolean Museum, Oxford.

Pollock, Griselda. *After-Affects/After-Images: Trauma and Aesthetic Transformation in the Virtual Feminist Museum*. Manchester: Manchester University Press, 2013.

Potts, Alex. "Ideal Bodies." In *Flesh and the Ideal: Winckelmann and the Origins of Art History*, 145–181. New Haven, CT: Yale University Press, 1994.

Power, Marcus. "Angola 2025: The Future of the 'World's Richest Poor Country' as Seen through a Chinese Rear-View Mirror." *Antipode* 44, no. 3 (2012): 993–1014.

Precarias a la Deriva. "A Very Careful Strike." *Commoner* 11 (Spring 2006): 33–45.

Preciado, Beatriz. *Testo Junkie: Sex, Drugs, and Biopolitics in the Pharmacopornographic Era*. New York: Feminist Press at CUNY, 2013.

Price, Richard. *Maroon Societies: Rebel Slave Communities in the Americas*. Baltimore: Johns Hopkins University Press, 1996.

Procaccini, Alfonso. "Alberti and the Framing of Perspective." *Journal of Aesthetics and Art Criticism* 40, no. 1 (1981): 29–39.

Publica[c]tion Collective. *Publica[c]tion*. Johannesburg: Publica[c]tion Collective, 2016.

Pugliese, Joseph. "Biometrics, Infrastructural Whiteness, and the Racialized Degree Zero of Nonrepresentation." *boundary 2* 34, no. 2 (2007): 105–133.

Pulitzer Prizes. "Darnella Frazier." https://www.pulitzer.org/winners/darnella-frazier.

Quilligan, Maureen. "Theodor De Bry's Voyages to the New and Old Worlds." *Journal of Medieval and Early Modern Studies* 41, no. 1 (Winter 2011): 1–12.

Quinn, Stephen Christopher. *Windows on Nature: The Great Habitat Dioramas of the American Museum of Natural History*. New York: Harry N. Abrams, 2006.

Rader, Karen A., and Victoria E. M. Cain. *Life on Display: Revolutionizing U.S. Museums of Science and Natural History in the Twentieth Century*. Chicago: University of Chicago Press, 2014.

Raiford, Leigh. *Imprisoned in a Luminous Glare: Photography and the African American Freedom Struggle*. Chapel Hill: University of North Carolina Press, 2011.

Raiford, Leigh. "*Burning All Illusion*: Abstraction, Black Life, and the Unmaking of White Supremacy." *Art Journal* (Winter 2020): 77–91.

Rainger, Ronald. *An Agenda for Antiquity: Henry Fairfield Osborn and Vertebrate Paleontology at the American Museum of Natural History, 1890–1935*. Tuscaloosa: University of Alabama Press, 1991.

Rancière, Jacques. *The Politics of Aesthetics*. Translated by Gabriel Rockhill. New York: Continuum, 2004.

Ratcliff, John. "Caddo Confederate Monument: Undemocratic, Unjust." *Shreveport Times*, October 28, 2017. https://www.shreveporttimes.com/story/opinion/2017/10/18 /caddo-confederate-monument-undemocratic-unjust/775335001.

Raymond, Joad. "In 1649, to St. George's Hill." *Huntington Library Quarterly* 75, no. 3 (2012): 429–446.

Rediker, Marcus. *The Slave Ship: A Human History*. New York: Viking, 2007.

Regal, Brian. *Henry Fairfield Osborn: Race and the Search for the Origins of Man*. Burlington, VT: Ashgate, 2002.

Reinhardt, Mark. "Vision's Unseen: On Sovereignty, Race, and the Optical Unconscious." In *Photography and the Optical Unconscious*, edited by Shawn Michelle Smith and Sharon Sliwinksi, 174–222. Durham, NC: Duke University Press, 2017.

Relman, Eliza. "Trump Shares Tweet That Argues Face Masks Represent 'Silence, Slavery, and Social Death,'" *Business Insider*, May 28, 2020. https://www.businessinsider .com/trump-shares-tweet-that-says-masks-represent-slavery-and-social-death-2020-5.

Rhodes, Richard. *John James Audubon: The Making of an American*. New York: Alfred A. Knopf, 2004.

"Rhodes Must Fall Statement." Facebook, February 15, 2016. https://www.facebook .com/RhodesMustFall/posts/1676179165990908.

"Rhodes Must Fall UCT: Mission Statement." *Poor Print*, April 28, 2017. https://thepoor print.com/2017/04/28/rhodes-must-fall-uct-mission-statement.

Ricketts, Charles. *A List of Books Issued by Messrs Hacon and Ricketts*. London, 1898.

Ricketts, Charles. *Oscar Wilde: Recollections by Jean Paul Raymond*. London: Nonesuch Press, 1932.

Ritko, Harriet. *The Platypus and the Mermaid, and Other Figments of the Classifying Imagination*. Cambridge, MA: Harvard University Press, 1998.

Robcis, Camille. "François Tosquelles and the Psychiatric Revolution in Postwar France." *Constellations* 23, no. 2 (2016): 212–222.

Robcis, Camille. "Frantz Fanon, the Pathologies of Freedom, and the Decolonization of Institutional Psychotherapy." *Disalienation: Politics, Philosophy, and Radical Psychiatry in Postwar France*, 48–73. Chicago: University of Chicago Press, 2021.

Roberts, Jennifer L. *Transporting Visions: The Movement of Images in Early America*. Berkeley: University of California Press, 2014.

Robinson, Cedric J. *Black Marxism: The Making of the Black Radical Tradition*. Foreword by Robin D. G. Kelley. Chapel Hill: University of North Carolina Press, 2000.

Robinson, Cedric J. *Forgeries of Memory and Meaning: Blacks and the Regimes of Race in American Theater and Film before World War II.* Raleigh: University of North Carolina Press, 2012.

Robinson, Clarence A., Jr. "Surveillance Integration Pivotal in Israeli Successes." *Aviation Week and Space Technology* 117 no. 1 (July 5, 1982): 46–50.

Rodríguez, Dylan. *White Reconstruction: Domestic Warfare and the Logics of Genocide.* New York: Fordham University Press, 2020.

Roediger, David R. *The Wages of Whiteness: Race and the Making of the American Working Class.* New York: Verso, 1999.

Rogers, Elizabeth Barlow. "Representing Nature: The Dioramas of the American Museum of Natural History." *SiteLINES: A Journal of Place* 8, no. 2 (Spring 2013): 10–14.

Rogers, Molly. *Delia's Tears: Race, Science, and Photography in Nineteenth-Century America.* New Haven, CT: Yale University Press, 2010.

Rosemont, Franklin, and Robin D. G. Kelley, eds. *Black, Brown, and Beige: Surrealist Writings from Africa and the Diaspora.* Austin: University of Texas Press, 2009.

Rosen, Mark. "Pietro Tacca's *Quattro Mori* and the Conditions of Slavery in Early Seicento Tuscany." *Art Bulletin* 97, no. 1 (2015): 34–57.

Rothenstein, William. *Men and Memories: Recollections.* 2 vols. London: Faber and Faber, 1932.

Rowland, Cameron. *3 & 4 Will. IV c. 73.* London: Institute of Contemporary Art, 2020.

Roy, Arundhati. "The Pandemic Is a Portal." *Financial Times,* April 3, 2020. https://www.ft.com/content/10d8f5e8-74eb-11ea-95fe-fcd274e920ca.

Ruppert, Bob. "The Statue of George III." *Journal of the American Revolution* (September 28, 2014). https://allthingsliberty.com/2014/09/the-statue-of-george-iii.

Ruskin, John. *The Elements of Perspective.* London: Smith, Elder and Co., 1859.

Ruskin, John. *Lectures on Art.* Oxford, 1871.

Said, Edward. *Orientalism.* New York: Vintage, 1978.

Samuel, Wilfred S. *A Review of the Jewish Colonists in Barbados.* London: Purnell, 1936.

Sartre, Jean-Paul. *Anti-Semite and Jew: An Exploration of the Etiology of Hate.* Translated by George J. Becker. New York: Schocken Books, 1948.

Savage, Kirk. *Standing Soldiers, Kneeling Slaves: Race, War, and Monument in Nineteenth-Century America.* 2nd ed. Princeton, NJ: Princeton University Press, 2018.

Schivelbusch, Wolfgang. *The Railway Journey: The Industrialization and Perception of Time and Space in the Nineteenth Century.* Berkeley: University of California Press, 1987.

Schmahmann, Brenda. "The Fall of Rhodes: The Removal of a Sculpture from the University of Cape Town." *Public Art Dialogue* 6, no. 1 (2016): 90–115.

Schofield, Camilla, and Ben Jones. "'Whatever Community Is, This Is Not It': Notting Hill and the Reconstruction of 'Race' in Britain after 1958." *Journal of British Studies* 58, no. 1 (January 2019): 142–173.

Schulman, Sarah. *Let the Record Show: A Political History of ACT UP New York, 1987–1993*. New York: Farrar, Straus and Giroux, 2021.

Scott, David. "The Sovereignty of the Imagination: An Interview with George Lamming." *Small Axe* 12 (September 2002): 72–200.

Scott, James C. *The Art of Not Being Governed: An Anarchist History of Upland Southeast Asia*. New Haven, CT: Yale University Press, 2009.

Scott, James C. *Seeing Like a State: How Certain Schemes to Improve the Human Condition Have Failed*. New Haven, CT: Yale University Press, 1998.

Scott, Julius S. *The Common Wind: Afro-American Currents in the Age of the Haitian Revolution*. New York: Verso, 2018.

Sell, Zach. *Trouble of the World: Slavery and Empire in the Age of Capital*. Chapel Hill: University of North Carolina Press, 2021.

Sessions, Jennifer. "Entangled Politics of Postcolonial Commemorations." In *Algeria Revisited: History, Culture and Identity*, edited by Rabah Aissaoui and Claire Eldridge, 193–211. London: Bloomsbury, 2017.

Sharpe, Christina. *In the Wake: On Blackness and Being*. Durham, NC: Duke University Press, 2016.

Sheehan, Tanya. "In a New Light: Early African American Photography." *American Studies* 52, no. 3 (2013): 7–24.

Shukaitis, Stevphen, and David Graeber. "Introduction." In *Constituent Imagination: Militant Investigations // Collective Theorizations*, edited by Stevphen Shukaitis and David Graeber with Erika Biddle, 11–36. Oakland, CA: AK Press, 2007.

Siegert, Nadine. "Art Topples Monuments: Artistic Practice and Colonial/Postcolonial Relations in the Public Space of Luanda." *Portuguese Literary and Cultural Studies* 30–31 (2017): 150–173.

Simkin, John. "Jewish League for Woman Suffrage." Spartacus Educational. https://spartacus-educational.com/Wjewish.htm.

Simpson, Audra. "The State Is a Man: Theresa Spence, Loretta Saunders and the Gender of Settler Sovereignty." *Theory and Event* 19, no. 4 (2016): 1–16.

Sinha, Manisha. "Of Scientific Racists and Black Abolitionists: The Forgotten Debate over Slavery and Race." In *To Make Their Own Way in the World: The Enduring Legacy of the Zealy Daguerreotypes*, edited by Llisa Barbash, Molly Rogers, and Deborah Willis, 235–258. Cambridge, MA: Peabody Museum Press, 2020.

Sitrin, Marina, and Colectiva Sembrar. *Pandemic Solidarity: Mutual Aid during the Covid-19 Crisis*. London: Pluto Press, 2020.

Skinner, Alanson. "The Indians of Manhattan Island and Vicinity." *American Museum Journal* 9, no. 6 (October 1909): 143–193.

Skinner, Quentin. *From Humanism to Hobbes: Studies in Rhetoric and Politics*. Cambridge: Cambridge University Press, 2018.

Smith, James McCune [Communipaw]. "'Heads of the Colored People,' Done with a Whitewash Brush." *Frederick Douglass' Paper*, March 25, 1852.

Smith, James McCune [Communipaw]. "Letter from Communipaw." *Frederick Douglass' Paper*, February 26, 1852.

Smith, James McCune. *The Works of James McCune Smith: Black Intellectual and Abolitionist*. Edited by John Stauffer. New York: Oxford University Press, 2006.

Smith, Jeffrey Chipps. "Dürer and Sculpture." In *The Essential Dürer*, edited by Larry Silver and Jeffrey Chipps Smith, 74–98. Philadelphia: University of Pennsylvania Press, 2010.

Smith, Shawn Michelle. *American Archives: Gender, Race, and Class in Visual Culture*. Princeton, NJ: Princeton University Press, 1999.

Smith, Shawn Michelle, and Sharon Sliwinski, eds. *Photography and the Optical Unconscious*. Durham, NC: Duke University Press, 2017.

Sorkin, Amy David. "Freddie Gray's Death Becomes a Murder." *New Yorker*, May 1, 2015. https://www.newyorker.com/news/amy-davidson/freddie-grays-death-becomes-a-murder-case.

Speaight, Robert. *William Rothenstein: The Portrait of an Artist in His Time*. London: Eyre and Spottiswoode, 1962.

Spencer, Herbert. *Social Statics: or, the Conditions Essential to Human Happiness Specified, and the First of Them Developed*. London: George Woodfall, 1850.

Sperling, John. *John Berger*. New York: Verso, 2018.

"SP-4402 Origins of NASA Names." History of NASA. https://history.nasa.gov/SP-4402/ch4.htm.

Spillers, Hortense J. *Black and White and in Color: Essays on American Literature and Culture*. Chicago: University of Chicago Press, 2003.

Spiro, Jonathan. *Defending the Master Race: Conservation, Eugenics, and the Legacy of Madison Grant*. Hanover, NH: University Press of New England, 2008.

Springborg, Patricia, ed. *The Cambridge Companion to Hobbes's Leviathan*. Cambridge: Cambridge University Press, 2007.

Stauffer, John. "'Not Suitable for Public Notice': Agassiz's Evidence." In *To Make Their Own Way in the World: The Enduring Legacy of the Zealy Daguerreotypes*, edited by Llisa Barbash, Molly Rogers, and Deborah Willis, 279–296. Cambridge, MA: Peabody Museum Press, 2020.

Stauffer, John, Zoe Trodd, and Celeste-Marie Bernier, eds. *Picturing Frederick Douglass: An Illustrated Biography of the Nineteenth Century's Most Photographed American.* New York: W. W. Norton, 2015.

Stepan, Nancy Leys. *Picturing Tropical Nature.* Ithaca, NY: Cornell University Press, 2001.

Stewart, Vicky. "East End Suffrage Map." Spitalfields Life, August 3, 2014. https://spitalfieldslife.com/2014/08/03/east-end-suffragette-map.

Stoneley, Peter. "'Looking at the Others': Oscar Wilde and the Reading Gaol Archive." *Journal of Victorian Culture* 19, no. 4 (2014): 457–480.

Stowe, Harriet Beecher. "Sojourner Truth, the Libyan Sibyl." *Atlantic Monthly* 11 (April 1863): 473–481. https://www.theatlantic.com/magazine/archive/1863/04/sojourner-truth-the-libyan-sibyl/308775.

Sullivan, Robert. "It's Hard to Get Rid of a Confederate Memorial in New York City." *New Yorker*, August 23, 2017. https://www.newyorker.com/culture/culture-desk/its-hard-to-get-rid-of-a-confederate-memorial-in-new-york-city.

Taghavi, Doreh. "Exploring Fallism: Student Protests and the Decolonization of Education in South Africa." *Kölner Ethnologische Beiträge* 48 (2017). http://www.researchgate.net/publication/323487222_Exploring_Fallism_Student_Protests_and_the_Decolonization_of_Education_in_South_Africa.

Taylor, A. R. E. "The Technoaesthetics of Data Centre 'White Space.'" *Imaginations* 8, no. 2 (2017): 42–55.

Taylor, Dorcetta A. *The Rise of the American Conservation Movement: Power, Privilege, and Environmental Protection.* Durham, NC: Duke University Press, 2016.

Taylor, Keeanga-Yamahtta, *How We Get Free: Black Feminism and the Combahee River Collective*, Chicago: Haymarket Books, 2017.

Theweleit, Klaus. *Male Fantasies.* 2 vols. Minneapolis: University of Minnesota Press, 1987.

Thompson, Erin L. *Smashing Statues: The Rise and Fall of America's Public Monuments.* New York: W. W. Norton, 2022.

"Three Negroes Lynched." *New York Times*, December 1, 1903. https://nyti.ms/3tTLeNX.

Times Editorial Board. "Editorial: COVID-19 Is Disproportionately Killing Minorities. That's Not a Coincidence." *Los Angeles Times*, April 8, 2020. https://www.latimes.com/opinion/story/2020-04-08/coronavirus-racial-disparity.

Tóibín, Colm. "Falling in Love with Lucian." *London Review of Books* 41, no. 19 (October 10, 2019). https://www.lrb.co.uk/the-paper/v41/n19/colm-toibin/falling-in-love-with-lucian.

Toscano, Alberto. "Images of the State and Stásis." https://cartographiesoftheabsolute.wordpress.com/2015/11/16/images-of-state-and-stasis.

Tralau, Johann. "Leviathan, the Beast of Myth: Medusa, Dionysos, and the Riddle of Hobbes's Sovereign Monster. In *The Cambridge Companion to Hobbes's* Leviathan, edited by Patricia Springborg, 61–81. Cambridge University Press, 2007.

Trouillot, Michel-Rolph, *Silencing the Past: Power and the Production of History* (Boston: Beacon Press, 1995).

"T. S. Eliot and the Jews." *Jewish Chronicle*, February 23, 1951.

Tsing, Anna Lowenhaupt. *The Mushroom at the End of the World: On the Possibility of Life in Capitalist Ruins*. Princeton, NJ: Princeton University Press, 2015.

Tydeman, William, and Steven Price. *Wilde: Salome*. Cambridge: Cambridge University Press, 1996.

"UCT's Maxwele Slammed over Physical Altercation with Female Wits Student." News24, April 5, 2016. https://www.news24.com/News24/ucts-maxwele-slammed-over-physical-altercation-with-female-wits-student-20160405.

UCT Trans Collective. "Trans Capture Status." In *Publica[c]tion*, edited by Publica[c]tion Collective, 26–27. Johannesburg: Publica[c]tion Collective, 2016.

Vallee, Mickey. "Animal, Body, Data: Starling Murmurations and the Dynamic of Becoming In-formation." *Body and Society* 27, no. (2021): 83–106.

Vandal, Gilles. "'Bloody Caddo': White Violence against Blacks in a Louisiana Parish, 1865–1876." *Journal of Social History* 25, no. 2 (Winter 1991): 373–388.

van der Wal, Ernest. "Killing Rhodes: Decolonization and Memorial Practices in Post-Apartheid South Africa." *Folk Life* (October 2018): 1–18.

Vartanian, Hrag. "How Do We Photograph Freedom? A Conversation with Leigh Raiford." *Hyperallergic*, June 21, 2020. https://hyperallergic.com/572314/photographs-freedom-liegh-raiford/.

Vaughan, Alden T., and Virginia Mason Vaughan. *Shakespeare's Caliban: A Cultural History*. New York: Cambridge University Press, 1993.

Vazquez, Rolando. *Vistas of Modernity: Decolonial Aesthesis and the End of the Contemporary*. Amsterdam: Mondrian Foundation, 2020.

Veracini, Lorenzo. *The Settler Colonial Present*. London: Palgrave Macmillan, 2015.

Vessey, Kevin. News 12, May 14, 2020. https://www.facebook.com/watch/live/?v=883142372184772&ref=watch_permalink.

Vicinus, Martha. "'Sister Souls': Bernard Berenson and Michael Field (Katherine Bradley and Edith Cooper)." *Nineteenth-Century Literature* 60, no. 3 (December 2005): 326–354.

Virey, Julien-Joseph. *Histoire naturelle du genre humain*. Paris: Crochard, 1801.

Virey, Julien-Joseph. *Histoire naturelle du genre humain, Nouvelle edition*. Paris: Crochard, 1824.

Virno, Paolo. "Interview with Brandon W. Joseph." *Grey Room* 21 (Fall 2005): 26–37.

Vitale, Alex S. *The End of Policing.* New York: Verso, 2017.

Walcott, Rinaldo. *The Long Emancipation: Moving toward Black Freedom.* Durham, NC: Duke University Press, 2021.

Walker, James. "More Than 80 Percent Support National Stay-at-Home Order." *Newsweek,* April 9, 2020. https://www.newsweek.com/americans-back-national-stay-home -order-1496997.

Walkowitz, Judith. *City of Dreadful Delight: Narratives of Sexual Danger in Late-Victorian London.* Chicago: University of Chicago Press, 1992.

Wallace, Maurice O., and Shawn Michelle Smith, eds. *Pictures and Progress: Early Photography and the Making of African-American Identity.* Durham, NC: Duke University Press, 2012.

Waller, Allyson. "Charlottesville Can Remove Confederate Statues, High Court Rules." *New York Times,* April 1, 2021. https://www.nytimes.com/2021/04/01/us/charlottes ville-confederate-statues.html.

Wallis, Brian. "Black Bodies, White Science: Louis Agassiz's Slave Daguerreotypes." *American Art* 9, no. 2 (Summer 1995): 38–61.

Wallis, Jim. "America's Original Sin: The Legacy of White Racism." *CrossCurrents* 57, no. 2 (2007): 197–202.

Wang, Jackie. *Carceral Capitalism.* Los Angeles: Semiotext(e), 2018.

Wark, McKenzie. "Editorial: 'Trans | Femme | Aesthetics.'" *e-flux* 117 (April 2021). https://www.e-flux.com/journal/117/387952/editorial-trans-femme-aesthetics/.

Warner, Marina. *Monuments and Maidens: The Allegory of the Female Form.* London: Picador, 1985.

Warner, Michael. "Publics and Counterpublics." *Public Culture* 14, no. 1 (2002): 49–90.

Waters, Chris. "'Dark Strangers' in Our Midst': Discourses of Race and Nation in Britain, 1947–1963." *Journal of British Studies* 36, no. 2 (April 1997): 207–238.

Wax, Amy. "Debating Immigration Restriction: The Case for Low and Slow." Special issue, *Georgetown Journal of Law and Public Policy* 16, no. 3 (2018): 837–864.

Weheliye, Alexander G. *Habeas Viscus: Racializing Assemblages, Biopolitics, and Black Feminist Theories of the Human.* Durham, NC: Duke University Press, 2014.

Weintraub, Stanley. "Disraeli and Wilde's Dorian Gray." *Cahiers Victoriens et Edouardiens* 36 (October 1992): 19–27.

Wekker, Gloria. *White Innocence: Paradoxes of Colonialism and Race.* Durham, NC: Duke University Press, 2016.

Wellborn, Vicky. "Confederate Monument Removal Proposal Exceeds Caddo Commission's Budget." KTBS, April 16, 2021. https://www.ktbs.com/news/confederate

-monument-removal-proposal-exceeds-caddo-commissions-budget/article_d7619dba
-9f00-11eb-a0a3-e39890e48386.html.

Wexler, Laura. "'A More Perfect Likeness': Frederick Douglass and the Image of the Nation." In *Pictures and Progress: Early Photography and the Making of African American Identity*, edited by Maurice O. Wallace and Shawn Mitchell Smith, 18–40. Durham, NC: Duke University Press, 2012.

Wheeler, Roxanne. *The Complexion of Race: Categories of Difference in Eighteenth-Century British Culture*. Philadelphia: University of Pennsylvania Press, 2010.

White, Jessica. "Police, Press and Race in the Notting Hill Carnival 'Disturbances.'" History Workshop, August 31, 2020. https://www.historyworkshop.org.uk/notting -hill-carnival-disturbances.

Whiteley, Nigel. *Art and Pluralism: Lawrence Alloway's Cultural Criticism*. Liverpool: Liverpool University Press, 2012.

Wilde, Oscar. "The Decay of Lying." *Intentions*. New York: Breinard, 1909.

Wilde, Oscar. "Ireland and the Irish during the Latter Half of the Eighteenth Century" (1889). In *The Prose of Oscar Wilde*. New York: Bonibooks, 1935.

Wilde, Oscar. *The Portrait of Dorian Gray*. London: Ward, Lock, 1890.

Wilder, Gary. *Freedom Time: Negritude, Decolonization and the Future of the World*. Durham, NC: Duke University Press, 2015.

Winckelmann, Johann. *Winckelmann: Writings on Art*. Selected and edited by David Irwin. New York: Phaidon, 1972.

Wolfe, Patrick. "Settler Colonialism and the Elimination of the Native." *Journal of Genocide Research* 8, no. 4 (2006): 387–409.

Wolfe, Patrick. "*Corpus nullius*: The Exception of Indians and Other Aliens in US Constitutional Discourse." *Postcolonial Studies* 10, no. 2 (2007): 127–151.

Wolfe, Patrick. *Traces of History: Elementary Structures of Race*. New York: Verso, 2016.

Wolfe, Richard. *Moa: The Dramatic Story of the Discovery of a Giant Bird*. Auckland: Penguin, 2003.

Worsley, Peter. "Frantz Fanon and the 'Lumpenproletariat.'" *Socialist Register* (1972): 193–230.

Worthy, Trevor H., and Richard N. Holdaway. *The Lost World of the Moa: Prehistoric Life of New Zealand*. Bloomington: Indiana University Press, 2002.

Wray, Helena. "The Aliens Act 1905 and the Immigration Dilemma." *Journal of Law and Society* 33, no. 2 (2006): 302–323.

Wray, Matt. *Not Quite White: White Trash and the Boundaries of Whiteness*. Durham, NC: Duke University Press, 2006.

Wyndham, Violet. *The Sphinx and Her Circle: A Biographical Sketch of Ada Leverson 1862–1933*. London: Andre Deutsch, 1963.

Wynter, Sylvia. "The Ceremony Found: Towards the Autopoetic Turn/Overturn, Its Autonomy of Human Agency and Extraterritoriality of (Self-)Cognition." In *Black Knowledges / Black Struggles: Essays in Critical Epistemology*, edited by Jason R. Ambroise and Sabine Broeck, 184–252. Liverpool: Liverpool University Press, 2015.

Yusoff, Katherine. *A Billion Black Anthropocenes or None*. Minneapolis: University of Minnesota Press, 2019.

Zuboff, Shoshana. *The Age of Surveillance Capitalism: The Fight for a Human Future at the New Frontier of Power*. London: Profile Books, 2019.

INDEX